Finish Your Film!

Finish Your Film!

Tips and Tricks for Making an Animated Short in Maya

Kenny Roy

Routledge
Taylor & Francis Group
New York London

First published 2014 by Focal Press

Published 2019 by Routledge
52 Vanderbilt Avenue, New York, NY 10017
2 Park Square, Milton Park, Abingdon, Oxon OX14 4RN

Routledge is an imprint of the Taylor & Francis Group, an informa business

© 2014 Taylor & Francis

The right of Kenny Roy to be identified as the author of this work has been asserted by him in accordance with sections 77 and 78 of the Copyright, Designs and Patents Act 1988.

Notices
Knowledge and best practice in this field are constantly changing. As new research and experience broaden our understanding, changes in research methods, professional practices, or medical treatment may become necessary.

Practitioners and researchers must always rely on their own experience and knowledge in evaluating and using any information, methods, compounds, or experiments described herein. In using such information or methods they should be mindful of their own safety and the safety of others, including parties for whom they have a professional responsibility.

Product or corporate names may be trademarks or registered trademarks, and are used only for identification and explanation without intent to infringe.

Library of Congress Cataloging in Publication Data
Roy, Kenny.
Finish your film!: tips and tricks for making an animated short in Maya/Kenny Roy.
pagescm
1. Maya (Computer file) 2. Computer animation. I. Title.
TR897.72.M39R6852014
006.6'96—dc23

2013047111

ISBN: 978-0-415-66181-2 (pbk)
ISBN: 978-0-203-38535-7 (ebk)

Typeset in Myriad Pro
By MPS Limited, Chennai, India

Pain is temporary, film is forever.

Three O'Clock High (1987)

Contents

Contents

Contents

Contents

Contents

Contents

Acknowledgements

First and foremost, I'd like to thank my amazing wife, Tamaryn, for being a pillar of support on these crazy adventures. I love you very much.

To David Tousek, a visionary and an entertainer at heart, thanks for putting on such an amazing workshop each year at Anomalia.eu.

Also to Jake Bergman, thank you for being there for me in a pinch.

Finally, thanks to all of the Anomalia artists below whose hard work brought Babinsky to life and made this book possible!

Jordi Gaspar Aldea	Tomas Juchnevic	David Toušek
Jan Bílek	Tyson Karl	Victor Vinyals
Jocelyn Cervenka	Angelique Kesselring	Jiří Vyšohlíd
Joost De Jong	Adam Krofián	Petr Vyšohlíd
Edwin De Loor	Carlo Loffredo	Irina Wolf
Victor Escardo	Jan Petrov	Georgi Zahariev
Martin Hammerschlag	Adam Pospíšil	Daniel Zeman
Pavel Hruboš	Daniel Řehák	Jan Živocký
Nick Groeneveld	Jan Saska	Juraj Zubáň
Michaela Jindra	Vít Sedláček	

About Anomalia

ANOMALIA, the professional training and networking lab in 3D animation, trains professionals in the field of modern CG animation with a view to increasing the competitiveness of modern animation filmmaking in an overall European context.

About Media

The film "Booty Call" and this book would not have been possible without support from MEDIA, the EU's support programme for the European audiovisual industry.

MEDIA
EUROPE LOVES CINEMA

ANOMALIA
PROFESSIONAL TRAINING & NETWORK IN 3D ANIMATION

Acknowledgments

First and foremost I'd like to thank my amazing wife Tamryn, for being a pillar of support on these crazy adventures. I love you very much.

To David Tosek, a visionary and an entertainer at heart. Thanks for putting on such an amazing workshop each year at Anomalia.eu.

Also to Jake Denman, thank you for being there for me in a pinch.

Finally, thanks to all of the Anomalia artists below whose hard work brought Rainsky to life and made this book possible:

Jordi Gaspar Aldea	Tomas Tuchowic	David Tousek
Jan Blaha	J Bon Kad	Viktor Vitvars
Jocelyn Cervanka	Angelina Casselling	Jiri Wschila
Joost De Jong	Adam Kohan	Petr Vuschild
Edwin De Loor	Carlo Lobredo	Tina Wolf
Victor Escordo	Ebi Pavor	Bernat Zalhovsy
Martin Hanmarschlag	Adam Pyzs111	Daniel Zeman
Pavel Hrbsus	Daniel Bazak	Jan Zlevsky
Nick Greenovisil	Jan Seska	Juraj Zabah
Michaela Indra	Yr Sedlovoik	

About Anomalia

ANOMALIA, the professional training and network in 2D/3D animation, trains professionals in the field of modern CG animation with a view to increasing the competitiveness of modern animation filmmaking in an overall European context.

About Media

The film really can and this book would not have been possible without support from MEDIA, the EU's support programme for the European audiovisual industry.

ANOMALIA

Foreword by Bill Kroyer

At last … a book about how to actually *finish* a short film. The minute I read Kenny Roy's suggestion that you should avoid distraction by working on a computer not connected to the internet, I knew I was listening to the voice of someone who knows how to get it done.

Of course, you can use your router's block settings to limit distractions, but should we get caught get up in these small details? YES! It is the small things that can stop you cold, derail your momentum, and prevent you from ever realizing that grand idea you believe you started with in the first place.

I recently spoke with a student filmmaker who had successfully completed all the animation tests for his film on his own workstation, only to discover in the last month of production that the render farm he needed to use for his finished product didn't support his rigging software. He had never tested that. He did a workaround but lost quality. His small oversight cost him, big time.

They say you can't think of everything, but actually Kenny has pretty much done that. From the big picture to the smallest tip, *Finish Your Film* is the book I will be recommending to anyone who wants to make a short. There's nothing more agonizing than having your visionary motion picture mired in production woes, and nothing more exhilarating than seeing it finished, on the screen, in front of a cheering audience.

The business is full of sad stories of projects that got derailed, and I've never seen a text that so thoroughly and deftly touches on just about every recorded pitfall—and solves them!

FIG 0.1

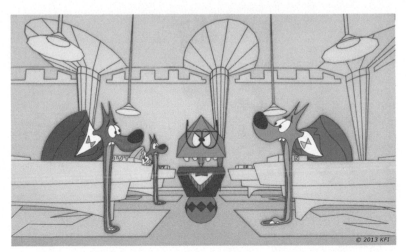

In the way-back-when days when I was lucky enough to train (on punched paper) with Disney's nine old men, we were taught the three steps of successful animation:

1. Idea!
2. Communicate!
3. Captivate!

You had to start with a terrific idea, one that would knock your socks off. But the greatest idea in the world is worthless if you can't *communicate* it to others. In animation, that means going through the complex process of creating and finishing an animated scene. I'm tired of being pitched "great" ideas. Show me, and let me see it being great. Let it captivate me.

In those days, doing twelve drawings for a second of movement was a lot of work. It took an infrastructure to finish a scene: desk, drawing disc, camera, lab, edit bench, movieola, projector, ink, paint, etc. Now every one of these processes lives in your laptop. Because of that we're seeing the greatest explosion of short film production in the history of the business.

The catch is that you have to know how to access, manage, and exploit all these wonderful new tools. When I made my short film *Technological Threat* in 1988, computer graphics was in its infancy. There were no online tutorials, no books on CG techniques, no YouTube how-to demos to watch. In fact,—we had to write the software we used in the film! It was a time when you had to invent your own filmmaking process.

The story of *Technological Threat* was a child of that situation. After my work on *Tron* (1982) I was hooked on the new frontier of CGI. I loved making the impossibly precise, complex, and geometric imagery a computer allowed. Being a Disney-trained animator, it pained me that I couldn't get the computer

FIG 0.2

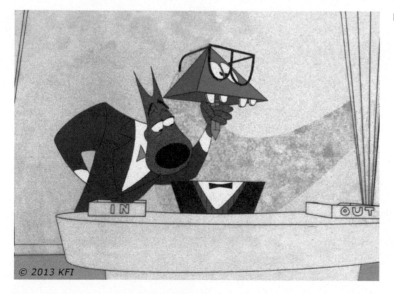

© 2013 KFI

to do organic, sensitive character acting. My idea was to exploit the best of both worlds: combine computer animation with hand-drawn animation.

So we invented a process where we'd model objects in the computer, render them as cleaned-up line drawings, then print them on punched animation paper. That way we could easily add hand drawing. That printer (a Hewlett-Packard rapidograph) could do a complex drawing in ten seconds. My character animator friends stood over that machine and felt they were witnessing their own doom. No human could draw that fast!

Thus—a story concept! I pictured a world where organic characters lived in terror of being replaced by computer characters. What could be more iconic than cartoony wolves? And for heavy symbolism we'd do the computer characters by computer and the organic characters by hand!

You'd think that would be enough, but as Kenny illustrates so well in this book, a concept is not a story! You need those classic elements of character, created world, conflict, and resolution. It took a lot of brainstorming, storyboarding, and gag sessions to make that concept (simple though it was) into a five-minute piece that explained the world, explained the conflict, and had a surprising, satisfying, provocative ending.

Remember: nothing is free in animation! Nothing just happens. You have to think of, create, and implant every last image and idea in your film. Don't think that just because you have something in your mind it will magically get on the screen. It takes work. We made a dozen endings for *Technological Threat* before we felt we got it right. The results were good; the film got an Oscar nomination, and I got into the Motion Picture Academy.

Today, as a governor of the Short Films and Feature Animation branch of the Academy I see a lot of shorts in competition. To me, the short film is the epitome of personal expression. It is every bit as artistically impactful as a feature because nowhere in the world is it stated that art must exist only as one length, or breadth or depth. *War and Peace* is 1,440 pages; the Gettysburg address is 268 words.

In an age when feature films can cost north of $250 million dollars, with credit lists scrolling a thousand names, *one artist* can still make a short film, a film that will entertain, delight, and captivate an entire jam-packed theater.

You can do that—if you can finish your film!

Here's the book that will help you do that, written in language you can understand, illustrated with clear examples, augmented with tools and tips. Read it, read it again, and follow it. We'll be waiting for you in theater!

Introduction to Short Film

Congratulations on embarking on the exciting journey of making an animated short film in Maya. Even though this process is long, difficult, tiring, and sometimes maddening, you are in good hands with this book. Before we dive into the technical and creative discussion of actually making your film, we should make sure you are up to speed on the overall concept of short film making. We need to be sure we know what we're getting ourselves into!

Key Characteristics of Short Filmmaking

The only technical characteristics you will find when researching short filmmaking is that the Academy of Motion Picture Arts and Sciences defines an animated short film as "not more than 40 minutes, including all credits."[1]

This leaves us with a wide-open idea of what a short should be, at least technically. In actuality, the fact is that most animated short films are between one and ten minutes long, with the average somewhere around two–three minutes for an individual effort and five–eight minutes for a group effort. Don't worry, you are *not* expected to produce a 40-minute masterpiece after reading this book!

So what are the characteristics of short filmmaking? To phrase it simply, I prefer to call what we are doing "short film making" rather than "short filmmaking." This acknowledges the key technical and artistic differences between what we are doing and what the major studios are doing. Simply put, we are NOT just doing a shorter version of what Pixar or Dreamworks puts in theaters. We are NOT employing the same techniques and decisions throughout the process on a smaller scale. And most importantly, we are *not* operating with a mentality that our film will have the same scale as its feature-length counterparts.

The real key characteristic of short film as it applies to us animating at home is that we are going to be economical in all of our decisions. From story choices to character descriptions, our film has to convey as much as possible while still being possible to complete individually or in a small group. We will talk more about these decisions in the next few chapters, but suffice it to say that being economical does *not* mean being boring. On the contrary, some of the best short films in history are the simplest in both story and technical achievement. We will talk about how to strike the perfect balance in this book.

Learn to ask yourself, "Am I showing exactly what needs to be shown to get my point across?" and, "How can I improve the message and make it easier on myself to get this done?" These questions should be answered repeatedly throughout your production, not just at the beginning.

One of the last characteristics of this process that is worth considering is that it is *very* intensive and difficult no matter how much preparation you make or how economical you are in your choices. There are literally tens of thousands of animators around the world who have the technical skill to pull off a short film, but for some reason we don't see thousands and thousands of shorts every year. We see a couple of dozen. This should be a sobering fact and make you really consider if you are in the right place to make a film. Not just technically or with a good enough idea, but in the right place in your life to embark on this journey. To get a film completed you must sacrifice a lot of time and energy. You may work many late nights and weekends to finish it. Especially if you have a full-time job and a family, starting a short film should be a decision taken very seriously. The entire aim of this book is to get you to *finish* the film, so if you do not feel like you are in a good place to finish, you should not start.

Finish by Making a Plan

The first thing you need to do is create a plan to finish your film. The best advice I can give, repeated by all of the filmmakers in this book and by the many artists I've encountered in my career, is to set a rigid schedule to follow. If you are taking time off of work to complete your film, make sure you start at the same time every single day. Even if you only have nights and weekends to work on the short, the most helpful thing to do for yourself is to set aside time every day for your work. This schedule should be explained to your loved ones so that there is no conflict; a short film can be as stressful for a spouse and kids as for an animator. Better yet, post your schedule up where everyone can see it. This has the double benefit of not only helping everyone see your plan but also making you probably a little bit more responsible in keeping to the schedule since your family is watching!

Workspace is Essential

Having done a lot of freelance work from home, I can state with certainty that you have to separate your work area from the rest of the house. A room that can serve as your office is the best situation: you can go inside, close the door when it is time for work, and emerge only when you need to. Get yourself completely out of the way of distractions for the best chance of success.

If you don't have a separate room that can be utilized as your workstation, or if you have a shared workspace with a spouse or family member, the schedule will come very much into play. If you are a young animator still living at home with your parents, for instance, and your siblings have to use your animation computer for homework, then it is good for you to schedule your work time right after school; more than likely homework is going to hog the computer "until it's done," meaning that once your siblings get on the computer, they aren't getting off for the night. In this way you will get some work time in before the computer is hogged.

Older animators living on their own should still heed the workspace warning. From experience I can say that even when there are no distractions, having your workspace in or near your common area can lead to huge problems. First, you are probably more likely to take unnecessary breaks when you are staring over your monitor in the kitchen or the bathroom hallway. Second, you will more likely be able to keep your schedule if there is at least an area partitioned off for work; experience has shown that when you go into a certain area *just* for work, you are more likely to stick to the task. Your mind sort of switches modes when you enter your space. This also means that you should not be using your workspace for common purposes. Hopefully you have an animation computer and then as well a laptop or tablet

(or even another desktop) that you can use for other purposes such as emailing and web browsing. You should not be going into your work area to watch YouTube or catch up on Facebook posts in your breaks. Lastly, and perhaps most importantly, if you are working in your house all day without a separate workspace, you will start *hating* your house. I know it sounds weird, but there's a feeling that starts creeping in as you work for long hours in your home with no separation between workspace and living space. Your short film will be filled with struggles, frustration, and a ton of hard work (and that's if everything goes right). In the same way, you do not want your home life to encroach on your work: you have to be able to unplug after a long work session and feel like you are actually getting away from the film. A chance to unwind, relax, gather your thoughts for the next time you sit down for work. Earlier in my career I would really "burn out" my house by trying to work in the middle of the living room. The result was a very distracted animator always feeling like he was not getting anything done and then stewing on the work when it was family time. To really feel like you are getting away from the film when your work session is over is to give yourself the benefit of a daily sense of accomplishment.

Further Removing Distractions

There are even more ways to remove distractions from your work. If you have more than one computer it is much easier, simply because you cannot connect your work computer to the internet. This solves 90 percent of all problems to do with focusing. YouTube, email, Facebook, etc., are all going to be things that stand in the way of your finished film. You may not think it's possible to work on a film without a connection to the internet, but believe me, it is; in many VFX houses I've worked for, computers are disconnected from the internet to protect the secrecy of projects that clients are trying to keep under wraps. At those studios there are normally internet kiosks that you can use to check email or look at for reference once a day or so. Think about it; depending on which point of production you are at, there is very little need for internet access.

Many people don't have more than one computer or it might be prohibitive to unplug completely. The next best thing is to block sites on a schedule using your router's block settings. Almost all modern routers have a setting that will allow you to add keywords or URLs to a schedule that will block them. I am not afraid to admit that I have Reddit.com blocked at the office 100 percent, and that Facebook is only available on a schedule (I post status updates to my friends letting them know about new content and webcasts on kennyroy. com, so I do need a *little* bit of Facebook every day). A simple and easy way to make sure you are not wasting time on the internet is to adjust your router's blocking schedule to coincide with the work schedule that you have created. *Et voilà*, when you sit down, there are no cat pictures clawing your attention from your precious short.

Sound is even more distracting when you are in the zone. A pair of noise-cancelling headphones and a great playlist can also mean the difference between piddling along on your film and having really productive work sessions every day. Make sure the headphones are really comfortable though; even the best ones that I've found end up making my ears sore after six hours or so. I can't even *imagine* what a pair of clunky headphones would do to my poor earlobes.

For music, I've seen animators who can work to every type of music that exists. Death metal to dubstep, rock to reggae—all that matters is that you can concentrate. I have a very hard time focusing if the music I'm listening to has lyrics. But give me some sweet drum and bass and I go straight into the zone.

Beginning to Understand Short Film as a Medium

We are going to embark on a journey that hundreds if not thousands of animators begin each year but never finish. We will excel where others fail because of our understanding of short film as a medium, combined with the technical workflows lauded in this book.

What are some of these first considerations?

To start with, we should cast off any expectations of making a film that looks like a shortened version of, or a scene from, a feature-length animation. From a technical as well as story standpoint, trying to replicate the scope of a feature film, even a shortened version, almost guarantees us an extremely tough time. Our goal should be to tell a simple story using the most effective visuals possible. We should not measure our success by comparison to our favorite animated films.

As a medium, shorts endeavor to propose a very simple story with a clear standpoint on the part of the writer/director (in this case, it's the same person, so we will use just "Creator" when referring to you, both writer and director). Instead of a comparison with animation we see in the theaters, we will measure our success by how clearly and succinctly we tell our story. And to measure this is very easy; your friends, family, and fellow animators are wonderful critics to help you hone the film you want to make.

If a feature seeks to establish a world and tell a story about characters in that world, then a short builds on a world we are familiar with. That does not mean you have to base your short on Earth; it means that as far as possible you rely on the preconceived notions of the audience to fill in the blanks. Your story will therefore be simpler because you do not have to go against our notions of our world. I'm already getting ahead of myself; let's save that good stuff for Chapter 3 (Story).

As far as subject matter goes, shorts are wide open. They can be as silly and meaningless as you wish, or they can be serious and highly dramatic. A funny short is expected to have a big payoff. Serious shorts are generally expected to exhibit a point of view more dearly held by the Creator, since his/her singular vision is on display.

How to Use This Book

Whether you bought this book with a short film in mind or are planning on starting the entire process from scratch, you should definitely read the first three chapters all the way through. There is a lot of information presented in them that I have not seen assembled in a concise manner before. Many of the techniques for working with story apply even to stories that you have already created. It will be good practice to apply these story-strengthening techniques to your film even if you've had a clear idea of what you want to create for a while. Also, the Introduction to 3D Production chapter will give you a good overview of the whole process and inform you about areas which you might be lacking the technical knowledge to complete.

Once you have read the first three chapters, you should begin to plan and design your film. Then, when you are ready, you can move on to each chapter in turn as you arrive at those points in production, referring to the tips given whenever you are stuck. I do recommend, however, that you at least glance over the chapters before you begin any part of your film. This book was designed to help you avoid the common pitfalls of making a short on your own. For that reason you should consider almost all of the information presented to be much more than helpful hints; in some cases the techniques and strategies are the difference between newcomers finishing their films or not. When you have finished your film, hang on to this book! Doubtless you will want to do another, and you can refer to the book whenever you need a refresher or inspiration.

Introducing *Booty Call* and Our Supporting Films

Booty Call

In late 2011 I contacted the organizer of Anomalia, a workshop-style CG and animation course given every year in the Czech Republic. David was very receptive to the idea of me creating a Short Film Production class. He and I and 16 students from all over Europe gathered in the small town of Litomysl and, in just two weeks, animated the film that is the case study for this book. The film is called *Booty Call* and is the tale of a greedy pirate named Babinksy who steals treasure from a ship.

FIG 1.1

I employed every single one of the strategies that are lauded in this book and for that reason we were able to complete the film in a short time. Of course, every production has its ups and downs, but in a production time of about ten workdays, our 'downs' normally only lasted an hour or so. In the end we all learned a lot, worked extremely hard, and are proud of our film.

All of the practical technical advice will be given in the form of tutorials and demonstrations, using the assets from *Booty Call*. When I have a modeling tip, I'll give you a demonstration using a model employed in the film. The same applies to our story discussion; I used the same story strategies to write the film you see here. When it comes to texturing, you will see the techniques described in this book in action.

You will also have access to these assets. I have included all of the Maya scene files and textures, etc., that you need in order to follow along with the book. Using these assets, you should be able to get up to speed very quickly even if you don't yet have your own film ready for production. By practicing with the assets included here you will develop the skills you need to habitually apply to your own short.

Supporting Films

Our book would not be the same without the filmmakers who have graciously allowed us to use their shorts to demonstrate concepts and further our discussion of the medium. Chosen for both the circumstances under which they were created (by either individuals or small teams) and their quality, these shorts will surely inspire and entertain you.

Adrift

Adrift is a beautiful short by Creators Ben Caset, Matt Smart, and Ben Clube. Set atop a flying whale, the short tells a sweet tale of the lengths we go to for love.

FIG 1.2

Beat

This incredibly imaginative short by Or Bar-El tells the tale of a worker caught in the drone of his everyday life breaking his routine and finding excitement in drumming his own beat.

FIG 1.3

Crayon Dragon

It's rare to get such a touching story in a simple package, but *Crayon Dragon* by Toniko Pantoja succeeds. Our only 2D animated example in this book, it holds up great among its 3D peers.

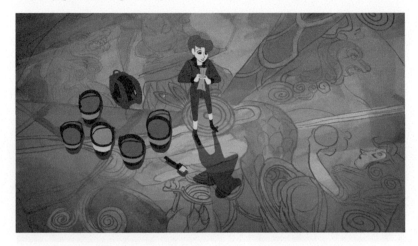

FIG 1.4

Devils, Angels, and Dating

This short, created by Michael Cawood and a team of artists spread around the globe, pits the Devil against Cupid in a fight for the affections of the alluring and buxom Lady Death. A great example of a full-blown home production gone right!

FIG 1.5

Drink Drunk

When all else fails, beg! That's the motto behind this simple yet entertaining short film from Leonardo Bonisolli. I admired the pushed style and the freedom in the posing, which is why it's included in the book.

FIG 1.6

Dubstep Dispute

All right, maybe this film is one of my favorites because I love dubstep. But on top of the awesome soundtrack, filmmaker Jason Giles shows you can lean heavily on visuals and a few gags to get an entertaining piece.

FIG 1.7

For the Remainder

This moody short by Omer Ben David exhibits an extremely poignant style choice paired with a morbid plot. It is a testament to how a strong vision can carry a film.

FIG 1.8

Meet Buck

This hilarious and stupendously animated short from Denis Bouyer, Vincent E. Sousa, Laurent Monneron, and Yann de Preval almost defies description. Suffice it to say, your day will be better after watching it.

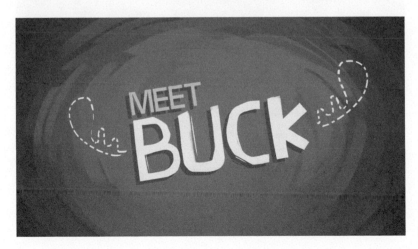

FIG 1.9

Our Wonderful Nature

One of my favorite types of short is those that have a twist in the middle that throws the audience for a huge loop. Tomer Eshed executes this perfectly in this hysterical short.

FIG 1.10

Paths of Hate

Paths of Hate was created by multi-award-winning filmmaker Damien Nenow. Many aspiring filmmakers create a short with humor and appeal, whereas Damien's film is a powerhouse of intense visuals and a serious message that leaves you thinking for a long time after watching. Truly great.

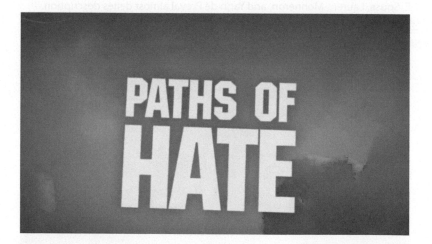

FIG 1.11

Reverso

Rounding out our example films is *Reverso*, a brilliant blend of humor and wit from creators Kim Honma, Clément Lauricella, and Arthur Seguin. I really admire the animation style, and what a strong concept!

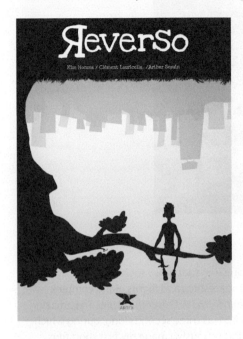

FIG 1.12

Finish Your Film!

No matter what brought you here, you are here to Finish Your Film. I promise that nothing will be more satisfying than the feeling of having completed your project. No pain is too great, no span of sleepless nights too long, no eyeballs too dry from staring at the monitor to make creating your own film not worthwhile.

I will be here with you every step of the way. And so, without further ado, let's get to work.

As always, Rock On.

Note

[1] www.oscars.org/awards/academyawards/rules/rule19.html

Interview

Paths of Hate by Damien Nenow

FIG 1.13

What was your first experience of creating a short film?

As soon as I discovered the world of 3D graphics I got the impression that those tools were made for film. I ignored high school for several months doing flying spaceships and flights along complex corridors. My first film recorded as a video file was *UFO nad czajnikiem (UFO over the kettle)*. The amazing epic about an ordinary kettle from the 3ds Max programme v2.5 was three seconds long, during which a spotlight moved over the kettle from point A to point B …. But seriously, I made my first short film in the last year of the art high school. It was about five seconds long and its title was *Ars Creativa*. The most important experience I gained working on that project was waking up from the "high" of slickness. It is very easy to relish the availability of the many effects in computer animation. *Ars Creativa* was crammed with all things possible. I'm ashamed of it even today. I learnt that films are not made of special effects and technological show-off.

When you felt technically challenged or blocked, what was your go-to resource?

The biggest problem with *Paths of Hate* was the fact that I wanted to create something fresh and artistically new at all costs, using a technology that is optimally designed for photo-realistic pictures. It was difficult to find any sources that would have made this task easier. All problems were solved by applying many techniques intended for completely different purposes. Those were weeks or months even of tests and trials. There are no handbooks describing the creation of new solutions.

What were some of the biggest challenges in creating your film?

It is probably easy to guess that the clouds sets were, definitely the most difficult and challenging elements to create in this film. It is always difficult to create clouds in 3D. Especially if you want them to look photo-realistic. Having them realistic and stylized at the same time was even more difficult. Choreography and dogfights and camera animation in *Paths of Hate* are very spacious and dynamic. So the clouds sets had to be completely three-dimensional. There was no way to use any kind half measures such as flat, fake, matte painted plates or stock shoots. Of course, you can always use

volumetric solutions. But they are very hard to control, and very slow to render. For clouds sets that big, it is almost impossible to control. I wanted to have full control over the shape and lighting in my clouds; they had to be geometry-based.

What was your main focus in completing this project? Completing a film? Making a statement? Getting a job?
Pure artistic calling. This is not a joke. I really wanted to make a film out of passion and so I did. That gave me huge satisfaction. From more down-to-earth motivations: I'd already had a job and had done several shorts. I dreamt about festival success. I wanted to create a film which would be watched by thousands of people, not only my friends and viewers at local screenings.

Did you employ any organizational tools such as charts or calendars that were pivotal in staying on deadline?
Paths of Hate had a lot of takes for a short—over 200. Plus there [are] a myriad composition layers—sometimes over 40 per shot. There are no such masters who would have it all in their heads. Fortunately, I managed to fit it all in one huge spreadsheet table. We would change colours of rows from red to green. We were sometimes so excited by the number of "greens" that we'd remove singular "red" shots so that they didn't spoil the green whole.

Was there another medium you considered for this short film? What were the benefits of working in the medium you chose?
I was thinking about combining 3D animation with classical, frame-by-frame 2D animation. These were just a few attempts. The effect was distracting. It focused the attention of the viewer who would wonder about the reason for applying the technique instead of focusing on plot and narration. Frame-by-frame animation is a particularly time-consuming medium. It complicates the pipeline of the project and makes it difficult to gather the team. I decided to make the whole film in 3D. Such a dynamic and dimension-focused theme as plane fights requires a three-dimensional medium. There was no other choice here.

What were some of your favorite tools to work with? What did they do to increase the quality of your film?
Almost the whole film was made using 3ds Max. Composition in After Effects. These are basic, well-known tools. We managed to do without specialist programs and plug-ins. I love mixing simple techniques and tools used for extremely different goals. I like 3ds Max a lot. It gives a huge field for using the tools "against the instructions." Some effects could not have been achieved with the use of existing tools, e.g. the clouds. It designed a pattern of creating my stylized clouds consisting only of the available tools, sometimes very surprising or old-fashioned ones. This effect still cannot be achieved even with the use of specialized tools for generating atmospheric effects.

What were some tricks to keeping you/your team motivated during this film?
Passion. If you carefully pick a team of people for whom work is more than making money you know you hit the spot. Shorts are rather not profitable; it's a job for real enthusiasts.

What sort of problems will someone likely run into when creating their own short film?
Shorts are sometimes a trap. They are usually flexible when it comes to deadlines and you make them with passion. You can easily fall into a never-ending process of perfecting things. It's a vicious circle. Frequently the author or individuals on the team are in control of huge part of the final effect. In such

conditions it is easy to lose the distance. Many short films were never made because the authors would incessantly correct the already perfect elements and forget about the rest of the film. Young authors of computer animations are frequently impressed with the inexhaustible resources of options and effects. I know it from experience. They forget what their film is and create meaningless technological show-offs. It also happens frequently that the directors of animated films are at the same time very good graphic artists: they make a lot of graphic-related work in their films. They are so excited with the production that they ignore conceptual work and immediately start generating assets. Then they work on details for months, create beautiful sets and then realize that they haven't even written the script yet.

In your opinion, what are the must-have skills that a person needs to create their own short, and what can be learned along the way?
You can learn or work out almost everything. Animation is a very visual medium. You can certainly use a bit of artistic sensitivity. On the other hand, an animated film is still a film. Animation is just a technique. Film language and certain rules are the same. You need to know about editing and directing. It is worth remembering that animation broadens the spectrum of available means of expression in film almost into infinity. However, I think that it's like running—first you have to learn to walk. Picasso first perfected his workshop creating realistic images of nature and only later started deforming reality. It's like that with film: it's worth know[ing] the basic, academic rules of the art.

How did your workflow/pipeline for this short differ from other pipelines you have been a part of? What do you think was the reason behind this change (if any)?
Workflow in *Paths of Hate* was definitely simpler than in case of a standard 3D project. Mostly because of a small team. I wanted to control a lot of elements so I worked on them alone. In such situation workflow is an abstraction, really. Everything is in my head so I know what I have and don't have, what I'll need in the next stage. The small team was also the result of the limited budget and people's availability. The majority of my colleagues were busy working on commercial projects of higher priority.

Was there a moment you knew your film was going to be a success?
In a sense—positive reception of the first teaser. We knew then that we'd hit the spot. If the film worked could only be checked after finishing the layout. During its first local screenings the audiences loved the film, but we only found out if it was a success after its first big festival screenings.

Describe your process for coming up with the idea. Did you build around a simple idea? Cut down from a larger idea? Explain.
The idea appeared six years ago, when I was still studying at the Polish National Film School. It was my own idea. A very simple one. It is not complicated, dynamic and surrealistic anecdote. A story about [a] duel which may not be completed without losing one's humanity. I'm a huge fan of aviation. So, let's say that I just couldn't imagine a greater subject for dynamic animation than a duel of two fighter planes. I don't want to spoil it now, so I won't tell how the story goes and how it ends.

I want to show one thing, however, which might be considered as the most direct reference for the story and idea behind Paths of Hate.
There was a photo that I saw, somewhere. These are pictures taken probably in London during [the] Battle of Britain in 1940. As you can see, there are hundreds of white lines left by fighting planes. It looks a little bit like scars. I thought that some of them were the only remains that were left after planes and pilots who didn't survive this fight. There must be thousands of stories behind them. These white trails are the most important elements in *Paths of Hate*. I have named the film because of them. These are the paths, from the title.

Explain your pre-production methods and planning. Did you use an animatic, pre-visualization, scratch recordings, or just go straight into production, modeling, and animation?

Pre-production was extremely important for me. First, there were many versions of the storyboard, then the animatic made up of edited storyboard images, then, sequence after sequence, the layout which was the previz at the same time as created. Each of these stages was accompanied by editing—that was very important to me. I tried to control the composition of the whole. It was only when I was completely satisfied with the effect that the actual production of the film and final assets began. This makes things that much easier. You create elements to match the already existing shots and camera angles. Thanks to that nothing is wasted because we create no unnecessary sets and objects not visible within frames.

What words of encouragement do you have for someone who wants to create a 3D film at home?

These films are not made for money, their production costs are never returned. An animated short is almost never a product in itself.

It is a thing, however, that we can show to the whole world. They circulate around festivals around the world, they are shown at various screenings. Also, animated short films have their own categories at those most prestigious festivals. Besides, animated shorts are probably the only form allowing the artist, the creator, almost complete freedom of creation. He or she is not restrained by the laws of market: the contents don't have to sell; resources don't have to be returned. In an animated film everything can be created from the beginning with no limitations. That is why we like making them so much.

Introduction to 3D Production

This is, at its heart, a Maya book geared towards giving you at-home animation creators the skills you need to make your dream film. In reality though, a 3D production has dozens and sometimes hundreds of artists all working in concert to create an animated piece. Even short films in a very large studio environment will be touched by artists numbered in triple digits.

Because the process is so collaborative and multi-faceted, my first task is to break down the steps involved in creating a piece of animation so that you can have an overview of the tasks ahead. You should also use this chapter to gauge where your strengths and weaknesses lie; if there is anything that you are sure you will have difficulty with, look to our example films to see where they might have cut corners to make the production possible.

Remember: even in a high-end professional animation studio (actually, especially in a high-end studio), artists are rarely asked to perform in multiple

disciplines. Creating a short film on your own is bucking the traditional role of an animator and stepping up to the challenge of executing a vision in its entirety. There are going to be parts of the pipeline where you should seek help. There just *are*. You should not count it as defeat, but rather a chance to learn. Or if you can find a brilliant way to sidestep the technical aspects that you dislike or cannot perform, bully for you!

Using This Chapter

We all have our weaknesses. I advise you skim this chapter and make sure you've at least heard of all of the names of the production processes. If one of the following terms is foreign to you, do further research into the process and then come back to the book. If you see a certain step that is one of your lesser favorites or you don't think you have the technical or artistic chops to handle, then we can plan for that too. This chapter can set you up for success by giving you a heads-up for the difficult tasks ahead. As we discuss story and pre-production, take some time to brush up on some of the disciplines where you may feel you are weak.

The Standard Studio Pipeline

Roughly speaking, our process mirrors that of a feature animation studio. This is very roughly speaking. Many things will change in our pipeline, for reasons that include our film not being nearly as long, not having anywhere near as many assets, and probably being all pantomime.

Even so, here is the rough order of processes for a studio film:

Script

Design

Visual Development

Storyboards

Recording

Animatic

Modeling

Texturing

Rigging

Layout

Animation

Lighting

Rendering

Compositing

Editing

Sound Effects/Music

Color/Master

Processes Explained In Depth

Despite any surprises you may just have had looking over the rough list, read on to see the different tasks explained in more detail. Again, if you are feeling a little overwhelmed, now is the time to start trying to familiarize yourself with these processes. I will also point out where in *Booty Call* and our other supporting films intelligent choices were made to make these tasks manageable.

Script

Simply put, writing the script starts with an idea. You've had a really interesting character knocking around in your head for a while, maybe you have even written the story down. Regardless of the strength of your idea, you need to write the story down so that you can start *working the ideas out in an organized way.*

Booty Call utilized all of the story tips that I present in this book, so the script for the film was actually extremely simple:

> *Booty Call: a pirate story about greed*
>
> *It's night-time, and under the cover of darkness the pirate Babinksy rows a small boat up to a huge ship anchored in a bay. On board is a treasure of immeasurable worth. Babinsky cuts a hole in the side of the ship to steal the treasure chest inside, chuckling to himself the whole time. Once inside, Babinsky sees the treasure is more than he could have imagined! But when he lifts the overflowing treasure chest into his rowboat, a single coin falls out and rolls deep into the ship. Even though it's only a single coin from the massive treasure, Babinsky's greed gets the better of him and he chases the rolling coin throughout the ship until it falls through a grate covering a dark hole. Without thinking, he pulls open the grate, but red eyes FLASH in the darkness. Uh oh. Before Babinsky can cover the grate back up, a barrel rolls into him, and knocks him into the pit below. ROARING and SCRATCHING accompany Babinsky's screams, then, just before the silence, we hear a big BURP and the coin is spat out of the grate.*

You do not need to get more complicated than that, especially if your film does not contain dialogue. The point is, following the Writer's Guild official screenplay format is a step that you should take only if you have aspirations to write in the future. For the purposes of your short film it is best to keep the script in an at-a-glance readable format for a while.

Design

We will, of course, talk much more about design in the preproduction chapters, but it is worth mentioning here that a huge number of the

decisions that make or break a film occur at this point. Designing characters, environments, and props is an essential part of the process for any film and should not be skipped; but if you do not have the skills, doing it on your own is almost as bad as not doing it at all. Can you model a character that has ten tentacles? Let alone *rig* that many complex appendages? Are you falling back on humanoid characters when your story would be just as strong with extremely simple designs, such as flour-sack characters, boxes, or spheres? I would be remiss in my duties of making sure you finish your film if I did not mention the fact that there are hundreds of thousands of extremely talented designers who post their work on the internet. Many times I've contacted artists whose designs inspire me, and many times they are happy to collaborate on a project. You would be surprised how exciting it is for a talented young designer to see their characters come to life in 3D, especially in short film format. No matter the medium used, good design will catapult the film into a different league So reach out to designers who inspire you if you have a lot of trouble in this area.

FIG 2.1 This design from the film *For the Remainder* captures the essence of the cat without being overly designed. There is a distinct style here, though not so abstract that we cannot tell what the character is. The filmmaker was smart with this decision.

This is not to negate the positive effect that learning while doing can have. However, seeing many projects fail from lack of design makes me recommend you err on the side of caution and perhaps learn while doing on other tasks such as modeling and lighting.

Visual Development

Much as for design, this step means searching for the "look" of a film. In visual development, or viz dev, as it's called, we jump ahead a bit in the process. It's not uncommon to start experimenting with shaders in Maya at this stage, to try to come up with a unique render style. It's not uncommon to start fiddling

around with scripts that automate tasks or give you a unique effect in your scenes. It's fine to do a few very simple animation tests that employ the viz dev experiments that you conducted. It should be noted that the assets created during this stage should not be considered as production assets but rather as good examples of certain visual statements you'd like to make. Of course, you can save materials for use later on and I'm sure even a light rig will make an appearance, but this is not you "starting work" on the short. Think of this stage as giving you a little time in Maya to answer the questions, "What will this look like?" and, "How would I begin the process of achieving this look?"

As far as finishing your film goes, many of my projects have stalled in viz dev for months. To combat this, you should set a very clear schedule for yourself for viz dev entry and exit. Truly, there is no limit to what you can do in Maya, so you will be tempted to develop the look forever. When this happens to me, I just tell myself, "This is awesome, but the film I'm working on already has a good look; I'll use this new thing on the next film." Stick to your schedule and you should be ok.

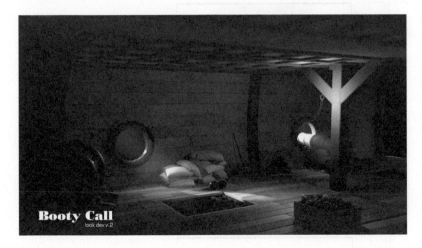

FIG 2.2 This early image from the look development of *Booty Call* shows some of the decisions of lighting and atmosphere we wanted to get into the film. Notice how nothing is textured; we are simply looking at solutions to get the right "mood" in the belly of the ship.

Storyboards

"Boarding," as it's called, is the process of drawing each scene out so as to get a good sense of the camera moves, staging, and action. Boarding is another one of the essential processes of short film creation; while you might get away with an extremely short viz dev stage, skipping boards means you are inventing each shot as you go. This is a recipe for disaster, and another one of the critical points that determine whether you finish your film or not. We will talk much more about storyboards in the chapters that follow, but it is worth mentioning early on that this phase is your last chance to create editing choices. What I mean is, after this point you will almost certainly be using all of

the animated footage you create. It would be adding an impossible amount of work to an already intense process to assume you can fix an animation in editing. Put another way, we have no "cutting room floor" in animation (reel upon reel of b-roll, extra footage, multiple angles, etc.). Take the time to really experiment here: it will pay off.

FIG 2.3 This storyboard from *Reverso* is clear, simple, and essential for getting an early look at the direction of the film.

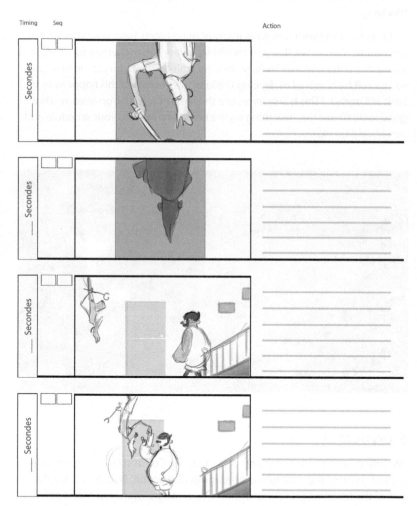

Recording

If your film has a character that makes a noise or if there's dialogue or any other need for recorded sound, it should be tackled at this stage. After the boards have dictated the direction of the film and the script is locked, you can

record your voices and hopefully all of the secondary sound effects you will need later on. The only advice I can give at this stage is that good recording quality can make or break a short film. Buying equipment normally costs more than an hour or two in a really high-end recording studio, which is all you'll need. And this is the real clincher as far as finishing your film goes: the more skills you have to learn from scratch during production, the higher the chance that you won't succeed. If you're not familiar with equipment, recording levels, soundproofing, and the myriad other issues that make up audio recording, you may just be dragged down by it all. Though recording really interests me, I use a professional studio nearby for all my audio. It normally runs me about $200, far less than a decent microphone—and we haven't even started talking about the time investment necessary to figure all of this out.

Animatic

One of my favorite parts of the process is the animatic phase. This is when you take your drawn storyboards and begin editing them into a movie with your dialogue, music, and sound effects. Technically, this is the beginning of the editorial phase as well, which lasts through the entire film.

The real advantage of the animatic phase is that it gives you an early peek at the strengths and weaknesses of the film. You get to see the pace and can start making adjustments to the project at a holistic level. It's a great time to get the pencils back out; gaps in the plot that surface during this phase are easily corrected by some new boards. This back-and-forth development is very enticing, but do not get caught in a cycle. Many first-time filmmakers fall into an endless loop of tweaking the storyboard and editing.

FIG 2.4 During the planning of *Booty Call*, I was lucky enough to have the time to massage the edit a little bit before the animation began. I found that the shots that I had come up with were almost the perfect length after we had animated, something only possible if you have a thoughtful animatic.

Modeling

With final character designs in place and an animatic to guide you on the kinds of props and environments you are going to encounter, it is time to start building assets. Modeling is when you create the assets out of geometry in Maya. For the purposes of completing a short film, the modeling phase should also be when you consider the purchase of models from online repositories like www.turbosquid.com and www.creativecrash.com.

Think long about this: how can you be the most efficient? Is there a smarter way to get the characters, props, and environments you need for your film? We will talk at length about the shortcuts I employed to get *Booty Call* up and running for the animators in record time. Some of these considerations will be based on your modeling skills, others will be based on the availability of the models you need. For instance, you are almost certainly going to be modeling your main character if it is a unique design, but if you need a battleship for the climax of your short, chances are it will be more worth your time to purchase that asset.

FIG 2.5 Talk about efficiency! In *Beat*, the artist used the most simple shape imaginable to create a lively performance: a box. Think about all of the modeling time saved with this choice, and rather than suffer from this choice, the film actually shines.

Texturing

Another one of the classic CG (computer graphics) tasks is texturing, or creating the colors and surface qualities of your objects. This phase bears similarity to the modeling phase in that the level of skill you possess will determine how many of your assets should be purchased or whether you should leave out texturing altogether. In fact, many successful films bypass the texturing challenges of a traditional "look" and use solid, bold colors to tell their stories. A couple of our supporting films do this.

You will also find that many of the assets you can purchase online have texturing included in them; building out your scenes will come down to a matter of budget, time, and your skill level in this area.

FIG 2.6 In *Drink Drunk*, many of the characters, props, and 3D set pieces all rely on flat color to get the point across. In a fun short that is more about the movement of the characters than the realism of the scenery, this choice makes a lot of sense.

Rigging

In the rigging phase we add articulation to our characters so they can be animated through the scenes and give us a performance. Rigging is also the phase when we ready props for animation and create helper objects in our sets to give us some technical relief down the road. Truly every asset needs a "rig" of *some* sort. You will see when we discuss this phase in *Booty Call* how having a rig for every object came in handy.

On the other hand, rigging—specifically, creating articulation for characters—is one of the most complex technical tasks in filmmaking. With no time restrictions and a huge sense of curiosity, you *may* be able to pick up rigging on your first film. Not everyone is lucky enough to be able to spend a few consecutive weeks learning the basics of rigging, though.

So to start to quell the rising stress levels I am sure you are feeling, I say this: there are literally dozens of automatic rigging scripts that will get you in great shape for your film. Most are free, and the paid-for ones are affordable and full-featured enough to be considered a cost-effective solution for your project. On top of the automatic character rigging tools that are available, another option is to use a character rig that can change itself. "Morpheus" by Josh Burton (www.cgmonks.com) is one such, and we have included version 1.0 with this book so that you can start experimenting with his controls. Other characters exist, but check before you use them to make sure they are free for commercial use (even festival entry is considered commercial).

FIG 2.7 Morpheus is included in this book's source files. He is one of many rigs that are freely available and fully customizable to your needs. If rigging is not your forte, I highly recommend you utilize automatic rig tools or completed characters to finish your film.

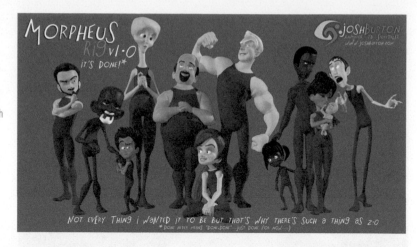

FIG 2.8 When we got to doing layout for *Booty Call*, the film was already shaping up. The animators had an easy time creating their animation from this point onwards (as easy as it goes).

Layout

In the layout phase things start to get very exciting. You begin assembling the scenes in your film and finalizing what assets are needed to complete each shot. If you missed a set piece, prop, or (hopefully not) character, in layout you will be able to take note of it and start creation right away. Sometimes

layout is considered "previz" because you will also be moving the characters and cameras around in a crude way to further gauge the pacing and direction of your short. Remember also that editorial is going on during all of this, so anything you create you will be cutting into the piece to replace boards. Eventually, when the entire film is laid out (and it is wise to lay out your entire film rather than commence with animation on shots) you will have a new 3D animatic. This new animatic will inform you of certain choices, such as camera and staging, as even the best storyboard artists won't be able to get everything totally perfect in drawings. This is why things get exciting; in layout, you finally move all of the development into 3D.

Animation

The one phase you can't fake or skip and which will definitely need the skills to execute is the animation phase. This is when we take all of our completed rigged assets, including characters, props, and cameras, and move them in the scene. More than likely you yourself are an animator, wanting to get a leg up on the rest of the tasks, which is why you bought this book. If you are not primarily an animator, then we have a lot of work ahead of us. I am not saying it is impossible, but it is extremely difficult to learn the art of creating believable, engaging performances while also creating a film. You really need the freedom of being able to experiment, make mistakes, and follow wild tangents in your work to learn animation the best way. This is contrary to the way we should go about creating a film, which is focused, regimented, and methodical. I can't prevent you from attempting a short if you've never animated before, but please at least sign up to some forums or take advantage of the free trial on my animation training portal www.kennyroy.com—you are going to need all of the support you can get.

FIG 2.9 Moving characters in a believable way is a skill that many spend years acquiring.

I wrote this book with animators in mind, and more than likely you have some experience with animation. As we move on, though, I will try to help you make smart choices to avoid the common pitfalls of animating your own short.

Lighting

When the scenes are ready to render (i.e. when the computer takes the grey, unlit scenes and draws the final colored, lit images), you must first position and edit lights. This phase is strikingly similar to its real-world equivalent in film and photography. If you have experience or interest in either of those areas, lighting in CG will come naturally to you. In truth, it is one of the more intuitive phases in CG, but it should also not be underestimated. A huge portion of the time spent on lighting involves troubleshooting problems created much earlier in the pipeline that only rear their ugly heads once you are almost finished.

We will show you how to save time by creating light rigs beforehand, and some settings and presets that will serve you in your endeavors. Just remember that this phase is marked with long periods of waiting as the computer calculates.

FIG 2.10 Lighting can have a very important role in your film. In *Paths of Hate*, the lighting is controlled in a meticulous way that really makes the viewer feel the intensity of the scenes.

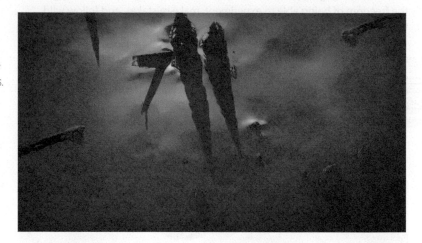

Rendering

Rarely is rendering your film merely an act of clicking the "render" button and going out for coffee, returning hours later to a perfect image. In a traditional production pipeline, the scenes are broken into layers and objects, so that each facet of an image can be edited after the render is complete. Want to change the amount of reflection on an object? Just adjust the opacity of the reflection layer. Want to change the glossiness of a highlight? Change

the levels on the specular pass. We will go through how to break up your scenes into a good bare minimum of layers so that you don't have to re-render the entire shot if only one of the passes has a problem. Suffice it to say that the number of layers that go into a single shot in a feature film can number in the hundreds.

FIG 2.11 The computer will calculate the images one at a time when you render, which can take hours per frame. To avoid such long render times, we can use tricks I will show you in this book.

Compositing

Remember all of those rendered layers? Assembling them into a final image is called compositing. We will go over the basic tenets of compositing so that you can get a sense of the workflows involved. However, beginners should strike a balance between rendering in layers and getting a near-final image out of a single Maya render, erring on the side of the single image. Compositing is another of those tasks that can be show-stopping if you have to learn advanced techniques in the middle of working on a film. We will look at both kinds of compositing situations.

Editing

In reality you have been editing the film the entire time. However, when you are done compositing shots, you can insert them into your timeline and start making final edit decisions. This "final cut" will be the piece that is scored and to which the Foley and sound effects tracks will be applied. In large-scale productions, the amount of footage that is being produced every day determines the need for assistant editors—people whose job is to organize and assemble the animation for the editors to actually create the sequences. We are working on a much smaller scale, but I mention this because you

should also be thinking up front about what methods you are going to use to stay organized as you edit the film.

Sound Effects/Music

As the edit is being completed, the sequences will be sent to a sound mixer and a composer or music editor. These individuals will be fleshing out the sound of the film, and it should be noted that they are working with final or near-final sequences due to so much of the impact of their work depending on the marriage between sight and sound.

Color/Master

The very last visual step is to color the film. This is when the final images are tweaked by a colorist to finalize the mood, look, and feel of the film. Subtle adjustments at this stage can vastly impact on the visuals. With our schedules and budgets at the shorts level, coloring can be done as the last part of compositing, so long as you are sure you are working with enough of the film to be making overall color choices.

Mastering is the act of taking the final colored film and final audio mix and creating the final file or media from them. Whether it's a Blu-ray, DVD, HD tape, or, if you want to be adventurous, film, this is the final step of your production.

Getting Started

At this point it would be a good idea to stop and research any of the steps mentioned here that you are not familiar with. Come back to the book when you feel you have at least a cursory knowledge of the step. I promise that you will be in good hands with all of the tasks in Maya that are covered in this book. And, if I haven't scared you out of making a film by now, you are probably serious enough to finish it!

Let's get started …

Interview

Beat by Or Bar-el

FIG 2.12

What was your first experience of creating a short film?

Actually, other than some school exercises *Beat* was my first short film. I had a "head start" on *Beat*; in my second year of school I created a short exercise called "Rimshot" (www.youtube.com/watch?v=8HYiQg0EMA4). This exercise was also an attempt to base a film on rhythm and beat and in a sense it paved the way to the making of *Beat*.

When you felt technically challenged or blocked, what was your go-to resource?

Other than the obvious place to find technical resources (Google), I have the fortune to have some very talented and helpful friends. My good friend (and technical director) Yair Halpern was my go-to person for any technical glitch I encountered. I don't come from a technical background so he played an essential role in helping me complete *Beat*.

What were some of the biggest challenges in creating your film?

Developing a different world, with a different set of "rules," I had to pay extremely close attention to developing the rules of the world my character lives in, and to making sure my character evolves and acts within those "rules." The rhythm leading the film was also a challenge, staying "on beat" but not sacrificing the tempo of the film as a whole at the same time.

What was your main focus in completing this project? Completing a film? Making a statement? Getting a job?

Definitely making a statement. It was very important for me to be able to "say something" with this short film. I felt it was essential for me to try to convey my view of the world. I knew that there would be added bonuses too, such as perfecting certain skills and learning others, for example, but making a statement about the world is the reason this film was made.

What inspiration or reference outside of animation did you use to complete your film? For example, cinematography, classic paintings, music?

It would be a cliché to say that everyday life is my inspiration, but what can I say? A usual experience from my everyday life, riding the bus, looking at the people in the street and how they move, their rhythm, thinking about what their lives must be like. I can say that I listen to a lot of music, almost constantly, and therefore music is an inherent part of how and why I create, and so is cinema; it would be almost impossible to point out the few that made the most difference.

Did you employ any organizational tools such as charts or calendars that were pivotal in keeping to your deadline?

Staying on deadline is always a challenge. Staying on schedule but still creating something that I see as good. So to try to stay on schedule I did have some production charts. I had to find a way to organize around a hundred shots of animation, render, etc. I had ordinary "to do" lists and my charts helped me stay focused on my tasks and not worry (too much) and finishing on time.

Was there another medium you considered for this short film? What were the benefits of working in the medium you chose?

No. I always knew it was going to be a 3D film. The way I saw the film in my mind, from the stage of the concept I felt that the 3D was essential to tell the story and create the feeling in that world.

What were some of your favorite tools to work with? What did they do to increase the quality of your film?

First of all, the most important "tool" I had, if it can be called a tool, was the pipeline. If the production process hadn't been organized, I would have had a very hard time staying on top of everything. Having good 3D rig to work with was a blessing. I had two rigs (created by Yair Halpern) that were made especially to the specifications of the film, allowing me to concentrate on the animation, timing, and acting rather than having to deal with technical glitches and finding workarounds.

What sort of problems will someone likely run into when creating their own short film?

There are potential problems in every single step of the process, from finding an idea and concept that you believe in all the way to the editing or rendering. Even once you've found that "idea" you have to make sure you don't lose sight of that idea during the process. A lot of films lose sight of their initial idea and end up being "just" beautiful but the story or concept are vague, or the other way around. The trick is to find the balance

In your opinion, what are the must-have skills a person needs to create their own short, and what can be learned along the way?

First and foremost you need to have the motivation to make a film. You have to want to make it and have to be willing to go with it all the way. You have to be aware of the work you are doing, or have a supportive and honest network of people around you. It is important to have people you trust around you who will be able to provide some critique in the stages you know aren't your strongest, be it the technical side, the design, the story, etc.

Was there a moment when you knew your film was going to be a success?

I think I believed all through the process that this film tells the story I want to tell, and that it "works." I just got to the point that I had to finish it and not worry what others might say or think. I was overwhelmed by the response. I never imagined it would touch so many people and appeal to so many. I am still overwhelmed by the extent of the response when I stop and think about it.

Are you planning on creating another 3D short film?

There's always a plan. After working on *Beat* for over two years I'm trying to "take it easy", trying to explore my creative outlets and rest from the production of *Beat*, but I already have around three ideas for short films looming about in my head, waiting to be made.

Describe your process for coming up with the idea. Do you build around a simple idea? Cut down from a larger idea? Explain.

In the case of *Beat*, it started as a tiny idea that grew around the technique I saw it in. Everything came from those to anchors: I had the story and basic design in my head, I knew it would be based on a soundtrack of drums (as that was already in the initial exercise "Rimshot") and I knew I wanted it in 3D. I think that in the case of *Beat* the technical aspects helped make the statement I was trying to make. Though I'm not sure how the development process would be if I didn't know all these things in advance.

Explain your pre-production methods and planning. Did you use an animatic, pre-visualization, scratch recordings, or just go straight into production, modeling, and animation?

I started with the storyboard, but as I dove into the process I had to "feel" it in the 3D space and on a timeline. It took a few runs of previz on a sound sketch, and I worked with a sound editor and the soundtrack went through a process much as the visual side of the film did. Once I was happy with how the film sounded and felt in terms of tempo and timing, I went on to animate. The modeling happened at the time the storyboard and previz were made and the rigging as well.

What words of encouragement do you have for someone who wants to create a 3D film at home?

It's worth it. It's worth all the hard work and the difficult times a creator has during his process, having a good, successful film that you are proud of is worth all the hard work. I have things I would've done differently, after learning all the skills I have during the production, but it's been a fun ride, and I hope the next one will be even better.

Please discuss the message you were trying to convey with this film.

We live in a world full of rules and conventions; we have little to no control of them. Very easily you can find yourself in this world, living with these rules and losing what makes you. The statement I was trying to make was to encourage you to find what makes you happy and what your reason is for doing what you do, and not losing sight of that while living this life of rules and conventions.

Discuss the red square on your character.

The red character is what lies within the main character of the film. The drummer is the catalyst of the whole episode. The red square on the character, other than being the obvious red beating heart, is also where we see this drummer starting to appear. It is what drives the character in the end, the part that in the beginning was dormant.

Story

If you take away all of the production problems, technical obstacles, and sheer hard work that goes into a film, you get to the seed that starts it all: story. They say that story is king. Indeed, no matter how fancy the lighting, how beautiful the animation, or how detailed the models, no audience will appreciate a film that has a weak story.

This book seeks to unblock you, the independent fledgling filmmaker, in your quest to bring an animated short to the screen. So while it is outside the purview of this book to explain the story process in enough creative detail to be a replacement for a short story writing class, my explanation of how to craft a story suited to an individual effort will offer a lot of insight into the overall creative process. Remember, all of the elements of your film need to work together, so the shortcuts in story I am going to show you also give you a head start in terms of technically achieving the film you set out to make. The technical tips and the story tips go hand in hand, but remember: story is king.

Structure

How is the structure of a short film different to a medium or long-format structure? The simple answer is that the basic structure is no different. There will be some tricks we use to maximize the time we have. We want to capitalize on the fact that audiences are sophisticated and will do a lot of the "work" for us with story. Only when it means that we will be getting more bang for the buck will we deviate from normal story structure for this short. In terms of the length of short films, we generally accept that the stories are going to be more compact. While it's true we don't have time to let an epic unfold, this does not mean that our stories need to feel "small." On the contrary, some of the best animated short films make clever use of some of the tricks explained in this chapter to bring a rich, full world to the audience. Let's talk briefly about the parts of a story that never change. They are:

> Beginning
> Middle
> End

If you are scratching your head or laughing or both (wow, you're coordinated!), that's OK. It may seem overly simple, but there have been many occasions while teaching short film to students when I've said, "This film seems great, but it doesn't have an ending." Understanding the function this story structure serves is important for utilizing the time and energy-saving tips that we will discuss later.

Beginning

This is the first part of your film, of course. But the beginning actually serves many important functions. It introduces your character(s), your setting, and the conflict. By the end of the beginning, you will have set up the scene and also the problem that needs to be solved. More on this in a bit. There are several great ways of ensuring that your beginning is effective.

Instantly Recognizable Characters

You only have a few seconds to establish the characters and setting of your film before you have spent too much time doing so. Meaning, if you are going to create a two-minute film, you should not spend the first 30 seconds using animation to explain the detailed nuances of your main character. While it may seem that you are limiting your options if you don't have a highly original character, the reality is that we are more invested in characters we can relate to. Therefore, choosing characters that are easy to recognize is a good way to get the audience started on the right foot.

Choosing instantly recognizable characters starts with deciding on what response you want from the audience. Choose characters to fill roles that

fit the cultural or social norm for that role. Meaning, if you are telling a story about a character that is officious and authoritative, perhaps a police officer can fill that role. Most of us have a healthy respect/fear of police and so will instantly be on board to accept this character in that role. If you have a character you want us to dislike, then perhaps the police officer could be writing a parking ticket for a car, looking gleeful the entire time. This character elicits an immediate negative response from the audience as we've all received a parking ticket unfairly at some point. When it comes time for this character to be punished, the audience will rejoice.

Don't despair that you won't be able to have a unique character; this is not so. Even if you have a character that has never been seen before (an alien, perhaps), you can still use the concept of the "instantly recognizable character." What you have to do is choose a familiar character trait and have your unique character display just a little bit of this trait. For instance, if your character will later save the day due to his honesty, start the short with him returning money mistakenly given to him as change at the store. Even if your character is highly nuanced and specific, as an audience we recognize the extraordinary honesty it takes to return money. If there is a role for a dishonest person in your short but you can't think of a familiar character, have them start off the film by banging their fist on a vending machine, making a free snack pop out. Then as they enjoy their stolen treat and walk towards the setting where the bulk of the story is going to take place, you've only spent three–five seconds of animation establishing a character the entire audience will recognize.

Middle

In this section of your story you will develop the character and problem through escalating the conflict in either a subtle or blatant way. This builds up to the climax, which is the most intense or exciting part of your story and is the end of the middle section.

The middle is the "meat" of your story, in that normally the most happens here. This is true of short films as well as feature films. We are going to make use of a very special trick to ensure that your middle does not give you problems as you start to make your short film.

The Modular Middle

The middle of your story is going to contain all of the plot twists and turns that escalate the conflict. To take some popular films: in *Finding Nemo*, the beginning is everything up to when Nemo is taken. The middle of the film is the entire adventure under the sea as Marlin and Dory try to find him. In *Snow White and the Seven Dwarfs*, the middle is everything that occurs once Snow White finds the cottage and has to learn to live with the messy dwarves. Just as with feature films, a short film's middle can have parts that can be rearranged to enhance the effect. Take, for example, the film *Pulp Fiction*,

where filmmaker Quentin Tarantino edited the scenes completely out of chronological order but still created a solid beginning, middle, and end.

Especially in short film, the middle can be edited to escalate the conflict in a calculated way. This is why we want to create what I call the "modular middle." You write the middle of your story to be able to have a very wide variety of separate, individual shots that you can mix and match to create the best story. I call it modular because you want to give yourself the opportunity to add or subtract shots from the middle as you go along, with no adverse effect on the quality of the story. This is really valuable for the technical process as well because giving yourself the ability to add or subtract shots in the middle of production might mean the difference between finishing your film or being too overwhelmed to continue.

There are numerous possible "types" of middle that can accept modular shots. A chase sequence is a good example of a middle that can accept a huge number of totally different modular shots. You can add twists and turns, ups and downs, or pretty much anything you want to a chase without severely affecting the core purpose of this sequence. The "puzzle sequence" (as I like to call it) is a sequence in which a character tries multiple ways of solving the same problem. The first teaser trailer for *The Incredibles* featured Mr Incredible trying different ways of putting on a belt that no longer fit him. The story of a bank robbery might have a puzzle sequence showing him trying all manner of ways of breaking into the vault; dynamite, pneumatic drills, maybe even banging his head against the vault door. The point is, when we make our middle modular, we free ourselves to have a little bit of breathing room to come up with new ideas as we are working on the film. This can be a great motivator and a great way to keep creative energy high at the same time. As we talk about the film we made for this book we'll go through the entire process of creating the modular middle.

End

The end section starts with your character resolving the problem, overcoming the obstacle, winning, or losing. The resolution does not have to be as long as the other sections; in fact, normally it isn't. The end is a powerful moment too. By the time we are done talking about how to write a good story suited to completing your film on your own, you will understand how the end factors into your story decisions.

Simple Structure

The very, very basic structure we are going to use has a beginning, a modular middle, and an end. In order to write the story to correctly fit with this format, we have to think about the beginning and end very carefully, and to do that we will employ some tools that strengthen our story. More on that in a bit.

Examples

Here are a few examples of stories that follow the structure we are going to use:

1. An old man sits down to play a game of chess with himself. He gets increasingly excited as the pieces start falling. In the last second, he plays a trick on himself by spinning the board, stealing the win.
2. A babysitter assures a couple that their baby is in good hands as they leave. However, as the night goes on, the baby starts demonstrating some crazy superpowers! When it all seems like too much, another babysitter arrives and offers to take over—it's another superhero.
3. A boy, his father, and grandfather set about their nightly task of sweeping up falling stars. When a *massive* star defies all attempts to clean it up, they seem stumped. Finally, the boy decides to smash the huge star, splitting it into thousands of smaller stars that they begin to sweep up.
4. A magician, in his rush to get out on stage, neglects to feed his rabbit. Unwilling to perform on an empty stomach, the rabbit puts the magician through increasing torment and embarrassment as he is smashed, pinched, punched, even electrocuted. It escalates until finally the rabbit saves the magician from certain death, earning his carrot.
5. An alien tractor beam lifts a sleeping man out of bed, and we see that an alien abductor in training is at the controls. He fails miserably at his tasks and grows increasingly frustrated as the man's limp body bounces around the room. Finally the instructor takes over and sets everything back in place.
6. Two musicians vie for the attention (and coin) of a little girl in a town square about to make a wish in a well. They play their hearts out but scare her as they strum, bow, and blow furiously, making her drop her money. Angry, she whips out her own violin, and promptly deposits the money she earns into the well as she stares coldly at the poor musicians.
7. Up in the sky we see that baby animals are made from little clouds by puffy vaporous beings, before being whisked away to their parents by storks. One stork, however, has the misfortune to have to deliver all of the dangerous animals in the world, and looks increasingly ragged as he is poked, bitten, and shocked by tiny predators. Just when it looks like he is about to quit, though, he devises a plan and shows up for his next delivery wearing football pads and a satisfied grin.

Did I trick you? Probably not. You're probably a big enough short film fan that you realized I was just describing some of my favorite Pixar shorts. The ones above, in order, are:

1. *Geri's Game*
2. *Jack-Jack Attack*
3. *La Luna*
4. *Presto!*
5. *Lifted*

6. *One Man Band*
7. *Partly Cloudy*

Can you see how every single one of these stories relies on a strong setup and a great ending and builds tension and humor by escalating the plot with a modular middle? See if you can expand on the modular middle of each one of these films. For example, in *Partly Cloudy*, could you think of another dangerous animal that it might be funny to see the poor stork trying to deliver? In *Jack-Jack Attack*, is there another superpower that would be funny to watch the babysitter try to contend with? I am not proposing that these films are necessarily missing anything, only that you can tell that the writer went through a process to escalate the film so that the ending would be a big payoff. Try to come up with more for the modular middle of all of these films. Practice makes perfect.

Keeping It Under Control

You have doubtless heard how having an epic idea can lead to disaster with a short. Now that we have a structure, how can we turn your monstrous film idea into a manageable short? It is simple; start with the beginning and go straight to creating the end. Skip the middle for now. You will find that you probably had too much going on in the middle. Too many details, too many twists and turns, too much minutiae. Think hard about that story that has been knocking around in your head for a few years—does it have a convoluted middle? I know mine did before I noticed this pattern in successful shorts.

Mine used to go something like this:

> A pirate named Babinsky sees a ship in the distance and decides to steal the treasure kept on board. He sneaks aboard and finds the treasure. But then as he is about to steal the treasure, the other pirates aboard notice his rowboat and start looking for him. Babinsky hides, but the pirates search the whole ship and find him. He is tied to the mast and it looks like certain death until he wriggles free just enough to get his arms out. Suddenly, Babinsky bursts out of nowhere with a sword in hand and gets into a swashbuckling battle with the pirate captain. They battle until Babinsky falls through a grate! He miraculously lands right next to the treasure and pushes it out of the ship into his rowboat before the crew can catch him. Babinsky turns and salutes to yelling pirates as he makes his getaway.

While this might be pure visual entertainment, the story is so convoluted that an audience would have great difficulty in following the plot. More than that, I've signed myself up for creating a large number of assets, characters, props, and animation that don't escalate the plot in a great way. If you are like me, then you get some really inspiring ideas for scenes for the middle of a film. But rather than stop there, ask yourself what the strong beginning and end of that same film would be. Then ask yourself if you can make a modular middle that supports the beginning and end and nicely escalates the plot.

Number of Characters

To keep everything basically under control, you should have something between one and three characters for an individual effort (taking into consideration rig scripts, downloadable models, and other time-saving tools we discuss in this book). Small teams can up the complexity a bit, so your film can star between two and five characters. Story-wise, the rule is that more characters tend to "spread the plot around."

In short film, we have precious little time to develop the plot. Development needs to come at a fast and also *constant* pace. The more characters you have, the more likely it is that you will end up having to develop their individual plots rather than developing a single plot. To explain, let's take an example:

> *Three young boys meet in a park to play baseball. When one of them hits the ball it lands in a sandbox next to a huge young boy with a vicious-looking face. They run away scared. The next day they come and play again, and the same thing happens. On the third day, they run out of baseballs so have to try to get one of the balls out of the sandbox. They creep up to the sandbox when the bully turns away, but he suddenly spins round and stares at them just as they set foot in the sand! They are terrified and hug together for their lives. Funnily enough, he holds out a hand with the ball in it, and smiles. He even puts his glove on and gestures as if to ask if he can join in! They breathe a sigh of relief, and we fade out on the whole group laughing and playing baseball as the sun sets behind them.*

Cute story, right? But think about it. Is there any real advantage to there being three boys playing baseball at the beginning? I'm sure since that was the format you just read it is hard to imagine the story with as large a change as removing one of the boys. But let's do that. How does this new version compare? Is it just as good? Better? Worse?

When we make this adjustment it becomes clear that the real strength of this story has nothing to do with the number of boys, but rather that the bully was misunderstood and not a bully at all. Whether we watch one, two, or three boys have a misconception of a person, the net effect is the same. But the impact of the realization that they were wrong gets spread out over the three boys in the crowded version. Let's remove another boy and see what we come up with. Of course, the first problem is that it is kind of impossible to play baseball with yourself. But as long as we are open and accepting of story changes that will improve our film we can make simple adjustments that will manage this. Try this new version on for size:

> *A boy is playing soccer in the park, dribbling a ball, bouncing it on his feet and head. He missteps and the ball goes rolling into a sandbox where a huge, mean-looking kid sits staring at him. Too scared to go anywhere near, the first child runs away. The next day he is back, playing with a new ball, but eventually the ball gets away from him again and he leaves,*

sad, with another ball lying in the sand. Finally, on the third day, he loses his last ball and, swallowing a huge lump in his throat, carefully tiptoes towards the dreaded sandbox. He looks like he's just about to grab his ball when the huge bully turns and looks him right in the eye. Terrified, he shrinks away and covers up, but when he looks again, the bully has completely transformed; he's happily dribbling the soccer ball and bouncing it around. We fade out on the two boys, now new best friends, playing soccer together and laughing as the sun sets behind them.

All we needed was to change the sport and we can cut our character count down from four to two. Not only that, the story is now stronger because we are not spreading the plot over three boys: only one goes through the character arc that we set out to portray. Don't for a second think that by taking out characters (and trying to be more realistic) you are *losing* something from your film. Restrictions inspire us to be creative with our storytelling and should be seen as a blessing rather than a curse.

Number of Environments

The other major consideration in terms of story scope is the number of environments that you are creating. As far as you possibly can, restrict your short to one or two locations *max* with an individual effort. A group effort should not go above five or so locations or you are really asking for trouble. In *Booty Call* I tried mightily to make sure I only had one environment, but ended up *having* to have the establishing shot of the pirate ship floating in the bay.

FIG 3.1 This shot was simple to set up and nicely establishes the scene.

It was pivotal to the story of *Booty Call* to make it clear that Babinsky is on board a pirate ship that is not his own. We achieve this by showing him rowing under the cover of darkness towards the ship in the first shot. In the end, it did not take much effort to create that shot as the pirate ship was downloaded from TurboSquid, the water was point-and-click water material in Maya, and

the rocks are simple polygonal geometry extruded into shape. I like to think I was really economical when it came to my second environment.

The other main consideration is whether you can also make your environment modular. Think of a lot of freedom to animate. Some of our supporting films have modular environments that really helped give the storytellers the freedom they needed to advance the plot.

FIG 3.2 Nothing like a simple, modular environment to make it easier to establish your film's setting.

Another great example, though it is not included in this book, is *The Race*, a 2006 short film from Gobelins. The racecourse is made up of countertops and stoves lined up in a kitchen. This is brilliant use of modular design because adding more length to the race does not depend on modeling more race "track"; all the animators have to do is bring the counters and stoves into another scene and arrange them as a new course section. Watch it and I think you'll agree that the environment choice was quite clever.

Do not underestimate how much work goes into an environment! Reduce the scope of your ideas to fall within these guidelines and you will have a much better time finishing your film.

Theme Versus Moral

We generally think of stories in terms of theme and moral. "What is the story about?" is a question that could be answered by a discussion of either of these terms. When we talk about theme, we are talking about the underlying concept portrayed in the film. It is the common thread, the *subject*. The moral, on the other hand, is the statement you are trying to make about the theme. In other words, it is the clearest and strongest opinion you have about the subject of the film. When talking about moral, a person will sometimes ask, "What did we learn from this story?" Actually we don't learn the moral from what happens in the plot. Too often students think the moral is the resolution

of the story. But in fact we learn the lesson from how the writer and director (in your case, the same person) comment on the theme, using devices such as plot, character development, setting, etc. You could simplify it down to the theme being the subject of the film, and the moral being how you *feel* about the subject. It might seem that I'm harping on a simple idea here. However, understanding the difference between theme and moral allows us to use the difference to our advantage.

The Theme/Moral Feedback Loop

This is a technique that I created after years of helping students write their stories. The way it works is simple. Come up with a theme. Devise a plot that touches on that theme. When you get to the end of the story, ask yourself the question, "Does the moral convey the clearest, strongest opinion I have about the theme?" If the answer is no, then we work backwards. We analyze each plot point in reverse and decide if the stakes can be heightened, if any adjustment can be made, or if the right series of events is unfolding to make our opinion heard loud and clear. When we get to the beginning, we ask ourselves if this is really a film about the theme that we started with. Quite often my students would complete one cycle of this feedback loop and find themselves realizing "No!": they had set out to tell a story about one theme, but as they honed in on their opinion of the subject, a different, if highly related, theme emerged as the more compelling discussion.

All of this is quite difficult without some examples. I love to use Disney/Pixar's *Finding Nemo*, written and directed by Andrew Stanton, as the framework for the theme/moral feedback loop. Hopefully you've seen this film, but I will describe the plot points in enough detail for you to follow along regardless (but seriously, why haven't you seen it!?).

In the beginning we are presented with Marlin and Nemo, father and son clownfish, on the first day of school. Nemo has a handicap and cannot swim strongly. Immediately, the over-protective and smothering relationship between Marlin and Nemo is shown. Not too long after Marlin drops his son off at school, Nemo is scooped up by a scuba diver and taken by boat far away from the reef that is his home. Marlin pursues but is too slow. Marlin meets Dora, a forgetful fish who happily agrees to help him find his son, and the bulk of the adventure unfolds. Nemo is deposited in a dentist's office aquarium where he meets a cast of characters, all of whom have staged numerous unsuccessful escapes. Marlin and Dora brave the open ocean, sharks, mines, jellyfish, whales, and seagulls to find Nemo. As they near Sydney harbor, where they believe Nemo to be, Nemo himself gains confidence as he helps set in motion what seems to be the surest escape plan yet. In the climax, after being briefly reunited, Marlin and Nemo are separated again when Nemo is caught in a net. As the net rises out of the water, Marlin hangs on to his son for dear life, but Nemo tells him that he has a plan and he can do it. Marlin lets go

and Nemo's plan works; the net is pulled to the seafloor and the fish escape. They live happily ever after.

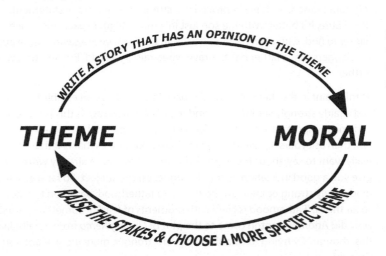

THEME — WRITE A STORY THAT HAS AN OPINION OF THE THEME → **MORAL**
MORAL — RAISE THE STAKES & CHOOSE A MORE SPECIFIC THEME → **THEME**

FIG 3.3 Using the Theme/Moral loop, we can strengthen a story until we have the *clearest* opinion of the most *specific* theme.

Now let's put the theme/moral feedback loop to use. An obvious theme of *Nemo* is "fatherhood," as Marlin goes through an intense experience to find his only son. With "fatherhood" as a theme, you can begin to devise a plot that really speaks your thoughts about what it means to be a dad. Here's a story example:

> A father in a toy store walks the aisles with his son. The boy is very excited and runs around in circles. As he does so, he knocks toys off of the shelves and the father struggles to keep up. Suddenly, he can't see his son anywhere. No matter how much he looks, the little boy seems to have vanished. In a panic, the father starts pulling toys off of shelves, but nothing! He is about to scream when he hears a little giggle coming from a ball pit. As he pokes his head in, the boy emerges and gives him a reassuring hug.

This story is a good place to start, but it's nowhere near ready to animate, nor is it really even worthy of our efforts to do in animation. This story has the same theme of "fatherhood" but is much weaker than *Nemo*. Let's use our story tools to improve it.

We learn about a father who loses his son, only to discover him moments later. Is that high stakes? No, the stakes can be raised much further. In fact, there should be more getting in the way of the father finding his son, beyond his inability to look. There should be *real* obstacles. Further, as it is fairly easy to identify one's own child, we could make the search more intense by creating a crowd that the father searches through over the course of the film. Let's make those changes. We should make the toy store a toy *warehouse*, and give his son a school uniform that makes him impossible to tell from the other kids in the film.

What we now try to do is make it to the end of our film using the new setup and see how strongly stated our opinion of the theme really is. Certainly, with the stakes raised, we have improved the strength of our moral statement, right? Sure, it's better. With the son lost in a much bigger space and much harder to find, with even more obstacles in the way, we are saying more about the dangers that a father has to brave when raising a child. But let's go even further.

At this point in the theme/moral feedback loop we have an established theme and a fairly strongly stated moral and must ask ourselves, "Is this the strongest and, most importantly, the *truest* form of my opinion on the theme?" If it is not, then ask yourself, "What is?" Think hard about this. What is it that you really want to say about the theme? The story that you've already written will give you a good indication of your thoughts on the subject. So far we have a moderately strong opinion on the theme of fatherhood; based on the story so far this is: "Fatherhood is filled with moments of fear," or something similar. How did Andrew Stanton come to the plot of *Finding Nemo* from a point like this, though? By trying to establish an even stronger, more incisive opinion on the subject.

Let's keep going.

So perhaps showing a father losing his son is not the end but the means to the real seed of the moral of our film. We can raise the stakes even higher. And this is where it gets interesting. When you start thinking about the greatest possible dangers that a human father will go through for his child, you start to feel like anything that is realistic will fall short. This is why we choose animation to tell our stories. In animation, everything is possible. Therefore, we can create a situation with characters and settings that perfectly illustrate our opinion of the theme. With the entire universe at our disposal, how do we raise the stakes even further? By changing the father from a human to a clownfish. And instead of a toy store or warehouse, separate the characters by the entire Pacific Ocean. Let's also make the son disabled for good measure.

Suddenly, with the stakes so astronomically high, we see how clear the moral is. No matter what the father tries to do, the big scary world is going to present situations that are unbelievably dangerous. How is the father going to cope with this? What kind of life is ahead for his son if he is not allowed to really live?

Can you see now how, when a father loses track of his son in a toy store, he goes through the exact same emotions as a clownfish that loses his son in the ocean? By making these comparisons we get to the heart of the story.

The theme inspires a story. The plot points of the story support stakes that determine the strength of the opinion of the theme. With this first inkling of your moral, you can look at how the plot could be enhanced to support even higher stakes. This, in turn, makes you scrutinize the theme. Inspired by the ever-improving story, your theme becomes more and more specific. This back

and forth process can be repeated over and over, and using the theme/moral feedback loop you will eventually arrive at the true theme and your absolute strongest opinion of the theme, the moral.

The theme needs to be more specific and meaningful than just "fatherhood." When we get down to it, the lesson that Marlin learns is about "letting go." Finally we've arrived at a theme that can be supported by the astronomical stakes of the film, and at the end of the movie, when Marlin literally lets go of Nemo's hand, the moral is learned. And a few tears are shed in the process (which is great!).

Booty Call

FIG 3.4 The story for *Booty Call* came about through a highly methodical progression. It is easy to develop story when you use the theme/moral feedback loop.

I used the theme/moral feedback loop to create the story for *Booty Call*. I make no claims that my film is the *best* story, but it is damn near a perfect story. Inspired by the designs I saw for the character being built for *Anomalia 2012* (a pirate), I began to think about an interesting theme. Pirates naturally elicit certain themes. Piracy, for one, but also fighting, drinking, robbery, dishonesty, etc.

The very first theme I started with was stealing. The rough story was as follows:

> *Babinksy boards a ship in the night. The pirates are all asleep and he sneaks through the ship until he finds a huge treasure. However, the treasure is locked inside a huge cage. He tries to break the lock with his sword but it is much too strong. He tries to pry the lock with a crowbar but the metal just won't budge. In a fit of mad rage, he rolls a barrel of gunpowder next to the cage and lights the fuse. Instantly, Babinksy regrets his decision as he looks around at the dozens of barrels of gunpowder that*

fill the ship's hold. As the fuse burns, he slumps to his knees. From far away in the harbor we see the entire ship explode in a plume of flames.

The main issue I had with this first story was that absolutely everyone on board dies because of Babinsky's thievery. It didn't seem right. I had arrived at the end of my story and I was dissatisfied with my moral. It seemed that my opinion of stealing was that it hurts everyone around you. So I turned around and raised the stakes in the story. Rather than Babinsky trying to get to the treasure itself, what if he gets his hands on the treasure easily but wants more than he can take? I tried out this version:

Babinsky boards a ship at night; the pirates are all drinking and singing too loudly to notice him saw a hole in the ship's side. He finds the treasure in the center of the ship and sees there is more than he could ever want! With a huge amount of effort he pushes, pulls, pries, and slides the treasure to the hole and starts emptying the chest into his rowboat. Piece after piece falls into the waiting vessel and it begins to be weighed down. As the treasure chest empties, the rowboat sinks lower and lower. Babinksy gingerly tosses single coins atop the huge pile of treasure until it looks like the boat is below water level. Without thinking, he leaps into his boat. It immediately sinks with a huge splash, and Babinksy is never seen again.

Getting there. Raising the stakes made it so that when we get to the beginning again, the story is clearly about "greed." And I like this new theme, but we can create even higher stakes and arrive at a conclusion that will have a stronger, clearer moral. I thought about how to make these changes, and finally settled on the story that we went with.

It's night-time, and under the cover of darkness the pirate Babinksy rows a small boat up to a huge ship anchored in a bay. On board is a treasure of immeasurable worth. Babinsky cuts a hole in the side of the ship to steal the treasure chest inside, chuckling to himself the whole time. Once inside, Babinsky sees the treasure is more than he could have imagined! But when he lifts the overflowing treasure chest into his rowboat, a single coin falls out and rolls deep into the ship. Even though it's only a single coin from a massive treasure, Babinsky's greed gets the better of him and he chases the rolling coin through the ship until it falls through a grate covering a dark hole. Without thinking, he pulls open the grate, but red eyes flash in the darkness. Uh oh. Before Babinsky can cover the grate back up, a barrel rolls into him and knocks him into the pit below. Roaring and scratching accompany Babinsky's screams, then just before the silence, we hear a big burp, and the coin is spat out of the grate.

This has all the elements I need. A simple beginning that sets up the conflict. A modular middle that can grow or shrink according to my needs. And an ending that really sells the theme. When Babinsky has got the treasure but has to decide between being content with what he has and risking it all for just a

single coin, we get a very high-stakes example of the theme of greed. Finally, seeing Babinksy meet his demise while literally following greed is a clear statement of my opinion. The moral is, "Greed will lead you to your demise."

Our Supporting Films

Although they don't all follow the same structure, the films chosen to be in this book all have something to teach us in terms of story. Whether it is how to be economical with your theme or its simple story structure, we should find what makes each of these films work.

Adrift

FIG 3.5

For me, this film follows simple story structure to a T. It is also economical in its story choices. What I mean by that is it would be quite easy to get caught up in the minutiae of the world of this film. How did the main character come to live on the back of a flying whale? Are there others like her? How does she eat or drink? Is she a prisoner there? Can she land? The lack of an explanation of her circumstances actually serves as a benefit in the film. The less we harp on the details of her situation, the less gets in the way of the real story that unfolds in front of our eyes. Simply showing her looking longingly into the distance in the first few shots is enough to give a clear setup.

Beat

Storywise, this film also follows a very simple structure. A character is stuck in a routine. When a simple change to his routine shows him he doesn't have to follow the same rhythm every day, his creativity explodes out of him and he expresses his unique inner self. The length of the sequence following the

FIG 3.6

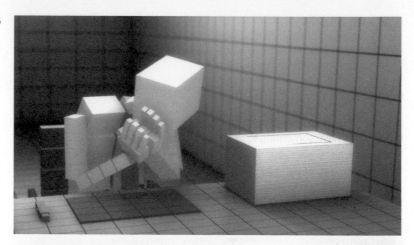

break in his routine is *completely* up in the air. If this were your film, you would have a good chance of finishing it due to the degree of flexibility you afford yourself by making the story work at nearly any length. I am not suggesting that the film as it exists is too long, but Or Bar-el did complete a large amount of work on this short.

Crayon Dragon

FIG 3.7

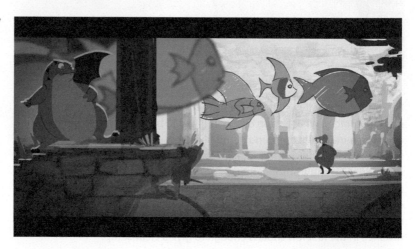

I simply love the story here. We open on an artist charged with the task of painting over a mural that has dragons playing. This film features a modular middle; once the artist is taken to the world inside the mural, all the spectacular imagery that the dragon shows her is completely modular. The animator was free to add or subtract shots from this sequence at will.

If you are not quite convinced of this concept, just look to the Pixar films that I pointed out; even studios with unlimited budgets turn to modular middles to give themselves the opportunity to fine-tune their films.

Also, take special note of how high the stakes are in this film. Animators often think that life and death are the highest stakes that are possible in film. And truly, life-and-death stakes are very high. However, you can have stakes that are even greater than life and death. In this case, the dragon will be forgotten forever if he is painted over. This is a fate worse than death because at least after we die we are remembered. Since the stakes are so high, the moral of this film sings clearly through the beautiful imagery. We're lucky to have this short!

Devils, Angels, & Dating

FIG 3.8

This story follows the simple structure, with a brief modular middle in the form of a fight sequence. As in so many good films, the stakes are extremely high. Some would say that spending an eternity being unnoticed by a love interest is another fate worse than death. With these high stakes, the theme of "love" (another very ambitious theme, I might add) comes fully into play.

Looking at the story, it's worth mentioning that a narrator can serve a very important purpose. In *Devils, Angels, & Dating*, the narrator is also the character of the Devil. You can add a narrator to your film to speed up exposition that would otherwise be lengthy or technically cumbersome. As long as a narrator does not simply describe what is happening on-screen, there is no reason to shy away from using one. More on this in Chapter 9.

Drink Drunk

FIG 3.9

Simple structure comes through in this short, sweet film about the perils of having "one too many." The setup is extremely economical; a character bursts through a pub door, visibly drunk, and starts to make his way home. Right away he runs into a police officer and seems to be in huge trouble. No matter how he tries to prove his sobriety, the officer won't budge. When he comes to the realization that the "officer" is just a streetlight, he stumbles on home.

This story has it all. The beginning features an instantly recognizable situation, the middle is modular and has some great gags, and the end is quick and to the point.

Dubstep Dispute

FIG 3.10

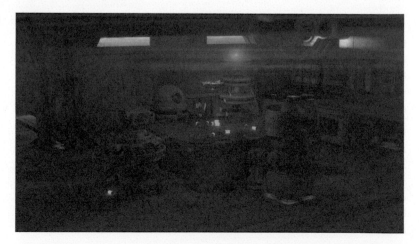

This film just makes me chuckle every time. In a single shot, the animator finds a way to make something visually interesting despite the simple story. The chef robot cooks a meal and carelessly drops it on the table in front of a group of other robots. A fight immediately ensues, but instead of physically fighting each other, they engage in a raucous battle of light and sound.

There is something to be said for a film whose story is so simple it almost defies categorization. I applaud Jason Giles' efforts to create something visually interesting but with a simple story. As far as finishing films is concerned, *Dubstep Dispute* is a flag-bearer for the cause. Think about how pairing film to music allows animators to create just the footage they need; when you are nearing the end of your production time, simply designate your ending and have the robots return to their positions when they are done! I am very interested in you finishing your film. For this reason, it would be a great exercise for you to try to come up with a story as simple as *Dubstep Dispute*. In many cases you will have been thinking about intricate details and interwoven plotlines for a long time: a simple story is harder!

For the Remainder

FIG 3.11

Another foray into simple story, *For the Remainder* stands as probably our finest example of simplicity being best. In this film the director's main objective is to establish mood and have the main character (the cat) bid farewell to the world. If there was ever a simpler objective, I have yet to see it. Aside from being visually unique and masterful in evoking its melancholy mood, this film is planned brilliantly as a piece that is "finishable."

This is another structure you might want to try if you are not quite up to the task of creating a more complex story with theme and moral. There are plenty

of amazing films that are simply about the expression of a feeling. What makes *For the Remainder* so successful in my eyes is just how far the director went to make sure that everything meshed together. From the sound design to the character design, from animation style to rendering, everything blends wonderfully in a clear exhibition of mood.

I will add the following caveat: if one of your main goals is to create a film to be a demo reel piece, then you are better off trying to come up with a film that follows our simple structure. The main reason for this is that supervisors and directors like to work with animators who understand story. Coming to an interview with a film like *For the Remainder* may leave the recruiters feeling that you are lacking a bit in your story chops. Even the simplest idea with a beginning, middle, and end will lend more weight to your abilities as an animator.

On the other hand, if your main goal is simply to "make your mark" on the industry, express an idea, learn different disciplines and the different parts of a pipeline, then a film like this one is perfect. The bar has been set very high, though; in terms of the aesthetic matching the tone, you are going to be hard-pressed to do better than *For the Remainder*. Take it as a challenge!

Meet Buck

FIG 3.12

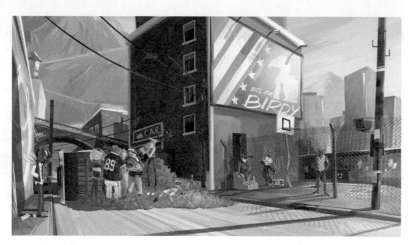

Our simple structure shines through here. See if you can pick out the component pieces in my breakdown of the film:

> *A young buck (literally) leaves the city for the woods and visits the house of a girl he likes, where he comes face to face with her crazy homicidal father! A chase ensues over hill and dale, Buck narrowly escaping death over and again. Finally, he comes to a crashing stop back in the city and, just when it looks like he is going to be killed, the other animals in the city come to his rescue.*

This film starts brilliantly, with a setup that comes so fast at the audience we have no time to prepare. With a concept like the one proposed in the beginning of this film (that there are human-animal hybrids living in a city), you can get the audience on board by jumping right into the action. As I mentioned before, there is no big build-up, no drawn out explanation of the source of these creatures or their motivations. We just see the main character and he goes off on his date.

The modular middle starts the moment the father sees Buck. In the shots of the chase sequence we get to see some brilliant animation, but it doesn't feel either too long or too short. That is yet another benefit of the modular middle; however many shots you end up doing, it always feels as though that is the length the film was *supposed* to be. There are limits to this effect, of course, but in general the modular middle is hugely useful for finishing your film in the way that it allows you to determine the length while you are in production.

The ending is short and sweet. There is a lesson to be learned here. After the modular middle is done, the filmmakers have only a couple of shots that show the father in deep trouble and Buck as probably going to end up OK. In *Booty Call* there are only three or four shots that you could call the end of the film. You do not want to have a long ending because, after the conflict is resolved, the audience is going to be waiting around for either the next conflict to present itself or the film to finish.

Our Wonderful Nature

FIG 3.13

Perhaps more than any of our other supporting films, *Our Wonderful Nature* follows a structure that is highly rigid, but which is really successful in execution. We open on scenes of nature, and the narration informs us that this will indeed be a nature show such as we are very accustomed to. But in the middle we are presented with a hilarious interpretation of the mating rituals of the water shrew. The throw-down bare-knuckle fight that ensues is both awesome and brilliant from a story perspective.

By making the "gag" of the film the entire modular middle, the director was able to nicely leverage the work of creating a fight scene. Put simply, the work that

goes into the modular middle serves a double purpose in also making the film funnier. This is due to the fact that the more that goes into the middle, the longer (and therefore funnier) the actions are that take place during that first speedy, blurred encounter between the shrews. Every second of animation is not only entertaining to watch but also provides further contrast between the fast and slow motion versions of the fight. What a great usage of the modular middle!

Paths of Hate

FIG 3.14

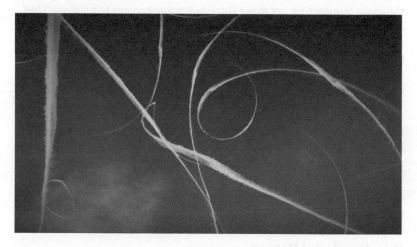

Even though this film was intended to be our most serious, *Paths of Hate* still follows the simple structure. It just goes to prove that structure on its own does not denote content, only a way for ideas to be presented.

The beginning of this film is wide open. We don't know really how these two pilots came to be in a dogfight, only that they are in combat. So the beginning of the film is really only a couple of seconds long. The real meat is in the middle, where the dogfighting plays out. Again, not to suggest there is anything wrong with the film in its current state, you can well imagine the film without some of the shots in the dogfight. If the director experienced some constraints on finishing the film, he could stand to lose some of those shots and the film would suffer far less than if the shots weren't so modular.

Watch closely and see how the trails behind the planes, or the "paths of hate," come back as visual repetition throughout the film. The middle, though modular, is marked by this progression. That is, we can clearly see from the deterioration of the planes, the loss of ammo and fuel, the blood and debris in the planes, and, most profoundly, the color of the trails the state of the characters. Hate fuels this raging battle.

The end shows how, even after the men's bodies are destroyed, the hate that fuels them lives on, perpetuating violence for eternity.

What could have been the progression of this story? Can you imagine the thought process behind a story like this? For this film, the raising of the stakes works only until the writer realizes that life and death stakes are kind of pitiful in the face of hatred at the level we see on screen. No, only when we see that what is at stake is their *souls* do we get to the heart of the story. The theme/moral feedback loop still holds up.

Reverso

FIG 3.15

Beautiful, well animated, and a charming story. *Reverso* shows how sometimes the best way to make a character likeable is to show them in difficult positions. We empathize with characters that seem to have good intentions but cannot get a break.

A clever idea can spawn an entire story. This film makes some great examinations of different character types (the silent, strong single father, the jerk co-worker) in the process of playing out the middle. The middle is not quite modular, but it is strong nevertheless. By the time the character falls out of the tree (doing something chivalrous, it should be noted), we care for him enough to feel upset because it looks like he is going to die. But, as he falls through the amazing sunset and closes his eyes as he rises, we feel a sense of relief that he no longer has to fight to stay grounded in a world that doesn't understand him or think he is special.

Plus, I love films with a great gag, and this short is full of them.

Pitching the Story

Following the simple structure will get you halfway there. The other half is really going through the motions of using the theme/moral feedback loop

and working the story until it is feeling really good. But you are not done with your story until you have turned it into a successful pitch.

The art of pitching is a dying art, seeing as how most interaction between young artists has moved from the classroom to the online forum. Since there is no interaction when you are coming up with ideas, there doesn't seem to be any reason to condense your idea to a bite-size consumable format.

Well, I think that learning how to pitch your film is one of the single best ways of firming up the story, not only in your own mind but make it understandable for your audience. The rules are simple; make sure you are standing up and using your whole body to gesture as you tell the story. Next, describe the story in a simple pitch that takes the *exact* same length of time as the film you want to create. This is very important. Only when you can pitch the film in the same time as the film itself will you really have a handle on what is important in the short. Last, you have to pitch it to people. As in real, actual human beings. I know it is scary, but practice it repeatedly before you do it in front of an audience. You should have a very well-rehearsed pitch and it will go fine. With a little experience under your belt you will become more comfortable, and the story-clarifying benefits of pitching will be felt to an ever-greater extent.

Wrapping Up Story

Remember that the simple structure gives you the flexibility of making some story adjustments while your film's in progress. The goal should always be to finish as much as find the strongest story. I know it must really boil the blood of die-hard story fans out there to say this, but my job with this book is to make sure that you finish your short. And in order to finish, you have to start.

After a few iterations, adjustments, strengthening of the moral, raising of the stakes, and at least a few pitches, you should step confidently into pre-production.

Interview

Meet Buck by Denis Bouyer, Vincent E. Sousa, Laurent Monneron, and Yann de Preval

FIG 3.16

What was your first experience of creating a short film? Each person can answer separately.
In our school, Supinfocom, we had to make a 1mm movie individually during our third year there. It was a good experience for everybody because, since you're alone, you have to go through every step of the production and you start to see what you like to do and what you don't. The next year, we also had to create a short movie for a TV channel contest, and this time it was a great experience because we started giving each other tasks and specializ[ing].

Then we made *Meet Buck*!

When you felt technically challenged or blocked, what was your go-to resource?
We're a team of friends, we see each other very often, and we talk a lot about our work.

When we're stuck on something, usually we give that task to somebody so he can bring a new eye on it. That doesn't mean he's going to find the solutions, but at least he'll explore new ways to solve the problem. Also, when something is really too complicated to do, we simplify it, if it's not necessary for the story. That became our rule. Simplify and go straight to the point.

What were some of the biggest challenges in creating your film?
Painting all the backgrounds was a good challenge, haha. Denis and Vincent never really painted before (digitally or on paper), so they had to learn really fast.

Also for Vincent, creating a good rig so Yann could animate as he wanted was time and energy-consuming. But we're all happy with the result and he still continues to improve it.

A smaller challenge was, for example, to create the deer head and to make it appealing so the audience could feel sympathy for him. We struggled a bit on where to put the mouth, the eyes, while still making it look like an animal. I think every one of us worked on his head, haha.

61

What was your main focus in completing this project? Completing a film? Making a statement? Getting a job?

A little of each. Of course we wanted to find a job after that, but we mainly wanted to have fun during the production. Lots of students try to do awesome-looking realistic CG stuff to impress companies, but it seems really boring to do and you can feel it in the movie.

We tried to do a movie for us first, but to do it good so we could find a job, and also kick the ass of previous graduates from our school, haha. That's why the movies are improving each year.

What inspiration or reference outside of animation did you use to complete your film? For example, cinematography, classic paintings, music?

We watched a movie called *Guess Who's Coming to Dinner*, a B&W movie, very good movie about racism: a woman introduces her partner to her parents and they see the guy is black. So they freak out. We wanted to call our movie *Guess Who'll Be the Diner* at the beginning, or something like that.

For the visual style, we were inspired by American illustrators like Leyendecker and Rockwell; we're in awe when we see their painting. Each brush stroke gives dynamism to the picture.

For music, we just like rock and country music, so we just made something like that!

Which was your favorite character to work on in the film? Why?

I think the father is our favorite character, the easiest to model, the funniest to animate. I think it's always easier to make bad guys, and complicated to make not-boring heroes.

Also, we love mustaches …

Did you employ any organizational tools such as charts or calendars that were pivotal in keeping to your deadline?

We had regular meetings with our teachers so they could make sure we were still on deadline. Also, yeah, we made schedules, but not really good-looking ones, mostly badly handwritten on pieces of paper flying around on our desks, haha. We were not that organized. We learned how to be more organized when we got our first job.

What were some of the benefits of working in a small group?

When you work in small groups you have more control over the final product, it's easier to give and receive feedbacks. And like I said, we're a group of friends, so even when we're out of school/work, we still discuss things, solutions to our problems. And it helps keeping a same style, without having too many things going in every direction depending on each other's taste. We know what we want to achieve, so we stick to it.

Was there another medium you considered for this short film? What were the benefits of working in the medium you chose?

Since it was our graduation movie in a 3D school, we didn't really have the choice, haha. But now that we're working and we have time for personal projects (strangely), we try to find new ways to do things, stop-motion, pictures, live footage, etc. We're just trying to have fun with it!

What were some of your favorite tools to work with? What did they do to increase the quality of your film?

If the choice of cartoonish 2D style is a tool, I'd say that it helped a lot during the production because the renders were really fast, we were able to go back and forth, changing stuff, etc. all the time without having to wait hours for it.

And it was fun, because we were doing something different, we were drawing and doing 3D, and for us it was much more interesting and satisfying.

What were some tricks for keeping you/your team motivated during this film?
We were not always really motivated … when we were having issues with that kind of thing we just tried to do something different on the movie, or when we were not working (and that was not very often), we played videogames or went to see a movie.

Oh and we yelled at each other. A lot. Haha.

In your opinion, what are the must-have skills a person needs to create their own short, and what can be learned along the way?
It is hard to keep the motivation; also it is complicated to stick to what you wanted to do at the beginning. You always have to make compromises. Sometimes you start with something in mind, but for the good of the story you have to get rid of it: it's painful but it's necessary.

You also have to be very, very patient. Sometimes between the moment you have something in mind and the moment you see it on screen, it can take ages.

And of course, having artistic freedom is essential, and these days it's something that not everybody can get.

How did you decide who would be in charge of your film?
We were all in charge regarding our speciality. Vincent was giving advice on everything technical, Yann was in charge of the visual style, Laurent the FXs and simulations. And Denis was in charge of the story and other few things. But most of the time we listen to the most talented one in the domain.

How did your workflow/pipeline for this short differ from other pipelines you have been a part of? What do you think was the reason behind this change (if any)?
Our pipeline was pretty close to other 3D pipelines, if you exclude the painted backgrounds. With the background we had to think really carefully our layout and storyboard, making sure that we were not putting [in] too much camera moves. Otherwise it would take too long to do. So it helped us staying simple.

Also, as I said, our cartoonish render style was really fast to do, allowing us to change things at the last minute if we wanted to.

Did you develop any new tools or innovative workarounds that you would like to share? For example, if the hair didn't render properly, you created a new script.
Our process was very very simple: we just painted the textures, applied some passes during the compositing (nothing fancy). We didn't use any shader or any advanced rendering system. But Vincent worked a lot on the rigging, making adapt[ions to] the different characters, making the deer's "mouth" easy to control and good-looking. That was a challenge, even if it's based on the same tools that everybody else in the industry uses.

Did your workflow change when you had to work with specialists outside the animation realm, such as designers or musicians? Do you have any advice for those who are creating a film and don't know anything about those areas?
We had the chance to work with a very good sound designer (Julien Begault); we talked a lot with him and he made an amazing job. The most important thing when you work on your movie's sound and

music is to start as soon as possible. Put some sounds on your animatic (2D or 3D) so people who will work with you understand what you have in mind.

Was there a moment when you knew your film was going to be a success?
It was a success for us when we finished it; we were really, really happy. We didn't know if people were actually going to like it, but at least we enjoyed doing it!

Putting the last details and adjustments at the end of the production is a real pleasure, even if at that time we looked like zombies.

Were there any major plot points or features of the film that changed because of your capabilities? Would you change it now that you have more experience?
If we could change things on our movie, it would be really different; we would work more on the story. We would keep the same visual style but we would push it way more, as we do it now in our jobs.

But yeah, the story would be the main thing to change. Making it a bit more original.

Are you or is anyone on your team planning on creating another 3D short film?
We're working together along with the team who created the short movie *SalesmanPete* (we're all friends) on a new animated TV show, that we hope will be produced soon.

And at the same time we always work on personal stuff, trying to improve and create new things. Mainly we're trying to make us laugh, and if other people laugh as well while watching our shorts, we're really happy!

Describe your process for coming up with the idea. Did you build around a simple idea? Cut down from a larger idea? Explain.
At the beginning we started to think about a reversed hunt: animals chasing humans. But it was too general, not really appealing. We had to stick with a character, having his point of view. So we thought that we could follow the life of a guy with a deer head, and when we started to think about his girlfriend (and so his stepdad), we knew that's the story we wanted to tell. Most of the time, looking at a drawing or anything else can give good ideas. As one of our teacher said: everything has already been done, but you can still do it your own way.

Explain your pre-production methods and planning. Did you use an animatic, pre-visualization, scratch recordings, or just go straight into production, modeling, and animation?
We had a very normal pre-production method. We started by writing the story, creating a storyboard, an animatic, then we jumped into 3D and created the characters and backgrounds.

Pre-production is essential. We know it's a lot more fun to start modeling characters and doing render tests, but people have to take the time to create a good story, something that they like. Not something that they think maybe other people will like.

What words of encouragement do you have for someone who wants to create a 3D film at home?
Well, good luck! It's going to be hard, but at the end it's worth it. Try to create something new; we'll be the first to watch it and admire it. Right now is a very good time in animation, because students are becoming aware of their potential and freedom, so they are really making awesome movies.

Do something that you like; don't worry about other people.

Please discuss your decision for the ending of the film.

We didn't really have time to finish the movie before we showed it to our teachers. So we had to finish it after we graduated (was hard to find the motivation). We simply wanted to go back to the city we showed at the beginning. It was funny for us to say, "Hey, the deer is not the only guy with an animal head!"

Describe your workflow for developing the look of this film.

We first started by making render tests with advanced renderers. Like Vray, we soon understood it would take too much time and we didn't like the look of it. We wanted something closer to our first drawings. So we stayed late at night and made a few tests on the dad character, making it look more like our drawings. We liked it, but it lacked detail, so we added a lot of passes during the compositing step, to detach it from the background.

Pre-production

Before you begin animating and creating the final images of your film, a lot of pre-production is necessary. The main task areas of pre-production are setup, design, storyboards, animatic, and final prep. In general, completing pre-production before moving on to any production tasks is a good idea. There is no hard and fast rule about doing more pre-production as you go along, but you can get distracted if you are constantly (and literally) "going back to the drawing board." On *Booty Call*, all the pre-production and 3D pre-production was completed before we began animating, except for a little bit of modeling and rigging on some of the props that the animators dreamed up while we were on course. No more than 10 percent of my time was spent going back and modeling and rigging props while animation was underway. To finish your film requires planning; here's how we did it with success on our film.

Setup

Project setup includes all of the preparation you must do on your computer and in your workspace in order to begin your project. There are many sub-categories, so let's not waste any time but jump right in.

Software and Hardware

Obviously, this being a Maya book, I am assuming you will be using Autodesk Maya to create all of the 3D imagery in your animated film. While I am confident that many aspects of this book have cross-platform applicability, I naturally tailored the technical sections as in-depth Maya tutorials. However, you will need more than Maya in order to complete a short film. As a bare minimum you will need a 2D painting program or a 3D painting program for textures, a compositing program for assembling the rendered images, and an editing package for editing your film and combining video and audio. Of course, you can have many more programs at your disposal for completing the picture, but the bottom line is that you should have at least a medium skill level with all of the software's functionality *before* you start your film. I repeat that the middle of production is a dangerous time for you to have to pick up a brand new skill. If you know more than one 3D software package, great; many studios use multiple packages even on the same shot (different software products have different strengths). But again, you should not assemble an array of software all of which are foreign to you for this project. Just because you have heard that Realflow is perfect for water and ZBrush is great for sculpting characters doesn't mean you should be getting them.

In my projects I depend on Maya for all of my 3D needs, with occasional sculpting and displacement mapping in Autodesk Mudbox. For texturing I often create some base materials in Mudbox and refine them in Adobe Photoshop. For compositing I love the ease of use of Adobe After Effects; editing is done in Adobe Premiere. Don't worry; the demonstrations of the tasks outside of our hero package (Maya) will be very software-nonspecific.

Hardware

This is a contentious issue and will depend greatly on your budget and the scope of your film. In general you should be using a computer that has enough power to play back your animation scenes at speed, though you may have to hide objects and display an unsmoothed mesh to do so. This is all so you don't have to playblast every single time you want to watch your animation at speed. Thus, the requirements in terms of hardware are actually relative. If you are making a short film using a downloaded flour-sack rig from the internet, you can probably get away with a computer that is a few years old. But if you are thinking of an effects-heavy, multiple-character epic, hardware limitations will come into play. Do not underestimate how frustrating and demotivating it is to wait for a computer. If you want to finish your film, you need the hardware to do it.

I go to lengths to describe hardware needs in *How to Cheat in Maya*, so I won't repeat it all here. To summarize, I feel that a dual-monitor setup is incredibly useful for animation. Once you try it, truly there is no way to return to a single-display system. On top of that, the single most impressive computer upgrade I've made in the last ten years has been putting my operating system and programs on a solid state drive. With a 128 GB SSD you can install Windows and the entire Adobe Creative Suite and Autodesk Entertainment Creation Suite, with room to spare. All of your film's files go on a separate, normal hard disk. There is also something really pleasing about being able to boot Windows in under 20 seconds and be staring at the Maya UI literally five seconds after you click on the program's icon. These would be my essentials. The rest (processor power, RAM, video card, etc.) are all relative to the film you are trying to make. Barring the technical and artistic skills necessary to finish a film, having your short held up by hardware problems would be a tragic way to stall out.

Finally, a word about backups: *do them*. Even if you just have an external hard drive that you copy your project to daily, you absolutely must protect your data. Failing to back up your data is rolling a dice with your future. At my office, our server utilizes a RAID 5 array, so a disk can fail in our server and I can slide in a brand new one with no loss of data. Also, I have an off-site backup done to cloud storage nightly, so even in the event of a total catastrophe we would never lose more than a day's work. When I was learning animation, though, and creating little shorts and animations every day, online storage did not exist and I certainly did not have the technical know-how to create a RAID array. Crashes, disk malfunctions, and plain old screw-ups meant my data was always in danger of being lost—and lost it indeed was. Suffice it to say that somewhere floating around in the ethereal digital graveyard are about five of my short films, maybe three dozen animation sequences, and countless textures, reference images, and other resources. As there are numerous cloud backup solutions on offer these days, most of them extremely affordable and easy to set up, there is really no excuse not to have a backup for your project. Look into Amazon S3 and Glacier storage (some setup required) or automatic cloud backup solutions like Carbonite and BackBlaze.

Ergonomics

In the long term, your most valuable asset is your body. During my career I've seen my share of animators drop out due to tendonitis and carpal tunnel syndrome. In fact, I've seen animators who have ruined not only their wrists but even their feet when they switched to a foot mouse! Seriously! Invest in the equipment you need in order to protect your most valuable asset. Personally, a Wacom tablet has replaced a mouse as my primary input device. Also, I have a standing desk at the office, and though I switch between sitting and standing, my sitting-related back problems have all but disappeared. I no longer suffer from repetitive stress injury in my wrists (unless I am doing a lot of writing, wink wink).

File Management

One of the most overlooked aspects of pre-production is file management, which is why we're putting it first. File management concerns deciding on how you are going to structure the project on your hard drive for organization and easy access. It also involves determining a naming convention for your assets that gives you as much information as possible from looking at the file name itself without being too cumbersome. Most first-time filmmakers decide on a directory structure and naming convention long after they've begun animating. It takes much longer to conform existing assets to a new structure than to create them with the right structure in mind. We're going to take a look at a simple, clean naming convention and folder structure to manage our files as we create our film. You will notice that the structure we are going to use can be scaled nicely to fit films of from one to 90 minutes in length but works best at the one to five-minute range.

Folder Structure

We first have to decide on a folder structure. One very nice feature in Maya is the built-in project folder structure. We are going to take advantage of Maya's default structure as well as add our own. The first step is defining what *type* of asset each task creates. Meaning, how do we establish the proper workflow and pipeline flow of assets as they progress from concept to completion? Let's start with the basics. I'm going to create a folder to house my film called "BootyCall."

Since our film is primarily a Maya project, we must first decide where the Maya-generated project folders will live. It can be misleading and confusing to set your main film's directory to be your Maya project directory. Seeing a slew of auto-generated "cache" and "3DPaintTexture" folders among your other project directories is just messy. For the first folder structure (and workflow) choice we're going to create a folder within our main project directory called simply "3D." This is actually a workflow choice because what we are basically telling ourselves is that anything that is read or created by a 3D package will always be found within the "3D" directory. Notice that I said "read or created." This is not a directory exclusively for things that are literally three-dimensional assets, like models and rigs. There will be plenty of non-3D assets within this folder. Both 2D texture files that decorate our objects and our characters and renders that fill our "images" directory will be within our 3D directory. So let's create the 3D folder within the main BootyCall folder. When you "Set Project" in Maya, Maya creates "assets," "scenes," and "edits" directories anywhere you set your project. If you like, now is a good time to open Maya and go to File > Project > Project Window and set your project to the "3D" directory. Maya will populate your project directory with many subfolders, most of which you will not use. Let's be careful here. Being inundated with too many folders can be just as bad as having too *simple* a folder structure. The main folders we will need are "assets," "shaders," "scenes," and "sourceimages." Maya will create other folders by default as you create certain types of objects, run

certain types of caches, etc. We'll wait for Maya to create these rather than worry about them now. I will begin using the standard Maya project directory notation now so you can get used to it; also for efficiency: \\ denotes the Maya project's workspace root directory, so \\assets means BootyCall\3D\assets\. All 3D assets belong in the \\assets directory, naturally. This includes props, characters, and environments. Now comes our first decision about what to call, and where to place, different types of asset. Let's start with character models. We need to be careful as we start naming directories to hold certain assets. One danger is that we have too many folders with the same name (like \\sourceimages\babinsky and \\assets\babinsky), or start creating assets that don't have a place in existing folders. I've found that things stay pretty organized if you create a mini-Maya project structure within each asset's folder within the \\assets directory. It requires more organization and more care as you are working to conform to this structure; however, in the long run it is far superior to saving things in Maya's default folders. Here's why. A finished character (Babinsky) could have associated files in every single one of these directories, and more:

```
\\assets\rigs\chars\babinsky
\\assets\models\chars\babinsky
\\sourceimages\chars\babinsky
\\sourceimages\chars\babinsky\WIP
\\fur\babinsky
\\fur\furAttrMap\babinsky
\\scenes\chars\babinsky
\\data\chars\babinsky
```

Now imagine having to navigate and manipulate all files associated with this asset. You'd spend half of your time navigating folders, looking for latest versions, and wasting precious energy. Instead we're going to create the necessary folders within Babinsky's asset directory. This makes sure that we only have a *single* folder named "Babinsky" and that all of the associated files are in one place and not mixed together with unrelated files. Our corrected folder structure looks like this:

```
\\assets\chars\babinksy\models
\\assets\chars\babinksy\rigs
\\assets\chars\babinksy\fur
\\assets\chars\babinksy\data
\\assets\chars\babinksy\sourceimages
\\assets\chars\babinksy\sourceimages\_working
```

… and a few more as we get into 3D pre-production.

Notice how much cleaner, simpler, and easy to navigate this structure is. We can create all of these folders ahead of time if we know what is going to be needed, or we can make sure we stick to our directory structure as we create and finalize new assets. With a little bit of practice, this comes naturally.

Let's move on for now and come back when it's time to add more assets to this directory.

Other Folders and Conventions

We will need only a few other main directories inside our main film directory. The "2D" folder holds all things created and read by 2D applications, including tracking applications, compositing packages, and editing packages. You may have noticed that there is a conflict between the compositing program and Maya because of the fact that a render is created by Maya but also read by the compositing package. This is, as far as I know, the only inherent conflict in this directory structure, and it should not actually present too big an issue for us. Just know that rendered comps are going to live in the 2D directory because they are truly created from the compositing package.

Note that I capitalize all of our film's main directories because it looks nicer and more official, but it doesn't matter whether you do or not. Once inside one of the main directories I follow Maya's folder and file-naming conventions, with the first letter lower case and subsequent first letters capitalized, even after an underscore.

Next we'll need a main "Audio" directory in the BootyCall root folder. Inside this folder live your music and sound effects libraries. If you are having a friend score the film, his/her files will go in here as well. This folder can be organized however you see fit, as most likely you will be only working with this directory when you are editing. Notice that audio files that go with your film's specific shots do not go in here. Why not? Audio that you are going to import into your Maya files goes in the 3D folder (remember, anything read or created by Maya goes there). This seems confusing until you actually start cutting your animatic and making headway on the scene setup. It's much nicer to have those files within the Maya project structure when you are importing because Maya will open up the project's root directory ("3D") whenever you try to import something. It would be a huge pain to have to navigate up to the film's root directory and then down into the Audio directory. Trust me, when you start setting this up, you'll see.

In the "Story" folder live the scripts, notes, rough sketches, and ideas that helped you create your story. You can have a "reference" subdirectory in this folder, but I do not for the simple reason that none of the references I gathered for this film are public domain, so they cannot be redistributed with the book. Suffice it to say that you should be gathering lots of story references to help you write a rich story. This directory can also be organized in any way you see fit because there will not be many linked files or much high traffic in here, unlike the "3D" directory. As pre-production hots up we'll be creating further directories within the other main folders too.

The last two main directories I like to create are "_IN" and an "_OUT" directories. The underscore in front of the names ensures that these two folders stay at the top of your explorer window when you are looking at your

film directory (this is done within some of the asset folders, too). These folders hold all of the files that are sent or received regarding your film. You must create a subdirectory for every file or group of files you receive from someone else, named in such a way as to show you at a glance when it was sent or received and what it was.

A good example would be when your composer sends you an updated score for the film, you might download it to the newly created "_IN\2013_05_25 – Updated Score\" folder. Notice how the year comes first in the date, and the description comes after everything. This is so the folders stay in chronological order when sorted by name. Another important advantage of having these two directories is that they memorialize and record the transfer of files. When you need to implement a file that you've received, you copy the file to the appropriate directory. You don't want to move it because you need there to be a pristine copy of the file in the "_IN" directory in case you screw something up when working with this received file. Same thing with the "_OUT" directory; copy files out of their respective folders into a dated and named folder in the "_OUT" directory before sending. Do not either move the files or send them directly from their source folders. This can be one of the hardest parts of file management and the quickest to go off-track, especially if you are collaborating with others, but stick to it anyway. In the end you'll be glad you have an organized folder that you can refer to at a glance, and can also retrieve any file that has been sent or received long after your project is done. With storage prices continuously falling, the excuse of not following this file management system to conserve hard drive space is quickly losing its weight.

Please look in this chapter's source files for an example directory structure that you can use for your projects. With each directory that contains a folder named "_template", copy that folder and rename it to create the appropriate folder for the new asset. For instance, in the \\assets\chars directory there is a "_template" folder: you would copy this folder and rename it "Bob" if your main character was named Bob.

File-Naming Convention

Now that we have our basic folder structure, let's take a close look at how the folders and files are going to be organized within them. For most of the time on this project we're going to be working within Maya, so we'll conform to Maya's file-naming convention to keep everything simple.

The basic asset file-naming convention looks like this:

project_assetName_assetType_assetVersion_optionalDescription. extension

And the basic shot file-naming convention looks like this:

project_sequenceName_shotNumber_taskType_taskVersion_ frameCount_optionalDescription.extension

This changes slightly with different types of assets, but for the most part we can follow this with all of our files. Also, you should create standardized abbreviations for common asset types, sequences, and the project itself. "BootyCall" becomes "BC," the "Opening Sequence" becomes "OPN," " Chase Sequence" becomes "CHS." This naming convention gives us at a glance a good idea of what a file contains and also displays nicely when you sort your folders by name. Let's take a few examples and see what they would be named when we save the files. For example, if you have just finished working on the fifth revision of an animated scene in the opening sequence, shot 5, it's 25 frames long, and you're trying something totally different from before (Babinsky waves instead of jumps in the shot), then it would look like this:

BC_OPN_050_anim_v05_f25_tryingWave.ma

If you are lighting the same shot, it's the tenth version, and there's no need for description (things are just going smoothly), then it would look like this:

BC_OPN_050_light_v10_f25.ma

If you are adding effects to the first shot in the chase sequence, your third save, and you want to remind yourself the file needs to be saved with the masterLayer selected, then you would call this file:

BC_CHS_010_fx_v03_f88_saveWithMasterLayerSelected.ma

Let's do a few more. If you are saving the third revision of Babinsky's face color map, and you are trying it a tad darker than before, then it would be called:

BC_Babinksy_faceDiffuse_v03_tadDarker.tga

The sixth version of a barrel model with no description needed would be:

BC_barrel_model_v06.ma

The twentieth time you save his hands bump map (man, you just can't seem to get it right!), it would be named:

BC_Babinsky_handsBump_v20_ohGodPleaseBeDone.tga

If you think this is confusing to look at, you've never seen a project-wide \\sourceimages directory with literally *thousands* of textures in progress and names like grass5_final_v2.psd and greengrassworkinprogress2_done.tga. I have, and the nightmares are starting to subside, thanks!

Working and Publishing

The last thing we need to work out with folder and file-naming conventions is the idea of publishing. Publishing means saving a file in a location and with a specific naming convention that denotes it as the most up-to-date asset. Even if you are working alone on your film, a certain amount of predictability in the naming of the latest assets helps a lot. So far, *all* of the asset files we've named

above should go into the "_working" directory of their respective folders. So the file above named

BC_Babinsky_handsBump_v20_ohGodPleaseBeDone.tga

should actually go into the folder:

\\assets\chars\Babinksy\sourceimages_working

This file is actually just a working file. You do not want to have to go into every single scene that uses this texture and swap out for the latest whenever you update it. So rather than have to figure out which version of a file is the latest, we always save a copy of the working file as a "_PUB" (publish) file. The _PUB versions of all of your assets are the *only* files that live outside of the "_working" folder in each asset's folder. This is the best way to limit clutter. When you save a new version to the _working directory, save again right after, overwriting the PUB file in the main asset folder. This way, you know you will always bring in just the _PUB file into your scenes and that it will be the most up-to-date version. The hands bump map mentioned above would be saved as:

BC_Babinsky_handsBump_PUB.tga

And it would be saved in the directory:

\\assets\chars\Babinsky\sourceimages\

Remember, when you go back to working on this texture again, open up the latest from the "_working" directory. Save it as a new version (v21 in this case) when you are done working on it some more, then save it again as the _PUB and overwrite. This is called a "push" workflow.

Push or Pull Workflow

There are two main kinds of workflow when it comes to making sure that you are working with the latest assets. They are called push and pull workflows.

A push workflow means that you are constantly overwriting a single file (in our case, the _PUB) that all the scenes reference. This way, when you update the _PUB file (otherwise called "pushing" the file), all the scenes that need the updated asset get it automatically. So if you are working on Babinsky_rig_v02.ma and save a new version as Babinsky_rig_v03.ma, all you need to do is save it again and overwrite the _PUB and every animation scene that references that file will be updated. This is a huge saving of time and energy.

A pull workflow means that you have to open every file and "pull" the updated assets into your scene whenever there is a change. To take the last example, saving v03 of the Babinksy rig means that you must now go into every single animation file and replace the v02 with the v03. A pull workflow has its advantages; there is never a chance that a scene is going to be messed up unintentionally. With films that have only a few shots (under 10 or so), a pull workflow is perfectly valid a way to work. You may want the peace of mind

that comes with knowing that all your scenes are going to continue to work after you have updated an asset.

In general, push workflows are utilized ubiquitously in large studios because the amount of time it would take to update file references would be astronomical on a major project. Pull workflows are utilized on projects with unique assets that are very different in each scene. A good example is commercials; often each shot will have its own unique assets, sometimes requiring multiple versions of the same asset. A character rig that needs to squash well in one shot might not be very useful for doing a run cycle in the next shot. We will be using a push workflow exclusively, as a pull workflow can become too cumbersome in the late stages of a short. In order to finish your film, everything needs to go smoothly!

Design

The design phase can be thought of as the stage when you answer the greatest number of questions. What will the main character look like? What will the environments look like? How will you create a modular environment to give yourself some flexibility and save time creating the short? What kind of complexity is really needed in the character to convey the story? These questions and more will be answered in the design phase.

Drawing Skill

Unfortunately, there is no way of working around drawing at this point in the short. Many animators today are fantastic at moving characters but can't even draw a straight line. This is not going to hold up for very much longer. As the industry matures, so will the demands of the job. Graduates from schools will need to be trained in traditional art as well as the digital medium. If things really do swing back and forth like a pendulum, then the pendulum is quickly swinging in the way of CG animators being required to know many more disciplines.

There's some good news though. It is really easy to improve at drawing. All you have to do is draw. Draw every day. After only a little while of drawing every single day you will start to see improvement. Stick with it, and after another little while you'll see that your observational skills are improving and your drawings becoming less sketchy and more confident. Continue to stick with it and you'll become an extremely competent artist in less time than you thought, I promise.

Shake it Out

One of the first things I want to point out is that there is no need to go with the first or most obvious choice with your designs. Remember the story about the kid playing soccer who is scared of the bully? Ask yourself now, do you really need to create that story with realistic bipedal human kids? Absolutely

not. You could create that exact story, point by point, using flour-sack rigs. Or with a simplified character rig made of cubes proportioned like a child. Or with a puppet rig (humanoid but without a face). The point is, for an individual effort it is folly to try to create a host of characters that are realistic. The usual result is that animation fidelity doesn't match character design. So relax and have fun with the designs.

Notice how the Devil character in Michael Cawood's film is pushed and stylized. The eyes especially have a classic cartoon look. Contrast that with the highly realistic characters in *Paths of Hate* and you will begin to see the value of being loose and fun with your designs, especially on your first film.

FIG 4.1 In *Devil's, Angels, and Dating*, the characters are a great blend of cartoony and realistic. The animation style can be loose and fun and match the character designs.

FIG 4.2 This film's realistic character designs demands that animation fidelity be very high. That's a lot of work!

Consider the movement style when designing your characters, as the styles need to match. In *Paths of Hate*, it would completely ruin the film if the animation was cartoony or used common shortcuts to save on animation time. You are not only choosing the character designs when you create your characters, you are homing in on the movement too.

Have Fun

Now that you are all loosened up, it's time to get down to designing. While an entire character design course is outside the scope of this book, I do have one major tip that will keep you loose and thinking outside your normal comfort zone. It's a trick I practice to try and find good designs in everything I do. Start with a blank piece of paper or a new image if you are working in Sketchbook or Photoshop. Draw between eight and twelve random shapes—and be sure you are drawing them completely randomly. Do not think about what the shapes are supposed to represent. Do not be concerned with the size of the shape, or if the lines cross; again, these are to be completely random.

FIG 4.3 Here are my random squiggles. Sure, they have similar properties, but apart from their similar size on the page they are totally random.

Now what you must do is look at each random shape and try to see the character design hiding within. Use just one of the lines, or all of the lines, and incorporate it/them into your rough character drawing. What you will quickly find is that you are constantly fighting against your instincts regarding where to put the features of the figure. There may be no line where a nose is supposed to go, or the limbs might seem totally out of proportion to the figure. This is *good*. This means that you are allowing your design muscles to stretch a bit and be more relaxed than they were before. I have designed many characters based on random shapes like these. Of course, a lot of refining goes into the final character designs, but for really breaking down the walls in your head, nothing works faster than this exercise, in my opinion.

FIG 4.4 Here are my rough character sketches based on the random shapes drawn earlier. Notice how the shapes inspired many different genres of character, from cartoony to gestural to realistic.

I recommend you try this method for a few hours before beginning your character designs, to keep you loose and thinking outside the box. In the end your story will inform the designs to a large degree, but it is also good to leave some story discoveries to the design phase. This is still early on in your film, so changing bits of story is allowed!

Babinsky's Design

By the time we were preparing for the animation course there was design already happening from the very talented Jan Zivocky. Take a look at some of the amazing artwork he sent our way.

FIG 4.5 This design was one of the first sent to us. As much as I liked it, I felt it looked a little bit too much like a carnival strong man.

Your first designs don't mean a thing. There is no such thing as getting it perfect on the first try. Even designers who have worked 35 years in the business tell me that there is always a little bit of warm-up with a character. The best advice is to let the designs inspire the story a bit. What would be the best choice for our character? To me, it would be better if the character was not a captain but a more lowly pirate. The kind that has to swab the deck, raise the sails, etc. If he didn't look like the head of a ship, it would be even more dastardly a deed to be sneaking aboard. Who knows, maybe the treasure he is stealing is from his own ship! I liked the ambiguity here. With that direction, Jan sent some more designs.

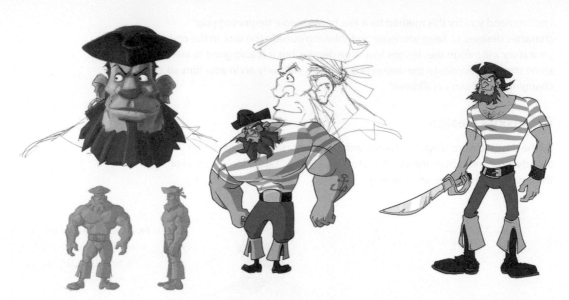

FIG 4.6 This was very close, but there was still something not quite right.

I was very happy with the design now. I loved the striped shirt, the beard, and the big leather boots. But something was not quite right about it. It suddenly dawned on me that only captains wear a hat like that. And they are the only ones on a ship to have a big hat. To finally distinguish Babinsky from a top-level pirate and relegate him to the belly of the ship, we decided to ditch the hat. (It was modeled in to the character, but in the short it was never used.) With that final direction (along with the choice to go with the skinnier pirate), we were sent back this:

FIG 4.7 Here is our final design. I knew that he'd look even lowlier without his fancy tri-corner hat. I wouldn't trust this guy as far as I could throw him!

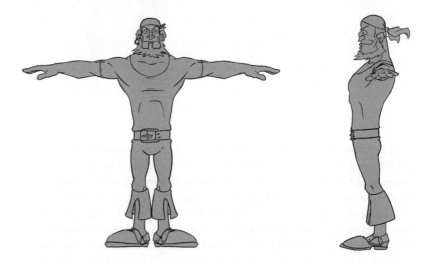

Our supporting films have some pretty inventive designs. Take a look at a few of these and you'll see some brilliant ideas.

FIG 4.8 The cat from *For the Remainder* evokes a very eerie mood. These rough silhouettes are all that are necessary for an artist to be inspired and jump into creating the cat.

There is such a thing as over-designing a character. Especially in short film, you want to give yourself the leeway to be able to make adjustments when you get into 3D and begin modeling. Think about how much time you might waste trying to get minute details into your designs, only to start building the character and find many of your choices have to be scrapped by way of technical considerations. I prefer looser designs so that a certain amount of discovery is left for the modeling phase.

FIG 4.9A,B *Reverso* has some of the strongest designs I've seen from such a small team.

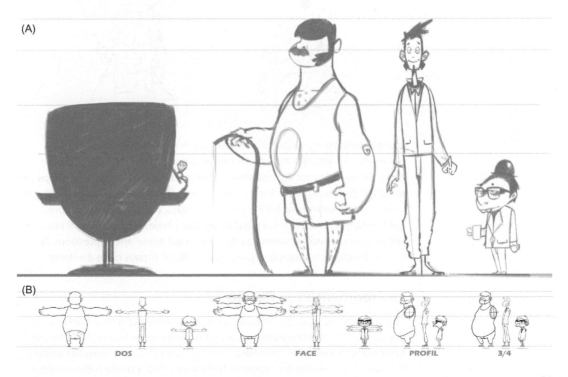

(A)

(B)

DOS FACE PROFIL 3/4

What makes a design strong is the harmony it has with the story, the other characters, and the environments. In *Reverso,* the father is grounded and therefore fatter and stockier than the son. While the main character does live with gravity reversed, it doesn't mean he is weightless. The reflex might have been to create him as even skinnier than he is, but I'm glad the artists didn't follow that reflex. As he is, he meshes well with the other characters and is fun to watch.

Further Exploration

After you have your base design in good shape, you can explore some further design questions. Create a few studies of the head and figure out what the face might look like in different poses.

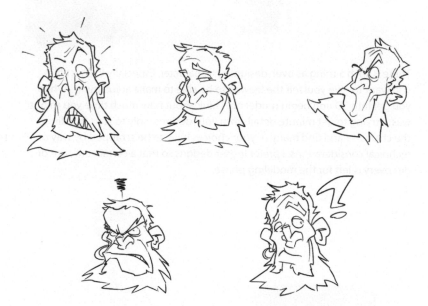

FIG 4.10 Face studies like this one are worth the effort. You can begin to get a sense of how the face will move and, even more importantly, a sense of the structure of the head. If something is going to give you problems later on, it will start being indicated to you here.

I am all about being economical in your efforts when trying to finish a film. However, I am also realistic when it comes to tasks that really save you time down the road. I'm not against a little sidetrack as long as it pays off or helps you avoid the common pitfalls. Face studies fall into this category. Just beginning to see the character moving his/her face hours, days, weeks before you would ever get a suitable blendshape is a great thing. Many times huge structural problems will present themselves when you do some head "turns" and expressions. No matter the character complexity, exploration like this pays huge dividends.

Environment/Prop Design

The number one goal should be to create an environment that can be multi-purposed. This I learned from a stop-motion animator who created a film that takes place in a hospital. The character runs through what seems like *endless* hallways, but in reality the animator had created just a single hallway with a

turn at the end. When the animator needed a turn in the other direction, he just flipped the frame when he was done shooting. When he got to the end of the hallway in a shot, he would just cut to a new angle and move the camera and character back to the corner to give himself plenty of room to shoot. And he would control the set dressings (plants, doors, chairs, lights) meticulously so that each stretch of hallway felt unique. I thought it was brilliant and it inspired me to do the same thing.

To really take advantage of the modular middle, you must also try to maximize your environment design. Your middle is not truly modular if you have to create a custom environment for each shot. Props, on the other hand, are fine to create on a per-shot basis.

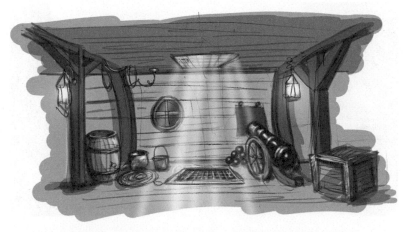

FIG 4.11 Here is my environment design. Yep, that's all of it. When you are planning on a modular set, all you need is one section to be done and you are finished. Imagine the time saving over having a large number of detailed sets.

I kept my design loose and fun, again. There were a few props drawn in to the design, but for the most part modelers could just create anything they wanted. I had some help in my studio from Tyson Karl and Jocelyn Cervenka, and what they created for the short was awesome. But even better, take a look at a photo of the space where we animated *Booty Call*:

FIG 4.12 It was almost as if it was fated. When I arrived at Anomalia, I was almost floored when I saw that the room that we were animating in was the interior of the pirate ship, almost to the inch!

You might not have as much luck with your environment as I did, but suffice it to say that a loose design is a handy thing. Discovery can happen in the environment to a much greater extent than with the characters, so keep things open for interpretation at the modeling stage. There are also opportunities for inspiration to come from your environment, so you want that to be possible too. For instance, in our film, one of the set dressings is a hanging chain; when one of the animators saw the chain, he based his entire shot around the character "clotheslining" himself as he runs through the ship. It meant I had to create a rig for the chain, but nevertheless, it shows how the environment can be a source of later inspiration. Plan for the modular middle to take advantage of everything you are putting into your environment, while at the same time not planning too much.

FIG 4.13 This environment is very moody. Also being worked out in this design is the light treatment.

Your environment is made up of more than just objects. If you are creating a short that deals with nightmares and shadows, then light is a part of your environment. If you are talented enough to do digital paintings, then your environment designs can serve as more than just form and function. You can even move into the realm of look development.

FIG 4.14A These designs from *Meet Buck* serve many uses. I mean, just look at them. So pretty.

FIG 4.14B (Continued)

If the advantage of being trained in traditional art disciplines is not readily apparent to you by now, I don't know what else to show you to convince you. These environment designs embody the whole awesome, unique look that *Meet Buck* is known for. The painterly style, the light bloom, the contrast of large and small brush strokes—I almost want to frame them! Whether you can make designs of this quality or not, they have a level of artistry to aspire to.

FIG 4.15 The props from *Meet Buck* do not disappoint either.

When designing props, your main aim is to establish a level of detail for your objects. This is to avoid being in the middle of modeling a prop, then having to stop because you can't quite figure out how to finish it. After establishing a look for your film with a library of designs, you will have a bit of a shorthand for describing objects that fit into your film visually. And because modeling is so much slower and more laborious than a sketch, prop designing is another one of those things that pay huge dividends when you are pressed for time.

FIG 4.16 This design for the cannons in *Booty Call* was needed because the cannons are featured so specifically.

For *Booty Call*, the modular middle was the majority of the time on screen. It is also the only section in which Babinsky is really interacting with any props. Since the only prop that I knew would be featured was the cannons, the only detailed prop design went into those. The rest of the props, for the most part, were modeled off of the dressed environment design that you see above and google image searches open on a second monitor.

Environment Economy

In your short films, the environment can't feel like it is completely empty except for the characters that show up on screen. The best way to make it feel like your film is much more "full" is by pulling some tricks with the environment. Notice how in my environment design there are rays that are coming through the grate in the ceiling? Combining the *sound* of the pirates that are up above on the deck with the *visual* of the rays being blocked by pirates walking over the grate, and we get the feeling that this is actually a very full ship.

FIG 4.17 This render of the treasure chest shows the rays that are coming through the grate. At any time I can block the rays with a simple piece of geometry and it will look as though people are passing over the grate.

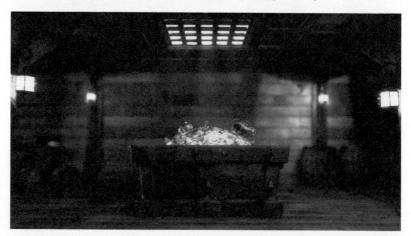

Using sound in conjunction with smart environmental visuals makes your short feel a lot more than a single-person effort. The best part about this is that the audience doesn't care as long as it is done in a way that is not too "in-your-face." Imagine, for instance, you are writing a story about a spy that steals a diamond from a mansion during a gala event. You don't need to show the rest of the guests! All you need to show is the spy sneaking into a room, and in the hallway behind him a glimpse of the shadows of dancing people just before he closes the door. You could achieve this effect with simple polygonal cutouts, or even planes with the silhouettes of dancers as the alpha channel casting shadows on the wall. Combine that with the sound of a string quartet and some background voices and you have yourself a full *world*. Think about how you are going to fill your film with the hints of other people and you will elevate your film from a single-person project to a world that feels inhabited.

FIG 4.18 This familiar frame from *Drink Drunk* shows an environment that was designed to be very economical in the way it performed.

In *Drink Drunk*, the bar doesn't need to be highly fleshed out to convey the feeling that the main character is alone in the world. We hear the sounds of patrons inside, while at the same time showing the bar only through a narrowly open door means that not very much had to be modeled to give the impression of more inside. As an audience we assume there are bottles, stools, tables, booths, a dartboard, maybe a jukebox, but in actuality I'd be surprised if there is any more geometry than a few pixels off-screen!

Although it doesn't qualify as a modular middle, the makers of *Reverso* were very economical with the work environment. How better to give the impression of workers crammed into a beehive than to design and build almost endless rows of cubicles? The sounds of a busy office (phones, typing, etc.) contribute to the "fullness" of this environment. If your film has this much modularity, you are in great shape.

FIG 4.19 Talk about economy! In *Reverso*, the middle of the film features the main character's workplace, which is modular to the extreme.

Storyboards

Storyboards are drawings of the shots in your film, simply put. We draw the "boards" because before you can create the scenes, you must see them all to understand how the shots will flow from one moment to the next. I cannot stress enough how important it is to create the storyboards for your film. The reason is because storyboarding is where 90 percent of the directing takes place. I have had many arguments with clients on this very subject. Allow me to explain.

In the animation service business, clients come to your company looking for animation, all with projects at various stages of completion. Some clients will come to you only with designs, some will have storyboards, some might have some rigs completed. Whatever the case, there is one thing I always put my foot down about to make sure it is understood: whoever does the boards either sits with the director or *is* the director on the project. Meaning, if I am handed boards that the director has not seen, I refuse to start on the project until he/she has approved them. Conversely, if a client comes into my studio expecting to direct the project and I am creating the boards, I also demand they sit with me as the decisions are made. The storyboards are where staging is chosen, the mood is defined, the camera angles and movements are worked out, and the film takes direction. For the purpose of finishing your film, you should know that storyboarding is the stage that is skipped or completed half-heartedly by throngs of students who never finish their films. In fact, I would probably go so far as to stand behind a statement that half-assed or missing storyboards account for the *majority* of unfinished short films. Have I convinced you yet!?

In the early days of animation the storyboards stood in place of a script long into the production process. I had a chance to listen to story legend Floyd Norman from Disney give a talk on story, and he lauded storyboards as an even more powerful story tool than a script. Apparently, in the days after

Snow White, the entire story would be worked out with boards before a single word was written. In fact, I am fine with you concurrently working on your script and storyboards. Nothing bad will come from getting an early start on your visual plan.

The Cutting Room Floor

In live-action filmmaking, the cutting room floor refers to old-fashioned film editing in which the film itself was physically cut and spliced together. When an edit was made, the extra footage would fall to the ground. I'm told it could get quite messy. Actors would lament that their best performances would end up "on the cutting room floor." Sometimes, though, filmmakers would refer to scenes cut from the film already when they wanted to improve the editing; director's cuts normally include scenes that didn't originally make it past the cutting room floor. Also, you might say that films that needed a huge amount of editing were made entirely *from* the cutting room floor.

Why I'm bringing this up is because, in CG, we don't get a cutting room floor. We aren't making loads of extra footage and then cutting the film together into a coherent piece. Instead, we have to carefully plan every single shot to avoid redoing work that is costly both in time and money. Since we must plan so much, the single moment in our entire production when we can utilize the same attitude as editors of yore is when we are storyboarding. It is up to you to try lots of different versions of the exact same sequence. If you are having trouble mixing it up (it is common to have a strong idea and then be unable to imagine the scene any differently), then my advice is to do literally the opposite of what you were thinking before. If you started a scene with a really wide shot, start it close up instead. If the character entered from screen left in the first version of your film, make him enter from the right on an alternative storyboard. Then, armed with your multiple angles, stagings, and scene setups, you can emulate the "cutting room floor" when making your animatic.

Booty Boards

My first step is always to do what I call "quick boards." These storyboards are *tiny*, no more than an inch both ways. The goal with the quick boards is to pre-plan your planning. It may seem a little overdoing it, but even storyboards can be time consuming. Finishing your film depends on taking even the smallest shortcut to get to a better result. I find the quick boards do just that.

Then you move on to the real storyboards. At the very least your boards should have the rough staging of your shot. If you are communicative with your boards, they are more than just drawings of your shots—they convey the staging, the mood, even camera and lighting information. Not all of us can be world-class boarders, so do these "for you" rather than for others to interpret.

FIG 4.20 Here are the quick boards for *Booty Call*. As you can see, they are extremely loose. You can do quick boards for your film in about twenty minutes. I advise you to create quick boards for the entire film so you can begin to see continuity and editing choices (as opposed to doing the quick boards as merely a first thumbnail for your real storyboards).

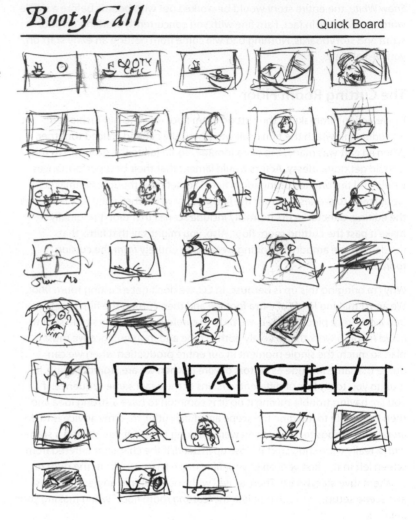

Here are my boards, derived from the quick boards you see above:

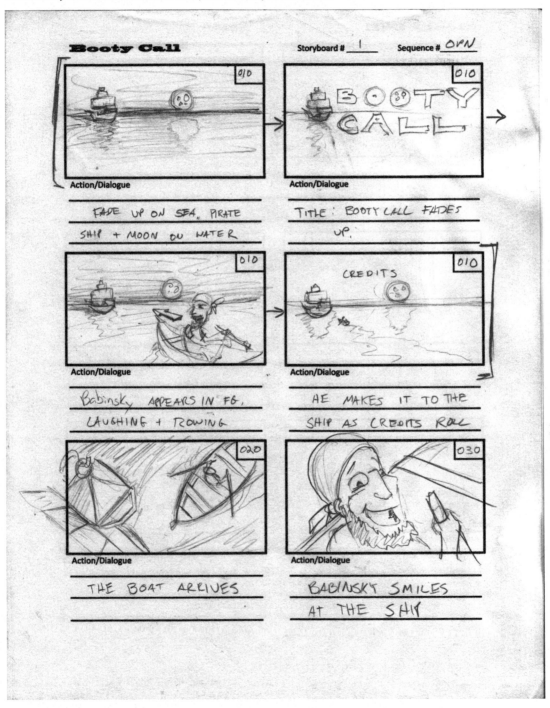

FIG 4.21A–G Here are my boards. In drawing them, I wanted to be very specific with certain key shots because I knew they would be pivotal in setting up the conflict and the modular middle.

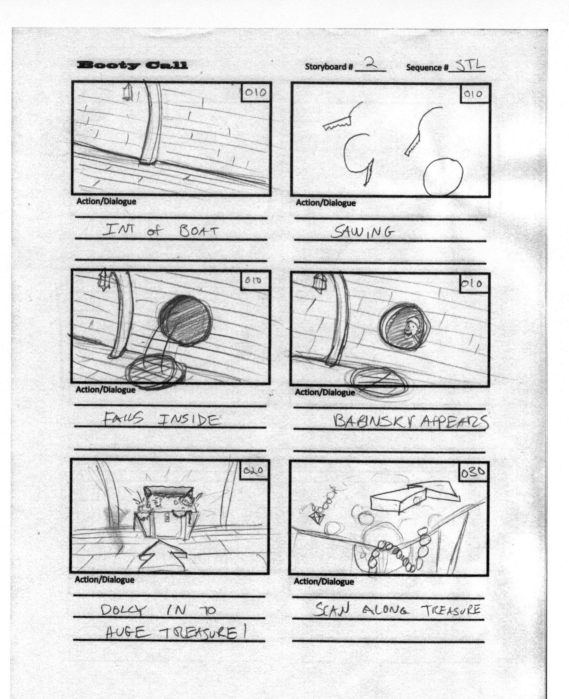

FIG 4.21A–G (Continued)

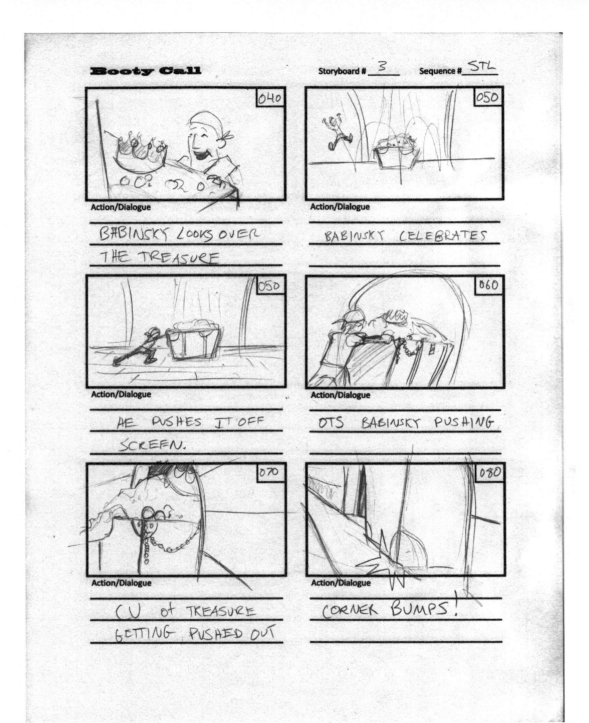

FIG 4.21A–G (Continued)

FIG 4.21A–G (Continued)

Booty Call

Storyboard # 5 Sequence # STL

140

Action/Dialogue

150

Action/Dialogue

160

Action/Dialogue

Action/Dialogue

Action/Dialogue

Action/Dialogue

FIG 4.21A–G (Continued)

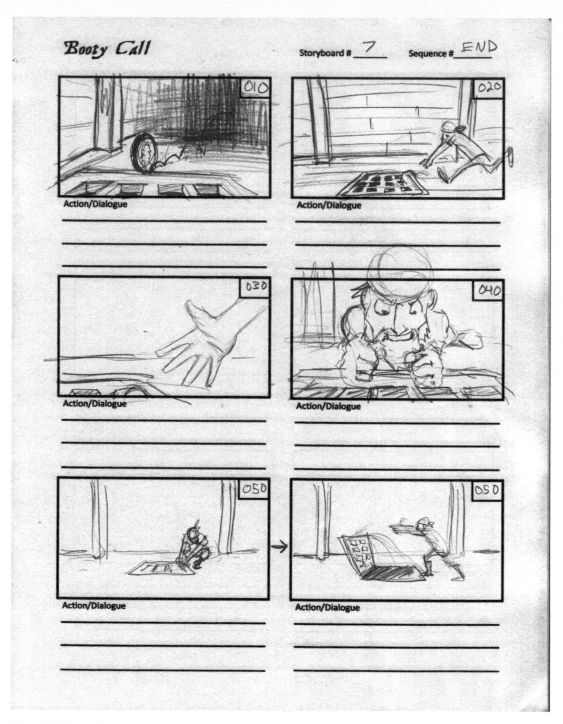

FIG 4.21A–G (Continued)

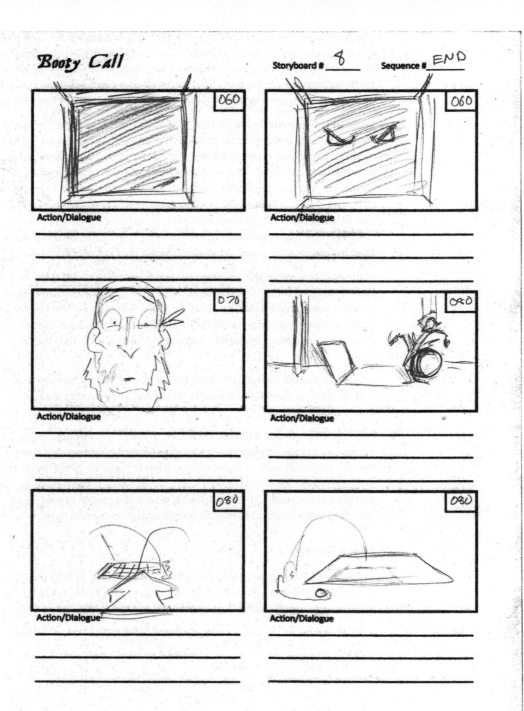

FIG 4.21A–G (Continued)

The storyboard template I use has a spot for the shot number (remember we number everything by tens). There is a page number (simply for keeping the film in order), as well as space for action and dialogue. These are simple and to the point, not meant to be framed pieces of art—good enough to plan the film properly. I have included the template PDF in this chapter's source files.

Notice first how in the board for OPN_020 (look at the top of the page for the sequence name and the corner of the boxes for the shot number) it is a high angle looking down on Babinsky. The first consideration was that I wanted to make sure that we hear the pirates on board. We therefore had to be high enough to hear the commotion on deck. I also wanted the light to be in the foreground and for Babinsky to be lurking in the shadows. The ominous smile that he cracks in OPN_030 (next frame) is a great foreshadowing of what is to come. Note that even though the OPN sequence finishes on this page of boards, I always start a new sequence on a new sheet of paper.

In the next sequence (STL: Stealing Sequence) you will notice the first board has the components of a saw blade and a circular cut drawn into it. These elements were created to allow me to do a little animation of the sawing action within the animatic. You'll see if you open "animatic.mp4" in this chapter's source files that the little bit of animation helps to time the shot nicely.

On page 4 you see the two different kinds of arrows. The solid arrows indicate that an object is moving, whereas the 3D shaded arrows indicate a camera move. Simple as that.

I want to reiterate that it is more important to utilize this opportunity to explore numerous different choices for your film than it is to create boards that are extremely well rendered. Do you want to make an "art of" book or finish your film? Spending the time to polish your boards marries you to ideas that are not necessarily the best ones. So, do not get caught in the trap of spending more time and energy on your boards than the film itself.

More Boards

The makers of *Reverso* were kind enough to provide some of their boards for us to look at. These are great. If you opt for drawing your boards in a digital medium, you can get some great base lighting and mood, as these show.

REVERSO STORYBOARD
Page ___

Timing	Seq		Action

Secondes ___

Secondes ___

Secondes ___

Secondes ___

FIG 4.22A–C These boards are simply great—literally. They are simple yet great drawings that provide a lot for the animator to rely on when creating the shots. Some lighting choices are even worked out—for example, when the main character recedes into the shadow of the house.

FIG 4.22A–C (Continued)

REVERSO STORYBOARD
Page ___

Take a close look at these boards and the *Booty Call* boards and compare them to the final film. What you will notice, I hope, is how closely we were able to get the film to look like the boards. This is obviously by design. It came from making a conscious decision to think cinematically and not in an illustrative way. The last best piece of advice I can give concerning boards (besides drawing a lot of them) is to remember you have to create the shots in 3D at the end of the day. If you keep this in mind you will no doubt create great boards that will inspire you to work hard creating the film in front of you.

REVERSO STORYBOARD
Page ____

FIG 4.22A–C (Continued)

Timing	Seq	Action

The Animatic

An animatic is simply the storyboards edited together in your favorite editing package. It is not difficult technically to create your animatic, but you can get lost on this phase if you are not careful. The following has some good tips for making sure you don't drown in work when you create your edited animatic.

Work in Layers

Create layers ahead of time in your editing package that will serve as placeholders for your shots as they are completed. The bottom layer is for your

storyboards, as they are the first visual element that you are manipulating on the timeline. Above that layer are open layers for your playblasts and renders. You will then need some layers for titles that will serve as labels for your shots. You will want labels on both your sequences and your shots. You will want frame counters on each shot in your editing package so you don't have to remember to add them in Maya when playblasting. You will want a mask if you are rendering at an aspect ratio other than HD. I count at least five layers, six with a mask.

FIG 23 Here is how my animatic is set up, even before I started timing the boards. Notice all the layer names on the left.

As you can see, with my editing timeline set up to have all of my layers, I am free just to create after this stage. Boards will be put into the "Boards" layer, timed, and then labeled with the sequence and shot number that goes with them. Note that when numbering the shots, the board numbers should give way to the labels that you have created in your editing program. Meaning, if you switch around the order of shots, cut some out, or chop up a shot, you use fresh numbering in the editing package with your labels. It's just cleaner in the end, and you will anyway be starting fresh when you move into layout.

Adding Frame Counters

Why add frame counters in the edit? It saves a lot of time not having to make sure to always playblast with the frame counter showing. Also, you still want to see the frame count when you are at the rendering stage; since you won't be adding a frame counter to a render, the only option is to create frame counters on a layer above the rendered images in your editing software.

In Premiere you apply a frame counter by clicking in the Effects tab on Video Effects > Video > Timecode. Most editing packages have something similar. I've included a screenshot of the common Premiere Timecode settings below.

Add the frame counter to the shot label. Why? Because if you add a playblast over a storyboard, you don't want to have to re-add your counter. If you add a render over that playblast, same issue. And if you replace a piece of footage altogether, again, recreating the timecode is a pain. This way the timecode is always on the shot label, which never gets covered or changed. The only thing to remember is that the label needs to match the footage. Meaning, if you edit the footage to start on a frame later than frame 1, you have to edit the timecode to be offset on that new frame. In the screenshot below, imagine the storyboard I shortened in the beginning was an animation scene that now starts on frame 13. Well, my shot label timecode is going to display a start frame of 1 if I simply drag it to start on the same frame as the animation. So you must first look at what the new start frame is (in this case, 13) and change the "offset" on your timecode to match. As you get closer and closer to the end of production, the little tweaks you are doing in the edit will not require timecode, so editing it is not too cumbersome.

FIG 4.24 Here is my timeline with the boards inserted, timed, and labeled appropriately. As you can see, the shot has the labels displaying, along with a frame counter.

103

FIG 4.25 Here are the right settings for adding a frame counter to your shots.

FIG 4.26 The shots should always have consistent frame counters based on the Maya scenes. If you slide a piece of footage, as was done here, make sure you adjust the frame counter.

Editing the Animatic

For me, editing the animatic (putting the storyboard in sequence on the timeline and creating the overall flow of the film) is one of the most exciting parts of creating a short film. Truly, this is where the film starts to really come to life. I love how so many choices are available to you even at this early stage. It will also inform you of choices you've made that need to be rethought. Choices such as camera angles in your storyboards, number of characters, the setting, etc.

As you are editing your animatic, ask yourself: "Are all of these shots necessary?" and "Is there a necessary shot that is missing?" The answers to these questions hinge on whether or not, as you are editing your film, you

can see a clear storyline. Are you dedicating the right amount of time (not too much, not too little) to establishing your character? I knew that we had established Babinsky clearly by choosing a pirate as our character and showing him rowing up to a ship under cover of darkness. Immediately, the audience is totally aware that he is a scoundrel. Remember the tips on choosing recognizable characters in the story chapter. A good rule of thumb is that if you are beginning to edit your animatic and find that you must go back to the boards in order to fill in a lot of shots, especially at the start, you might have not chosen the right characters or setting for your film. But this is still the exciting part; editing the piece together is such a powerful moment in the life of your short that you should revel in the possibilities that lie ahead. But also approach this phase thoughtfully and use caution when making decisions.

Making Timing Decisions

To make the right decisions regarding how long to time shots, I employ a very simple workflow: I hit play on my timeline and imagine the animation happening in front of me; hit stop when it feels like the shot is over (in Adobe Premiere this is as simple as pressing the spacebar). Then I start again. Do this up to a dozen times per shot and, as you "perform" the animation over and over, you start to get a feel for the timing. After at least five to ten tries, place your storyboard image on the timeline, timing it out to end right where the slider is. Then do it some more! Rewind the playback to the beginning of the shot and time it a dozen *more* times. Only when you've completed this process at least two dozen times are you ready to move on to the next shot. Be careful, though, to play the previous shot when timing your boards so as to get a sense of the flow of the scene.

This simple workflow is just one of the ways to time your boards. Another fun and equally valid way to time the animatic is to use music. This method will actually *generate* new timing ideas and new shot ideas because you are building from something that already exists.

Watch the animatic in this chapter's source files folder again. This was all temp audio that I used to help me keep the pace of the film. While not much of the film took direct animation cues from the music, certain parts—the beginning and end, especially—were timed particularly easily because of the temp music. When the score was finally written, the timing choices had a musicality and rhythm to them that made them easier for our musician to score.

Animatic v1.0

It's time to see if your film is "working." One of the best and worst things about working in animation is that our friends and family are the audience we are trying to entertain. While they may not understand how much work goes into even two seconds of animation, they can pick out problems as well as any animator. While sometimes the words escape them as to *why* something doesn't look quite right, they are never wrong. After you've made your timing decisions

for the whole film, export a movie of the entire animatic and start showing it to friends and family. Explain that it is the rough version of the film and that you are using it to make decisions about the number of shots you'll need, pacing, etc. Ask them if they can tell you what is happening in the film. You have a home run if the majority of people who see the animatic tell you exactly what is happening as you imagined it. Things such as your drawing skill can get in the way of this, so don't argue with a positive review; take it and move on with production. Negative feedback needs to be scrutinized for the real story notes that will help you hone the film. It is easy to get indignant when you receive negative feedback at this point. What you have to understand is that nobody can see the film *you* see in your head right now. Instead of fighting against the feedback you are getting, embrace it. Unless people are seriously offended by the film there should always be a way to turn negative feedback into positive criticism. Follow the story and pre-production steps again to address the notes of your audience, but at the same time make sure you are making *your* film.

Cutting Audio for Layout

Once you have your all storyboards timed to the film, you need to export the audio files that you are going to use to time your Maya files. This is another of the things that few people think to do but which saves loads of time in the long run.

To do this, constrain your export range to the start frame and end frame for each shot and export a .wav file. Save this file to the \\sound directory. Remember, \\ denotes the Maya project directory, so we are talking about the 3D\sound directory. Each sequence should have its folder within the sound directory as well. Why are we going through this seemingly useless step? If you have no dialogue or even music picked out, the sound files will not have anything in them. These blank files are still perfect. Name the files according to sequence and shot number as you would any other asset. For example, OPN_020.wav is fine. Later, you'll see that the reason for these files is that they allow us to create the layouts of our shots extremely quickly.

Final Prep

A few more things to do before we're ready for production. Let's finish up pre-production on the right foot.

Setting Up Your Backup

I highly recommend that you have an automatic data backup solution. I'm not in the business of data backup, nor am I completely positive that I'm using the best solution out there, but knowing I have a system in place gives me huge peace of mind. It can be frustrating setting up a system, so I looked for a solution that I could set up easily, was relatively cheap, and would just work. Having an external hard drive that your files are mirrored onto is a good idea, but if lightning strikes your house nothing will save your film. So I recommend having

FIG 4.27 In Premiere, you simply constrain the "in" and "out" point on the timeline and press Ctrl + M to export media. I chose Windows Waveform, and have set up the audio to save in the 3d\audio directory.

an on-site and a cloud backup. The combination I use (and again, there may be better out there, I just like the ease of use and automation) is the following:

- For on-site backup, I used a Western Digital Passport 1 TB drive, connected by USB 3.0. A free program called Syncback (www.2brightsparks.com) allows me to set automatic backups on a nightly basis.
- For cloud backup I have an Amazon Web Services account (aws.amazon. com), which gives me access to their fast storage solution (S3) and their slow archive solution (Glacier). A handy program called Cloudberry Backup (www.cloudberry.com) allows you to set up automatic cloud backups. I use Glacier because, even though they say it could take up to a few hours for your files to become available if you need to restore them, I figure I will only be grabbing the files if there is a catastrophic event and my on-site backup doesn't work either. They charge only 1 cent per gigabyte a month to backup your files. *Booty Call* at its completion is around 75–86 gb. I don't mind paying less than a king-size candy bar to protect thousands of hours of work.

Whatever you come up with, it is absolutely imperative that you protect your time investment. Many a short film has had everything going for it, only for it to be lost in an accident or theft. Please take it seriously.

Communication and Planning

Working in a small team means dividing the work between multiple artists, and communication becomes an issue. When working on your own, there are no gaps in communication. Nothing is lost in the shuffle when it's all in your head. With teams of three or more, pre-production must include establishing a means of communication and charting progress.

107

Communication Methods

Assuming you are not working in the same room as your collaborators, good old email will suffice for much of your communication. However, if there is a hierarchy, meaning people are taking direction from you, then it is good practice to memorialize notes and direction in some way. Consider moving to an online shared-access system like Google Docs for this. Create a new document for each asset and shot, organize the docs into folders based on asset types or sequences, and, whenever feedback is needed, leave the notes in the document and email the person to let them know the feedback is there. This is just as much about covering yourself for problems down the line as it is good practice to consolidate feedback in a single place. Although it adds quite a bit of work to create a system for managing your project, that effort is hopefully offset by the shared workload on the animation.

Project Management Software

An alternative to creating your own project management structure with something like Google Docs is to use one of the many free project management sites that exist. Zoho.com offers a free small-team version of its project management system and it has all the features you need—task management, document sharing, a calendar, forums. Probably the most widely known software is called BaseCamp. This is a fully featured web-based project management solution and they offer a free 60-day trial; it's only $20 a month after that for a small project. Teamworkpm.com and 5pm.com are also good solutions; both have free versions with lower functionality or trial periods.

The point is that if you have a small team, the benefits of having help on the project if you are working together online can be quickly overshadowed by the work it takes to organize multiple artists. I recommend looking into project management before accepting help from too many people.

Charting Progress

At the very least you should put together a schedule for your film for yourself. If you like to see progress charted on a daily basis, then you can create some form of chart to do that. Since we were working together for a very short amount of time on *Booty Call* there was really no need to chart the progress. However, Michael Cawood did an outstanding job charting the progress on his film, *Devils, Angels, and Dating*.

In his words, Michael felt that being able to show the numbers behind the progress of a film is much better than just saying, "We're working on it ..." or some other general answer. It indicates a solid structure upon which you can build confidence and get legitimately excited about as work is completed. It also allows you to reassign tasks if certain departments are falling behind and pivot in production much quicker if you can see the work slowing down. If you want to see all of Michael's work, visit animatedfilmmaker.blogspot.com.

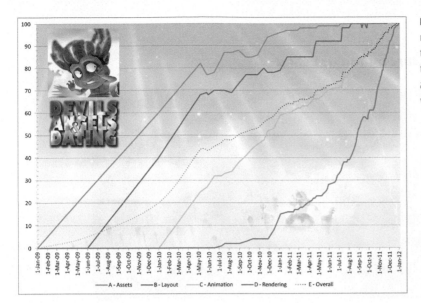

FIG 4.28 During his film, Cawood made frequent charts and shared them with the team. This one shows the progress of the film's many assets and animations and kept the people who were working on it motivated.

All-Over Solutions

There are several online 3D pipelines available, and if you want the convenience of working with a completely assembled tool *meant* for 3D production, it makes sense to use one of these. They are not free, though. The most popular online pipeline is called Shotgun, which has a web-based tool priced at $49 per month. It has tools built in to track progress on every single asset and shot in your film. For a single person it is probably overkill, but for multiple-person teams it can be quite useful, even if a little cumbersome. Another up-and-coming web-based 3D pipeline tool is called TheoryAnimation.com. I've had the pleasure to work with the team that created this easy-to-use yet powerful task management and file transfer tool. I highly recommend you contact them when all your pre-production is in place, because they are great collaborators and want to see films finished.

Ready? Get Set

As you complete each phase it always seems you are on the verge of being ready to "actually" start the film. This time, it's for real. You are ready to begin production, ready to create the shots that are going to make up your short. I want to take this moment to remind you of all the preparation that you've done mentally to finish your film. Keep your schedule close by. Make sure you have a clean pad of paper for jotting down notes and ideas. Remind your family or roommates that your workspace is off limits during work hours. Put on a pot of coffee, and …

Go!

Interview

Our Wonderful Nature by Tomer Eshed

FIG 4.29

What was your first experience of creating a short film?
The work on *Our Wonderful Nature* was my first attempt at directing and animating a film project. Having had no previous experience in the field at the time, all of the steps along the way were new to me, so facing the unknown was the first thing I experienced. All I knew then was that I was eager to try out the process.

When you felt technically challenged or blocked, what was your go-to resource?
The technical difficulties were the most challenging aspects of the production. I didn't realize what was involved in creating a realistic 3D environment, which was a crucial aspect for the concept. I was lucky enough to have only one main set and one main character model (that was used for all the three characters in the film), which made the general overview easier. After the work on the designs ended, I managed to struggle my way through the first stages of modeling and rigging using the help of my teachers, fellow students and internet tutorials. I got to the point where the film was roughly animated and timed over a layout sound layer, but as I made the first rendering attempts I realized that the technical challenges were too big for me, and started looking for help. At that point I met Dennis Rettkowski, who joined the project as technical director. With his help we overcame the technical hurdles, and successfully finished the work on the visual layer.

What were some of the biggest challenges in creating your film?
Apart from the technical difficulties mentioned above, creating the score and sound design proved to be major tasks. Since most of the film was being played in slow motion, the characters and their actions needed to sound accordingly. The score involved a full film orchestra and a live women's choir in order to intensify the viewing experience and make the jump between the nature documentary atmosphere and an action blockbuster vibe extremer.

What was your main focus in completing this project? Completing a film? Making a statement? Getting a job?

Our Wonderful Nature was my pre-graduation project. As a student, my main goal was to finish the project as expected from me, but I was also driven by a lot of passion for the creation process and the opportunity to make use of the supportive conditions provided by the school. Although the film was originally conceived as an exercise in 3D animation, I ended up being mostly curious about the subsequent reactions of the audience.

What inspiration or reference outside of animation did you use to complete your film? For example, cinematography, classic paintings, music?

The inspiration sources for *Our Wonderful Nature* were diverse. I watched a lot of nature documentaries as an inspiration for the first part of the film and many action films for the slow motion part. I used to practice Capoeira (a Brazilian martial art) at the time, which also inspired a lot of the moves the shrews perform in the fight scene.

Which was your favorite character to work on in the film? Why?

Since the two main characters in the film look practically identical, I couldn't really say that I enjoyed animating one particularly more than the other. Animating the fight scene was a lot of fun because I was able to work intuitively on it.

Did you employ any organizational tools such as charts or calendars that were pivotal in staying on deadline?

The creation of the film required basically three characters, one set, and a few additional elements for the intro sequence. When I worked alone at the beginning of the production, the creation of each one of those elements was meant to be a learning experience, and as a result lasted longer. It didn't make much sense to me to work with internal deadlines in that stage, since I was basically constantly looking for the best and fastest way to reach my goals. Only after the film was blocked and we had moved on to the production of the final shots [did] it become important to work on the internal structure in order to optimize the workflow. This became even more extreme regarding the work on the sound design and score, which advanced in parallel and was directly influenced by the progress of the visual layer.

Was there another medium you considered for this short film? What were the benefits of working in the medium you chose?

Working in another medium was not an option for me since I was aiming to play with different film genres using computer animation. Choosing the medium came before the concept in this case. Coming from the background of illustration I assumed I would concentrate my work mostly on drawn animation when I started my studies. In the first year I got to try out different animation techniques, and when I had to decide which one to choose for my first project, I went for computer animation. I asked myself what were the things that could only be achieved with this technique and that would not be possible in any other, and tried to focus on them. Being able to create a naturalistic look was one of the features that stood out, so I decided to explore that direction by making a parody about a nature film.

What were some of your favorite tools to work with? What did they do to increase the quality of your film?

I really enjoyed animating the characters using a 3D software. It enabled me to concentrate on the movement as the basic element of the shot and [gave me] a lot of freedom to manipulate it as I saw fit.

111

What were some tricks for keeping you/your team motivated during this film?

Having fun working on a project was a very important factor in the creation of the film. The playful approach toward the medium, the experimental aspects of it, and the intention to make the best out of the given conditions were all part of the motivation behind the project. All the individuals that were involved considered the project as a personal challenge, and did their best in order to meet the demands of the production. I came to realize that a lot of people preferred to invest their time and talent working on something they enjoyed, and tried to follow that understanding ever since. This attitude became eventually a guideline in my general approach toward filmmaking.

What sort of problems will someone likely run into when creating their own short film?

Creating a short film is a big personal challenge. Different problems come up at every step of the way and finding the appropriate solutions for them can be a demanding task. Usually it's hard to get short films project financed, since they have practically no commercial value. Besides the financial aspects, there are the conceptual and technical issues. Finding a good idea can be difficult, and there are no guarantees regarding that. Even after finding one, it comes down to how strongly you believe in the concept, since it needs to be behind the production until the very end. Overcoming technical problems is also a part of every film production, which can also sometimes be a big practical barrier. As challenging as it might be, defining the problems and finding their solutions is the normal way in any creative process, and managing to do that is very satisfying.

In your opinion, what are the must-have skills a person needs to create their own short, and what can be learned along the way?

There are many approaches that apply to filmmaking generally. I don't believe there is a right or wrong approach, as it is a very subjective matter. I believe that a strong will is one of the basic requirements. Whether experimental or classical, each filmmaker needs to have the willingness to persevere through a production until it's done. Some people in the field of animation prefer to work alone, but for those who work in teams, good communication skills are very important. Being able to create a rough sketch that communicates the basic ideas can be very useful when addressing potential team members or investors. I personally wanted to create films that I could imagine myself enjoying as a viewer.

How did your workflow/pipeline for this short differ from other pipelines you have been a part of? What do you think was the reason behind this change (if any)?

I didn't have any yardstick regarding a 3D pipeline, as this was my first 3D production. I learned a lot about the way things work in the field through the practical work, especially with the aid of other team members that were more experienced than me. It was a big relief for me to realize that I didn't have to do everything alone as I had assumed in the beginning of the process. Learning to trust others is a very important aspect of directing a film, in my opinion.

Did you develop any new tools or innovative work-arounds that you would like to share? For example, if the hair didn't render properly, you created a new script.

A few solutions needed to be especially developed in order to achieve certain effects in the film. One of the issues that needed to be specially solved concerned the camera motion and the presentation of the ground. Since some shots involved the camera moving from a near to a far distance, one texture could not have been sufficient. Three different resolution levels were needed in order to be able to render these shots properly. In order to be able to do that, we constructed a physical model of the set (which was formed according to the original one that was designed and constructed digitally), and

took neutrally lit, high-resolution photos of all the distance levels that were required. We used the same setting in order to create matching displacement maps, using three different light sources that enabled us to get the maximal amount of information. The textures and displacement layers were than merged into each other using a script that defined the use of the different resolutions depending on the position of the camera from the surface. We also used a special tool for defining the contact points of the characters with the ground (which were then also translated into animated displacement maps) in order to create a believable interaction with the ground. Memory limitations were a big problem we had to overcome. We managed to save some memory by baking light information into all the static elements in the scene and having to re-calculate it only for the dynamic ones. Extra scripts were written in order to simulate wind and water movement.

Did your workflow change when you had to work with specialists outside the animation realm, such as designers or musicians? Do you have any advice for those who are creating a film and don't know anything about those areas?

Using references is always a good way to communicate ideas with other people, and providing a sketch defines things even more. Any kind of rough visualization can be very helpful when it comes to working with others, especially if they are not used to animation productions. Musicians and sound designers sometimes require exact timing to work with, but can also sometimes influence the animation, depending on the approach of the creator. In the case of computer animation, elements such as folies and different sound design information can only be created after an image is rendered, since only then do the substances and material qualities of the different visual elements get defined.

Was there a moment when you knew your film was going to be a success?

Not really. I was very excited when I realized that the idea I chose as an exercise evolved into a larger scale production through the collaboration with other people, and was mostly curious to see how far we could go with it. I was very happy when the first positive reactions came, but I didn't anticipate the festival successes that followed. I concentrated mainly on submitting the film to as many festivals as I could, hoping it would be viewed by as many people as possible.

Were there any major plot points or features of the film that changed because of your capabilities? Would you change anything now that you have more experience?

Most of the mistakes I see in the film now stem from my lack of experience in the early stages. Several elements were improved or replaced for the final shots, but some (like the character models, for example) remained the same. I was also not aware, at the time, of a lot of very useful and available animation tools, which I would probably use today.

Are you or is anyone on your team planning on creating another 3D short film?

After *Our Wonderful Nature* I went into the development stages of my graduation project as a part of the schools program. The same technique and team remained at the core of this project, but many other team members joined in since we took on a much more ambitious project. After deciding on a concept, the pre-production process started, and with the support of the school and German film foundations we managed to complete the second short in 2011. It is named *Flamingo Pride* and it tells the story of a flamingo who is the only heterosexual in a flock of gays and his desperate attempt to find love. The film was made at Talking Animals animation studio in Berlin (which was founded during the production) as a co-production with the school and myself, and is currently running in film festivals worldwide. So far it is very well received and [has] won a few significant awards.

113

Describe your process for coming up with the idea. Did you build around a simple idea? Cut down from a larger idea? Explain.

The idea came up in an unexpected way. I was looking for a concept that would go well with 3D animation, and considered several options. A friend told me about a nature documentary he saw on television, which featured water shrews. According to his description, a fight scene was seen—first in real time and then again in slow motion. I figured that if I could re-enact that scene, I could play around with the slow motion sequence and use the freedom of animation to create a Hollywood-style action sequence. The only thing I added was the female character as the reason for the fight and the conclusion of the film.

Explain your pre-production methods and planning. Did you use an animatic, pre-visualization, scratch recordings, or just go straight into production, modeling, and animation?

The pre-production stage included mostly research and design. I looked for the nature film my friend told me about, but wasn't able to find it. Instead I found similar films about water shrews that provided me with good references to the behavior and appearance of the animal. The designs were made in a way that would show the characters in a naturalistic way and also as cartoon figures as another way to emphasize the switch between the film genres. The set was designed as a naturalistic environment. After collecting enough information, I continued with modeling the characters. No storyboards were involved in the creation process. Once the characters were modeled and rigged, I started animating the slow motion sequence spontaneously, basically inventing the shots as I was animating them. When the slow motion sequence was done, I animated the documentary part, using filmed material as reference. The last part that was animated was the intro sequence, which featured other characters and sets. When the animation process was done, I basically had a non-rendered version of the film, which was used as a detailed animatic for the rest of the production. All the shots were then set up for the final rendering process, in parallel with the score and sound design development.

How important was organization to your process? Do you feel being unorganized would have drastically changed the outcome of your film?

Organization is very important for any animation production, especially while dealing with large amounts of information. In the beginning of the process I worked in a very free fashion, and was basically learning by doing. Since I did not know how the first steps would affect the final ones at the time, I made quite a few mistakes that needed to be corrected in the more advanced stages. Only after the shots were optimized was it possible to finalize them, and since the amount of data that was additionally produced for each shot was very large, working in an organized way was extremely important. This experience was very valuable when it came to working on future productions.

Please discuss your inspiration for making a comedic nature film.

Animal behavior reflects on human behavior in several ways. I always enjoyed watching animal documentaries and animals in real life when I had the chance. In animation every character receives a certain symbolic value, animals being ideal for fables. The story in *Our Wonderful Nature* didn't require the characters to have actual personalities and I was therefore able to focus on their natural behavior as a guideline for the film. I was fascinated by the idea of having nature as the first source of inspiration and then develop[ing] a concept on top of that, which would eventually refer more to human behavior.

Talk a little about the slow-mo fight scene.

The slow motion sequence is the main part of the film and was a decisive factor in the choice of computer animation, since it is an effect that is very hard to achieve in other animation techniques.

The actual speed of the action didn't depend on the real-time events and was free for manipulation even after the characters were animated. I liked the fact that the camera could move freely while the characters' motion was slowed down. Since there were practically no limitations regarding what the fight should look like, the process of animating was very intuitive on one hand, but very sensitive regarding the overall timing on the other. Several attempts were made until the rhythm got to the point where it was fast enough for the flow of the film without losing the slow-motion character of the action.

Why did you choose water shrews for your characters?

The choice of water shrews was based on the behavior of the actual animals, but it could have easily been any other animal that behaved in a similar fashion. I wasn't really aware of the existence of this particular animal until I came across it by chance, but I liked the fact that it was an animal that [had] never featured in an animation film (to the best of my knowledge) but still had a lot of features that made it suitable as an animated figure.

What words of encouragement do you have for someone who wants to create a 3D film at home?

3D animation is known to be a very technical process that requires deep understanding of the tools and the way each step affects the others. Some people have a natural talent for the technical aspects, while others are stronger in the artistic ones. The optimal working environment is a collaboration between these two talents. Since the tools get more and more intuitive and the creative options more and more diverse, some people manage to reach high levels in both fields. If you are a beginner, I would suggest trying to work on a concept that would require a minimal amount of sets and characters, in order to be able to maintain an overview at all times. Each step of the way requires a lot of experience in order to be done optimally, and this experience can only be gained by trying to express a vision, slowly understanding the general steps, and defining the specific challenges involved. Working with more experienced people or as a part of a study program is very helpful, but there are also a lot of informative internet tutorials that could provide a good way to start. At first, progress is slow and requires a lot of patience and dedication. The simpler the idea, the easier and faster it is to reach results.

3D Pre-production

Before you can begin production, you must first create all of the assets
for your film. This is perhaps the most dangerous stage of a film because
decisions made earlier on in terms of the scope of the film will either pay
off or come back to bite you. And while it was those choices early on that
determined the amount of work you have to do in 3D pre-production, how
you react now to the workload will determine whether you finish your film
or not. It should be noted as well that no matter what you decided before
beginning 3D pre-production, you should always try to work with a little bit
of flexibility. If the scope of your film was a little too ambitious, do not work
yourself to the point of burning out just to stick with the original plan. The
converse is not true, though; if you are finding yourself ahead of schedule
and with plenty of time to complete everything, do not add work for yourself.
Consider yourself really fortunate that you created an idea simple enough to
execute with the resources you have, and move on. One thing that sinks films

often is the feeling early on that you have more time than you do. Novices will add all sorts of new elements and scope to the film at the beginning of 3D pre-production, only to realize later on that keeping up this new level of detail is impossible. Also, it is common to get discouraged when you realize just how much work it will be to prepare your film for production even when you have planned well. The tips in this chapter will I hope make your journey through this phase of your film easier and more enjoyable. For the film *Booty Call*, the pre-production was simple and efficient, which paid off hugely in the end when it came time to create the film. But this was not chance; decisions made very early on, especially with regard to our "modular middle," turned out to be lifesavers when we created the short.

To create a film on your own or with a small team, a certain level of generalist expertise is necessary. Though it is technically possible to download free or purchased assets to populate the world of your film, a good generalist foundation is very helpful. You will find that even the most seemingly plug-and-play asset might need to be retextured, scaled, rigged, or otherwise modified before it can be used in your film. With some of such tasks taking multiple hours, it might be worthwhile creating most simple assets and even some complex assets yourself.

Deciding What to Create and What to Download

The first stage of 3D pre-production is deciding what should be created and what can be purchased or downloaded. Remember, your main consideration is finishing the film, so the first question you must ask is whether you can create the asset yourself in the time that you have, not whether you could make something better. On a long enough timeline, of course you could model something that is better than the freely available version on Turbosquid. com. Give me a couple of years and I'll model you all of Manhattan, but the one available online for $50 will suffice. The next question, even more crucial than whether you could create the asset in less time or better than what is obtainable online, is how important is the asset to your film.

If you are talking about the main character of your film, then it is risky to use a distinctive downloadable character for the role. CreativeCrash.com has dozens and dozens of character rigs that are free to use in non-commercial projects, but just because they are free doesn't mean that you should be using one of them for your main character. Your short film is your calling card, and if you aren't making a strong design statement with at least your main character, your short is only going part of the way to show the world who you are as an artist. If it comes down to a question of your not being able to create your main character yourself and you cannot get help from a friend, it is time to go back to your story and figure out if there is a simpler way to tell it. Another reason that using a downloadable character for your main character

is dangerous is that there may be hundreds of animations floating around on the internet with that character animated poorly, with a different voice, or worst of all, animated in a distasteful way. As beautiful as your short may turn out to be, if your main character suddenly shows up in a viral video humping a fire hydrant, your film's success has been severely undermined.

Remember, I pointed out in the story chapter that your story does not have to be told with a bipedal human character. The story about the kids playing soccer is told just as well with simple box characters or flour sacks. Think long and hard about how complex the characters really *need* to be to tell the story you are trying to tell. In the end, my hope is that this first film is just one of many that you produce and finish. Each successive film can be more detailed, complex, and ambitious.

Booty Call's Downloaded Assets

For *Booty Call* there were only a few assets that I determined would not be economical for me to create myself. The biggest consideration was how much screen time was going to be allotted to the assets that I needed to create. After hearing that, you might have already guessed which assets I downloaded. If you guessed the pirate ship and the rowboat in the first few shots, you would be right.

FIG 5.1 The pirate ship is hugely detailed and perfect for what I needed. But since it is only seen in its entirety in a single shot, it would have been a huge mistake to work on it myself.

Take a look at this ship. It's actually beautifully done. I found it on Turbosquid. com for $200, and it's called "Jolly Roger Pirate Ship" by MantifangMediaPro. It needed to be retextured and a little bit of topology changed for my film, but altogether it took perhaps two hours to get this asset in shape for production.

FIG 5.2 The rowboat was also downloaded from TurboSquid. Why reinvent the wheel (or the boat, for that matter)?

Compare that to an estimated 40–50 hours to model the ship and it was a no-brainer. However, if the film took place on the deck and there was a huge amount of interaction with the ship itself, it would be a totally different story. I might have opted to build the ship myself and be sure that every plank was in the right spot. Imagine how disruptive to production it might be to discover that a problem with a downloaded model is holding up your shots.

I found a great rowboat on Turbosquid for $15, called simply "Boat" by Panait George Dorin. It was highly detailed and even included the piece of rope dangling on the bow. The main consideration again was time and energy. I don't know how the boards actually go together on a boat or really anything at all about hydrodynamics and boat design. I could have faked it, but that would still have taken hours and hours. For $15 I was almost 90 percent done with this asset. All that needed to be done was rig the oars to move correctly in the rowlocks and add Babinsky's lantern. Overall, maybe three hours of work, saving another 20–30 hours in total.

There's no rule that says you can't download a free asset and take a closer look at it. I do not want my advice in this section to discourage you from experimenting and exploring the offerings of the free online model repositories. On the contrary, you should be downloading all of the free models you possibly can! Amass a gigantic model library and see how much easier it makes it to populate your film with sets, props, and characters.

Level of Detail

For the most part, the choice of level of detail comes down to matching your designs. Your designs being cohesive means they have common design

elements and also that all characters, props, and environments have similar detail. But this raises the issue of how each object is going to be *seen* by your audience. Why did I not spend long retexturing the pirate ship for the shot in the harbor in the beginning of *Booty Call*? Because I made the choice early on that the ship was going to be mostly silhouetted against the background and far away in the frame. For every single object in your short, think about how closely the audience is going to view it; this determines the *relative* level of detail you will need. Honor the designs, but also manage your workload by adjusting detail according to the audience's view.

FIG 5.3 The treasure chest is viewed extremely closely in the film, unlike the pirate ship. That is why the treasure chest has almost three times as much geometric detail.

Looking at the treasure chest object, you will see that there is a huge amount of detail. There are more than a few shots in which we are zoomed fully into the chest and the prop needs to hold up at very close range.

Don't forget, level of detail applies not just to geometric detail but to texture detail as well. We will talk about those considerations a little later on.

FIG 5.4 In *Adrift*, we see far less of the boy's floating island than we do the surface of the girl's flying whale, so much less detail is needed.

FIG 5.5 In *Drink Drunk*, another character comes along and talks to "Harry." What do you think the level of detail was on this character?

If you really scrutinize the level of detail in this frame you will see that it is far lower than the detail we see on the back of the flying whale. It makes absolutely no difference to the impact of the film though, so the filmmakers managed the level of detail wisely.

I would be very surprised if this character even had a face modeled into his mesh, let alone controllers and a rig that could do the lipsync. Although the character comes along and delivers a line, the director keeps this character (who is only on screen for one shot) turned away from us the whole time. Notice, however, how as an audience we don't miss the fact we can't see this person's face; the body performance is enough to satisfy us. Overall, it was a very wise decision.

Prop Creation

Though the first stage of 3D pre-production is modeling, not prop modeling, I highly recommend you work on a few props before starting to tackle characters. The reason is, you do not want to make mistakes on your character models as a result of not being "warmed up" enough. It is rather better to get some stylistic choices out of the way, start seeing how designs are translating into models, and find a rhythm as you are working.

Working From Designs

Hopefully you have designed most if not all of the props that are going into your film. The props for *Booty Call* were designed en masse because all of them were used to help create different scenes in the modular middle. Apart from the "Hero Coin," all the props can basically be interchanged to give new

ideas for shots that can go into the modular middle. In fact, once animators had understood the concept of the modular middle, I gave them some time to go through the props folder and see exactly what objects they had at their disposal. I believe that having some great props actually inspired a lot of the awesome choices that ended up making it into the film. If the animators came up with an idea for a shot that used props I didn't have, a quick design was made and the object was modeled in the middle of production. The beauty of the modular middle is that it gives you a huge amount of flexibility deep into production. Nothing is more fun than collaborating with people on a project and for new ideas to inspire even more great ideas for the shots.

Overall, you should try to design as many of the more prominent props as possible, and create front and side orthos for them. An orthographic drawing is a drawing that has no perspective. It shows a single view of an object, as if the object is projected flat. See page 80 for our finished orthographic drawings of Babinsky. Once you have designs for your prop models, it is easy to bring them in to Maya to work from them in panel. First, make sure (for the sake of ease) that any designs for the same prop have been created with the same image dimensions and that the front and side view images line up. With these nicely conformed images, we will create image planes in our front and side panels.

1. Create a new Maya scene.
2. In the front panel, go to View > Image Plane > Import Image.
3. Navigate to this chapter's files and choose "prop_Design_Front.jpg."
4. Repeat steps 2 and 3 in the side panel, choosing "prop_Design_Side.jpg."
5. If you are working on your own film, choose your own front and side orthographic drawings instead.
6. When you are finished, it should look like the image below.

FIG 5.6 The orthographic drawings of the rum bottle prop are loaded into Maya. This is the easiest way to get your prop designs into a scene and ready for working.

What you'll notice is that Maya makes it very easy to load image planes in your scenes and to start working. The best part is that if your images are the same size and lined up properly, you can begin modeling immediately with these designs as a guide without having to first resize and conform your designs in Maya. This is why the design workflow we used in Chapter 4 works so well. Having followed that workflow, you will save yourself a few steps with every model you create from a design. To resize your designs in the Maya panels, just use the "Width and Height" attributes found by clicking on the image planes and going into the Attribute Editor (Ctrl + A). Under the imagePlaneShape tabs, you will find these attributes, along with the ability to reposition the plane using the "image center" attribute. If you are concerned about the scale of the prop, don't worry; we will conform all the props to our environment, so it is acceptable workflow to model a prop in its own scene and then resize and conform the finished model later.

FIG 5.7 The lantern design being in good shape helps modeling go smoothly.

Take a look at the in-progress lantern mesh in the following image.

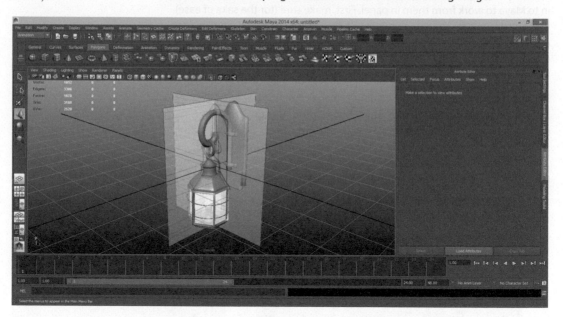

To make the designs see-through, select the image plane and go into the Attribute Editor (Ctrl + A); in the imagePlaneShape attributes, adjust the attribute called "Alpha Gain."

As you can see, the in-progress model bears great resemblance to the design because the orthos were set up correctly. Conforming designs that are mismatched, not lined up, or not correctly orthographic is a step you want to avoid.

At the risk of blaspheming the animation process, you have to consider what is going to work with your schedule and the resources you have. Recall that many of the ideas for the interior of the pirate ship were on a single page of designs (below).

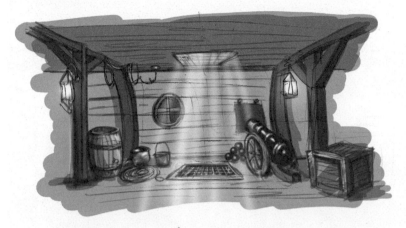

FIG 5.8 This single design is filled with ideas for props for the short, but a decision had to be made as to which props would be fleshed out into orthos.

Having a single environment design with props included allowed for the same kind of experimentation and discovery that I encourage during the writing process. Meaning, the modular middle can inform and inspire your design choices, but also you may get some awesome ideas for the modular middle story-wise when you let yourself freely design.

For instance, the shot in *Booty Call* when Babinksy runs on top of the globe was inspired by the globe itself. The globe was modeled and textured and placed in the assets folder, where it sat until I showed the assets off to the animators at Anomalia. An enthusiastic animator named Edwin was brainstorming shot ideas when he saw the globe and came up with a super high-energy idea. In fact, most of the animators on *Booty Call* did the same thing; referenced in the finished props and came up with ideas that were inspired in part by the models that were provided.

Starting the Props

Most of the props you are going to model take advantage of some sort of symmetry. I have a quick workflow for creating symmetrically modeled geometry that I use for all of my modeling, be it for props or characters.

1. Open a new scene in Maya.
2. Click Create > Polygon Primitives > Cube.
3. If Interactive Creation is turned on, follow the instructions to place and drag the size of the cube on your grid.

4. When the cube is created, change to the move tool (W) and hold down the X key while you use the MMB (middle mouse button) to drag the cube to the world origin. The X key is the shortcut to snap objects to the grid. It should look as below.

FIG 5.9 Here is how your scene should look so far.

5. RMB click drag on the cube and choose Face.
6. Select the face that is parallel to the YZ plane, on the negative X side (shown below).

FIG 5.10 Look at the axes in the corner of the panel or your move tool if you need to figure out which way is positive and negative for an axis—the arrow on the manipulator will always point towards positive.

7. Delete this face by pressing Delete on your keyboard.
8. RMB-click and drag on the cube again and choose Edges.
9. Double-click on the open edge that you created when you deleted this face. Double clicking on an edge selects an edge loop.

FIG 5.11 The deleted face and the open edge loop. Notice how the entire edge loop was selected when you double-clicked on a single edge.

10. Now move this edge to the middle of the world origin by switching to the move tool, holding the X key, and dragging on *just* the X axis on the move tool. The edges will snap to the origin. It will look as shown below.

FIG 5.12 We're getting there. The edges are now aligned to the origin in X.

11. Press F8 to leave component mode and go back to object mode, or RMB-click and drag on the cube and choose Object Mode.
12. With the cube selected, click on Edit > Duplicate Special > □. Note, whenever I show a □ symbol, it means clicking on the little square next to a tool's name, which opens the options box for that tool.
13. The options for Duplicate Special will open, and you should copy my settings shown below.

FIG 5.13 These settings will create an instance (like a copy of an object, with the added benefit that anything done to it or the object it is instancing will happen to the other as well).

14. Click on Duplicate Special, and you will see the cube duplicates from positive X to negative X.
15. Now RMB on the cube, and select Vertex.
16. Select one of the vertices, and move it around. Notice how the edit is mirrored in both objects, as shown below.

FIG 5.14 With the symmetrical editing in action, your modeling will go twice as fast.

Let's test it out further.

17. Go into the Polygons menu set by pressing F3.
18. Select the cube, then click on Edit Mesh > Insert Edge Loop Tool.
19. Click on a few places along the edge of the cube to insert edge loops.
 (a) You will notice that all the edits, such as subdividing, extruding, work with instancing (see below).

FIG 5.15 You are not restricted to simple transforms with instancing; all of the modeling tools can be used.

Now that we've seen how to set up symmetrical modeling, let's look at a prop a little further in progress and make some edits.

Anchor Model

Open anchor_Model_Start.ma in this chapter's source files. This is an in-progress model. I'll need you to add the ends of the anchor for me.

FIG 5.16 This model has already been instanced, so all edits to one side will affect the other.

Let's get started.

1. Select the right side of the anchor (positive X).
2. Switch to the Polygons menu set (F3).
3. RMB drag on the anchor and choose Face.
4. Select the face on the bottom of the anchor facing outwards, like below.

129

FIG 5.17 We are going to extrude this face to give our anchor its signature shape.

5. Click on Edit Mesh > Extrude. Using the manipulators, extrude the face outwards.
6. Press Enter to finish the extrude.
7. Press G to extrude the face again. Repeat this until the shape resembles what I have done in the image below.

FIG 5.18 After enough extrusions, the anchor is starting to take shape.

8. RMB-drag on the anchor and choose Vertex. Using the move tool, make fine-tuning adjustments to the vertices and finish out the anchor shape.
9. I decided to do another extrusion at the end of the anchor points and below is my finished model.

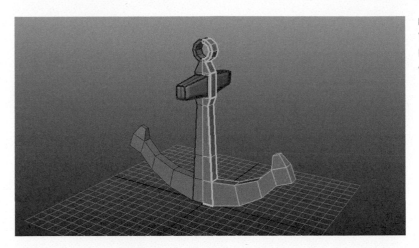

FIG 5.19 The final anchor model. Yours may look a little different, but hopefully the symmetrical modeling workflow is working well for you.

Stitching It Up

With the model complete, we have to connect both sides back together again for texturing, rigging, and smoothing purposes. Using the Duplicate Special, we actually scaled the object by -1 in X. What this does is effectively mirror the object, but actually the faces are inside out. The technical explanation is that the face "normals" (a normal is a vector that is perpendicular to a face that determines the side of a face that is visible) flip directions when you scale an object by -1. If you were to convert the instance to an independent object, you would see the faces are actually all facing inwards on the formerly instanced object. Luckily though, Maya conforms the normals of two objects when you combine them back together through some trickery we won't go into. There is still plenty to do to make sure your object stitches together nicely when it's done.

1. Open anchor_Stitch_Start.ma.

You will notice that our anchor is sitting completed as it was in the last exercise, but there are a few vertices that are out of place at the front. This is not an issue—in fact, it is common for the vertices along the center seam to get a little out of place as you are working on a model. The first step in stitching a model together is to correct this by moving the middle vertices back to the X origin.

2. Select either side of the anchor and RMB-drag to choose Vertex.
3. In the Top viewport, drag a selection box around all of the vertices that lie along the center seam, as in the image below.
 (a) Now switch to the move tool (W), and open up the Tool Settings window. The fastest way to do this is by double-clicking on the move tool in the Toolbox.

FIG 5.20 In order to stitch together our model nicely, we need to make sure the model's seam is lying perfectly on the X axis.

4. In the Tool Settings window, scroll down until you see the Move Snap Settings tab, and make sure "Retain Component Spacing" is unchecked (see below).

FIG 5.21 The move tool settings as they should be in order to snap the vertices.

If Retain Component Spacing is turned on, the vertices will move relative to each other. With this setting uncheck, you will be sure that snapping to the grid will work.

5. Now make sure you are moving the vertices in World space, by holding down the W key, and LMB-dragging on the vertices until a hotbox pops up. Choose World if it is not already checked.
6. Holding the X key, move the vertices only in X until the vertices snap to the X origin. Your vertices will look like mine in the image below.

FIG 5.22 The center vertices are aligned in X and can now be stitched together.

7. Press F8 to get back to Object Mode.
8. Select both sides of the anchor.
9. In the Polygons menus set, choose Mesh > Combine.

This combines both pieces of the geometry into a single shape. We are not done yet though. There are still two separate "shells" that need to be connected. This is what we will do now.

10. RMB-drag and select the center vertices again. This time you will be selecting the vertices that are in both shells.
11. We want to be absolutely sure that we are welding all of the vertices that are necessary and none are left behind. To make sure, click on Display > Heads Up Display > Poly Count. Orbiting around the scene refreshes the Poly Count display.

Now look how many vertices there are displayed in the Poly Count. The first column displays the count for objects that are on screen, even if part of the object is off screen. The second column displays the count for just the selected

object, and it still must be on screen to count. Finally the last column is the number of *selected* components, and again, they need to be on screen. So we can see that the number of vertices that make up the center seam in both shells is 48 (see below).

FIG 5.23 Use the Poly Count to make double sure you have welded the center seam perfectly.

What is 48 divided by 2? It's 24, so when we do the next command, the vertices should all weld together nicely and reduce to 24.

12. Click on Edit Mesh > Merge > □.
13. In the options box, change the Threshold to .01 and hit Merge.
14. Notice how the Poly Count updates and displays 24 selected vertices. Our merge worked perfectly, now the center seam is eliminated and we can move on with the other tasks of our project.
15. As with all objects that are completed, we are going to delete history. The shortcut to do this is Alt + Shift + D. With the anchor selected and the Channel Box displaying, delete history and make sure all of the nodes disappear from the Inputs section.

Asymmetry

With all of this talk about symmetry, it should be mentioned that there are plenty of models, both props and characters, that are not and *should* not be symmetrical. You can now add whatever pieces of asymmetry you'd like to the models to break up the form. To save time though, I always work symmetrically as long as possible. Then, just add extra elements that make the objects seem more realistic (asymmetry being more natural than perfect symmetry).

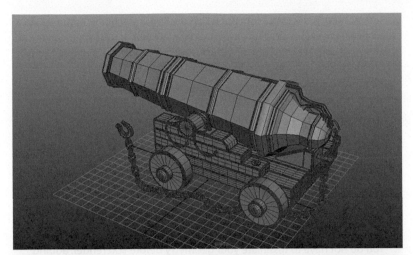

FIG 5.24 The cannon model is completely symmetrical, but the detail of the chain makes it feel natural and realistic. Little details like this can add a lot to your models.

FIG 5.25 The keys may be symmetrical, but the prop model that is referenced into the animator's scenes has them arranged in a way that doesn't feel mechanical.

FIG 5.26 Another good example of arranging making for a good sense of realism. These sugar bags are all pretty much the same model, but the way they look thrown into a pile makes it seem realistic.

We will talk about this same concept when dealing with character models in a little while. Suffice it to say that you should try to combat perfect, mechanical symmetry in your scenes. This can be achieved very easily by arranging your set dressings at odd angles, but you can give yourself an even bigger head start by building some asymmetry into the models themselves.

Smooth Mesh Preview

Maya comes with Mental Ray, a high-end renderer, built in. One of the best features of using Mental Ray is being able to preview the smoothing of a mesh by pressing the "3" key with an object selected. What you are seeing is the object subdivided in panel and how it will appear as smoothed if you render with Mental Ray. There are many advantages of using this, but the most important to us in terms of finishing your film are:

1. You do not have to tessellate your geometry before you render, adding history and complexity to the scene. You just press 3 with your object selected and you are done.
2. Going back to the unsmoothed geometry is as easy as pressing 1, so using Smooth Mesh Preview is great for an animator's workflow because no scene overhead is added.
3. It works very well with other tools built into Maya to handle geometry, which we will go over in just a minute.

Take a look at a cube that has Smooth Mesh Preview turned on; as you can see, the object is smoothed.

FIG 5.27 On the left, a simple polygon cube primitive. On the right, the same cube with the 3 key pressed, enabling Smooth Mesh Preview.

It is important to point out that you can still perform all of the component commands and modeling tools on an object that has Smooth Mesh Preview applied. In some cases (such as moving vertices) it is a little difficult to figure out what you are doing, but in others (adding creases) it is valuable to have

the object display as smoothed to be sure that the effect you are getting is exactly what you want.

Creased Edges

One of the most overlooked aspects of the Maya modeling workflow is creased edges. What are they? In short, creased edges are edges that Maya will render as hard corners, depending on the setting of the crease strength. They work hand-in-hand with Mental Ray's automatic mesh smoothing. Meaning, the crease that you see in viewport is extremely representative of the crease that you are going to see in the final render. Let's take a quick look at creased edges on a simple object before we go into too much depth on this concept with props.

FIG 5.28 This object is merely a demonstrative object that has some detail in the middle that we don't want to lose when it is smoothed. Without creased edges, the object changes shape drastically when smoothed (right).

When you smooth an object, a certain amount of averaging takes place. This is normally what you want, the model to become definitively smoother. However, in this case, I want the center crease to be much harder and I don't want to lose as much of the shape of the front of the object. I am going to use Creases to set the "hardness" of these areas.

FIG 5.29 The original model (left) and the smoothed mesh with Creases applied (center) bear a closer resemblance to each other than the simple smoothed mesh (right).

Let's take a look at a practical model in *Booty Call* that makes use of creases (truly, all of them do in some way though; just look through them and you'll see).

Consider the cannon model.

FIG 5.30 The cannon model makes ample use of Creases in Maya.

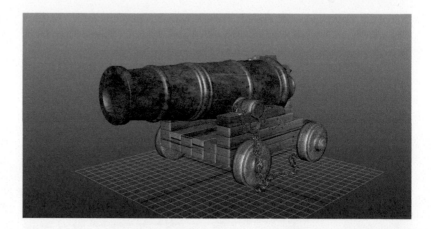

FIG 5.30 The cannon model makes ample use of Creases in Maya.

This model is a great example of how to get detail where it is necessary with creased edges. Before we take a closer look, you should be aware of a few important issues.

Issues to consider before using creased edges:

1. You should be sure which renderer you are using. The true power of creased edges is using them in conjunction with Mental Ray's smooth mesh preview function. If you are using software rendering or a third party plugin, creased edges lose much of their power.
2. Applying creased edges takes a little bit more planning at the modeling stage due to the fact that you are creating a crease out of a single edge and not bunching them together. The main saving of creased edges is less geometry, but it takes less planning to make your sharp edges the old way.
3. If you need extremely sharp edges, you might need to segment your model instead. Creased edges are sharper the more divisions a model has at render time. Consider how many divisions it will take to get your edges as sharp as you need, and perhaps add some divisions before creasing.

Using creased edges is very simple. We'll go through reapplying them to the cannon model right now.

1. Open cannon_Uncreased.ma in this chapter's files.
2. Select the cannon model and RMB-drag upwards to get to "Edge" component mode.
3. Press 3 and see that where there used to be nice hard edges in the barrel (see above), there is now only smoothness. We need to get the creases back.

FIG 5.31 Without the creases, the barrel is just blah. Let's put them back.

4. Select the edge loops that need creases by double clicking on an edge loop, then Shift + double-click on additional edge loops to add them to your selection.

FIG 5.32 The edge loops are properly selected.

5. Switch to the Polygons menu set (F3) and go to Edit Mesh > Crease Tool.
6. MMB-drag in the panel to raise the crease amount until the crease value is 10 (the highest). Notice how the edges create nice creases that add great detail to the area of the cannon that needs it.

As you can see, the cannon has the finer detail of the ribs in the barrel with the minimum amount of geometry possible. Using creased edges will prove even more valuable as we move on to character models.

Open up some of the other props that are in this chapter's source files and you will see how extensively creases are used to preserve detail. When skinning our character you will notice how essential creases become; rather than have to fiddle endlessly with skin weights in an effort to keep hard edges when the character deforms, just use creases and be done. The discovery of this tool was a boon to my workflow.

FIG 5.33 Our cannon, as we remember it, with the details in the barrel coming through even though it is smoothed.

UV Tricks

When it comes to creating UVs, you are still signed up for a lot of manual work when you are creating your props. There are a few tricks I will show you, and some things to consider when moving on to UVs.

Is It Necessary?

Too many short film makers put detail where it is not needed. Decisions to do with the placement of UVs run along the same lines as those concerning geometric detail. The question is the same one I asked before: what is the audience actually going to see? It could be argued that you should spend extra time working with UVs to make sure you can view an object from any angle and have the flexibility to add shots with new angles. At the same time, the storyboarding phase was your chance to really experiment. Giving yourself a huge number of shots to choose from was supposed to afford you the chance to explore all of your options and narrow down from there. Once you've moved on to pre-production you need to keep up the pace by building on choices you've already made. It is tempting to become sidetracked and put an incredible amount of detail into every little thing. If you give in to this, though, you are neither serving your film nor getting good practice in developing your instincts for your next short.

Making the Most of UVs

If you aren't already aware, it is good workflow to start with a Maya-generated UV type that generally matches the layout of your object. For instance, for our cannon it would be good to use cylindrical UVs to start with (Polygons menu set, Create UVs > Cylindrical). This simply creates the base UVs, though, and you want to move on from this point to try to hide seams.

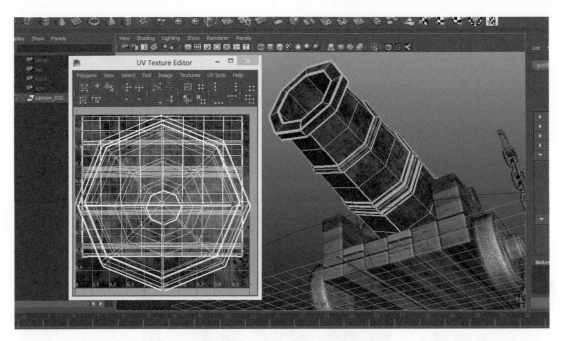

FIG 5.34 Notice how the UV seam is hidden on the underside of the cannon. The audience will not see the cannon from a low angle, so rather than try to hide the seam by creating parametric materials or painting the texture to be seamless, just hide it. As I mentioned above, we could of course paint the seam and manipulate the texture so that there would be no visible crease, but with over a dozen different props and dozens more objects that make up the modular set, do we really have the time for that when the audience doesn't even see it?

Look again at the UV texture editor for the cannon.

There are overlapping UVs on the cannon! Blasphemy, right? We are told not to have overlapping UVs anywhere. Well, that is right if the audience is going to see an object turn in full light and detail and see multiple sides of the same object for long enough to scrutinize the texture. Otherwise, this cardinal rule of UVing serves no other purpose than to waste our time. I need a rusted metal texture on my cannon and I don't have time to paint a texture all over. My best option is to find a good metal texture and arrange the UVs in a way that maximizes the space and covers the whole object. Be honest though, you didn't notice the texture was repeated on the cannon until I showed you the UV Editor, right? Right?

Ignoring the laws of UVing is not laziness, it is taking advantage of the focus of the audience and maximizing our effort. Even better, this trick can give you something that you can't get with other methods: variety in your texturing with minimal effort.

In this chapter's source files, open "overlapping_UVs.ma"

The place where I took advantage of this trick is the ship hull interior. Notice how the back wall is composed of numerous copies of the same mesh.

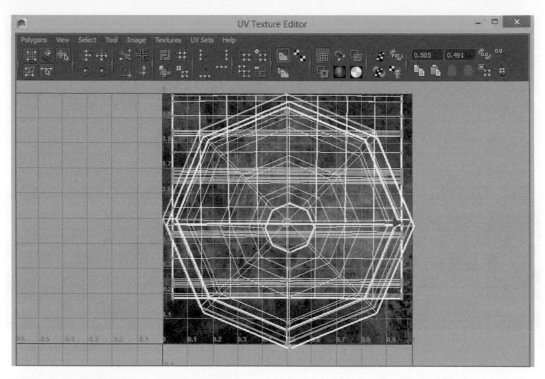

FIG 5.35 Notice anything strange? The cardinal rule of UVing has been disobeyed!

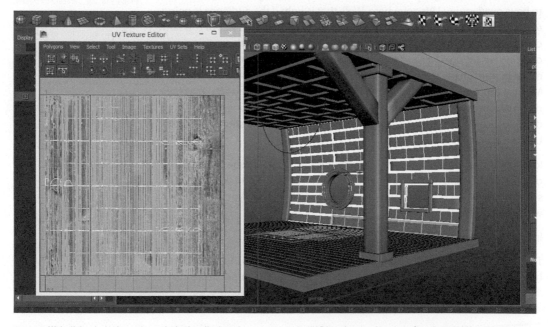

FIG 5.36 With all the planks that make up the back wall selected, you can see in the UV Editor that they have lots of overlapping UVs.

1. With the Persp panel selected, press 6 to change to the textured view.
2. Select all the boards that make up the back wall and open the UV Texture Editor by clicking Window > UV Texture Editor.
3. Change to the UV component by RMB clicking and dragging in the UV editor and choosing UV.
4. Select all of the UVs that are displaying, and switch to the move tool (W).

Now we are going to see using overlapping UVs in action.

5. With the UVs selected, move them to the right and left and watch the texture update in the Persp panel.

Pay particular attention to how, because the UVs are not arranged in the same way as they are in the panel, the texture moves unpredictably. It does not simply slide down the wall but is "cut up" instead. In fact, some of the UVs are oriented in the opposite way to other boards—notice how, when you slide the UVs left and right, the texture slides in the opposite direction on some of the planks.

FIG 5.37 When sliding the UVs you will see that the textures move in different directions in the panel.

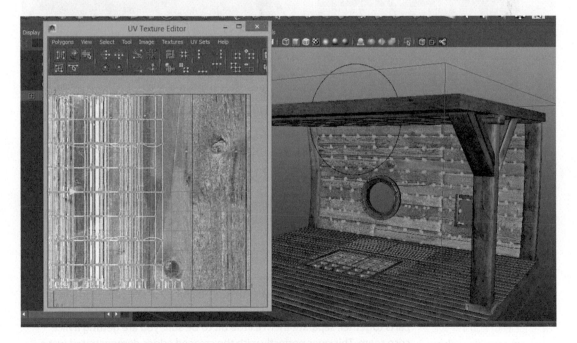

What is gained here? By using just a single texture and arranging the UVs of the back wall in a scattered pattern, I am able to create an entirely new back wall nearly instantaneously. When the camera pans across the ship, the audience will not pick up on any repetitiveness of the rear wall because there will be none. What could have been hours of setup and hours more of execution to randomize my modular set was reduced to mere minutes of work. Maybe it does come down to laziness, but if being lazy means saving

hours of work, then some of the best shorts I've ever seen were made by the laziest people I know.

Purposeful Seams

Any time you actually *want* a seam in your texture, you need a UV seam as opposed to seams just being painted into the texture. Allow me to demonstrate this concept.

FIG 5.38 Here is a sphere with a simple texture. Notice how fuzzy the seam is on the character, despite the detail of the texture map. If we want a seam on the sphere, we should put it in the UVs.

Your props and your characters will have parts that are connected by geometry but have a seam in the texture. Examples of this are seams in clothing, belts, logos and emblems, etc. Instead of keeping the UVs of these parts together, separate them a little bit to be sure you are getting a nice crisp seam. This goes perfectly with the creased edges demonstrated just a moment ago.

The small amount of UV space you lose in order to get razor sharp lines is worth the effort of splitting these UV edges.

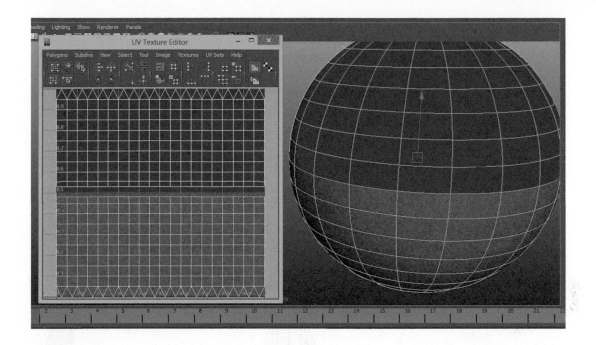

Character Modeling

Many of the same techniques we used for prop models can be used on the character models as well. To save your film from stalling, the character creation process needs to be *very* organized.

First, make sure Incremental Save is turned on.

1. File > Save ☐.
2. In the options dialogue that opens, check Incremental Save, and also Limit Incremental Saves. A good number is 10.

One of the most frustrating things that can happen to you is data loss in a crash, so remember to save frequently and early when creating your character models. Now if you have a catastrophic crash, you will have a version saved in the \incrementalSave folder that you can start again from.

Start With Edge Loops

When it comes to matching your designs, it will be super-advantageous to follow edge loops that clearly indicate the form. When modeling it is possible (even easy) to get caught up with edge loops, so you should create the distinctive edge loops first and figure out how to join these distinguishing

FIG 5.39 Now the seam is absolutely razor sharp and, if this was an edge that I wanted to crease, would work perfectly with the texture seam built into the UVs.

areas later. The motto is, "Get it in there, then clean it up later." In general, for the success of your film it's better to be an artist who can fix a myriad of problems than an artist who needs to take the time to be perfect on the first try. In fact, that is good advice for your career in CG as well. Practice problem solving so that nothing throws you off your guard.

Take a look at the Babinsky design one more time:

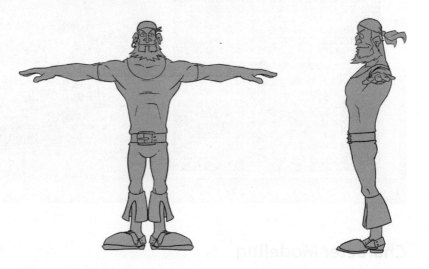

FIG 5.40 Babinsky has more than his fair share of distinctive edges. Look around his arms, chest, and face.

Because he has such distinctive hard edges in his design, we know in order to match the design's "feeling" it will be important to get the edges as close as possible.

Let's try to model a few of these together and see how it goes.

1. Open "babinsky_Start.ma" in this chapter's files.
2. You'll notice that the ortho designs are already loaded for you.

FIG 5.41 Ready to model! The orthos are imported and sized and all we need now is some geometry.

3. Create a polygon plane by clicking Create > Polygon Primitives > Plane.
4. In the Channel Box, set the Subdivisions Width and Height to 0.
5. Switch to the vertex component mode by RMB-dragging to the right on the poly plane.
6. In the front and side panels, move the four vertices of the plane in position with the ridge of the cheek as in the design, as shown below.

FIG 5.42 The very beginning of a character model. We have to start somewhere; I say the best place is in the face.

7. Now that it is lined up, switch to the Polgyons menu set by pressing F3.
8. Switch to Edge component mode by RMB-dragging towards "Edge" on the plane.
9. Use the extrude tool to extrude the edges of the plane along the lines of the cheek, as in the design. Switch back to Vertex component mode when you need to adjust the vertices to be in line with the cheek still.
10. Extrude all three of the directions of vertices that join at the cheek, as shown below.

FIG 5.43 The edges as they are beginning to be extruded and positioned.

11. Now we'll crease the edges to see how we're doing in terms of getting the right look on our character.
12. Press 3 to turn on the smooth mesh preview.
13. In Edge component mode, select all of the edges of the ridge of the cheek.

14. Go to Edit Mesh > Crease Edge Tool. MMB-drag to make the ridges nice and sharp, as shown below.

FIG 5.44 The creased edges of the cheek are looking pretty good. They are following the design nicely and will be easy to hook up to the rest of the face.

FIG 5.45 As the face starts to come together, we jump back and forth between using the extrude tool, moving vertices, creasing edges, and previewing the smoothed mesh.

Creased Edges and Character Models

It is looking pretty nice. Without creased edges, the amount of geometry it would take to make the model have edges like this would be pretty substantial. Closely packed edges also causes some other problems:

1. When UVing starts, you have to make sure that edges created very close together do not smooth out too much in the UV Texture Editor. The reason is that Maya wants to smooth geometry out, and in doing so will assign far too much UV space to the polygons that are close together. You will end up with weird stretching and compressing in the texture near these ridges.
2. At skinning time, the time it takes to make sure your sharp edges remain sharp when deforming is major. You will find yourself continuously smoothing and adjusting skin weights until you are so tired of the model you want to quit.

Remember that, as we are using Mental Ray to render this film, creased edges are a great idea. But if we had chosen a different renderer we would have no way to make sharp edges other than modeling the edges close together.

Separate Geometry

Many first-time CG filmmakers make the mistake of modeling too many separate pieces for their characters. This can create a lot of problems with skin weights down the road. As you can see on Babinksy below, the number of separate objects is determined by factors such as the difficulty of getting edge loops to fit and whether the objects need to be visible on all sides. At the same time, keeping some pieces separated sometimes makes sense. Let's go over both of these.

FIG 5.46 Babinsky has separate geometry as part of his model, but each piece is kept that way for good reason.

There are many considerations to bear in mind when trying to model your characters cleanly. Edge loops are the first consideration when deciding which geometry should be combined and which separated. Just as UV seams make better sense than trying to paint a razor-sharp line, separated geometry is called for when two objects don't really need to go together. This is evident in Babinsky's boots, which are made up of two primary pieces. These pieces fit together very well and when smoothed resemble normal boot construction. To get the edge loops of the top part to fit with the sole would be a nightmare.

Babinsky's beard definitely needs to be separate geometry because it would be unwise even to try to get the edge loops of the face and beard to work together to produce the detail and contours present in the design. Looking at the detail there I hope it's clear why.

The belt around his chest is also a separate object, as are the buckles. In terms of skinning, it will be easier for us to control the skinning of these objects on their own than paint their weights as part of the body mesh. Additionally, we

want the possibility of removing these objects from Babinksy if the shot calls for it. Maybe an animator will want him to take off the belt or get caught on it. Even though both those situations call for extra rigging, I'd much rather rig a new belt that has to deform than try to separate an attached object from a mesh.

If you look around Babinsky's neck, you will see that the shirt, chest, and arms are all a single piece of geometry. Why? Because, unlike objects that are just stuck to his body, like the belt and buckles, the shirt and skin will always move together. There is no instance when I need his shirt to come away from his neck and expose a hole in the mesh. Additionally, by applying a very hard creased edge at the points where they connect and applying different materials to the face, I am sure I will have no problem keeping the objects looking as though they are separate.

The basic rule is that for objects that need to move together at all times, combining the meshes and/or modeling them as a single piece is required. For objects that have different topological needs, separate objects will be fine.

Environment Modeling

The modular middle rears its head again here. Since we wrote a middle that is a chase through a modular set, our environment modeling was extremely simple, albeit a lot of work. All that was necessary was to model a single module and make sure that it blended together perfectly and we were done. For our environment, the same design drawing that contained our initial "visual list" of props served as the environment design (see below).

FIG 5.47 Here it is again, our modular set. We lucked out with our modular middle due to how easily this set could be dressed to make each section feel unique.

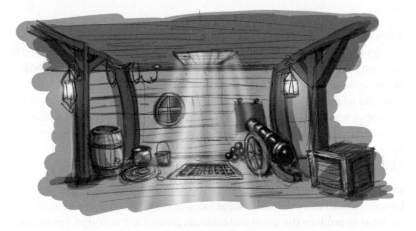

A good way to make sure your environment is easy to "stitch" together is to make sure there is a piece of geometry to cover the seam. Our set has a wooden beam that covers any separation that is happening behind the boards of the hull.

FIG 5.48 We really lucked out with this environment design, because an audience won't think twice about a board covering the seam in the set.

If you are using a modular set, remember that there shouldn't be anything too distinctive in your set or it will appear to be repeating. We get around this by making variations.

Variations in Your Environments

Even if your short takes place in a forest, if the audience sees the same tree too many times it will get completely bored. We create variations of our sets so that there are different combinations for the audience to see. In *Booty Call*, the set has four elements that we can mix and match to create variation. The ceiling grate, the floor grate, the cannon porthole, and the round porthole. Using just four different elements and without set dressings of any kind, we have 16 possible different combinations. Does that number seem high? Start running through the combinations in your head, you'll get it. With five different elements that can be turned "on" or "off" we would have 25 different combinations of sets, with six elements, 36 unique sets are available to us. So, even without filling our scenes with props all over the place (which we did as well), the scenes don't ever feel as though Babinsky is running through the same section of the ship over and over.

Think your set doesn't lend itself to a modular design? Think again! Building a modular set can really give the sense of there being a big world around your characters. Not that there is anything wrong with a short taking place in a broom closet, but if for minimal effort you can have an expansive set, why wouldn't you?

FIG 5.49 Just two variations of the same set. To create these extra variations takes very little time and extends the life of your modular set exponentially.

Texturing

Texturing your props, sets, and characters is a giant leap in terms of defining the look of your film. Here the color choices are going to be made, the level of texture detail determined, and the amount of realism decided. If you are like most first-time filmmakers, you are more than likely thinking about all the photographic reference you need in order to make your film look its very best. This is the first big mistake you can make regarding texturing your short. Just as we discussed regarding the geometric detail determining the level of sophistication with movement, texture detail can lock you into maintaining a certain level of detail that is not only unfeasible for a single-artist effort but also not the strongest look to begin with.

I am assuming that you are familiar with Maya's built-in materials and that what I can offer are some shortcuts that might make the texturing process easier and therefore help you finish your film.

Photoreal is Not the Only Choice

Look at some of our example films and see how their texturing choices made their films both more interesting and beautiful to watch and easier to achieve technically.

FIG 5.50 *Meet Buck* does everything right in my opinion; look how cohesive the look is in this shot.

Not only do the textures of the characters match the detail in the matte paintings used as backgrounds, but the solid colors make the 3D effects, like the smears in this shot, blend perfectly with the scene. The texturing choices in this short are nothing less than brilliant.

FIG 5.51 *Paths of Hate* also took a unique turn in texturing. Look at the interesting details included in these textures.

In *Paths of Hate*, the characters get comic-book-esque cross-hatching on their faces, which matches very nicely the flattened, almost toon-shaded outlines of the props and environments. Taking a step back to look at the film from a technical standpoint, it would have been a nightmare to texture these characters realistically, given how close the camera is placed to their faces throughout the film. In addition, the wide shots have expansive landscapes that would also pose major texturing problems for a single artist.

Both these films are great examples of how to avoid the obvious choice of using photographic textures. Instead, think how you can best utilize the time you have to make a strong artistic statement, allow yourself to tie together

certain effects (like the drawn-on effects in *Meet Buck* and 2D effects in *Reverso*) and, most importantly, give yourself a fighting chance of finishing your film.

Reusing Colors

When you do start making texturing and materials choices, you are going to be picking lots of colors. It makes sense that, as you develop your palette, you will want to reuse colors. A seemingly simple concept, reusing colors is not automatically built into Maya. Well, it is, but the implementation is clunky and doesn't always work as you assume it should. I'm referring to Maya swatches. The swatches file you create when you start choosing colors in the color pickers works fine only up to a point (when you run out of slots), and you can't name or organize the swatches. Lastly, the swatches themselves are very small.

FIG 5.52 Look at the swatches. How are you supposed to get anything done with these?

The swatches are not only small but they cannot be organized in any way. What are you supposed to do if you pick a lot of similar colors, as I did in the image above? Which is the one I want? I don't know! The solution to this is to create your own swatches, using Surface Shaders, and then export them when you have chosen your palette. You can then import or even reference these colors into all of your scenes—not to mention they are easily organized, large-sized, and work in any texture slot that a color picker does.

Here is an example of a surface shader doubling as a solid color and also as a texture that Maya can display in panel. In this example, all I have to do is click on the arrow next to the Diffuse color slot and choose "Surface Shader" from

FIG 5.53 Take Babinsky's skin shader as an example; tiny swatches are not the only problem that is remedied by using surface shaders.

the dialogue that opens. I then name this new surface shader something like "Babinsky_Skin_Color." Once that is done, I go back to the skin shader and navigate down the Hardware Texturing tab. In the Textured Channel drop-down box, I choose "Diffuse Color." Et voilà, the skin now appears correctly in the panel and I have a shader I can reuse in as many different color slots as I want.

FIG 5.54 The advantage of using the surface shader is first and foremost that I can connect the same color to as many different material slots as I want, but also that it displays correctly as a texture, as seen here.

Reusing the same surface shader within a Maya scene is also advisable. Here is an example of the same color being used in multiple materials.

FIG 5.55 The one surface shader is being used multiple times in the same scene.

Imagine how easy it is to change the overall palette in your scene when the same node is being used in multiple connections. Changing a hero color in your film would require changing the color of a single surface shader rather than having to click on perhaps dozens of swatches to load the color you want.

Painting Textures in Maya

Maya's 3D Paint Tool is an unsung hero of texture development. You do not have to have a high-end 3D painting tool like Mudbox, Zbrush, or Mari; the built-in tools in Maya are plenty powerful enough to allow you to block in some color shapes and be ready to export to a 2D painting tool like Photoshop. The very simple workflow for painting textures for further development is to apply the 3D paint texture, paint using the myriad of brushes found in the Visor, then save both the texture and a UV layout for further work in Photoshop. Let's run through this workflow.

1. Load your finished model with completed UVs into Maya.
2. Switch to the Rendering menu set by pressing F6.
3. Select the model and in the menu click on Texturing > 3D Paint Tool.
4. Your tool settings window will open and look like mine.

You cannot paint on the model until you have applied a 3D paint texture. When you use the 3D Paint Tool, Maya works behind the scenes to load a paintable texture atop the model that you can later export or apply as

a texture to the object's material. It's almost as if you are working with a temporary texture that can be saved or thrown out later.

5. Scroll down in the Tool Settings window to the File Textures tab.
6. Click on Assign/Edit Textures.
7. A dialogue will appear. Copy my settings for a high-resolution 3D paint texture that will give you plenty of detail to get things started on your mesh.

FIG 5.56 The 3D Paint Tool loaded. Notice how the brush is crossed out; you can't paint on the model until you apply a 3D paint texture.

FIG 5.57 A 2k image is plenty large enough for our character, and I chose the TGA file format so as to get an uncompressed color map.

8. Click assign.
9. You can now paint on your mesh by using the LMB. To scale the brush, hold B and scroll using LMB.
10. First step is to use the "Flood" tool to choose a good base color. I'll use Babinsky's skin color.

FIG 5.58 Babinksy flooded with a skin tone

Now, using the paint brush I will block in Babinsky's shirt color. When that is done I will start using the real strength of the 3D Paint Tool, which is placing details for later refinement in my texture-painting program of choice. It can be quite difficult to position things like decals and logos on shirts, scratches and scars on skin, or even just find the right orientation of stripes on pants without some feedback in 3D.

Let's say I want a rip in the shirt and skin showing underneath, with maybe a tattoo as well. This would be a very difficult thing to paint in even the most high-end of 3D painting software. It would also be cumbersome and ill-advised to jump straight into a 2D painting software like Photoshop because of the fact the UVs will be stretching and warping the rip in unpredictable ways. I will draw in the rip in a rough way for later export and refinement in a painting software.

Maya comes with dozens and dozens of premade brushes for your use. From color maps to different blending tools, all you have to do to access them is

FIG 5.59 Babinsky's shirt color is added; now on to more details.

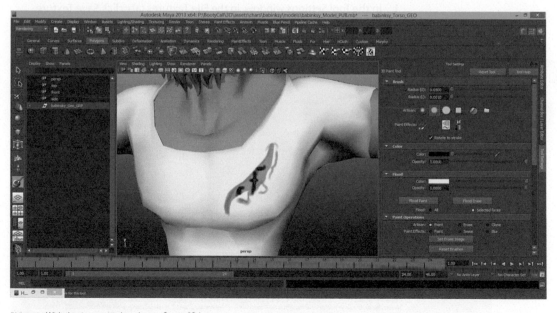

FIG 5.60 With the rip now in place, I can refine in 2D later on.

click on "Get Brush" in the Tool Settings window, and the Visor will open to display your choices.

FIG 5.61 With all of these brushes at your disposal you should have no trouble creating a great base layer for developing your textures further in 2D. As well as interesting effects and colored brushes, there are multiple brush tools that blend and smear paint. Check them out!

It is now to time export the 3D Paint Texture.

1. In the Tool Settings window, in the File Textures tab, click Save Texture. Maya will export the texture at the resolution you determined, in the file format you chose, to the 3D Paint Textures directory.

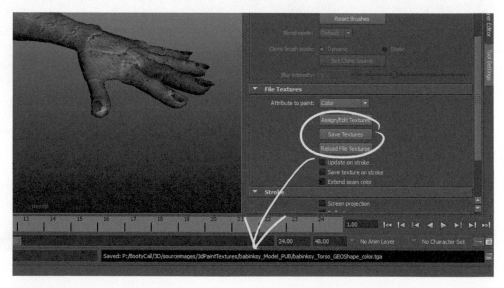

FIG 5.62 The Save Textures button will save your texture so you can open and work on it; the Script Editor will show you when the export is complete and where the file can be found.

Pay careful attention at this point because if your project is not correctly set you are going to have trouble hunting down your files.

Next, we must export a UV snapshot so that we can look at our texture in context when we further refine the texture in a 2D program. To do this, follow these steps:

1. Click on your model.
2. Open the UV Texture Editor by clicking Window > UV Texture Editor.
3. In the UV Texture Editor, click on Polygons > UV Snapshot.
4. Copy my settings for a good snapshot. I recommend you save the snapshot in the 3D Paint Textures directory where the color map was just saved, so they can be moved together.

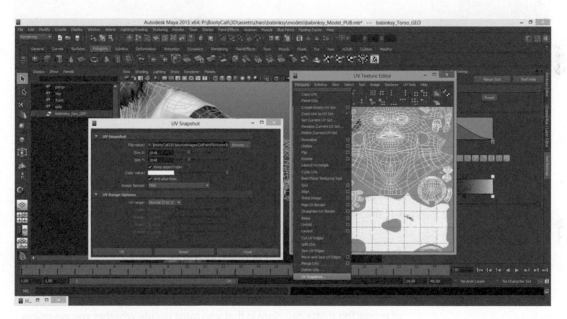

FIG 5.63 These settings will make for a fine snapshot.

5. Load both the 3D Paint Texture map and the UV Snapshot images into your favorite painting program, and begin the process of refining the work you've done so far.

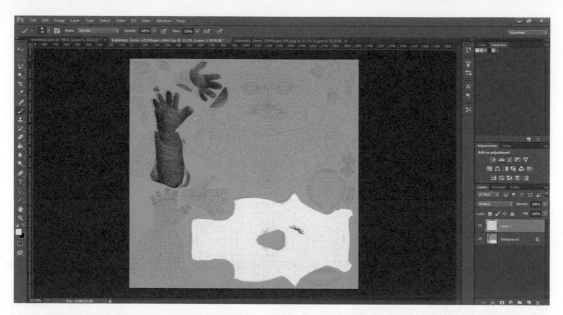

FIG 5.64 Now that we have a snapshot and the color map, developing this texture further will be quick and easy.

With the UV Snapshot as a guide, painting and refining the texture is much easier. This method of exporting rough color from Maya is underutilized, in my opinion. When you are working on your own it may take more time than you have to paint all of your textures in a 3D painting program. If this is the case, use this workflow to jump into 2D as quickly as possible and save time.

Blocking in Matte Paintings

The workflow we just introduced for painting textures on characters can be utilized fully for creating background matte paintings. Typically, the difficulty of producing matte paintings is that you must decide whether you are going to composite the painting in later or save the compositing time on a moving camera by painting the background on an object that is in the scene. Both ways have their advantages and disadvantages.

If you are going to rely solely on painting in 2D, you have to take perspective into account. This can be very difficult for the novice artist. On top of that, you will have to track the background in your compositing program, or at least import the camera data to set up a 3D composite.

If you block in the painting in 3D, the major advantage is that you can render the background with the rest of the shot and everything will work

together seamlessly in comp. The downside is that you have to set up objects beforehand in your scene, and those objects need to have very simple UVs. If they don't, the exported blocked-in Matte Painting you send to your 2D painting program of choice will have warping in it that could prove impossible to paint with. So either way, perspective is an issue.

Let's demonstrate this workflow.

1. Open "matte_start.ma" in this chapter's source files.

You will notice that we start with a scene of two buildings that the camera pans between. We want a matte painting behind the hills of the sun shining with a few clouds, and perhaps another city in the distance. Let's first create our geometry.

2. Switch to a four-view panel configuration and make sure you have one panel for the camera view and one panel for the persp panel.

FIG 5.65 Here is our starting scene with the four-pane configuration loaded, ready for us to create the matte painting object.

3. Create a polygon plane by clicking Create > Polygon Primitives > Plane.
4. Scale and position the plane behind the hills so that, as the camera pans from left to right, the edges of the plane are never visible in camera.

FIG 5.66 My plane is scaled and positioned so that we never see the sides as the camera pans across.

Now that is done, we need to make sure the UVs are going to work for us. Since we don't want to paint a larger image than we need to, we must edit the UVs. Right now they are square, but the texture is going to be much wider than it is tall. We have to convert the UVs to a projection, crop the projection in our 2D software, then reapply a best-fit UV layout to the matte object. Sound confusing? Don't worry—I'll walk you through it.

5. Select the matte object and switch to the Polygons menu set by pressing F3.
6. Click on Create UVs > Planar Mapping ☐ (remember to click on the square box whenever it is shown in instructions—this opens the options box for a tool).
7. Copy my settings, then click "Project."

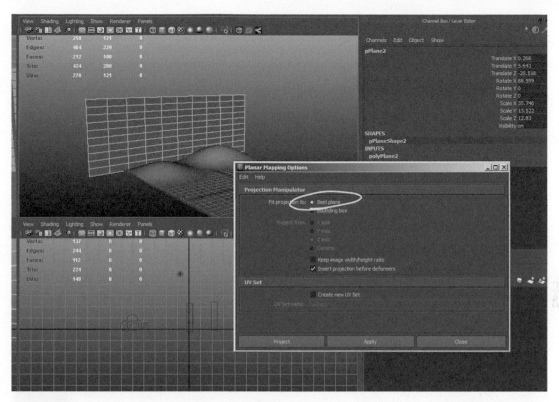

FIG 5.67 Here are the settings we need to make the UVs fit our matte object.

Notice how the projection plane fits our plane perfectly? That is not what we want; we actually want the UVs to be square pixels. In order to do that, we must modify the projection plane to have the same height and width. This is very easy.

8. In the Channel Box, change the height to match the width of the projection plane (or just make the smaller value match the bigger value).

9. Open the UV Texture by clicking Window > UV Texture Editor. Notice how the UVs are now correctly sized and shaped to the matte object.

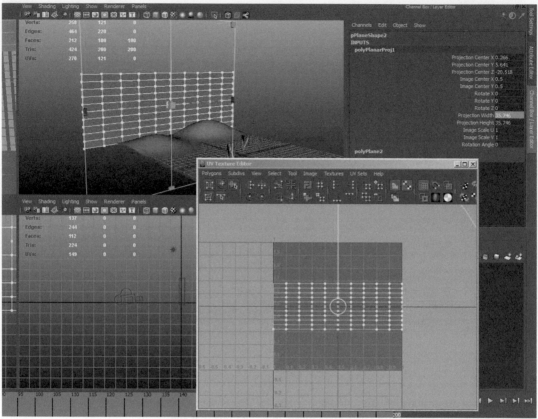

FIG 5.68 This UV layout will make sure I am painting using square pixels.

If your projection plane is rotated oddly, you may have to zero the rotations on your object and use either the X, Y, or Z axis to project your planar UVs. This setting is found in the options box we just used. After you have projected your UVs using a single axis, you can rotate the object.

10. Select the matte object and in the Rendering menu set (F6) click on Texturing > 3D Paint Tool.
11. Follow the same workflow as before to assign a new texture to this object, choosing the TGA format but this time going with a larger image size, such as 4096 square (4K square, as it's called).

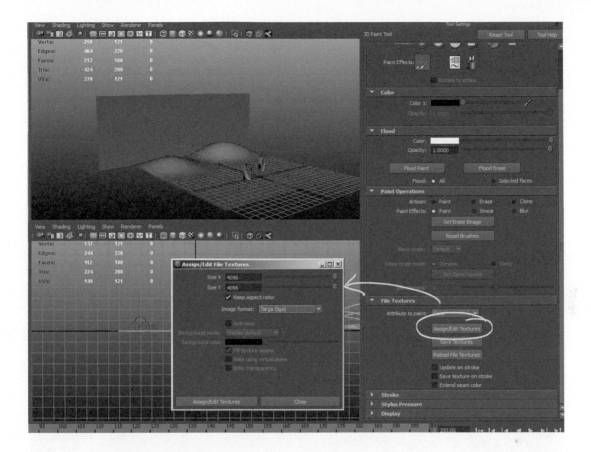

12. Use the workflow we used before to flood color, paint details, load brushes from the Visor, and block in the matte painting as you see fit. Remember, this is just for the purpose of being able to refine the painting with more powerful 2D painting software such as Photoshop.

13. In the Tool Settings window click on "Save Textures." The Script Editor will show you where you can find the newly saved image.

14. In Photoshop, or your painting program of choice, open the exported image.

15. Crop the image to just the portion that is painted. If you are not sure, you can create a UV Snapshot like we did in the last section.

FIG 5.69 The settings for our matte painting's texture.

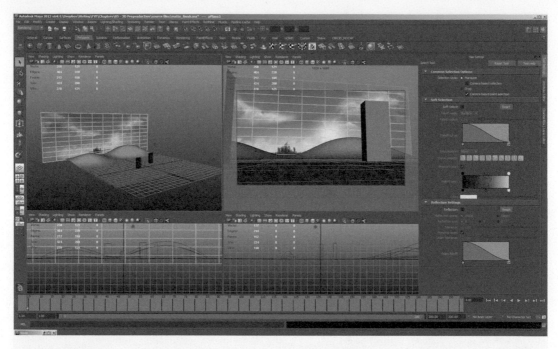

FIG 5.70 Here is my rough matte painting.

FIG 5.71 We are cropping the image so that we don't have wasted space on all our matte images.

16. Save the cropped image.
17. Back in Maya, right-click on the matte object and choose "Assign New Material."
18. Choose "Surface Shader" in the menu that opens.
19. Select the Surface Shader in the Attribute Editor.
20. Click on the Map button just to the right of the "Out Color" slider.
21. Choose "File."
22. In the File attributes, click on the folder icon to browse for the matte image we just cropped. Select it as the file.
23. Go back to the Surface Shader's attributes.
24. In the Hardware Texturing tab, change "Texture Resolution" to Highest.

FIG 5.72 We have loaded the texture as a surface shader on our object and, to be sure we are seeing everything, we turned up the texture resolution.

You will notice the texture is stretched. This is because our image is now cropped. All we have to do is return the UVs to cover the entire UV space and we'll be done.

25. Select the matte object.
26. In the Polygons menu set (F3), click on Create UVs > Planar.
27. If you haven't rotated the object, It should create new planar projected UVs that cover the entire object, thereby making the image fit perfectly again. If you have rotated the object, you may have to adjust the rotation settings in the Channel Box after the projection is created.

FIG 5.73 Check it out! Our image fits the matte object perfectly again, and looks great too.

Now we are totally free to work back and forth between 2D and 3D, updating and refining our matte painting and further developing the look of our film. Best of all, there is no wasted UV space, and we also have all the powerful 2D painting tools at our disposal.

Prop Rigging

Why must we rig our props? The simple answer is that you never want to be positioning or animating geometry in an animation scene. Instead, your animation should always be on controllers. There are also some side benefits to rigging your props. One of the best is that you can modify the prop geometry and the animation on the controllers will still work in all your scenes. I will go through the basic prop rigging workflow that will work for 90 percent of your props. Bear in mind that if your prop needs some customized deformations you are going to need some rigging knowledge beyond this chapter. Suffice it to say that this workflow is perfect for getting objects prepared to dress your sets, be picked up by your characters, or move on their own.

1. Open "prop_rig_start.ma" in this chapter's source files. You will see that the finished chair model from *Booty Call* is waiting for our attention.

First task is always to create a group that holds all of the geometry. This group serves like a "container" for our geometry. Using a group, you can add, subtract, or modify the geometry on a finished prop without adverse effects to the animation in scenes that use the prop.

2. Select all the geometry of the chair and press Ctrl + G to group it. In the outliner, rename this group to "chair_GEO_GRP."

3. Select the chair_GEO_GRP in the Outliner and press Ctrl + G again. Name this new group "chair_Rig." This is the main group that holds the rig.
4. Create a nurbs circle that will act as our animation controller. Click on Create > Nurbs Primitives > Circle.
5. Name this circle "chair_CTRL."

FIG 5.74 The chair geometry has been grouped and the group renamed. This is always the first step.

If you have Interactive Creation turned on, make the circle on the grid slightly bigger than the footprint of the chair. If you do not have Interactive Creation turned on, scale the circle after creation instead.

6. Controllers should always have transforms frozen before you integrate them into a rig. Select the circle and go to Modify > Freeze Transformations.
7. Place this sphere into the chair_Rig group either by MMB-dragging it into the group in the Outliner or by Ctrl + selecting the control, then the chair_Rig group, and pressing P on your keyboard. At this point your scene should look like mine.

FIG 5.75 Here is our progress so far.

The basic idea now is to make the controller constrain the prop's geometry group. Again, this level of separation between the animation and the geometry is necessary to give you the opportunity to edit the geometry. And, any time you can do something to keep your assets editable long into production with minimal impact, do it. Things *will* go wrong in the middle of your film, so take all means at your disposal to reduce the fallout from mishaps and changes.

8. Select the chair_CTRL, and in the Outliner, Ctrl + select the chair_GEO_GRP.
9. Switch to the Animation menu set by pressing F2.
10. Click on Constrain > Parent ☐ to open the options box for the constraint.
11. Copy my settings below and click Add.

FIG 5.76 Here are the correct settings for the parent constraint. We use constraints because we want to preserve the hierarchy of the GEO_GRP. You'll see why soon.

The constraints are almost done. We also want the prop to scale with the controller too. For this we need a scale constraint. Scale constraints are always done after parent constraints, by the way.

12. With every still selected, click on Constrain > Scale ☐ to open the options box.
13. Copy my settings below and click Add.

FIG 5.77 The correct settings for our scale constraint. The most important option to make sure is checked is "Maintain Offset."

Now select the chair_CTRL, move it around, rotate it around, and scale it. The chair should be moving around nicely with the newly created controller.

What is What?

A quick word below on what you should be doing with this new rig.

For the most part, any time you are moving the prop you should be using the controller you created. If you want your character to pick up the prop, then you will want to add the constraints to the main rig group. In this case it is the chair_Rig group. We do this because you are more than likely going to want the freedom to position and/or animate the prop even when it is constrained to a character's hand. Since the chair_CTRL is a child of the rig group, it can move freely around within the group even when the group is constrained. Creating this extra layer of separation removes the burden of adding multiple locators within your animation scenes when you are constraining props. I have been working in large studios that required their animators to create all sorts of locators and nested groups and constraints to get complex prop interaction into our scenes. Why have your entire team recreate the same setup in every animation scene when the prop rig itself can have enough levels of interaction to be useful in 90 percent of cases? It's baffling, but sometimes that is just how production is. Not in the case of your film, though!

Adding to the Prop

I gave the ability to modify this prop as one of the reasons to always rig our props. Let's just double-check this is working.

1. Save your scene so you are sure you have a clean version of your prop.
2. Select the control, and press the S key to set a keyframe on frame 1.
3. Scroll the timeline forward to frame 8 by LMB-dragging on the timeline.
4. Move, rotate, and scale the prop controller randomly around the scene on frames 8, 16, and 24, setting keys with the S key as you go.
5. Return to frame 1 on the timeline.
6. Create a polygon sphere by clicking Create > Polygon Primitives > Sphere.
7. Position it so that it looks like it is lying in the chair.
 (a) In the Outliner, add the sphere to the chair_GEO_GRP by MMB-dragging the sphere into the group, or by Ctrl + clicking the sphere, then Ctrl + clicking the GEO_GRP and pressing p.
 (b) Playback the animation by pressing Alt + v or by pressing the play button to the right of the timeline.

FIG 5.78 The chair is animated randomly around the scene, and on frame 1 I've positioned a sphere in the chair.

FIG 5.79 Look how nicely that sphere is behaving!

In all seriousness, this is a huge advantage over animating raw geometry in your animation scenes. You can add all sorts of variation to your props by creating the exact rig we just did. I created more than two-dozen props for *Booty Call*, all of which utilize a rig like this at the very least. In fact, many of the props had additions to them midway through animation. This meant that I was saved on numerous occasions by the ability to add and subtract geometry from the GEO group.

You can peruse many of the props from *Booty Call* in this chapter's source files. Open up each of these files and check out how they have been set up. You'll notice they all have at least one level of separation between the geometry and the controls. Some of the props, such as the candle, have some neat feature built into them—for example, the flame of the candle always points upwards the way a real flame does. By dissecting each of these files you will get ideas for your own prop rigs and hopefully be inspired to build a little extra dynamic control into your objects.

Character Rigging

The quality of your character rigs impacts the film in a profound way. Without enough controls, a character will not be able to perform the way you want him/her to. On the other hand, spending time adding functionality to a rig you will never use could mean a huge amount of wasted effort. If you are not an accomplished rigger then learning the skills you need to add the type of controls you see on professional rigs will take more time than animating the short! In light of the realities that surround rigging, I am going to make a rule:

If you are not a qualified rigger when beginning your short, you must *either* choose a downloadable character rig *or* create the rigs for your characters using automatic rigging scripts.

Now that we have our rule, let me talk a little bit about some of the fine offerings we have in this area.

AB Autorig

Head on over to www.supercrumbly.com to see AB AutoRig, a simple-to-use and very well-thought-out bipedal rig script. I have used AB Autorig for years, mostly for quickly rigging previz characters, but also for some main characters in short films and TV episodes.

AB Autorig creates a rig that is pretty powerful and full-featured. At the same time, it doesn't use a huge number of nested constraints, groups, or weird math nodes in its creation. Meaning you can edit the rig easily with a little bit of rigging knowledge. Adding further functionality to this rig is also fairly easy; I once added a tail to an AB Autorig by parenting an IK Spline to the root joint.

My advice with AB Autorig is that the character needs to be in true t-pose. That is, feet and knees pointing absolutely straight ahead and arms pointed straight out to the sides, with no rotation in the elbows and the wrists in line with both the elbows and shoulders. The reason is that AB Autorig creates some groups that assume the rotations of the helper objects when it creates the rig. With small rotations on these nested groups, you will find that your axes are not lining up correctly when you are trying to do things like accurate cycles (i.e. moving the foot forward in Z will also move it slightly in X if your helper objects are not lined up correctly). Even with this limitation AB Autorig is still, I find, the most user-friendly option out there.

Rapid Rig

Another favorite is a script called "Rapid Rig" (www.facebook.com/RapidRig). This script is slightly more complex but also more full-featured than AB Autorig. It adds full stretchy controls and shapers to all the limbs as well as the spine. With a system like this you would be hard-pressed to dream up a pose that your character would not be able to achieve.

FIG 5.81 Rapid Rig really delivers a huge punch in terms of controls, but the tradeoff is that it is more complex to understand than some other scripts. *Image courtesy of Joel Macmillan*

The great thing about this rig script is the community and support. The Facebook page is frequently updated and the developer is around to answer questions or respond to bugs. If you are doing some extreme cartoony motion, you should probably choose Rapid Rig to create your character rigs. There is almost nothing this rig can't do when it comes to bipedal motion.

The Setup Machine

A very well-known script in the 3D world, The Setup Machine (or TSM) is a plugin from Anzovin Studio (www.anzovin.com). Although not free, TSM is recommended simply for the fact that it allows you to create much more than

bipedal character rigs. Using a simple widget system you can add an arbitrary number of arms, legs, tails, and wings to a rig and be up and running with the final rig in a matter of hours.

FIG 5.82 This is the built-in widget configuration for a biped, but TSM allows you to create rigs for quadrupeds and flying or even fantasy creatures very quickly.

It is a little bit of an investment, but I think it is worth it for animators who don't have a strong grasp of rigging or if you do know how to rig but you don't have the time to rig all your characters. The rigs that TSM produces are decent on speed but do use more resources than the previous two rigs scripts I've mentioned.

The Face Machine

This automatic face-rigging system goes hand-in-hand with The Setup Machine. All you do is place curves at certain predefined points on the face and the script takes care of the rest. I should mention that while it is very easy to use and set up, The Face Machine is quite a resource hog. If you have an older computer or are doing lots of close-up facial animation, there are better choices out there.

More Custom Rigs

For those of you out there who are compelled to create your own rig from scratch, I highly recommend Jason Schleifer's website (http://jasonschleifer. com/) for some animator-friendly rigging tutorials. His very inexpensive course contains hours of instructional video and *hundreds* of pages of documentation, scripts, example files, and more.

Facial Rigging

Since my main goal is to get you over the finish line for the first time on a film, facial rigging is an area that must be discussed. We have already pointed out plenty of free rigging scripts but, apart from The Face Machine, none of them handle facial performances. The quickest way to rig a face is using Blend Shapes. This means creating models of the face in different poses that will be blended together to create the facial performance and lip sync. A common mistake for newbies is to make a shape for every single letter of the alphabet or all the phonemes. This is totally unnecessary. All the mouth shapes you need for great lipsync can be made from the blending of approximately 8–10 shapes. Assuming you are starting from a base model that has the mouth relaxed and jaw closed, the shapes you need are:

1. Jaw open
2. Corners of the mouth wide
3. Corners of the mouth narrow
4. Lower lip curl in
5. Lower lip curl out
6. Upper lip curl in
7. Upper lip curl out
8. Upper lip up
9. Lower lip down

With some extra shapes for good measure:

10. Jaw left
11. Jaw right
12. Cheek puff
13. Lips puff

That's really it. Thirteen shapes as opposed to 40 or so phonemes is a pretty good deal.

You can then move on to eyebrow movements, smile/frown shapes, squinting and sneering, etc.

If you don't have a sculpting tool like Mudbox or ZBrush, you can sculpt your character's facial shapes in Maya using the Sculpt Geometry Tool and moving vertices with soft selections and reflection turned on. However, splitting left and right sides of the model for left/right face shapes can be very hard. The following workflow makes it much easier.

Left/Right Facial Workflow

We want the best of both worlds: to be able to sculpt both sides of the face at the same time but also to be able to have separate sides of the face when animating. Thus, we need a way to "split" the faces that we create into left

and right sides. To do this, we set up two intermediate objects that use Blend Shape weighting to give us separate left and right shapes for the face.

1. Open "blend_Split_Start.mb" in this chapter's source files, or follow along with your own model.

You will notice that there is Babinsky's finished model and a single blend shape in the scene waiting to be applied. It is a blink blend shape, exactly the kind of shape that would need to be split into left and right shapes to be able to be animated correctly.

2. We must now create the intermediate Blend Shape objects that will serve as being our left and right "filters." Select the Babinsky base model and duplicate it twice.
3. Move the new models to be behind and just to the left and right of the base model.
4. Name them "blend_Left" and "blend_Right" respectively.
5. Select both of the new blend shapes, then shift + select the base model and in the Animation menu set (F2), click on Create Deformers > Blend Shape.
6. Your scene should look like mine, complete with the blendShape1 node in the Channel Box.

FIG 5.83 The scene is set up with the two intermediate blend shapes and the blink blend shape.

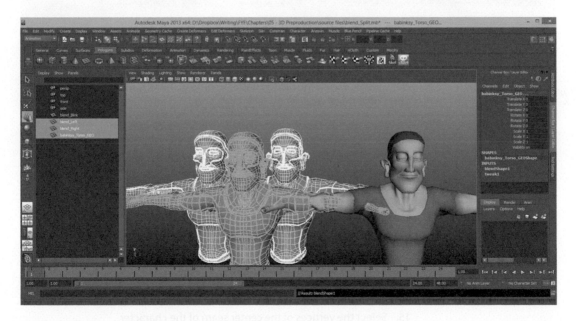

Now we will make sure that the left and right blend shapes only affect the left and ride sides of Babinsky's model, respectively.

7. Hit F8 to enter Component mode, or RMB-click and drag on the base model and go to "vertex" so that you can start selecting vertices.
8. In the top panel, select all of the vertices on the left, excluding the vertices that lie on the center seam.

FIG 5.84 The left vertices are selected. Remember that left and right are according to the *character's* position.

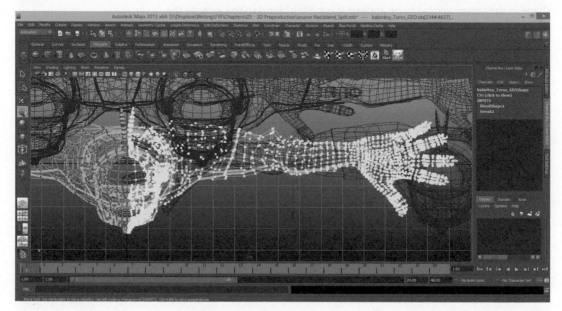

Now we will adjust the Blend Shape weights to make the left blend shape affect only these vertices.

9. Click on Edit Deformers > Paint Blend Shape Weights Tool.
10. In the Tool Settings, under the "Target" section, click on blend_Right.
11. In the Paint Weights section, change the Paint operation to "Replace" and the Value to 0.
12. In the same section, click on "Flood."

We basically just made it so that the blend_Left only affects the left side of the model. Let's make the seam in the character weighted 50 percent just in case a facial shape has some blending across the center we need to preserve.

13. Switch to the select tool (Q).
14. Right-click on the base model again and switch to the vertex component mode.
15. Select the vertices of the center seam of the character.
16. Click on Edit Deformers > Paint Blend Shape Weights Tool.
17. Make sure "blend_Right" is still selected in the Tool Settings.
18. In the Paint Weights section, change the value to .5.
19. Click on "Flood."

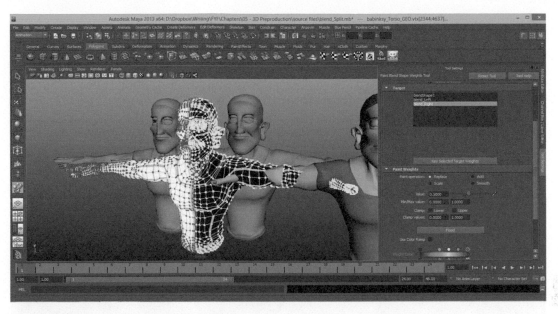

FIG 5.85 The vertices on the right side of the character have been assigned a weight of zero.

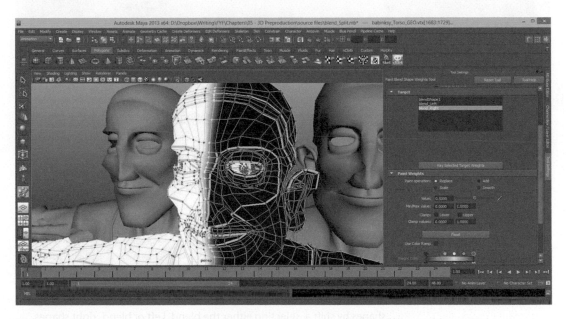

FIG 5.86 The center seam has a weight of .5 so that blend shapes with some blending across the center will have a smoother transition.

20. Repeat steps 1–19 for the right side of the character.
21. Select the blend_Blink shape and shift + select the blend_Left model.
22. Click Create Deformers > Blend Shape.
23. Repeat steps 21–22 for the right side.
24. In the blendshape Nodes for both the blend_Left and blend_Right, turn the channel labeled blend_Blink to 1.

FIG 5.87 Both the left and right blend shapes have the same blink blend shape applied and turned up to 1.

We will now take advantage of the weighting we created to make unique left and right blend shapes for the blink.

25. In the base model's blendShape node, turn the "blend_Left" channel to 1.
 (a) Select the base model, and hit Ctrl + d to duplicate the model.
26. Rename this model "blend_Blink_Left."
27. Repeat steps 25–27 for the right side.

To add more shapes to this setup and to give yourself the left and right split, the steps are simple:

1. Sculpt a new shape from your base model or import a new shape from another scene or modeling program like Mudbox.
2. Select the new shape and add it to both the blend_Left and blend_Right shapes by shift + selecting either the blend_Left or blend_right shapes and clicking on Edit Deformers > Blend Shape > Add ☐.
3. In the options box that opens, you must specify the Blend Shape node that you are adding the shape to; in the case of my scene, it's blendShape1.

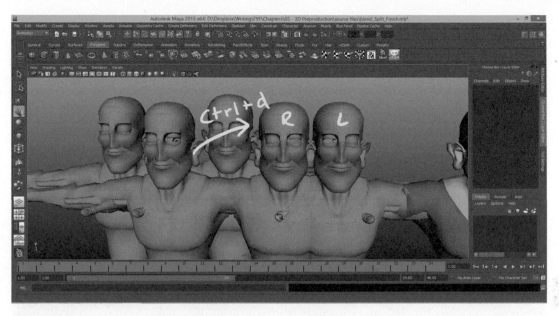

FIG 5.88 I have duplicated the model for both sides of the blink blend shape. I now have a perfect copy of the blink that I sculpted, with the benefit of being able to add these blend shapes separately to my rig.

4. Turn the new channels up to 1 in the blendShape node of the blend_Left and blend_Right models.
5. Make sure any other channels in the blendShape node are at 0.
6. In the base model's blendShape node, alternate dialing the left and right side's channel up to 1, duplicating the base model, and renaming the shape for the left and right side.
7. Move your new left/right split models out of the way and start again with a new shape.

With this workflow, you can save 50 percent of your modeling time, get the expanded control of left and right shapes, and hopefully work faster in the process.

Blend Shape Nodes and SkinCluster Nodes

As of Maya 2014, adding a Blend Shape node to an object that already has a SkinCluster node will order the nodes correctly, with the Blend Shape *before* the SkinCluster. If you do not have Maya 2014, it is easy to reorder them.

1. After adding the Blend Shape to the skinned object, right-click on the skinned object and click on Inputs > All Inputs.
2. It will open the Inputs List for the object. Simply MMB-drag the Blend Shape node underneath the SkinCluster node.

Now that they are in the right order you can add the rest of your blend shapes.

185

FIG 5.89 The Inputs List is not very well known, but it is essential.

Connecting Blend Shapes to Controllers

One of the last steps in creating your facial rigs is to connect the shapes to controllers. You may be familiar with using driven keys on nurbs controllers with custom attributes to control your Blend Shape weights. You may have even set up some in-panel controls with driven keys as well. Both of these methods are fine to use, though they add a lot of scene overhead. I like to use the remap value node instead because it calculates faster and for me it offers better control than a driven key. I have created a stock controller that you can use for anything you like and included it in this chapter's source files. I'll show you how to hook it up to your Blend Shapes now.

1. Open "blend_Control_Start.mb"
2. There are four Babinsky models and a base model waiting here. Select all four blend shapes, then shift + select the base model.
3. In the Animation menu set (F2), click Create Deformers > Blend Shape.
4. Select the base model and then click on Window > Animation Editors > Blend Shape.
5. In the Blend Shape editor, try the sliders to make sure the blend shapes are working.

Now we want to connect this to a convenient controller that can be parented to the head or to a facial animation camera. I have built a controller that you can import multiple times, rename, and use for all the facial animation you want. It just requires a little setup.

FIG 5.90 The scene with the blend shapes added to the base model and everything working correctly.

6. Click on File > Import.
7. In this chapter's source files, navigate to and import "face_Control.ma"
8. In the Outliner, select the face control's main group "ctrl_GRP".
9. Move and scale the control group next to Babinsky's head and a convenient scale.

FIG 5.91 The imported controller is now a nice distance from his head and a good scale.

I have created a little nurbs circle that is "holding" all of the values of the controller. The basic idea is that when the controller is centered in the box, moving it up and down will affect both sides of the face equally. However, if the controller is over to one side, it will diminish the effect on the opposite side of the face. You'll see shortly what I mean.

10. Open the connection editor by clicking Window > General Editors > Connection Editor.
11. Select the small nurbs circle in the controller called "ctrl_Connector."
12. In the Connection Editor, click "Reload Left."
13. In the Blend Shape Editor, click "Select."
14. In the Connection Editor, click "Reload Right."

FIG 5.92 The two nodes are loaded and ready to be connected.

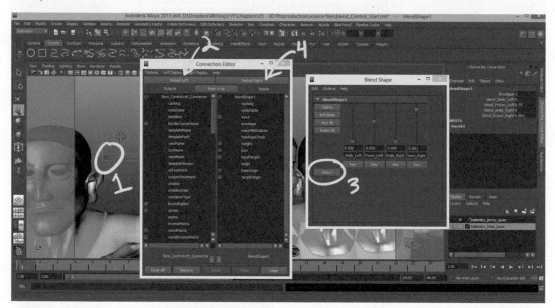

In the Connection Editor, any channel or attribute you choose on the left will directly "drive" any selected channel on the right. It's like a driven key but the effect is always 1:1. I have already created the remap value nodes that translate the controller's position into values between 0 and 1 for use with Blend Shapes. All you need to do now is decide what you want each corner of the controller to drive in the Blend Shape node. It's that simple.

15. In the Connection Editor, on the left side, scroll to the bottom and find the attribute called "Top Left" and click it.
16. On the right side of the Connection Editor, find the attribute called "Weight", and click on the "+" sign next to it to expand it. The weights of all the blend shapes will display.

17. Click on "blend_Smile_Left". Maya will connect the controller's output of "Top Left" to "blend_Smile_Left" and now the controller effectively controls that channel.

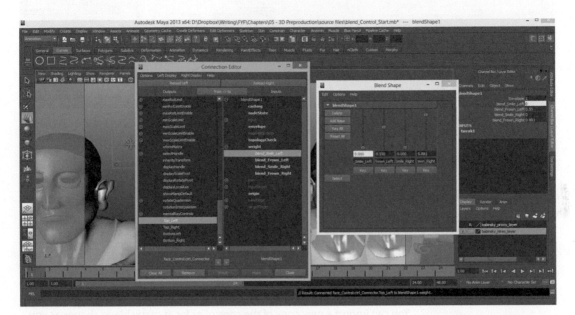

Now we just do the same thing for the rest of the channels.

18. On the left side of the Connection Editor, click on the "Top Right" attribute.
19. On the right side, click on "blend_Smile_Right."
20. On the left, click on "Bottom Left."
21. On the right, click on "blend_Frown_Left."
22. On the left click on "Bottom Right."
23. On the right, click on "blend_Frown_Right."
24. All of the connections are made, and if you select and move the controller around, you will see that the left and right sides of the face can be individually controlled.

FIG 5.93 The connection created between the ctrl_Connector and the Blend Shape node. Notice how both the channels in the Blend Shape node and the Channel Box are yellow.

189

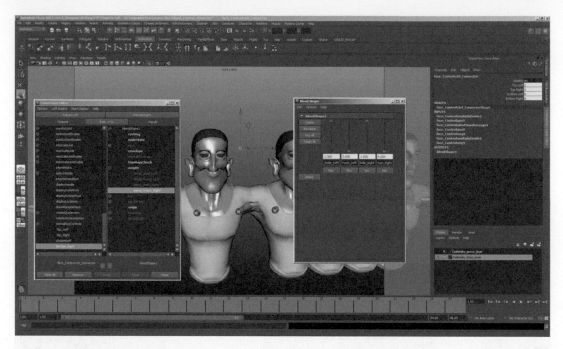

FIG 5.94 The connections are all made and the controller is working as expected.

You can import a new copy of the controller for as many blend shapes as you have in your scene. Follow the workflow again with each controller. Note that you don't have to use all the corners of the controller. For instance, you can use just one of the top corners, and you will effectively have a single up/down controller. Channels that you don't connect will not affect the rest. One last thing to do is to create an annotation node to label the controller. There are other ways to label controllers, but none as fast or simple.

1. Select the ctrl_Connector.
2. Click on Create > Annotation.
3. Type in "Smile/Frown" and hit enter.
4. The annotation node appears. Move it to the center of the control at the bottom where I've left a little room for you (I'm so thoughtful).
5. Scale the annotation to 0 using the Channel Box. Only the locator scales; the text is based on screen distance.

Feel free to use the included controller as much as you want. When you have all the controllers created, you will want to group them together and parent them under the head control if you want to keep them moving with the rig. Or you can create a camera and parent the controllers to the camera. Then,

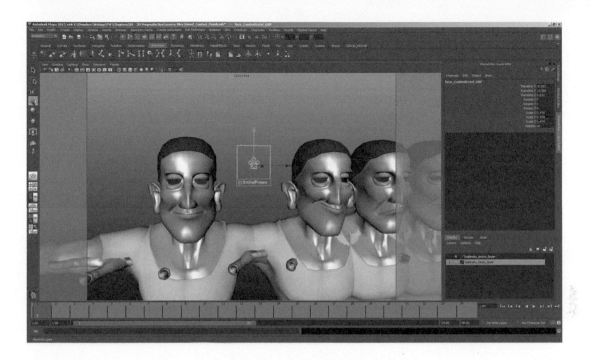

FIG 5.95 The controller is now
labeled and ready to go.

whenever you need to access the face controls you can switch a panel to this
"face cam."

Environment Rigging

If you are feeling that we are in the area of overkill, then you probably haven't
tried to lay out your shots in advance before or dealt with animation scenes
that have the environment oriented differently. One of the most frustrating
things is to realize that your light rig cannot be automatically oriented to your
set because it does not have any rig.

Modularity

A modular set is a great way to take full advantage of the modular middle.
You can get a sense of a large environment with just a few variations, as we've
shown before. In order to make sure your set is truly modular, though, you will
need to do a few simple things.

1. Make sure that the pivot point of your environment rig's main group
 is the point to which you can snap-move a duplicate of the rig and the
 environment modules will line up.

To make sure your environment is truly modular, you must make sure that if
you move a duplicated set and snap it to the pivot point, everything lines up
where it is supposed to.

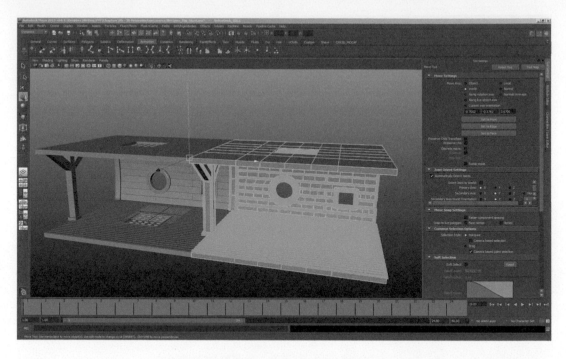

FIG 5.96 In *Booty Call* the environment has a pivot on a piece of sparse geometry, making snapping a duplicate to the correct location very simple.

Notice how the environment main group's pivot point is on the outside edge of the set. I carefully modeled this set to make sure that the left and right edge line up perfectly when I duplicate and move the group to the next pivot point. As you can see in the image, there's no seam on the ground because the boards line up. The curved back wall does not have a seam either, due to the large curved support beam that overlaps the two set pieces.

Open "env_Rig_Start.ma" to see my finished environment model.

2. In the Outliner, select the belowDeck_RIG group.
3. In the Persp panel, look at where the pivot point is.
 (a) Press "Ctrl + d" to duplicate the environment.
4. With the new group selected, switch to the move tool (W).

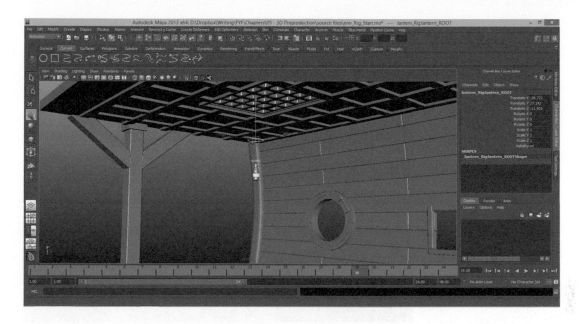

5. Holding the V key, MMB-drag the new belowDeck_RIG group to snap to the corner vertex, as in the image above.

FIG 5.97 The lantern is positioned where it will hang in the animation scenes.

Prop Locations

If you are using some props to dress your modular sets uniquely for each scene, then creating a snap point for the objects is also a good idea. This way, after referencing a new prop, all you have to do is snap the prop to the attachment point and you are good to go. Believe me when I say that having to individually position even a half-dozen props per shot will take hours and hours.

1. Open "env_Rig_Start.ma."
2. Click File > Create Reference.
3. In this chapter's source files, select and reference "lantern_Rig.ma."
4. Select the nurbs control called "lantern_Root" and move it to a position on the ceiling that you are happy with. In *Booty Call*, the hanging lanterns were hung in the background of the set, almost against the wall.

Now we must create the locator that will be saved into the environment rig that saves this position.

5. Click Create > Locator.
6. Rename this locator "prop_Loc_Lantern."
7. Select the control "lantern_Root" and then shift + select.
8. In the Animation menu set (F2), click on Constrain > Point □.
9. In the resulting options box, uncheck "Maintain Offset."

10. Click Apply. The locator will snap to the position of the lantern's controller.
11. In the Outliner, click the " + " sign next to the prop_Loc_Lantern locator. Select the point constraint, and delete it.

FIG 5.98 The locator has been snapped to the correct position by using a quick trick with a point constraint.

The workflow we just used to snap the locator to the lantern position is a little quicker than using Maya's somewhat cumbersome alignment tool. Just a note, you could use a parent constraint with "Maintain Offset" turned off if you wanted to snap to a position and rotation.

12. Select the locator and click on Modify > Freeze Transformations, so that when zeroed, the locator goes back to its proper location.
13. Remove the lantern by clicking File > Reference Editor, select the lantern reference in the Reference Editor, and click on Reference > Remove Reference.

Now you have a locator that you can save into your scene that will help you position props quickly. I recommend you also make a group for these locators so that they do not clutter the rig file's Outliner. They should be parented underneath the main rig group as well.

For every prop that you have in your short, especially those that can be placed in the modular middle, create a locator following the workflow above, so that you only have to position each object once.

Light Locations

We are going to create a light rig in a little bit that will also need to be positioned based on your environment. This rig will give us another time-saving step up as we are setting up our scenes for animation production. Creating the locator for the light rig is actually pretty easy, because it doesn't

require you to have any lights created. In fact, the locator can literally be anywhere. If this doesn't make sense, don't worry: you'll soon see the reasoning behind the decision.

1. In your environment rig scene, click Create > Locator.
2. Rename this locator "light_Pos."
 (a) Move it to where you think it will be easy to remember or easy to access. I like mine floating somewhere right in the middle of the scene, because I won't confuse it with prop locators if it's not near another object.
3. Freeze Transformations on the locator by clicking Modify > Freeze Transformations.

FIG 5.99 The light position locator is created, renamed, positioned, and zeroed. You don't have to worry at all about where this goes: whatever works for you!

That's it! After you have created locators for your most frequently used props, checked the modularity of your environment by duplicating and snapping the environment a few times, and made this light locator, you are in pretty good shape. We can now move on to layout.

Layout

Layout is the act of creating the Maya scenes files for each one of the shots. It is typical to lay out all the shots well before the animation takes place. One of the main reasons for this is so you will be able to quickly see any problems that exist. Problems such as the scale of objects being incorrect or the environment and character rigs not working well must be identified before you go into animation. You may think that you should lay out the scenes as you start animating, but that would be a mistake. What would you do if you animated half of your short film, only to find out that a change had to be made to an asset that affected the entire film? Since we are using references

and a push workflow, getting the changes into the actual animation files is not a problem, but what if there is another issue that needs fixing? You would then have to manually fix that problem in all the scenes that are already animated. This could take precious hours or days, depending on whether an animation fix is called for after the asset is updated. One such example is a short that my company worked on for an independent director. We didn't feel we had the time in the schedule to lay out all the shots beforehand, so animators laid out their shots before they started them. Only when we got to a sequence where all the characters were sitting down did it become apparent that their rigs were not made to bend gracefully at the waist; a lot of volume was lost in their midsections as they sat. It was a huge waste of production time fixing the weighting of the characters while simultaneously limping along with animation.

Referencing

Referencing files is when Maya reads a file and allows you to use its contents without importing it into the scene. The original file stays intact and you are merely manipulating a sort of "live" copy of, or link to, the original. The reason referencing is used so heavily in animation and visual effects is twofold. First, a push workflow would be completely impossible without the concept of referencing. Any changes made to a file would have to be repeated with every single shot that has an imported copy of the original. The ability to propagate changes to assets through the entire project's animation files is essential to production. And second, file sizes start to get astronomical if you do not integrate referencing into your workflow. A massive model (sets are normally the culprits of file size problems) duplicated hundreds or thousands of times into every shot would soon become a space hog. Then take into consideration the fact that each version of an animation file would have the geometry as well, and you can see that it gets out of control. Add incrementalSave into the mix, and forget about it. I once had an environment model that was almost 350 mb; imagine how much space would have been taken up if that file was imported into the dozens of shots for that project. Typically, a Maya file that uses entirely referenced assets might stay below 1 mb in total. Very rarely will it go above 10 mb if everything is set up correctly.

If the concept of referencing is still confusing you, just think about the way that textures work. Texture files are almost like references in that you don't actually import them into a scene, you merely tell Maya where to look for them and Maya makes the link. After the link is made, you can edit the original image, reload the texture in Maya, and Maya will automatically "pick up" the changes. And also, no changes that you do within Maya, such as contrast or color adjustment, affect the original image. So think of referencing as a way of creating a link in Maya similar to texture, except with characters, rigs, and props.

Notice how, in the referencing pipeline example, the files are "linked" into the "referenced_Scene." This link is called the "reference path." It is simply the

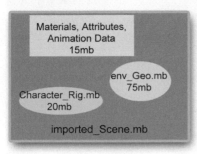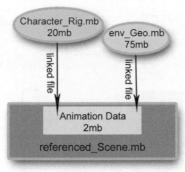

FIG 5.100 This illustration shows the two major reasons why referencing is essential to production: file size and the ability to propagate changes.

Total = 110mb
(Without Ability to Propagate Changes)

Total = 2mb
(WITH Ability to Propagate Changes)

location of the file you are referencing—again, much like the way a file texture works. Also, notice the difference in the file sizes of the animation scenes; the imported scene on the left contains full copies of all the environment and character models and materials and is a *very* large file. On the right, however, only the animation data is saved into the Maya file; the assets remain intact elsewhere on the drive. And once again, the ability to propagate changes to an asset to *all* animation files is quite literally the backbone of all modern pipelines.

Starting the Layout

The first thing you must do is reference in the characters that you are going to see in the shot. Find out from the storyboard which characters you are going to see, then do the following.

1. Set your project first, *always*! In a new Maya scene, click on File > Set Project.
2. Navigate to the 3D folder of your project and click "Set."
3. Now create the references. Click on File > Create Reference, or press Ctrl + R on your keyboard.
4. A dialogue box will open. Navigate to rig_Pub file for your main character, which hopefully is sitting in the \\assets\chars folder under his/her name. Our rig is found in \\assets\chars\babinsky\rigs\babinksy_rig_Pub.ma.
5. Click on Reference, which will reference the character and close the dialogue box. All the default settings are fine.
6. Repeat this for all the characters that are on screen.

The character will look like he is imported, but in fact he is referenced. You can tell by clicking on File > Reference Editor and seeing that the character is listed in the Reference Editor.

Now we're going to reference all the props and sets that are going to be used in this shot. I shall assume that only the deck and the cannon are going into this shot.

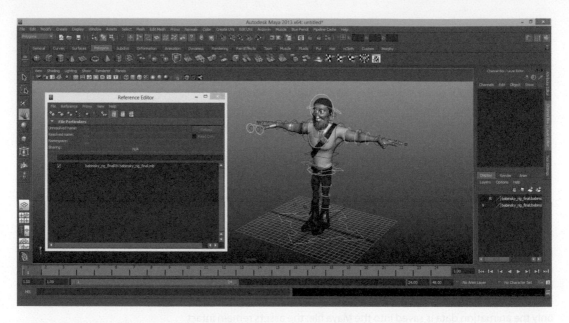

FIG 5.101 The first reference has been made, and it's of Babinksy, of course: he's our only character.

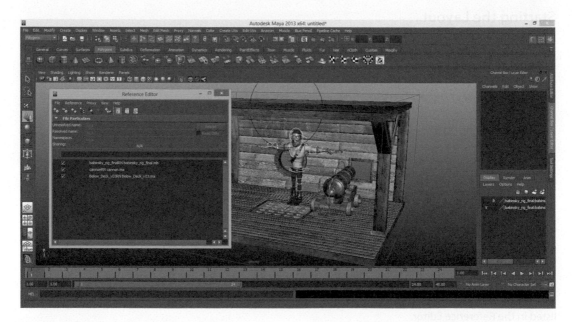

FIG 5.102 Babinsky, the cannon, and the deck are all referenced.

Multiple References

Instead of duplicating referenced objects in Maya by using Ctrl + D, you always want to create a new reference through the reference editor. This is so you continue to have the ability to modify just the original file and have those changes propagate down to your referenced scenes. Duplicating with Ctrl + D does *not* preserve this link; it creates an "orphaned" copy within the scene you are working in.

Relative Paths

With all of the layout items loaded into our scene, it is now time to make sure that the reference paths are relative. What does that mean? When you are dealing with multiple animators it is a good idea to make all your file paths point to a directory relative to the project directory. This is so that if somebody has their project folder in a different location than you do (likely), all the references will still work because they will still set their Maya project to the 3D folder. All we have to do is delete the path in the reference editor all the way up, and including the 3D folder.

FIG 5.103A,B The file path in the Reference Editor with the original, absolute path (above) and with the fixed, relative path (below).

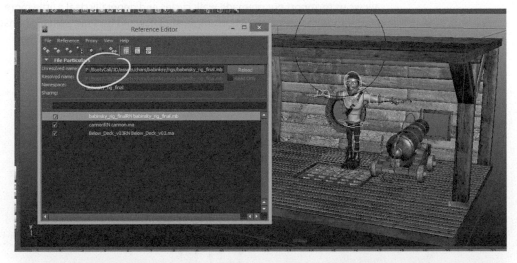

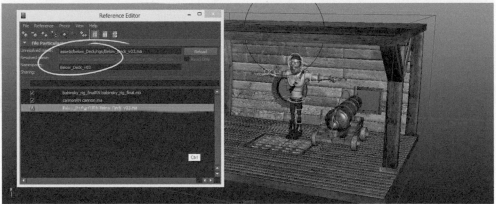

Now we can be sure that, as long as an artist sets their project to the 3D directory, the assets will be found when this scene is opened.

Starting Position

With your characters, props, and sets all referenced, you may now place them in their correct starting positions. When working with characters you should note that their starting position should be placed and rotated so that the Z axis of the character's master controller is facing forward for most of the animation. Meaning, sometimes a character will be not be facing forward along his Z axis at the start of a shot if he/she makes a quick turn and then moves off in another direction.

For instance, if your character is leaning against a wall, then ten frames into the shot turns and walks down the sidewalk, you would want the layout position of the character aligned so he is facing the sidewalk. We always want our Z axis pointing "forwards" for most of the time in our animations. This allows us to import our premade walk cycles and generally deal a little more efficiently with the scenes. The example above would be a big pain to animate if the character had to turn ten frames into the shot and then walk a great distance along the X axis.

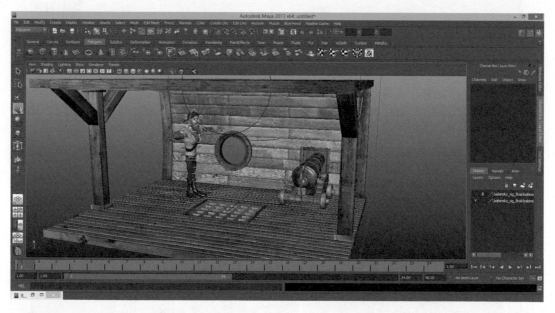

FIG 5.104 Babinsky is positioned and oriented correctly for my shot.

Set Render Size

Before you can create a camera, you need to set your render dimensions. If you do not deal with this first, it will be difficult to frame the action of your scene accurately because Maya displays the resolution gate (explained in a bit) based on the aspect ratio of your render settings. It is quick to do. Assuming you are rendering in HD aspect ratio (regardless of the size), do the following:

1. Click on Window > Rendering Editors > Render Settings.
2. In the Common tab, click on the "Image Size" drop-down box and choose HD1080.

Now when we create a camera, we can look through the resolution gate and see the actual renderable area.

FIG 5.105 The image size has been set to the correct aspect ratio of HD.

Camera

Now create your camera. In general, you want to avoid the standard Maya 35 mm camera because, since it is the default, it makes CG work look very amateurish. I will show you how to change your camera's focal length to get either a telephoto or a fisheye lens.

1. Create your camera by clicking on Create > Cameras > Camera.
2. A camera appears at the origin. It is sometimes easiest to position a camera by looking through it. In any panel, click on Panels > Look Through Selected.
3. Now using the normal Maya camera tools, place this camera where it is supposed to go according to the storyboards.
4. To change the amount of "Zoom" or focal length, double-click on the camera in a panel or select the camera in the Outliner and press Ctrl + A.
5. The Attribute Editor will open and the third attribute down is the zoom, or "focal length." The default of Maya is 35, but I like 50 as my standard, and on this shot I chose 100.

FIG 5.106 My shot needed to be highly zoomed, so I chose a high focal length of 100.

Let's turn on the resolution gate to check our camera's render area. The "rez gate" is a translucent mask over the camera area that shows you how much of the camera's visible area is actually going to render. Click on the resolution gate button at the top of the camera panel.

With the resolution gate displayed, we can fine-tune our camera and make sure everything will look correct at render time.

Now is not the time to put animation on the camera. That part comes when you begin animation. At this point, we are simply seeing how well our assets are fitting together and whether the shot can be set up. If we are getting close but there are issues with the camera moves, we will address them after the rest of the shots have been laid out.

FIG 5.107 This unassuming little button does a lot; now we get to look at how our image is going to actually render.

Importing Sound

Finally, we get to put those sound files we exported last chapter to good use! Remember I said that even a blank sound file is very useful? That's because we are going to use the sound files to let Maya automatically create shots of the right length. The alternative is very labor intensive. You would have to look at your edit, count the number of frames for the shots, and then save this information somewhere so it won't get lost. This could take a long time depending on the length of your film.

The first thing to do is open the Trax Editor. This little-used editor is designed for putting animation clips on tracks and mixing and editing motion together like layers. Its functionality as an animation tool is limited, but it is the easiest window to use when importing sound.

1. Open the Trax Editor by clicking Window > Animation Editors > Trax Editor. It will open and there will be absolutely nothing displaying in the window.
2. In the Trax Editor, click on File > Import Audio.

3. Navigate to the 3D sound directory and find the sound file for the shot you are setting up right now. I am going to assume I'm setting up STL_010 and choose that one.

FIG 5.108 The sound file is imported into the Trax Editor and is ready to be manipulated.

4. Click on Import and the dialogue box will close.
5. The sound file you chose will be sitting in the Trax Editor as a clip.

Now we must move the sound to the correct frame, because Maya puts the sound on frame 0 by default. However, the correct frame is not frame 1…

Frame 101

In 3D production, more tasks than just animation are affected by the time slider. Hair simulation, cloth simulation, muscle simulation, and particles all depend on the timeline. Each of these effects require "preroll" or a certain amount of time for the effect to "build up" in the scene—or in the case of cloth, for the folds to settle. Since we do not want to have preroll occur in the negative frames and since Maya starts all simulations on frame 1 anyway, we just start our animation on frame 101 instead. This way, you have up to 100 frames of preroll to work with when using effects. This amount of frames is more than adequate to get all of the effects mentioned into good shape for the render.

1. In the Trax Editor, select the audio clip you just imported.
2. Using the LMB, drag the audio clip to the right until the first frame reads "101" on the left side of the clip.

It is that easy; we now have the sound starting on the correct frame and it will guide us as to how long our animation file needs to be. Maya has a way to set

your timeline automatically, which is the second reason we spent so much time exporting audio even if the audio is blank.

1. Right-click on the time line and choose Set Range To > Sound Length.

FIG 5.109 The audio file has been positioned in the Trax Editor to start on frame 101.

FIG 5.110 This feature of Maya will set your timeline range to match the length of your audio file.

Now look at the timeline. Notice how the frame range has changed to match the length of your audio automatically. This is a huge time-saver! Instead of having to go into your editing software, write down the length of each shot, and then fish out these numbers when doing layout, it's all automatic. I bet you are happy that we exported all those sound files before, right?

Save and Close!

Your references are all loaded, your character is positioned, and the audio file is imported and placed on the timeline starting on frame 101. The frame range has been set, the camera created and adjusted for the right render aspect ratio, all you have to do now is save. Be careful! Keep up the good naming convention that we established before.

Remember the naming convention?

project_sequenceName_shotNumber_taskType_taskVersion_ frameCount_optionalDescription.extension

I am going to save my file now following this format. It will be called:

BC_STL_010_anim_v01_f248_layout.ma

That's it! Very simple. Get your frame count by subtracting 100 from the end frame in the timeline. Seeing the frame count is great when you are setting up renders on a third-party render manager and don't want to open the file to see how many frames need to render. Just looking at the file name tells you everything you need to know about it. Also, try to keep the optional comment at the end of the file name very brief—one or two words max.

Save the file to the appropriate directory (mine is 3d\scenes\STL\STL_010\) and start a new scene. Do it all over again for every shot in your short before you move on to animation!

Pre-Lighting/Look Development

The thing that will most set your film apart from others is how the film "looks." When a layperson says this, they are really referring to the lighting and rendering, even though as animators we know that texturing and animation also play a huge role in defining the look of a film. That being said, after your film's layout is done, it is a good idea to test out your lighting ideas and render some tests to see how all the elements are coming together. For instance, is the geometric detail you've chosen holding up? How about the texture detail? Hopefully these choices are all still looking good. Lighting choices can make the textures appear differently, so you may find that under the lighting conditions you want for the film, the textures might have to be tweaked slightly. In *Booty Call*, the lanterns give off very warm, very soft light. Working with the palette is a necessary step, and pre-production is when you

take that step, not halfway through animation or, worse, when everything is done moving.

Prelight

Before the production lighting takes place, we prelight our main sequences. I will go into lighting settings in more depth when we get to the production lighting section in the next chapter; here I will describe some of the main lighting concerns and how to achieve your base look.

We call this stage "prelight" because you are using a scene that has been set up as your example, but without any animation you cannot finalize any of the lighting decisions. Think of this step as a good first peek at how the film is going to look. We will first start by referencing in a scene that is in layout.

1. Start a new Maya file and press Ctrl + R to reference a file.
2. Navigate to any one of your scenes that you have already completed layout.
3. Click Reference.

This scene will be referenced into your Maya file. Why are we referencing the layout? When you are lighting, you want to be sure that you are always using the most recent animation. This is most easily achieved by referencing in the animation file as a whole into a separate *lighting* file. This part of the workflow is going to be a pull workflow. Remember that the difference between push and pull workflows is that in a pull workflow you must go out and find the most recent asset to work with manually. This is what you want in lighting, however. So many things can break a lighting scene that if you were to make an animation PUB file that the lighting file references in, you would be constantly fixing it. Rather than waste time on that, the normal workflow is to get the animation to the point where you can make some final lighting decisions for a scene, and then stop updating the animation reference in the lighting file until the animation is complete. Then you replace the referenced animation scene for the final and fix whatever breaks just *once*. It is one of the more cumbersome aspects of the production process, but we're not there yet, so let's not complain too early!

With the animation file referenced into your scene, you can start placing lights.

Light Placement

For the most part, CG animated shorts are lit with a simplified standard studio lighting setup. The terms you will need to understand are key light, fill light, rim light, and background light. Of course, lighting theory is far too extensive to be fully explored in a book like this, but if you are a first-time filmmaker, you deserve a run-through of the main ideas.

FIG 5.111 The standard studio lighting setup. I will describe what each of these lights do for your shots.

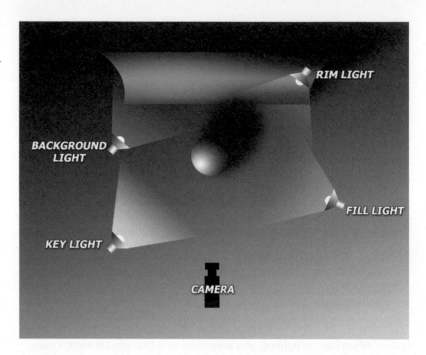

Key Light

Your key light can be considered your main light. It is the light that is generally the brightest and pointing directly at your subject. This light should also be casting the harshest shadows, so if the key light is diffused at all, then the rest of your lights should be diffused even more so they don't cast sharper shadows than your key light. In CG, you want your key to be a spotlight. As tempting as directional lights are because of the way they can be conveniently located anywhere in your shot and merely rotated for effect, using them as key lights quickly comes back to bite you when you want to do some serious lighting. Mainly, the casting of shadows from your environments to your characters becomes highly problematic, as do render times with raytraced shadows.

In your prelight scene, create a spot light and position it to be emanating from the closest light source. In *Booty Call*, the main light sources, where we based the key lights, are the lanterns towards the inside of the ship.

FIG 5.112 The main lights cast light across Babinsky's face.

I use a spot light as a key, and you will notice that the light is colored. Prelight is also your chance to start testing out how your lights and textures are interacting. Changes here are a good idea because you will want to make sure everything is working well before you get too far down the road in production. I also changed my shadow color to compliment the light color, which is an orange-yellow. My blue shadows will work very well with my fill light, which is also coming up. I am using raytraced shadows, but we will not go too far into the details of lighting until the production chapter. You should turn on shadow casting—either shadow maps or raytraced—though, to get a sense of how the lighting is going to look.

Fill Light

The fill light should be a spot light as well. This light generally "fills in" the darker shadow areas of your subject with a little bit of light and represents the bounced light that reflects around a scene in real life. In studio lighting setups, the fill light is sometimes not actually a light at all; it's a bounce card that does exactly what I have just described. Either way, the fill light should be bright enough to bring a little bit of detail to the features of the subject, but not so bright that it overpowers the key light. Doing so will make the entire subject look "flat" because, without shadows and contours, an object seems to have no features at all.

FIG 5.113 My fill light is "explained" by the moonlight that comes through the open portals in the ship.

Look how my fill light bathes Babinsky's face in a nice complimentary hue and brings out detail in his features, but does not overpower the key light. This is the goal of the fill, to bring light to the shaded areas without losing depth.

Rim Light

The purpose of the rim light is to separate the subject from the background. It is slightly harsher than the fill light, with a very narrow specular highlight as well. In almost all cases your rim light should also be a spot light in Maya. (I should just mention here that a directional light is useful in only a handful of cases, such as a completely barren outdoor environment, lighting a product render, etc.). In standard studio lighting setups, the rim light is most prominent on the same side of the subject as the fill light, although if there is a character that is very harshly back lit, the rim light can be made to surround the character. This is a common look for comic book characters and other dramatic lighting set ups, because a harsh rim light dramatically enhances the contours of a character's features.

FIG 5.114 My rim light was subtle on *Booty Call*, but notice how the narrow highlights on the edges of Babinsky's features enhance his face against the background.

The rim light *can* be a different color to your fill light, but show caution when choosing a new color for the rim light; your scenes can quickly start to look like a disco. The rim light does not necessarily need shadows applied. Mine does not have shadows applied in this shot. If you do have shadows applied, the shadow settings can be much lower quality than for key or fill lights: the angle of the rim needs to be extremely shallow so that only the edges are lit and, as the edges are the only things catching light, the middle of the face won't need detailed shadows.

Background Light

The background light is the light that illuminates the objects and scenery behind your character. It also determines how much depth there is to the scene. For instance, a very brightly lit background, such as an outdoor scene in the sun, can seem very flat if not shot correctly. If the background fades in brightness as it recedes in space, the feeling is that there is much more depth to the scene. There is a limit, though; a completely black background feels flat as well. You must find the right amount of light to establish the space of the shot.

FIG 5.115 I was very happy with the background of this shot, actually, so the amount of background light added was very subtle. Compare this to the render above and you'll notice the slight difference.

Background lights can be omni, spot, or even directional. However, you normally only add these lights to the objects you want to illuminate using Maya's light linking. We will go over this more in the lighting section of the next chapter.

More Setups

Here are a few shots from our supporting films with the light sources pointed out.

FIG 5.116 From *Devils, Angels, and Dating*. 1) Key light 2) Fill light 3) Rim light.

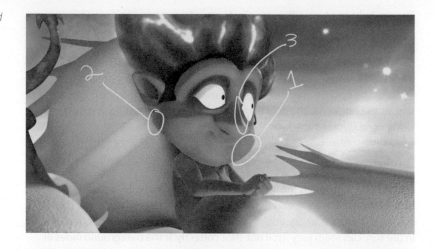

FIG 5.117 From *Adrift*. 1) Key light 2) Fill light 3) Rim light.

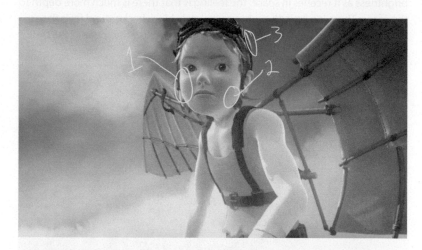

FIG 5.118 From *Dubstep Dispute*. If the main part of your film's concept is based on lighting, prelighting might not be possible!

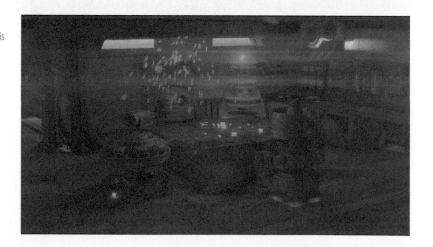

Once you have created the basic lighting setup for your major scenes (and definitely for your modular middle), you are ready to create your lighting rig.

Creating Light Rigs

We want to automate as much of the process as possible. In order to do that, we will create a light rig to use in your scenes as well. It is a fairly simple and straightforward process. I will demonstrate using the environment we created for *Booty Call*.

The first step is to group your lights.

1. Create a group for your key light or lights and call it simply "light_Key_ GRP."

The idea behind this naming convention is that we should try to keep objects that there will be many of in groups named with that object *type*. For example, there is only one "Babinksy" in the scene, so his rig group can be called "Babinksy_Rig." However, since there are going to be many lights in a scene, the group should be named with the word "light" first so that you can pick it out quickly in the outliner. If you had the word "key" first, then if you have many groups in your scene (a kayak, a kickboxer, a kangaroo, a kite) you might have trouble finding the group each time.

2. Create a group for each of the other light types: "light_Fill_GRP," etc.
3. Create a locator and call it "light_Loc."

This locator will serve as the main positioner for the light rig. Remember when we created a light locator in the environment rig? And if you thought it was strange that we didn't care where the locator was positioned when we created it, then you'll soon see why it didn't matter.

4. Snap the light_Loc to the position of the light_Pos locator from the environment rig. The easiest way to do this is to move the light_Loc while holding the V key down on your keyboard and MMB-clicking on the "light_Pos" locator.
5. Now select just the light_Loc and click on Modify > Freeze Transformations.
6. Select all of the light groups.
7. Parent them under the light_Loc by selecting the locator last and hitting "P" on your keyboard, or by MMB-dragging the groups onto the locator in the Outliner.
8. Now remove the layout animation reference from your scene by clicking on File > Reference Editor. Then select the layout animation scene in the Reference Editor and click on Reference > Remove Reference.

We've removed the reference so we can now save this scene as the light rig and have a clean scene that is ready to combine with finished animation scenes for a render scene. Your scene should now look like mine.

FIG 5.119 Here is the light rig scene. This locator can now be positioned to match any animation scene that we create.

Save this scene into the \scenes_common directory (you will need to create this folder). Remember: as we discussed before, the underscore before the name is so that the folder will always show at the top when arranged alphabetically. This file will not go through a huge amount of revision, so saving this one as the PUB file is fine. If you have more than one set that is reused many times in your short, name the light rig according to the set. Example: my "below deck" environment would have a light rig called "light_Rig_BelowDeck_PUB.ma." Just like the layout scenes, the light rig scene will be referenced, so any updates you do to the light rig will propagate out to the multiple render scenes.

Render Settings

Believe it or not, setting your render settings is a huge pain to do after the fact. So, because these settings save into a scene, we will create a completely blank scene that will be used as the basis for your lighting scenes, complete with render settings built in.

1. Create a new Maya scene.
2. Open the render settings dialogue (Window > Rendering Editors > Render Settings).

I will assume you are rendering with Mental Ray, Maya's built-in raytracing renderer. At the very least, we should change the renderer to Mental Ray, change the output resolution, and change a few of the file settings.

3. In the very top of the Render Settings window, click where it says "Render Using" and change it to Mental Ray.

4. In the "File Output" section of the Common tab, change the Frame/ Animation Ext to "Name.#.ext." This makes it so that Maya will name sequential images in the format most widely recognized by compositing programs.
5. Change "Frame Padding" to 3.
6. All the way at the bottom of the Common tab is the "Image Size" section. Click on the Presets drop-down box and choose "HD 1080."

This resolution is full HD 1920 × 1080 pixels. You want to make sure you are using the right render aspect ratio when you are working with cameras and staging action. Saving this setting into the scene will save you time, so let's do it!

Save this scene in the \scenes_common directory as "blank_Scene.ma."

Final Thoughts

Here are some final pieces of advice to help you get yourself ready to produce your film.

Take Notes

For most of you, this is a new process. Have a notepad next to your desk that you can use to jot down ideas and things you are learning along the way. In the end, you will need a record of the little discoveries you make along the way. I even recommend that you force yourself to take a break on a rigid schedule—a five-minute break every hour of work, at least. One of the things you can do to start off your break is write down a few notes or thoughts about the work. It can be anything; ideas you have for the next hour, thoughts on how well the process is going, and workflow discoveries. In my eight+ years of teaching, I've noticed it's always the students who are most critical about their workflow who improve the fastest. This is just another way to give yourself areas to work on.

Another function of the notepad is to have an at-a-glance list of things that need to be fixed in order for you to keep working. As stellar as your planning might be and no matter how diligently you've followed good workflow with your pre-production, *things are going to break*. In fact, I am literally looking at a list as I write this that has half a dozen things that need to be fixed on the rigs tomorrow before some shots. My list has things like, "smooth out skin weight maps on the back" and "change driven key curve to linear interpolation on head squash control." Try to make sure you clear your list of things to do at the *end* of the day, instead of waiting for the *beginning* of the day. It is easier to fix things when they are fresh in your mind. It is also discouraging to sit down with a cup of coffee in the beginning of the day and have a pile of fixes to do before you can get back to working on the film.

Take Pictures!

Memorialize your journey with photos of your workspace, your screen, and yourself as you embark on this adventure.

Double-Check Naming Convention and Cleanup

Be totally sure that you have named everything correctly and are following your naming structure explicitly. Misnamed assets, poorly set up directories, or temp files clogging up your project base directory are all much easier to remedy now than in the middle of production. This is your last chance to make sure everything is set up correctly. If you do find some things out of order, clean them up now! You won't get another chance.

Watch Your Animatic

Make it a daily habit to watch the latest animatic of your film all through production. This will help to motivate you and keep you on course. It also will force you to always keep an updated animatic, which can come in handy.

Test Your Backup System

By now it seems like I'm harping on this to the point of obsession. Maybe it's because I've lost a lot of work over the years, but I feel there is never enough emphasis on protecting your work. I have not one, not two, but three systems in place to make sure I can retrieve files in case of disaster. But I don't just rely on these: I have tested all my systems. Before I put any sensitive data on my Raid array, I put on some junk files and literally pulled one of the drives out of the server to see if it worked as advertised. Surprisingly, the server beeped in complaint, but my data was still present, as advertised. Replacing the drive brought my drives back to normal. When I actually *did* lose a hard drive a year later, I knew that all I had to do was unwrap one of my spare drives and replace the broken one in order to be back up and running in no time. I use Amazon Glacier as my online cloud backup and, lo and behold, I once lost all the data on my hard drives due to a catastrophic power failure that brought two of my hard drives down with it. Luckily, I had tested restoring from Amazon Glacier a few times, and knew the process was reliable, if slow (they don't call it Glacier for nothing). All kidding aside, test your backup system now. Back up some junk files, then delete them and test restoring the work. If all you have is an external drive for backup, that is better than nothing; I recommend using a program called Syncback from a company called 2BrightSparks.com. You do not want to use your operating system's file-copying tools—most are unreliable, slow, and do not keep a log of the files copied. Once you have tested your backup system and are satisfied that you are sufficiently covered for data loss, you are ready to begin production.

Get ready: now comes the *really* fun part.

Interview

Devils, Angels, and Dating by Michael Cawood

FIG 5.120

What was your first experience of creating a short film?

I made a number of short films in a DOS-based program called Autodesk Animator Pro way back from 1994 onwards. It was all 2D paint stuff but I used the program to its limits to create fake 3D effects. The first film I made I was making up each shot as I went along, just experimenting with the software. Later on I learned to do 2D animation and scanned it in. I even did some stop motion. I made a lot of short films before I graduated university!

When you felt technically challenged or blocked, what was your go-to resource?

I'd watch a movie. It's just enough time to forget about the problem, escape to another world and be inspired. That's not too easy when you're at work, but when I was working on my own film near the end I took most of the year off work to focus on the film so it was much easier to tackle a mental block by relaxing and walking away from the computer for a few hours. That arguably made me more productive than if I was tied to a desk for fixed hours.

What were some of the biggest challenges in creating your film?

Making a film is a lot of challenges so it's hard to know where to start. I guess the biggest block initially was trying to find talent to do the things I couldn't, like modeling and texturing. Once I was past that it was all downhill as there wasn't anything I hadn't already done before. It had been hanging over me as an issue that limited my creativity in the writing phase and it was really hard to guess how much I could include. So my drafts varied wildly from two characters to a dozen or so. I guess the biggest challenge was the writing then, especially when you're trying to hit a moving target with no idea if there will be time, money or talent to make it.

What was your main focus in completing this project? Completing a film? Making a statement? Getting a job?

At first it was a portfolio piece, something to sum up a lot of skills I'd collected over the years that you could convey in a short period of time (since no employer has the time to review a portfolio with years of work in so many areas of expertise). I seriously considered simply making the trailer as that would have covered most of my bases, but once it got going there was no way to not make the film too and that's really what everyone signed up for anyway. But by accepting that it wasn't supposed to be an

Oscar-winner, I got over the hump of it needing to be perfect and it actually got made. If I was trying to make a film that I would feel really proud of as a filmmaker it would either have taken twice as long or I'd still be writing drafts. At least this way we all have something to show for our efforts and it's opening doors … maybe the next project can be the Oscar-winner, when I know what the budget, talent and schedule is.

What inspiration or reference outside of animation did you use to complete your film? For example, cinematography, classic paintings, music?
I've always been fascinated with depictions of Heaven and in particular that limbo area outside Heaven's gates that you frequently see but never long enough to really appreciate. It felt like a world waiting to be explored that was underserved. I wanted to make something about modern forms of dating as well, something about internet dating or speed dating, all those curiosities that again in animation hadn't been addressed much. Animation still romanticizes relationships and the ways people meet in a very old-school way, and it was about time we saw how it was really happening these days. My only regret is that the theme got watered down over time as it was just too hard to explore that in a short time scale with so few resources.

Which was your favorite character to work on in the film? Why?
During the writing phase Cupid was really fun to work with. It was Cupid taken to his logical conclusion years later, well and truly grown out of his nappy. Devil was the hero of the piece so I put a lot into him but, as so often happens, the hero becomes the least interesting character as you want the audience to project themselves on to him. But the real surprise was Death. Initially, she was really just the object of their affections to fight over. I actually started with just the two male leads to reduce the models that needed to be made, but as time went on it just became easier to communicate their goals if she was actually there in the film. But naturally I wanted to give her more substance than that and when her design evolved, and the modeler had his fun with her, she was so striking to look at that she became everyone's favorite character. Over time her role expanded and she stole the show.

Did you employ any organizational tools such as charts or calendars that were pivotal in staying on deadline?
Yes, and that was something I was quite comfortable with. I found myself creating spreadsheets tracking tasks and plotting the progress of the production on a graph, so that we could all see how far we were and what our trajectory was. So when I set a theoretical deadline we could see if we were likely to make it, and if a department fell behind I could make an executive decision and do something about it. More than that, I published all of this online as we went along so that everyone could see how we were doing. This really helped to avoid confusion over where the quality bar was and encourage people to finish tasks because they knew they weren't being let down by their team mates.

What were some of the benefits of working in a small group?
It depends what you consider small. We had over 400 people volunteer to work on it, over 100 contributed enough to get a credit, although at its peak there was probably only about 30 or 40 simultaneously assigned to tasks (and working on them). But the fact that it wasn't being made with company politics to worry about or an army of employees that needed to be kept working did allow for some maverick filmmaking decisions. Things were much more nimble and flexible.

Was there another medium you considered for this short film? What were the benefits of working in the medium you chose?

I used to be a traditional 2D animator so I'd love to make a film like that, but I already have a few of those under my belt so I knew making one in CG was going to be more valuable for my portfolio and more likely to get attention from an audience.

What were some of your favorite tools to work with? What did they do to increase the quality of your film?

I didn't know After Effects when I started but I learned it since I knew I could find more talent for that than other packages at the time, and I loved just how much I found I could do at the effects and compositing end of the pipeline to really give the film a strong look. Besides that, Dropbox was a surprise, as was the Ning website platform I ran most of the project from. They were all new to me but in the end I took them all to places they weren't even designed for in order to achieve a pipeline no-one had ever really done before (without a budget).

What were some tricks for keeping you/your team motivated during this film?

Show and tell. I posted often on every area that was reasonable. I made sure that other team members did the same and the end result was a constant stream of progress and activity that everyone could see on the front page of our site. So no one was in the dark, and they all knew we were steaming ahead. I got a lot of compliments on that, and it also helped to attract talent too.

What sort of problems will someone likely run into when creating their own short film?

You need to ask yourself what people will think when they look at you, the director, and your project. Do you have the background necessary to convince your team that you can get the job done and make them look good? Will the project look appealing in their portfolio? If you can't get those two things right you can't attract talent … unless you have a budget … a big one!

In your opinion, what are the must-have skills a person needs to create their own short, and what can be learned along the way?

Communication, without that you're dead in the water. You also need to be a bit of a salesmen or have a producer that can be that salesman for you. It didn't come that naturally to me at first but I pushed through it and now I'm not afraid to say what needs to be said to get the job done.

How did you decide who would be in charge of your film?

There was a point [when] I tried to attract producers and partners and even tried out a few to help organize things and free up some of my time, but ultimately no one is as passionate as the person that starts it all and they couldn't put in the same time needed to manage the number of people we had. In the end I accepted it would have to be me the whole way.

How did your workflow/pipeline for this short differ from other pipelines you have been a part of? What do you think was the reason behind this change (if any)?

Not having a studio, a school, a budget, a centralized team, a client, a publisher, or any of those other trappings made it completely different … and very freeing. We were open to all kinds of ways to get the job done. In many ways it was a big experiment that worked remarkably well, to the point that I was approached by several organizations asking me to run the project through their beta tools to test and showcase their products! In most cases we were too far along to change our pipeline though, and it would have taken money and time just to change tracks … money and time we didn't have.

Did you develop any new tools or innovative work-arounds that you would like to share? For example, if the hair didn't render properly, you created a new script.

There were a load of scripts and tools, mostly created by our main technical director, Iskander Mellakh. He made dynamic solutions for elements that dragged on the characters, particle generators for the pixie dust and all kinds of things. One of the most valuable tools was created by Wesley Howe. It was an automated lighting setup script that could redo lighting setups for most situations in seconds. It took a while to develop but it was worth it as it brought consistency and speed to the lighting pipeline. If you build a lighting team and they aren't even working in the same room you'll notice just how much variation you'll get and it won't look like the same film shot to shot, so this script became invaluable.

Did your workflow change when you had to work with specialists outside the animation realm, such as designers or musicians? Do you have any advice for those who are creating a film and don't know anything about those areas?

Yes, I tried to make the film a musical for a while, and I tried hard to reach out to the music world, but it's a very different industry with different priorities and it wasn't easy to find a fit. I found some good songwriters and composers that resulted in surprising offshoots, a great score and song for the credits but I didn't reach my goal of making it a musical. Eventually I just had to accept that the film had moved on too far for a creative to want to get involved as they couldn't make their mark on the project enough to claim it as their own, and that's important to any artist.

Was there a moment when you knew your film was going to be a success?

I'm still not sure if it is! I'm just glad we managed to make it, considering just how many projects like this fail to get past the first hurdle. Time will tell if we can really consider it a success. But I do know about a good number of the team members that have gotten good jobs since this project, so it's definitely making some progress. It's opened a few doors for me too, but ask me again further down the line and maybe I can tell you its real measure of success.

Were there any major plot points or features of the film that changed because of your capabilities? Would you change anything now that you have more experience?

I've talked about the limitations of not being able to model myself, but one interesting change was that there was a section of the animatic that I couldn't convince animators to work on. Even if they started they never finished. Ultimately I had to surrender and re-edit the film in order to make sure it got made as it was dragging everything down. It would have really helped the logic of the final film and I should probably just have done that part myself, but one man can only do so much and it seemed easier at the time to just cut it and re-arrange the edit with what we did have.

Are you or anyone on your team planning on creating another 3D short film?

I'm surrounded by people wanting to make films now. Some are already on their way, some have copied elements of my production pipeline, many have asked for my advice. It's a very privileged position to be in and I'm loving it. I'll look back on this as a golden era some day, when I met and worked with the next wave of animated filmmakers.

Describe your process for coming up with the idea. Did you build around a simple idea? Cut down from a larger idea? Explain.

Internet dating and Heaven were my theme and setting, but the process I went around to get to the final film was too complex. I was at it for a couple of years and I still can't remember all the iterations it took. I often question how I got to the final film myself. It can be a challenge to preserve the core

voice of each project without losing your way. Ultimately life intervenes and you're inspired in different directions at different points in life.

Explain your pre-production methods and planning. Did you use an animatic, pre-visualization, scratch recordings, or just go straight into production, modeling, and animation?
All of the above. I started with a script, sketches of characters, and then went to thumbnail storyboards that I edited into an animatic, put temp tracks on and some sound effects. From there it built up to more detailed storyboards, previz, color script paintings, and so on.

How important was organization to your process? Do you feel being unorganized would have drastically changed the outcome of your film?
I'm very organized, so yes, it would have been very different if I wasn't. You need someone on the team who is, and has the authority to get things done. If you don't, the team will see it, and they won't stick around. On a number of occasions people told me they were impressed that I knew what I wanted, I communicated it well and managed the entire thing smoothly. I'm sure it could have been done even better, but only with a budget to pay for the areas that were the hardest to find talent for.

Please talk a little about your character design.
My aim was to make it appealing and original. Since I knew the target was online video portals, like YouTube, it had to stand out in a small thumbnail. So strong silhouettes, appealing colors and something unique. In order to save work I considered designs that focused on the faces and hands only, I even had floating heads and hands at one point. But that wasn't very appealing and I experimented with where to cut off the figure until I settled on giving each character a tail from the waist down. Because they were in heaven and there was no floor this was OK, and it also gave me an opportunity to give each character a look that related to their theme. Essentially I was toying with the look of ghosts for a while, and I wanted to make them partially transparent too but that proved tricky to develop in CG animation.

Discuss your approach to the wide range of special effects in this film.
The common effects, the ones in every shot, were usually created in 3D so that I could put the camera anywhere I needed to and semi-automate the process. Most of the rest were done in the comp on a case-by-case basis. It was a combination of experimentation and 2D particles. It was a lot of fun though. Attracting other artists to the project brought a few more tricks that could be duplicated out across other shots and it became a huge melting pot of tricks. Basically, whatever looked good and served the story was fine. We didn't need realism and it wasn't my goal to apply for jobs as a specialist effects artist, so I wasn't trying to do anything too wild … it was all just good enough to tell the story and catch people's attention. Fortunately, the world wasn't based on anything too realistic so no one could tell us, "That's not what it would look like."

Do you have any recommendations for teams which plan to work 100 percent remotely, like the production of Devils, Angels, & Dating?
You need a good website, with lots of well-structured communication options. Dropbox or similar tools are good for sharing your files quickly and getting a good turnaround. But remote work requires a lot more organization than onsite work; expect to do at least two to three times the amount of work to keep it going effectively.

We actually have a lot of making of videos, forums, blogs and audio podcasts that expand on how we made the film, all available at DevilsAngelsAndDating.com.

What words of encouragement do you have for someone who wants to create a 3D film at home?
Start small, really small … smaller than that, no … smaller than that. A film can quickly get ambitious and out of hand but not many people can follow through or anticipate the problems that can put an end to it. So keep it small, tight and make sure it's worthy from the earliest stages. Fixing it in post-production is nowhere near as meaningful as fixing it in the concept stage and pre-production.

3D Production

While you have done a huge amount of work already, 3D production is the largest part of your overall production. Comprised loosely of animation, effects, lighting, and rendering tasks, your shots will finally be taken through to completion (at least in Maya). The main thing to remember here is to not get off track; we have gone through a thorough pre-production on the film and should not have any surprises. All the planning and setup you have done was to make the 3D production phase as easy as possible. If not easy, then at least predictable. We want there to be no "uh oh" moments as you start creating your shots and take them through to render.

Scheduling

If you have not made an overall schedule for your film, you can get by. Especially if you are not trying to hit any hard deadlines. But you should at least have a schedule for 3D production, regardless of how much time you have to

finish the short. The reason for this is that there is far too much subjectivity in the assessment of "completion" when it comes to the animation phase. Put another way, we animators always feel we can do better because we see a better version in our heads. It's this amazing animation that inspires us and is the goal that we strive towards. It's also this imaginary perfect shot that can sink your film, and fast; the endless pursuit of the perfect shot will eventually burn you out. This is because, unless your animation workflow is absolutely rock-solid and you have the experience of hundreds of shots under your belt, you may not know what you can realistically achieve. A schedule helps remind you that you are working on a *whole* project that needs to be complete in order to be considered at all. A project that is going to be considered as much more than the sum of its parts. For this reason we have to fight the temptation to tweak and noodle the animation as much as we please; other parts of the film are going to engage the audience just as much as the fidelity of the motion.

You can use either a digital schedule or a paper one; I prefer paper schedules when working on something on my own for the mere fact that I can have it hanging right near my monitor. Then I do not have to navigate through folders or online to open the schedule, covering my Maya window, to look at it. A digital form of the schedule is fine as well, though.

FIG 6.1 This calendar format is simple to read and has the added benefit of showing you at a glance how much time you have left for a shot.

The two types of schedule that seem to work well are simple calendars with the shots written in for their progress status and "due dates," shot-based charts with due dates for specific tasks (animation, lighting, rendering). For my purposes, any cheap calendar from a pharmacy works perfectly.

January 2013

SUNDAY	MONDAY	TUESDAY	WEDNESDAY	THURSDAY	FRIDAY	SATURDAY
		1 STL_030 anim begin STL_020 anim finish	2 STL_030 anim WIP STL_040 anim begin	3 STL_030 anim WIP STL_040 anim WIP	4 STL_030 anim finish STL_040 anim WIP	5
6	7 STL_040 anim WIP STL_050 anim begin	8 STL_040 anim finish STL_050 anim WIP	9 STL_010 light begin STL_050 anim WIP	10 STL_010 light finish STL_050 anim WIP	11 STL_020 light begin STL_050 anim finish	12
13	14 STL_020 light finish STL_030 light start	15 STL_030 light finish STL_040 light begin	16 STL_040 light finish STL_050 light begin	17 STL_050 light begin STL_010 comp begin	18 STL_050 light finish STL_010 comp finish STL_020 comp begin	19
20	21 STL_020 comp finish STL_030 comp begin	22 STL_030 comp finish STL_040 comp begin	23 STL_040 comp finish STL_050 comp begin	24 STL_050 comp finish STL sequence edit begin	25 STL sequence Edit WIP	26
27	28 STL sequence edit WIP	29 STL sequence edit WIP	30 STL sequence edit WIP	31 STL sequence Final		

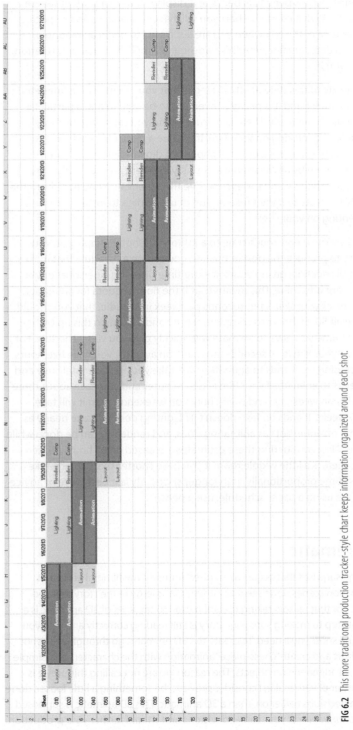

FIG 6.2 This more traditonal production tracker-style chart keeps information organized around each shot.

The calendar type is beneficial because it displays time in a context we are familiar with. With a complex chart you will have to search to find a specific shot's due date or the day when you are supposed to begin animating on a particular scene. I am fine with this trade-off of simplicity versus information, so I stick with it.

The downside to this style of scheduling is that you can miss deadlines easily, but on the other hand it is pretty convenient to be able to find a particular shot's status immediately. There is no rule saying you can't have both styles of schedule and tracking on your film. If you are a meticulous person and you don't mind updating a piece of paper or a digital chart every time you finish a task, then by all means have both styles. There are many other styles of progress tracking—and believe me, I've tried them all. None have both the simplicity to create *and* the presentation of useful data to make them worth implementing on your short.

How do you know how much time to allot to your shots? Simply put, you should try to produce the best animation you can on a schedule that makes sense for production, giving yourself extra time since it is a personal project and you want it to shine. This means that if the normal quota for animation of someone of your skill is ten seconds per week in a studio, that you should give yourself 50–60 hours to complete ten seconds. Dividing this up by the amount of time you have to animate will quickly give you your schedule. For example, if your film is 30 seconds long and, on average, you have five hours a day including weekends to animate, it will take you approximately five and a half weeks to animate. If your film is two minutes and you have about three hours a day on weekdays and seven hours on weekends, then it will take about 38 weeks. It adds up fast, doesn't it? Lighting does not take nearly as much time on your shots as animating does, and rendering can be done while you sleep. Also, considering these estimates are based on 60 hours per ten seconds, there is a little wiggle room if you have shorter shots (which take much less time proportionally than longer shots). My last best piece of advice is: if you are using a paper schedule, use a pencil!

3D Animatic

One of the surprises that occurs most often for first-time filmmakers is that the animation scenes don't seem to convey the energy of the storyboarded animatic. For that reason, taking the animation to the level of 3D animatic is a good first step to making sure your story is still reading correctly and that you have all the shots you'll need. To create the 3D animatic, go through each shot in your short and create "chess-piece" animation with the characters and simple previz-level animation on objects. The reason we are not calling this previz is only a matter of vernacular; I consider previz to be something a little looser, done to inform decisions earlier on, than a 3D animatic. This 3D animatic is supposed to be a *continuation* of your earlier decisions and should further your production.

By "chess-piece" animation, I mean using your characters' master controller to move them around the scene without doing any posing. You are looking for very little information from this step—no more than simple timing and staging. You will be surprised how much you get from looking at the shots in this form, though. After you have created the chess-piece animation, create your playblasts and save them to the \\images\playblasts directory. You can copy my settings for the playblast to get the best results.

FIG 6.3 The settings work nicely for playblasting.

Before you playblast though, select the camera and go into the attribute editor (Ctrl + a). In the "Display Options" section of the cameraShape tab, find the attribute called "Overscan" and make the value 1.0. What Overscan does is show you the area outside the camera's renderable view. While this can be useful, we do not need to see anything but the renderable area, and a value of 1.0 makes it so we see just that. Now you can create your playblasts.

When the playblasts are done, load them into a layer in your editing package of choice above the story. Do not remove the storyboards just yet; you may still need to do some editing and adjusting when you watch your 3D animatic for the first time. It is common and totally OK for there to be some glaring issues with your film once you watch the 3D animatic. Typically, there are too few shots, and the ones you have are too long. A :60 short made up of about ten six-second shots might work much better as 20 three-second shots, for example. Until we see the 3D animatic it is sometimes impossible to realize we are missing vital coverage of an action. Luckily, we set up our shots to be numbered by tens, so you can insert up to nine shots in between existing shots in your film without messing up your naming convention.

If you make new shots, take them all the way through the layout workflow that we talked about in the last chapter and up to the point of playblasting for the animatic again. Do not move on to animating any scenes until the

animatic is reading well and you have convinced yourself the film is in good shape. You can even show the film to other animators at this point; their feedback will be valuable. Do not show it to laypersons yet; for them it is too hard to look past the grey-shaded scenes and lifeless characters. Once you are completely satisfied, you can move on to animation.

Animation

While I have done my best to encourage you to work diligently and with caution so far on the film, the animation phase is a very tricky one. There are many pitfalls here that account for a large portion of unfinished films.

Working Too Long

As I said above, animators have, more than those in most other CG disciplines, the problem of striving for perfection. Or at least trying to get animation on screen that resembles the idea they have in their heads. The problem is that you are only ever improving your animation skills while you are animating. Meaning, if you have a very difficult scene to create that gives you a huge amount of trouble, the only way to finish your film might be to change the shot instead of working on it forever. You have to promise yourself that, when something is *just not working*, you'll try to find an ingenious solution around the problem instead of beating your head against the screen until you hate your short film.

For example, if a character's walk cycle is giving you a huge amount of trouble, consider changing the shot to show him only from the waist up. Moving the torso believably is not nearly so difficult and you'll save yourself a lot of time. The audience won't be looking for these kinds of shortcuts so you'll get away with it as long as you have a few shots of different lengths to show your character full-bodied.

Another example would be to have some reaction shots and over-the-shoulder shots of your characters that are speaking. Meaning, instead of doing the normal thing that first-timers do and have the camera pressed right up into the face of the character that is speaking, cut away from all that hard animation work. Use plenty of reaction shots, because you do not have to lip-sync the character in these. Also have some shots that are over the shoulder of the speaking character; all you must do is have some natural movement in their head to telegraph that they are speaking, together with the body performance that goes with the dialogue. Again, you've saved a lot of animation work by choosing these.

Shots Too Long

The most common problem amateur shorts suffer from is the long-shot syndrome. It is hard to prescribe an average shot length without disregarding some of the cardinal rules of filmmaking, but if I must, I would say that three

seconds is a good average. Something about the linearity of animation data in a Maya scene makes you assume an encumbering overhead as you approach ten-second shots or longer. You are building animation upon animation in long shots, as opposed to having a clean, short scene with little that needs to "work together." For me, the task of animating ten 100-frame shots is *half* the work of animating one 1000-frame shot. There is obviously a certain point where the sheer number of shots becomes far too cumbersome, but that point is further than you think. The good news is, with your 3D animatic in hand, you can make decisive changes to your film at this point with virtually no work lost. Sometimes the best thing you can do to unstick yourself when working on a difficult scene is to just break it up into two shots.

Create Cycles for Common Actions

Does your character have a lot of shots where they are running? Perhaps your film takes place in a park and the characters have a conversation on a bench instead? Where does most of the action take place? Even before you jump into actual shots, it would behoove you to create some animation that you can reuse and repurpose for some other scene, as long as there are enough shots with similar animation in them to support this. In the running example, you should of course have a run cycle worked out for your character that you can copy and paste into each shot that needs it. In the park bench example, you would want to create a cycle of the character posed, and maybe breathing, on the bench; perhaps on a different animation layer so that you could dial the breathing up or down depending on what the scene calls for.

In my studio we keep a library of *all* the animations that we create so that we can reuse as much as possible. Here's how you do this in Maya.

1. Open "anim_Export.mb" in this chapter's source files.

Babinksy is running with outstretched arms, a really good piece of animation to have for use in multiple shots in the film.

2. Select Babinksy's master controller on the ground "babinsky_ac_cn_base."
3. Click on File > Export Selected.
4. In the file dialogue and options box that opens, make your settings match mine.

Make sure you have chosen animExport in your file output box. If it is not displaying, then you do not have the plugin loaded.

5. Close the file dialogue box and click on Window > Settings/Preferences > Plug-In Manager.
6. Find "animImportExport.mll" near the top of the window and check both "Loaded" and "Auto Load."
7. Retry steps 2-4.
8. Save your file to the \\data directory in a new folder called "anim."
9. Name the file according to the character and the action; in my case it would be called "Babinsky_run."

FIG 6.4 Copy these settings to export the animation on your characters.

Testing Your Export

Once the animation has been exported, we should test it to make sure it all works correctly. The last step of this process will be to create a playblast for the animation that you will save alongside the exported animation data.

1. Create a new Maya scene.
2. Reference-in the Babinksy rig from the book's source files "babinksy_Rig_PUB.mb."
3. Select the master controller on the ground.

FIGURE 6.5 Babinksy is running just as he was in our source scene, so the export/import worked perfectly.

4. Click on File > Import and find the. anim file you just exported. Import using the default settings.

Wouldn't it be nice if you could look at animation files without opening Maya? I thought so too, so I added the step of creating a playblast of an animation to the \\data directory.

5. Create a playblast of the animation using the same settings as above.
6. Save this playblast to the \\data\anim directory, giving it the same name as the. anim file you've exported.

FIG 6.6 This directory exists for a project my company works on—just look at all of that animation!

Look at how convenient it is for me to look through my animations and preview the data right within Windows Explorer. Also, giving the movie the same name as the animation data file keeps things very organized. At the end of producing your film, you might have at least a dozen exported animations that can be easily repurposed elsewhere in the short.

A Few Notes On Exporting Animation

We selected the master controller of Babinsky because our export settings were set to copy all of the animation on nodes beneath the selected node. It is very important to remember to complete this step. It is also very important to remember that animExport only exports channels that have *keys* on them. Meaning, if you have the head posed in a certain way for your run cycle but not keyed, it will not be exported with the rest of the body movement. To get around this limitation, sometimes it's a good idea to select all of the character's controls and on frame 101 to hit "S" and set a key. You must be careful, however, because if there are channels that are cycling that have been offset from frame 101, you might be messing up those channels by setting a key on them. A sure-fire way to make your animation work correctly is to always key all the controllers in the default position on frame 101 when starting work on a shot.

Frame 101 Revisited

I mentioned in the last chapter that starting your animation on frame 101 was important for many reasons, one of which was to give effects and dynamics simulations time to precalculate. I am now going to further refine this understanding of frame 101.

Since we have discovered that only channels that are keyed export animation, we will add a step to our workflow that should happen at the start of every single one of your animation scenes. I call this step "zero-keying." Basically, what you must do is key all your controls not only on frame 101 but also on frame 1; however, the frame 1 keyframe should be the character completely zeroed and in his bind pose. As you start building the first pose for frame 101, you might realize why we have done this, because essentially you are creating slow animation from the bind pose to your start pose. In this time, the hair, cloth, and muscles, etc., all have the time they need to settle and feel natural for the start of the rendered animation frame range. Without this time, the dynamics and simulations will just mess up. Using the workflow of keying all of the zeroed controls on frame 1, then starting your animation on frame 101, will take care of all of the keying requirements you need for exporting animation as well.

Starting Your Shots

It is time to begin animating! The most important piece of advice I can give you right off the bat is: stick to your workflow. What is workflow? Uh oh.

Workflow

The major part of my teaching experience has revolved around teaching the concept of animation workflow. Simply put, your workflow is the step-by-step

process you use to create animation. While your workflow will be unique to you, most animation workflows have similar parts to them. The main thing to remember when talking about workflow is that you do not ever deviate from your workflow. Why? When you arbitrarily change something about your process, you lose the ability to tweak the workflow. You want to constantly use the same process and let the process change organically as you improve and as certain workflow steps prove themselves unworthy of being a part of your process.

Here is an example of the difference between arbitrarily changing your workflow and assimilating a better workflow choice naturally.

Let's say you are animating a character running and jumping over a wall. Typically, you would create pose-to-pose animation, posing in the major moments entirely before going back through the shot and making rough timing decisions. Today for some reason you decided you were going to do the whole shot straight ahead, keying on 8s, then 4s, then 2s, and refining pose as you went along. This experiment ended in disaster because it was bound to; this random change to your workflow has none of the experience of completed work behind it. There are no finished shots in your wake to support this workflow choice and hence the new method will not produce animation at the level you are used to. This is not to say that your workflow doesn't change; quite the opposite in fact. Your workflow should be malleable and somewhat flexible. Here's another example.

During the same shot of animating a character running and jumping over a wall, you went about creating your main poses, but this time, instead of creating the keys in stepped mode, you blocked in splines. You wanted to see what would happen if you let Maya do a little bit of interpolation for you even though you knew it was going to be floaty and mechanical. Lo and behold, you found that you could *edit* the main breakdowns from the Maya-interpolated in-betweens much more quickly than you could create the poses from scratch. Once you were finished with the main breakdowns, you switched to stepped preview mode and continued with your normal workflow.

Do you see how, in the latter example, the workflow adjustment came from an idea of how the current workflow might be *improved*? The experiment was an exercise designed to test a new method that worked within the framework of the current workflow. Faster, more drastic changes to your workflow in the middle of production spell trouble for the film's chance of seeing the light of day.

The first thing you must do is write down your workflow. What are the steps you take at each stage of a shot's animation, and in what order? Here is a typical workflow, simplified down to its bare bones:

1. Gather/shoot reference video
2. Create thumbnails

3. Block poses in stepped mode
4. Time poses roughly
5. Add breakdowns in stepped mode
6. Convert to splines, refine timing
7. Add further breakdowns and in-betweens
8. Add blocking to facial performance and lip-sync
9. Refine arcs in body, fine tune extremities
10. Add polish to body performance, refine facial animation
11. Final 5 percent polish (toe rolls, untwining details, remove knee pops, intersections, etc.)

Does your workflow look something like this? If not, that is fine, but you should by now have a written-out version of your workflow in order to be able to start looking critically at your process. In addition, only those with a workflow that is well defined can start to see areas that might have potential for adjustments to be made to improve their process. For example, perhaps a tool is added to Maya that you want to try out, such as the Grease Pencil tool. With your workflow written out, you might think of a few places where using the Grease Pencil might be beneficial. Doing your thumbnails directly in Maya might save you precious time that you used to spend scanning and importing images. Maybe the Grease Pencil could be used to quickly try out a few different ideas for breakdown poses. So, after step 3 in the above workflow, you would roughly copy the poses with the Grease Pencil and use it to add breakdowns before taking the time to pose the character in 3D. A more common use for any pencil tool is to refine arcs, so step 9 is a natural place to try this new tool out, maybe in lieu of your current system, which involves adding editable motion trails to your controllers. The benefit of having your workflow documented in front of you is obvious when you consider how many different methods there really are for making animation.

Sticking to Workflow

My advice to stick to your workflow should hopefully start making more sense now. Rather than a rigid system, it is a guide for you to make sure the improvements you are making on your process can be replicated as you continue work on the short film.

Sticking to workflow is best achieved in conjunction with "journaling" your progress. As you are working, make little notes about your progress on a pad of paper, recording your discoveries about your workflow as they pertain to getting work done on schedule and of the expected quality. This journal can be reviewed weekly and the workflow adjustments that seem to make the biggest difference should be added to your written workflow. Type it out, tape it up in your workspace, then start the new week with a new journal page and a fresh set of workflow ideas. Repeat as necessary!

Great Video Reference

The first step of most people's workflows is gathering and shooting reference video. I am a huge proponent of gathering lots of reference video for every single one of your shots, but there are a few caveats.

First, you should only ever try to glean one important thing from a piece of reference video. If you are looking to a single piece of reference video to provide *all* the information you need to animate a shot, you are just rotoscoping. Instead of copying everything from a video, try to hone in on the most important thing; the one thing that made you think to yourself, "I should use this as reference," in the first place. Be it a gesture or the silhouette, the interesting timing or performance choice, there is typically just one thing about a piece of video that stands out above the rest. Take this thing, be happy that you have it, and move on to another piece of reference. With four or five great pieces of reference, you can assemble the strongest combination of inspiring choices to help guide your shot.

When shooting reference, I have almost the same rule: *never* try to get everything in one go. Meaning, if you try a performance with your own body that takes everything into consideration, the result will be quite useless. The correct way to get inspiring reference video of yourself is to loosen up and break the performance down into its component parts, then shoot numerous takes of each component to assemble later. For example, if you have a shot where a character bursts out of a closet to scare his little sister but then sees she is nowhere to be found, then your first couple dozen takes should be *just* you jumping out of the closet. Forget trying to link the two phrases of the shot together; worrying about transitioning into your "acting" mode will water down the physicality you are putting into the door-bursting moment. And inversely, the higher the energy and more wildly you jump out of that closet, the more likely it is you are going to be too hyped up to remember the performance choice you wanted to try for the second half of the shot. So, in my opinion, the best way to get the most out of your reference video is to treat it like found footage and try to get just one strong idea out of each piece you use, shooting it in pieces and being very loose about things like timing and staging.

Reference Video as a Timing Tool

Many of the shots in our films are in a way "beyond reference." Truly, most of the things we put our characters through in our shorts could very well land you in hospital if you aren't careful when shooting your reference. So, especially for cartoon-style shots, I have a powerful tip that will give you a real leg-up with your scenes: shoot a piece of video that is going to be used solely as a timing tool.

Here's how it works: take your camera and point it at the surface of your desk. Using your hands to represent the characters and making lots of sound effects with your voice, create multiple takes of the shot in this "puppetteering"

manner. Open "shot_ref.mp4" in this chapter's source files to see my example of this method. When you are done shooting, choose the best take in terms of energy and style, and export the audio from the file. You may either use your editing program to do this, or if you have Quicktime Pro, you can use the export feature. Once you have the sound file isolated, load the audio into the Trax Editor in Maya (Window > Animation Editors > Trax Editor). Don't forget to move the audio to start on frame 101. Now use the sounds you hear in the audio file for help with timing your scene. You will immediately notice a huge speed increase when blocking your shots, because so much of the timing choices are already done; you just need to match the audio and you are halfway there. This is not cheating! It's using all the tools at our disposal to get the best results in the shortest amount of time. This one piece of advice will save you *days* of work. You're welcome to steal it!

Animating With Tempo

I have recently discovered a new way of looking at early animation progress in a scene and I want to share it first with you in this book. I am calling it "animating with tempo" because what the basic idea entails is looking to make as many unique and interesting timing choices as possible, as early on in the progress of your shot as possible. What normally hinders this is the fact that we are bound to work with character rigs that can sometimes have dozens if not hundreds of controls. Creating even a simple pose takes at least a few minutes. This time starts to add up, and by the time you have created the poses that you want to define your big moments, a lot of what might have inspired your timing choices is somewhat gone. How do we go about "getting at" those timing choices when we are bound to posing a complex character in order to see timing choices? The answer was right in front of me—all it required me to do to find it was drop the notion that we need to use our characters to make timing choices. Instead, we are going to use helper objects like spheres and cubes to play with timing as early as possible, *then* fill in the poses, following our inspired thumbnails and storyboards.

Open "anim_Tempo_Start.mb" in this chapter's source files. In this shot, the animator's idea was to have Babinsky run on screen and trip over a crate that is lying on the ground. He was to just miss the coin due to this fall. When I first saw the animator's layout, my initial reaction was that Babinsky seemed to be almost jumping when he hit the crate, not tripping. Also, the timing choice was a little flat to me; I encouraged the animator to do a little bit more with the timing and to add some variety.

When I next saw the shot, it was much improved, but it still had some of the problems that I noticed before, such as him jumping instead of tripping, and the timing remained a little lackluster. This is when I first suggested the animator (any animator, actually) create a helper object.

FIG 6.7 The scene as I first saw it. Though this animation is definitely on the right track, I felt it would be a very drawn-out process to get the strongest animation.

The helper object, in this case a sphere, is a piece of geometry that you animate in your scene to represent the gross movements of your character. The idea is to get a sense of the unique timing choice you are putting into this shot as soon as you can. With this sense of timing, you can always go in and strengthen the pose. Also, timing becomes harder to adjust and refine as you do more pose work, so my stance is to rather get an interesting timing choice right off the bat before your posing clutters your scene.

Open "anim_Tempo_Finish.mb." The first thing I want to call your attention to is the fact that the animator has a sphere animating through the scene in stepped mode. The helper object can be animated on stepped keys even if the character is already in splines. Ideally, you'd want to use a helper object to animate with tempo from the get-go, but this scene aptly demonstrates how powerful a helper object can be even late in an animation's life cycle.

Once the helper object is animated, your task becomes simply matching the animation with your character. The animator told me that the difference between editing animation to try to hit my notes and animating to a helper object was like the difference between night and day. I believe that if you consider this as a part of your workflow you will experience the same boost they did.

In Maya, unhide Babinksy by clicking on the display layer called "babinsky_hires_layer."

FIG 6.8 The scene with the helper object animated, providing interesting timing choices and a strong guide for the animator.

FIG 6.9 Unhide Babinsky by clicking on his display layer.

Now you can see how well the animator matched Babinsky to this newly timed helper object. Better yet, the poses themselves were easier to create once the animator could move forward with the confidence that the timing choices were near final. The entire process was a huge success.

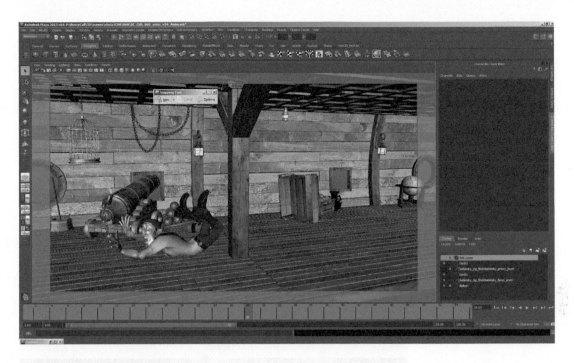

Incorporating Style

A common note I give animators is that all of the characters seem "the same."
This is primarily due to the fact that there is a single animator animating
the different characters and the animator is not taking style sufficiently into
consideration. To create really "full" performances, each of the characters
needs to have a unique feeling to their movement. The best way to
accomplish this is to establish a movement style for each one.

In the simplest sense, style means moving a character in a unique way, but it
must come with a certain consistency as well. It is not enough to have each
character moving wildly differently from shot to shot. To choose a style, look
at the character designs and let yourself be inspired. What about the story:

FIG 6.10 The final animated Babinsky
really shines.

FIG 6.11 In *Reverso*, the new
employee that gets our main
character in trouble is very rodent-like
in design, so it's no surprise he
twitches his nose and moves with
quick staccato movements.

is there a plot point that you can draw inspiration from? Maybe a character's upcoming character arc can inform your movement decisions. However you let the story inform the style, a little bit goes a long way.

Even more crafty is the filmmakers' decision to have the rodent character get the main character in trouble by tattle-tailing, or "ratting," on him. Very nice.

FIG 6.12 In *Crayon Dragon*, the animator used weight to their advantage to develop style.

The use of the different weights of the characters gives a very distinct feeling to each of their personalities. The dragon is very childlike, so when he loses his wing and starts crashing everywhere, it further invokes a feeling of innocence. The entire film supports this character choice, as he feels lighter and floatier than the human character. It is not a bad thing; this weightlessness makes the dragon feel that he is pure and sincere in his love of color and his world. It's very well done.

One way I like to describe style is that is it a "persistent answer to a variety of questions." For example, how would an evil, lanky character walk across a room? The superficial answer would be in a way that makes him look as evil as possible. That is good to keep in mind, but *stylistically* you aren't saying much yet. A stylistic choice might be to have this character *never* anticipate his movements. By breaking one of the rules of animation, you are putting the audience on their heels. They will not be able to anticipate what he is going to do next as they can with other characters, and it will make them feel uneasy. Pair this animation choice with the performance choice of him looking as evil as possible with everything he does and you've successfully developed a style that sets this villain apart.

Let's do one more. If your short is about a little boy who is constantly bullied, how could you distinguish the animation style of the bully from the other characters? One distinguishing characteristic of predators is that their eyes are forward-facing and they normally hold their head very steady even when moving quickly. Imagine a tiger stalking its prey and you'll get what I mean. You could have the bully's head snap into "predator" mode whenever he sees

the main character; tone the movement way down in the head so that he is "locked on" to our poor hero whenever he is near. Subconscious images are very powerful and the audience will doubtless pick up on a choice like this. For bonus points, you could have the love interest who saves the little boy always look at him with her head almost in profile. This will invoke images of safe creatures like deer and rabbits that have wide-set eyes placed on the sides of their heads. Again, it's a subtle trick, but by not animating every character the same way you will go far to convince your audience of the depth of the world you've created.

I know I'm piling on a lot to think about for the animation phase, but these kinds of choices make your short stand out in a sea of homogeny.

"Finishing" Shots

At some point a shot needs to be done. Many animators don't know when they are "done" with a shot. This comes down to workflow yet again. When sitting down at your computer for the first time of the day, or after a long break, instead of asking yourself, "What do I need to do on this shot?", ask yourself, "Where was I in my workflow on this shot?" It is a subtle difference in mindset, but the latter will lead you closer to the results you want. When you ask yourself where you are in your *process*, you are in fact acknowledging that each shot has to go through your process before it is complete. When you have no more steps to complete on a shot, it is done. Now, that doesn't bar you from changing your process slightly, as I illustrated above, to add a little extra to each shot as you get better and better. In fact, I very much encourage you to take the improvement you will undoubtedly experience when working on your film and refine your polishing workflow above all else (most animators are good blockers, because we start many more shots than we ever finish). For the purpose of making some of those polish tasks a little easier, I have included my polish checklist from my *How to Cheat in Maya* series as a guide. There are of course tasks that have been left out of this list and, equally, some of the tasks on this list won't apply to your scenes, but it is a good jumping-off point.

1. Make sure anything attached to the head that is keyable has good overlap and secondary movement. Floppy hats, ponytails, and antennae come to mind.
2. Make sure that the ears, if keyable, have a little bit of life to them, perhaps perking up when the character hears something. A tiny bit of wiggle in the tips is good too.
3. If any dynamics exist on the head, turn them on and adjust the settings.
4. Add a tiny bit of micro movement to match the inflection of the dialogue.
5. Check that the eyebrows and eyelids do not take on any unharmonious poses.
6. Add some overlap and overshoot to the eyebrow movement.
7. Add some microdarts to the eyes.
8. Untwin the keyframes of the eye blinks and eyebrow movements.
9. Key the cheeks and squints if they haven't been touched yet.

10. Key the sneer and nose controls if they haven't been done already.
11. Add a tiny but of puff to the cheeks on m, b, and p consonants in the dialogue.
12. Key the tongue if it has not been done already.
13. Add asymmetry to the mouth shapes in the dialogue.
14. Cheat emotional face shapes like smiles and frowns towards camera.
15. If there are lip puff controls, add them to m, b, and p shapes.
16. If there are controls to keep the lips stuck together as the jaw moves downwards, add a pass of that now for words in the dialogue that start with b and p, especially after a long pause.
17. If there are swallow or breathing controls for the neck, add those.
18. Check arcs are clean and smooth on all the head movements.
19. Add breathing movement to the chest.
20. Relieve a little bit of the distress in the neck and shoulder by keying the clavicles if they haven't been keyed already.
21. Check arcs on chest and upper torso.
22. Check arcs of elbows.
23. Make sure the pole vectors are animated—we don't want Maya deciding where our elbows are pointing.
24. If this is a character with wings, add the stretching of the wing membranes against the flow of air.
25. Check wing poses for good silhouette.
26. Refine and nail down overlap amount on wrists.
27. Add and refine overlap on fingers.
28. Break up finger animation timing.
29. Add contact of fingers on any props the character holds or touches.
30. Refine and nail down any IK/FK switching by matching the pose and movement perfectly.
31. Add moving holds to hand poses and finger poses.
32. Add micro movements to hands and fingers.
33. Make sure the spine controls are not counter-animated against each other and that each spine pose is explicit and meaningful.
34. If there is a stomach bulge control, use it in conjunction with the chest controls to further refine the subtle breathing movements.
35. Add secondary movement and overshoot to stomach bulges and fat.
36. Refine the hips by doing a pass where you look closely where the weight is distributed.
37. If the hips and lowest spine control both have IK movement, make sure there is no counter animation between them.
38. Refine arcs on the hips.
39. Make sure that all the main body movements have a weight shift in the hips to allow the legs to come off the ground.
40. If you are working on a dog-legged character, make sure the femur and the foot bones stay parallel nearly all the time.
41. If there is a tail, smooth the movement on the tail by reducing keys.
42. Add overlap and some bounce on the tail.

43. If the tail is prehensile, make sure there are no penetrations with props or the set and add contact poses if it touches objects.
44. Remove pops in the knees by refining the height of the root or by using the stretch control on the legs very sparingly.
45. Key knee pole vectors.
46. Add micro movements on the knees to indicate when a huge amount of force is applied, especially on large creatures.
47. Make sure the knees in general line up with the foot.
48. Avoid bow-legged poses or knees pressed together.
49. Key foot roll.
50. Key toe roll and a little bit of overlap on the foot and toes.
51. Key sliding and micro movements on the feet, even on a static character.
52. Fix any penetrations that are happening between the ground and feet.
53. Make sure all of the curves on the feet fast-in to the ground in TranslateY—we don't want the feet to slow-in to contact poses.
54. Make sure any FIK/IK switches on the legs are cleaned up nicely.
55. If you are working on a barefoot creature, key the toes splaying as the weight is applied to the foot.
56. Do an overall silhouette pass and make sure there are no unattractive slivers of light in the negative space or messy silhouettes.
57. Take once last look at your thumbnails and reference and compare your golden poses.
58. Watch the animation back with the lip-sync moved one frame earlier to see if it improves the readability.
59. Watch the animation play backwards to see any pops or hitches in the animation that you couldn't see before.

That's it. Hopefully you are spurred on to create your own list of things to check before finishing a shot by seeing this list. Remember, you are not finished on a shot until you have completed your workflow, and similarly, once you've come to the end of your workflow, it's time to wrap it up!

Creating Playblasts

For the purpose of being able to watch the latest edit with up-to-date animation, you should playblast after each work session. I recommend for ease of use overwriting the current playblast in your playblast folder. This way, opening up the edit will grab the latest animation playblast and you will not have to hunt around to swap one out. This potentially could get messy if you are looking for an old animation file that you liked better and you can't find the playblast, but that is so rarely an issue I think we can get away with this one little cheat on the pipeline.

A helpful tip is to turn off the sound file in Maya when you playblast for the edit. It is also a pain to mute or turn off the sound channels in most editing packages. You may as well just bring in silent files and use the sound from your edit instead. Just make sure they line up!

Effects

When we talk about effects in CG, we are talking about all of the things that go into a scene, such as dynamics, fluids, particles, cloth, and other simulations. These effects must be set up correctly or they could crash your scene. In rare cases, a major crash could truncate your file and you could lose substantial work. Luckily, done correctly, setting up effects does not have to be too big a headache. If all else fails, there's also a way to reduce the scene overhead by creating an "effects file" that will serve as a file that only applies these effects before the lighting file is created.

What's the Big Deal?

The single greatest problem with setting effects without proper planning is that Maya gets very quickly into a crash state if there are too many effects piled on. Furthermore, most dynamic effects rely on the concept of *time*, meaning you must play the effect frame by frame in order to have the correct result on the frame you choose. If you are using a small render farm to render your film, then you will notice that the load times of scenes quickly get out of control on shots that have effects. This is due to the fact that Maya has to play every single frame of the animation over and over again up to the frame that it is rendering if the effect is not properly set up. Just on a shot with 500 frames, loading the file can take hours.

Caching is the Name of the Game

It is fine to have dynamics objects like hair and cloth included in your rigs as long as you are aware of the correct workflow for getting these objects to work in your scenes. Very generally speaking, you will hide the dynamic objects as you are animating, then unhide them when you are done animation and start adjusting their settings to get the desired results. This tweaking normally starts at the very beginning (literally). By adjusting the settings of your dynamic objects in the time from frame 1 to frame 101, you will be setting up the scene for the desired effect. Then move on to the animation frame range, continuing to adjust settings to get a nice effect.

For example, an nCloth shirt might be created in the rig file. This shirt should be constrained to the character's master controller so that when you are chess-piece animating the character around, the cloth moves with it. Also, when the character transitions from bind pose (frame 1) to the scene's start pose (frame 101), you don't want to have to also contend with the master controller moving from the scene origin to wherever it needs to go on frame 101. To cache an nCloth, click on nCache > Create nCache while in the nDynamics menu set. Copy my settings.

You must cache every single dynamic object you have in your scene once the simulation looks correct to avoid problems that can arise from simulating in real-time.

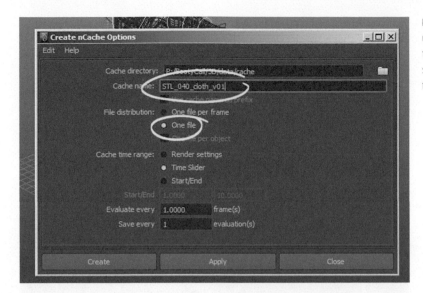

FIG 6.13 These are the settings to use when making an nCache. Notice that I named the cache with the scene name so that I can identify the file later.

Caching Objects Attached to Your Character Rigs

1. Open "cache_test.ma" in this chapter's source files.

This simple scene has a sphere and an nCloth for you to practice caching a dynamic object. Imagine this is your character with a cape or a ponytail. When the object is attached to your character, the caching workflow is simple.

2. Select the cloth object and, in the nDynamics menu set, click on nCache > Create New Cache > □.
3. In the options box, copy my settings above and create the nCache.
4. When this is done, select the cloth object again and notice there is a new tab in the Attribute Editor, called nClothShape1Cache1.

This new node allows you to enable or disable the cache of a dynamic object. Now watch how you can scroll forwards and backwards on the timeline and the cloth object plays from the cache. Caching is a last step before you are finished with an animated shot.

Caching Dynamics Affected By Your Characters

In other situations you will have a need to create caches for dynamics that are affected by your character. In these situations it is better to have a cached character to work with. By caching the character you are actually removing all of the rig data and forcing the geometry to read a cache file that tells the vertices how to deform. It is a way to remove scene overhead and make it so that there are fewer crashes (very complex character rigs have a way of crashing Maya when interacting with multiple levels of dynamics such as

245

particles, fluids, and nMeshes). With your cached character, you will create a new scene that is specifically your "Dynamics" scene.

5. Select the sphere and the cloth.
6. In the Animation menu set, click on Geometry Cache > Create New Cache > □.
7. Copy my settings below.

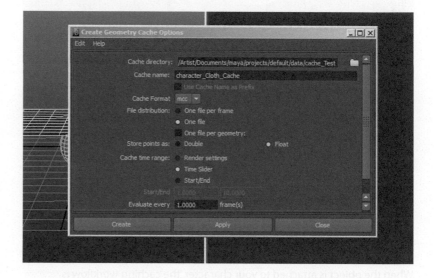

FIG 6.14 Much like a dynamics cache, a geometry cache will create a file that stores all the positional information for the deformed geometry. These settings will work fine.

Name your cache according to the shot number and the objects that you are caching so that everything stays organized.

8. In the Outliner, select the nucleus, nRigid, nCloth, and dynamicConstraint nodes, and delete them.

FIG 6.15 These are no longer needed since our objects are now cached.

Play back the animation and notice how the geometry is still deforming in the same way as when Maya's dynamics were deforming the objects in real time. If you select the objects, you will notice there is a new cache node in the Attribute Editor; it functions in the same way as the cloth cache as well.

9. Save this new file as "object_Cached.ma."

If this were your finished animation file, you would then start working from this cached version to add things like water the character is wading through, fire they swipe with their sword, or sparks that bounce off of their cape. With a cached scene, the overhead is much lower and the likelihood of running into crashes is also greatly reduced.

What about if you want to make a change to the animation? This is not a problem, as the cache is being read by the geometry with a link similar to a texture in the Hypershade or a file reference. Meaning, replacing the cache will immediately update the geometry. Let's put this into practice.

10. Open "cache_Test.ma" again to get back to our old animation.
11. Select the sphere and move it to a new starting and ending position, hitting "S" to set a key on frame 1 and frame 48 after you've moved the sphere.
12. Select the sphere and the cloth and in the Animation menu set, click on Geometry Cache > Create New Cache > □.
13. Make sure that your settings are the same as before and that the filename is also identical.
14. Maya will ask you what you want to do with the old cache, and you should choose "Replace Existing."
15. Save the scene (although you do not have to in order for the cache to be updated).
16. Open "object_Cached.ma" and look at the sphere and cloth.

The sphere and cloth are now updated with the latest animation that you cached from the "cache_Test.ma" scene. If this dynamics scene has effects based on interaction with your character, they will be updated automatically too. For instance, if the character's mesh is a passive collider nMesh, then particles and nCloths will still bounce off him when you overwrite the cache in your animation scene. The same is still true for dynamic effects like fluids.

Hence, the workflow for effects should be the following:

1. Make animation changes in your animation scene file.
2. When you are done animating, even if you may come back to the animation at a later point, save the file one last time before you cache the character.

247

3. Create a cache on the geometry of all characters and character dynamics like hair and cloth.
4. Save this new scene as your "_dyn" scene.
 (a) Create all the effects based on character interaction or otherwise populate the scene (i.e. the building is on fire that the character is running through).
5. Save this dynamics scene for lighting later.

For those keeping track, your scenes folder now has an animation scene, a dynamics scene, and will soon have a light scene.

Lighting

Our light rig will very much come in handy now that we are ready to light our scenes. Truthfully though, lighting artists spend as much time setting up render layers as they do placing lights and adjusting shadows. We can shorten the time it takes to position our lights by using Viewport 2.0. After some test renders of our "Beauty" render, we will go over the different render passes and set up the layers correctly.

Applying the Light Rig

You can start working on the lighting of your shot while animation is in progress, just not too early. The major elements of a scene need to be in place or you cannot light the shot accurately. That said, applying the light rig to your scene can be done early on and the lights then tweaked as the animation is refined. Let's practice this.

1. Open "light_Scene_Test.mb" in this chapter's source files.

Notice how the light rig from *Booty Call* is imported into this scene. The locator used for positioning the lights is also present, and we will shortly use this to align the light rig to the animation scene.

Notice that the lighting rig is imported, and not referenced. We will always want to reference our light rig into our light scenes, but for simplicity I decided to show this example with the step of referencing your light rig removed. You may follow our normal referencing workflow (including changing the reference file path to relative) when you are working on your own short.

2. Reference the finished animation file into your light scene by clicking File > Create Reference or by pressing Ctrl + r.
3. Choose "finished_Anim.mb" and click Reference.

We will now quickly align the lights to the light locator in the environment rig file. Remember when we created the light rig to match the position

FIG 6.16 The light rig is imported into a new scene for each lighting file you create.

FIG 6.17 Our animation scene is referenced into our light scene and we can begin to adjust the settings.

of the environment rig? This was all in an effort to streamline the alignment of the two.

4. Select the locator called "light_Pos" in the Outliner. This is the locator that controls the light rig position.

5. In the Persp panel, switch to the move tool by pressing "w", then hold down the "v" key to snap to points, and finally MMB-drag the light_Pos locator to the locator floating in the middle of the environment rig called "light_Loc."

FIG 6.18 Snap the light rig to the "light_Loc" locator in the environment rig.

It's that simple. Note that if your environment was rotated you could use an Orient Constraint to make sure the light rig is oriented the same way as your environment. Normally, positional information is all you need if you were careful to lay out your scenes.

6. If you are working on your own film, save this new scene with a reference to the animation version in the file name. Meaning, if the currently referenced animation file is v06, then you would save this new file as:

"BC_STL_010_anim_v06_light_v01.ma"

in a newly created "Light" folder in the "STL_010" folder.

Each time you iterate the lighting, version up the file and save it. If you happen to change the animation, then replace the reference in the lighting

scene and version up the animation to match the latest version as well. This is critical to staying organized as well as always being aware of what version of a scene you are working with. In production, the version number can get very high—I've had some shots the approved version of which was 75 or so. Imagine trying to keep track of the latest animation as a lighter if you don't at the very least include that info in the filename.

Using Viewport 2.0

For almost all our lighting needs, Viewport 2.0 serves very nicely. Using this hardware accelerates high quality preview—we can check shadow angles and light positions, estimate the intensity of our lights, and more. By taking the first crucial steps as a lighter in panel, you are saving yourself precious render time. Let's dive right in.

1. Still using the same light scene you just assembled, change your Panel layout to Four Panes view by clicking in the panel on Panels > Layouts > Four Panes.
2. Change the top right panel to the renderable camera (Panels > Perspective > Camera1) and the top left panel to the Persp panel (Panels > Perspective > Persp).
3. RMB-click anywhere in the Camera1 panel and then press 6 on your keyboard to turn on shaded textured mode. Then press 7 to turn on lighted mode.

FIG 6.19 The Camera1 panel with the familiar lighting of the default panel. We will use Viewport 2.0 to get a better approximation of the lighting in this scene.

4. In the Camera1 panel, click on Lighting > Shadows.

5. In the Camera1 panel, click on Renderer > Viewport 2.0 > ☐.

Your panel will switch to Viewport 2.0 and you can start making changes to the lighting. For example, I think the lighting on Babinsky's face coming from the opening in the ship is hitting him too much in profile. I'm going to move and rotate the "moonlight" to hit a little more of his face.

Using a closer representation of your final image will mean that you do not have to spend as much time using the renderer to preview your lighting work. Of course, you will eventually do dozens of test renders per shot, but Viewport 2.0 gives you a head start, particularly in shadow angles, intensities, and colors.

Also found within the options box for Viewport 2.0 are other handy previewing tools, like motion blur and ambient occlusion. Be forewarned, though: these give you less than useful preview of these effects. Motion blur is based on transformations, not deformations (so character rigs don't motion blur) and the ambient occlusion is rough. Still, anything that gives you a preview of the final result is beneficial.

When you are done positioning and orienting your lights and ready to do test renders, you can skip to the rendering section below or sit tight and work through the creation of the render layers first.

Setting Up Render Layers

I advocate getting your renders to look about as close to the final product as you can. If you are not comfortable with compositing, then certainly your beauty pass should be almost 95 percent representative of the final image. If you are looking for more control in compositing, then setting up individual passes for your renders is the way to go. Maya's built-in system for automatically creating render passes is *very* tricky. In fact, some shaders are not supported and other render pass presets give you results that are unusable.

The Main Passes

We will be setting up the following passes for your renders:

1. Beauty
2. Diffuse
3. Specular
4. Shadow
5. Reflection
6. Ambient occlusion
7. Depth

These seven passes should be more than enough to tweak your renders however you see fit. A beauty render is essentially created from combining the

diffuse, specular, shadow, and reflection passes, with added realism coming from Occlusion and Depth later in compositing. You may use your own scene or continue using the light file we've been working on until now.

Beauty

To create a render layer, go to the Channel Box/Layer Editor on the right side of the screen and click on the "Render" tab. This displays the render layers window. By default you are given just a masterLayer, which will render absolutely everything that is not hidden in your scene. When we are test rendering we are basically doing a beauty render. Since you will be creating other layers, though, you must create a new layer for your beauty pass.

1. In the Layer Editor, in the Render tab, click on the Create New Layer button.
2. Rename the new layer "Beauty."

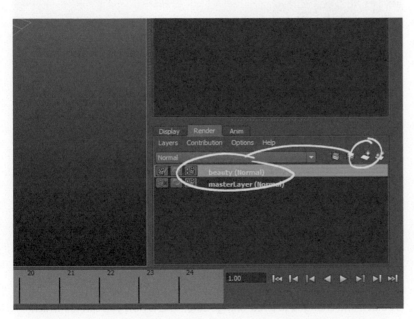

FIG 6.20 The Layer Editor with the newly created Beauty render layer.

When you create a new layer it is empty, so your scene will look blank. As with display layers, you need to add objects and lights to a render layer to populate it.

3. Select all the geometry and lights (groups work too) that need to be rendered in the Beauty layer. This includes Babinsky (or your characters), the sets, and the props.
4. Right-click on the Beauty layer and choose "Add selected objects to layer."

Now the objects are added that must render in our beauty pass. Making sure the Beauty layer is selected, do a test render and make sure the render layer

253

has been set up correctly. Know that the render settings that you've set up for the masterLayer are always going to be the default; in order to set up the rest of our passes, we will need to create layer overrides.

Layer Overrides

Nearly every single attribute can be set to have a value to 'override' when rendering a selected layer. A useful application of this is to have different materials properties on different layers. This is essential for separating the renders into passes like specular and diffuse. To create a layer override, all you have to do is have a layer selected other than the masterLayer, right-click on the desired attribute you wish to override, and choose "Create Layer Override."

FIG 6.21 To create an override is as easy as right-clicking on an attribute and choosing "Create Layer Override." Here I RMB-clicked on the diffuse attribute.

Once you have added an override, the attribute in question will have text that is bolded and changed to a red-orange color. This is how you can tell which attributes have an override on them. Any attribute you change will only have the changed value on the layer in which the override is applied. Remember that your masterLayer's settings are going to be used for default, so changing any attribute without first adding an override will mean the attribute will change in *every* layer that doesn't have an override. We must be careful.

Diffuse

The diffuse pass is essentially the pass that contains the color plus light *direction*. To set up this pass we must copy the Beauty render layer, which is simple to do.

1. Right-click on the Beauty render layer and choose "copy layer."
2. Rename this layer "Diffuse."

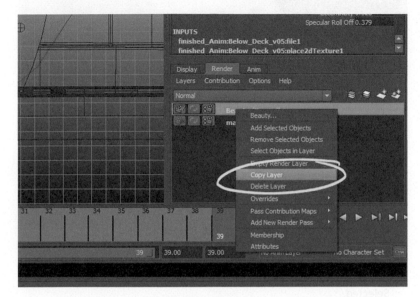

FIG 6.22 Copying a layer copies everything about it, including the objects and lights that are inside, as well as their overrides. We should be careful when copying, especially when setting up multiple render layers.

3. Open the Hypershade (Windows > Rendering Editors > Hypershade) and select Babinky's skin shader.
4. Open the Attribute Editor (Ctrl + a).

Since we are making a diffuse pass, we want to make sure there is no reflection, specularity, or shadows in this layer. We can get rid of the first two by creating overrides in the materials.

5. Create a layer override on every attribute that contributes to specularity and reflection.
6. After the override is created, zero all of these values.
7. Repeat this for all the materials in the scene, making sure you create the override first.

There are presets that will allow you to create the same effect, but as I mentioned before, they can be very finicky and produce undesired results. Although this process is labor-intensive, it is the most sure-fire way to make sure your passes are producing only the results you want.

Finish removing all the specular and reflectivity attributes, and then we will turn off the shadows for this layer.

1. In the Layer Editor, right click on the Diffuse layer and click on "Select Objects in Layer."
2. Open the Attribute Spreadsheet by clicking Window > General Editors > Attribute Spreadsheet.

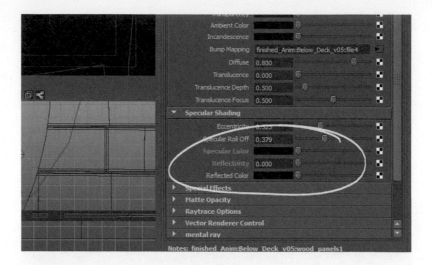

FIG 6.23 We are removing all the specular and reflectivity attributes, leaving only the diffuse information for our layer.

3. Click on the Render tab in the Attribute Spreadsheet.
4. Find the column labeled "Cast Shadows" and click on the column label to select all the channels in the column.
5. In the Attribute Spreadsheet menu, click on Layer > Create Override for Selected.
6. Click on the "Cast Shadows" column label one more time.
7. Type in "0" on your keyboard and press enter.
8. Repeat steps 4 through 7 for the "Receive Shadows" column.

Your diffuse pass is complete. Now let's make the rest.

Specular Pass

As with the diffuse pass, we need to create overrides and zero the channels that are not contributing to the specular highlights of our objects. Namely the diffuse and reflection channels (specularity is affected by shadows, so we do not want to turn them off for this pass).

1. Copy the Beauty layer again, and call it "Specular."
2. This time, go through each material and create an override for any diffuse or color attributes, zeroing them as you go.

For some materials, such as the Mental Ray fast skin shader, the color of the shader comes from a combination of many attributes, all of which need to be zeroed for your specular layer to work. This is the reason that the presets that Maya sets do not work very well; in many cases, diffuse is not a single channel that can just be turned off.

3. Also make sure any reflection has an override and is zeroed.

That is all the adjusting you need to do. Since specularity is affected by shadows, you do not need to turn the shadows off again.

FIG 6.24 You have just turned off shadows for all of the objects in the Diffuse layer. Select any of the objects individually and confirm by looking at the shape node in the Attribute Editor. You will see that both casting and receiving shadows have been turned off.

FIG 6.25 This is the diffuse render. Notice the light direction but lack of specular highlights and reflections.

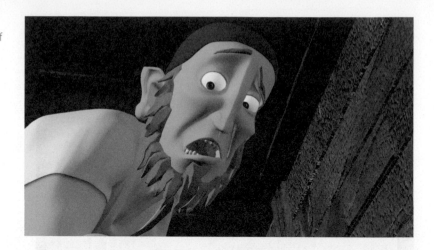

FIG 6.26 The specular pass is done. Notice how the shadows affect the specular pass: this is the desired result.

Shadow Pass

The shadow pass is one of the few presets that actually works reliably well in Maya. Follow these instructions:

1. Copy the Beauty layer and rename it "Shadow."
 (a) Right-click on the Shadow layer and choose "Attributes."
2. In the Attribute Editor, in the top right corner click on Presets > Shadow.

Maya assigns a layer-wide material override. Every object in the layer will get a Use Background material, which is a material that only renders shadows and the background.

FIG 6.27 The shadow pass preset actually works pretty well!

Reflection

By now you should be getting the hang of creating overrides and zeroing the attributes that you do not want to render in a pass. My scene does not have any reflection so I did not create this layer, but yours may. Reflection is also affected by shadows, so you need only zero the diffuse and specular channels for this pass.

Ambient Occlusion

This pass gives your renders a nice sense of realism. Ambient occlusion can be simplified down to basically "darkness in the cracks" of your objects. Specifically, ambient occlusion contributes a lot to outdoor renders, as the sky is a highly ambient light source. If your short takes place inside or under only a few spotlights, you may be able to forego creating this render pass. It is very easy to do, though, since it is the only other pass that works pretty well from a Maya preset.

1. Copy the Beauty layer once again and rename it "Occlusion."
2. Right-click on the Occlusion layer and choose "Attributes."
3. In the Attribute Editor, click on Presets > Occlusion.
4. In the Hypershade, find the new mib_ambient_occlusion material and change the samples from 16 to 24, or higher if you are getting jaggies in your renders.

FIG 6.28 Ambient occlusion takes into consideration all surfaces that are blocking ambient light, so you may want to consider creating an ambient occlusion layer for your characters and environments separately.

You're all done. Maya created another material override layer-wide that only calculates the occlusion of the objects.

Depth

If you are planning on adding depth of field in-post, then you will need a depth pass. This pass can be created from the preset, but it's advised that you do a little bit of tweaking.

1. Copy the Beauty layer once again, and rename it "Depth."
2. Right click on the Occlusion layer and choose "Attributes."
3. In the Attribute Editor, click on Presets > Luminance Depth.
4. In the Hypershade, find the newly created Surface Shader and select it.
5. Click on the "setRange" node and open the Attribute Editor.

What this node is doing is taking the near and far camera clipping planes and assigning values to them, so that close objects are brighter than far ones. However, the way that Maya calculates the camera clip planes and the size of your scene is more than likely going to create an unusable render pass by default. We can fix this easily.

6. Right-click on both the Old Min and Old Max channels and choose "Break Connection."
7. Enter a very small value, such as. 001, in the Old Min and for the Old Max value choose a value that, in Maya units, is the very furthest object you can see. Mine is about 75.

Another easy pass to set up, depth gives you a lot of leeway later on to add some nice depth effects.

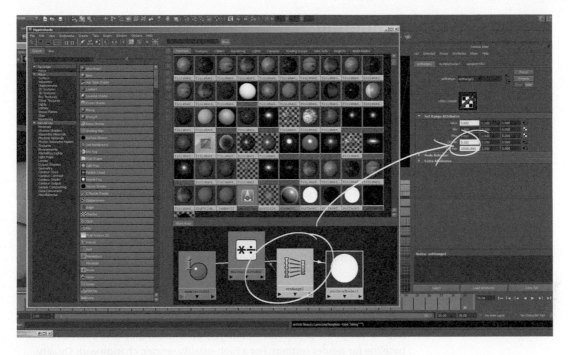

FIG 6.29 Maya gives you a pretty decent preset for depth; these settings just need adjusting before you can use this pass.

FIG 6.30 Here is my depth pass. It may not seem very detailed, but when we render these passes for final, I will use a high-bit depth image format to make sure there is a lot of range in the values on screen.

You're all done creating your basic passes. Now let's finish up by talking about some good render settings and establish our presets for this project.

Rendering

Time to render your project! This is an exciting moment to see final images on screen. We should go over some of the common render options to get a sense of what will work best for your film.

Resolution

The first consideration is resolution. I had you change the setup for your scenes to 1920 × 1080 resolution in your layout, because more than likely that will be the highest resolution you need to deliver your film to festivals or put it online. If you are sure your film is going to be projected on film, then you might have to render at 2k or 4k. If you don't have much render power, the difference on an HD screen between a full 1080p render and a 720p render is almost negligible, so don't feel distraught if 1080 renders are crashing your system and making the rendering phase impossible.

Render Options

For the purposes of this book I am assuming you are rendering using Mental Ray. Although the presets are not hugely optimized, they give users a nice baseline for render settings. For a high-quality render, change your Quality preset to "Production."

If you find that you are getting jagged edges on your renders, within textures or on the periphery of your objects or shadows, you may need a higher sampling rate. Sample rate increases your render times dramatically so this should not be done lightly. The "Production: Fine Trace" preset actually has the highest samples in a preset, so using it may be considered a sure-fire way to test whether your scene needs more sampling to look good. Let's stick with "Production" for now, as "Fine Trace" is overkill for most scenes.

Matching Settings to Your Scene

One aspect of the way Maya renders is that you have more than one attribute that contributes to a final look. For example, if you have raytraced shadows turned on for your lights, but "Raytracing" is not enabled in the Mental Ray render options, then lo and behold, you will not have any raytraced shadows. It can be a little confusing and also frustrating figuring out which setting is cancelling out the others when it comes time to render. In my opinion it's best to create a preset that covers all your bases in case your lights and materials take advantage of some detailed settings. In other words, turn up the settings in the Mental Ray options to accommodate high detail in shadows, reflections, etc., because the high quality settings will only be engaged if you set the attributes to match them in the lights and materials.

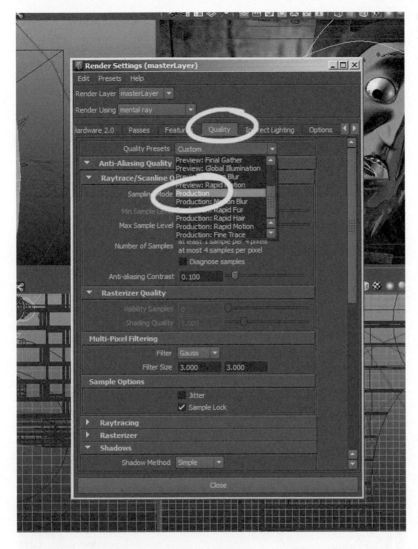

The raytracing settings shown here will make it so that any complex raytraced materials like glass will have the depth to render correctly.

Final Gathering

Final gathering is, simply put, a technique for creating diffuse light that bounces around your scene, adding additional illumination on the diffuse level. It is an approximation of the way that light is absorbed and reflected in the natural world. Because it is so complex, using Final Gather (FG) substantially increases render time. It is kind of expected of modern shorts, though, and audiences are getting savvy to the FG "look." If your film has even slight realism to it, then you can't really get away without using FG.

FIG 6.32 These settings on the depth limit are more than you will probably ever need. They won't slow down your scene unless you have materials/objects that are taking advantage of raytraced shadows.

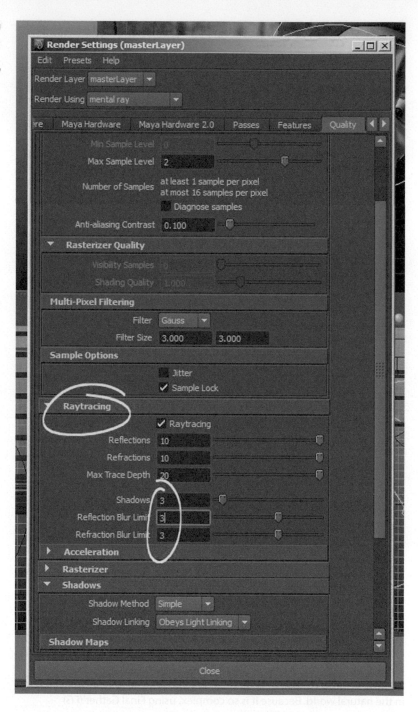

Find Final Gather in the "Indirect Lighting" tab in Mental Ray's settings.

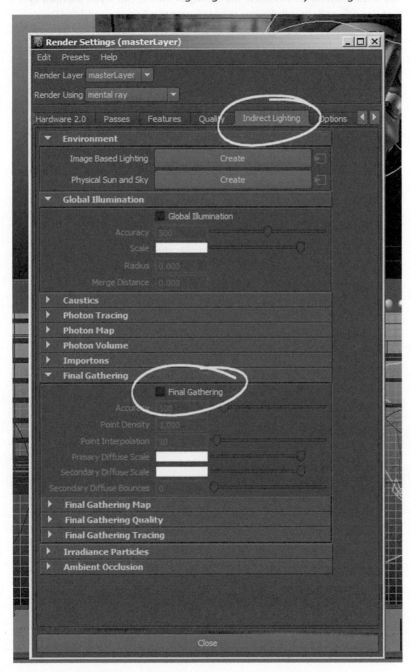

FIG 6.33 Here is where you enable final gathering. The default settings should suffice.

You should not have to increase the quality of the FG, but if you are finding that the diffuse light is flickering, then increase the Accuracy and the Point Density. Those two settings affect final gathering the most but can be *very* computationally expensive.

The next thing you will need to set is the overrides for final gathering. Only the beauty and diffuse passes need Final Gather. A quick way to make sure you are only getting Final Gather on your diffuse and beauty passes is to turn it *off* on the masterLayer and then add it back to those two layers. Select the Diffuse layer, RMB-click on the "Final Gather" checkbox and create a layer override. Do the same for the Beauty layer.

Other Render Settings

Some passes do not need all of the Mental Ray features. Here are some things you can turn off:

1. Your depth pass does not need raytracing, shadows, or FG.
2. Your occlusion pass does not need FG or any shadow raytracing depth, so you can create overrides for those.
3. Your specular pass does not need any reflection raytrace depth so you can create an override and turn it all the way down.

With any custom pass that you create, be it an object mask using Surface Shaders or any other kind, make sure you create overrides to remove the rendering options that will not contribute to the render.

Bit Depth

Color depth is the amount of color information in the channels of the render. For the most part, 8 bits per channel (the default) should be good enough for all of your purposes. However, if you are planning on outputting to film or want a huge amount of control in compositing or for some of your special passes, higher bit depth is necessary. One example is the depth pass; with a higher bit depth you can give your compositing program trillions of values to work with, as opposed to 256 values to work with in a normal 8-bit-per-channel render.

To change the bit depth, go into the "Framebuffer" section in the "Quality" tab.

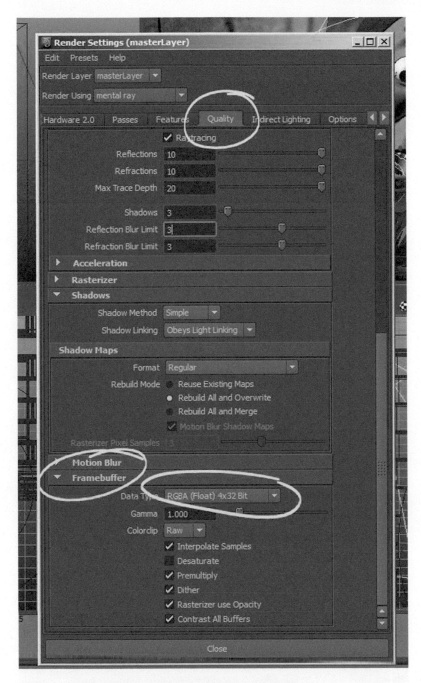

FIG 6.34 To change the bit depth of a render, change the "Data Type" setting.

A 16-bit render (RGBA Half) or a 32-bit render (RGBA Float) is necessary for your Depth layer, so create an override on that layer and enable it.

File Formats

Your file format must match the bit depth settings you are using, otherwise you will lose the data you are rendering. Personally, I find Maya's built-in IFF file format is very nice on file size/resolution ratio, and it is not compressed. There's not much more you could ask for from an 8-bit per channel file format. However, on all the layers that you have enabled a 16 or 32-bit per channel render, you will also need to create an override for the file format (found in the Common) tab. I prefer Tiff Uncompressed, or EXR for higher bit depth renders.

Batch Rendering

If you do not have a render farm then you are most likely going to rely on batch rendering. This just means that Mental Ray is going to render the shot in the background. Batch rendering takes advantage of two main settings that you have to be very aware of. The first is the frame range that is set in the "common" tab. You must set this frame range to be the correct range or Batch Render will leave out frames. The other setting is the "Images" directory that you've chosen in your Project settings. Before you start a batch render, create a new folder that will house those renders according to our naming convention. Maya will render each layer into its own folder within the Images directory that you've created. If you haven't already, make sure you've changed the Frame/

FIG 6.35 Here is the Maya Project with our new folder designated in the Images directory.

Ext setting in the Common Tab to "name.#.ext." This will make sure the images are numbered in a way that all compositing packages can read.

Once that is done, switch to the rendering menu set, and click on Render > Batch Render. You can watch the progress of the render in the bottom right corner of the screen. You can even continue working as a batch render is calculating, but it will definitely go slower if you choose to do so.

Remote Rendering

With cloud computing becoming ever more popular, remote rendering services have become very cheap. If your film is very long, has dozens of layers per shot, or you simply don't have the computing power to finish the film and you're getting nervous, then look into remote rendering before you lose hope. One of my favorites is www.foxrenderfarm.com; it is quick to set up and the cheapest one I've found. One thing to note; most of these services require you to transfer your scene files and all of the referenced files as well, which can be cumbersome. One of the nice things about Fox Render Farm is that it allows you to upload a zip. This is great because Maya can automatically gather your referenced and linked files together in what it calls "Archiving."

You may even use the archive function to send files to artists who are collaborating with you on your film. I use it frequently to send assets to animators working remotely.

Final Thoughts

No single piece of advice or workflow method I've shown you here can compare to the overall advice to stay on workflow for your 3D production phases. Being careless at this stage creates frustrating amounts of work when things don't work out. Changing your workflow mid-stream can have disastrous results. While you will meet many technical obstacles when producing a short film, my experience has shown me that it is the psychological and emotional let-downs that make short films hard to finish. Losing work to crashes, taking what feels like huge steps backwards on the animation, and getting stuck on a shot quickly drains you.

You are almost there. The animation, lighting, and rendering are complete and you can now assemble the film and finish it.

FIG 6.36 A little-known tool, "Archive Scene," assembles a .zip archive of *all* the referenced and linked files, including textures, making remote rendering much easier.

Interview

For the Remainder by Omer Ben David

FIG 6.37

What was your first experience of creating a short film?

I think that the first experience was overwhelm and excitement—the idea of bringing a small and vague concept to a complete screenable piece was beyond my practical abilities, yet I knew that I was going to spend a period of time figuring out how to do it. I did not have a clue where to start or what needed to be accomplished in order to say it can be done, so I was very nervous during the initial parts of the process. The wonderful thing about the beginning was the fact that everything was possible—I could go as far as my imagination will allow and it was doable.

When you felt technically challenged or blocked, what was your go-to resource?

Well, since I was working in a school environment I had many resources to go to—teachers, industry pros, students who already did their shorts, etc. The thing with my film was that I was kinda stepping into an unfamiliar territory. Since I tried to get a certain painterly look and feel to my 3D settings and characters, I had to learn certain tricks that were still not entirely figured out like the way classic 3D pipelines were already established. Tutorials regarding my needs were scarce, and people who developed tools to achieve similar looks to what I was looking for were, rightly so, very protective of their developments. I needed to develop my own technique to achieve my goal.

What were some of the biggest challenges in creating your film?

The main challenge of my film was to actually make this poem-like notion of a dying cat who says goodbye to his home work in a six-minute 3D short. The process of building the story, figuring it out while the look development was still incomplete, was nerve-racking and I constantly had to change and fit certain storytelling aspects to fit what was visually happening. I believe that technique and story are intertwined and neither should be pre-decided completely. I did know from start that I wanted a painterly look, but I didn't know how far am I going to take it and how precise[ly] should the story be told. As I said before, the technicality of getting the look of the film where I wanted was a serious challenge and developing it was as long and tense [a] process as the story development.

271

What was your main focus in completing this project? Completing a film? Making a statement? Getting a job?

It was a bit of "do or die" for me. I knew, from people around me who worked in the animation and film industries, that beyond school there is little to no time almost to create art the way you want it out there, and this might be the last chance to really explore an idea without any limitations other than what you limit yourself. I wanted, of course, to have my debut film be my bridge to The Industry, but I was thinking more about my need to make an art that I can call my own before conforming to the needs of the market.

What inspiration or reference outside of animation did you use to complete your film? For example, cinematography, classic paintings, music?

All of the above. Atmospheric cinematography was a big influence on me, since I was trying to achieve a very dreamlike atmosphere to the story, with a very slow-paced rhythm. I saw Tarkovsky's *Stalker* for the first time during my research, and I loved the way he addressed the settings and the way the characters interact with the environments. I loved the atmospheric segments of animated films such as *Ghost in the Shell* and the fabulous *Tekkonkinkreet* that showed so much depth in a few artsy shots. Since my film was done in way that needed some sort of contrast between the cat and the house, I watched many color patching paintings and block paintings that were the base for the house setting and calligraphy art that was the way I tried to make the cat look. I really loved a series of paintings from Lukasz Pazera called "Postcards from the Zone" and they really got me to understand contrast between roughness and aesthetics (later I found out that they were actually based on *Stalker*, so it all connected). My girlfriend Or, who worked on the script with me and was always a big influence on me when it came to music: at the time I started developing my initial thought regarding the way this story should be told, she introduced me to Joanna Newsom's poetry, and though it's hard for me to point to, a bit of her spirit went into the creation of the scenarios in the film (other than the name of the film).

Which was your favorite character to work on in the film? Why?

It's funny since, as it seems, there are very few characters in the film. But to me there are actually at least five: the cat, the house, the spider, the house owner, and the rain/weather. Since the cat was the most visually obvious one, I put a lot of thought into him, but I'm glad to say that in such a metaphoric environment, I was able to animate the other characters with as much importance as the cat itself. It's never about the "hero" alone for me, because he's built by his interactions with the "supporting" actors. I loved to animate the rain and to see how it can affect the cat, and the camera, which felt to me as the way I was representing the house's spirit, was also challenging and great fun. I knew that there's a relationship between the human owner and the cat that I wanted to discuss, but I didn't want to make their relationship the main issue.

Did you employ any organizational tools such as charts or calendars that were pivotal in staying on deadline?

I had an everyday changing timeline set as a wallpaper on my screen to show me how late I am in the schedule, and I was always late. I did not know how to estimate my production pipeline in terms of hours per task, so I just had the basic "deadline musts" put down before my eyes, and tried to aim to make more to that time to at least make my "musts" meet deadline. I have yet to come to a conclusion whether it's best to have a schedule from the get-go when creating a short film. I guess at some point, when you get entirely technical, it's important because it determines what parts you're gonna have to

lose in order to make the whole thing happen. You always have to lose some to get to a deadline. But I think it's important to have a bit of freedom in the early stages to experiment and really go wild with ideas. I saw students who always kept to their schedule and did everything on time and their films ended up very strict and uninspiring. I think it's great to stay unaffected by the pressures of deadlines when you begin your journey.

What were some tricks for keeping you/your team motivated during this film?

I think that the first thing was the knowledge that I was creating something that I truly believed in and was passionate about, had my own vision and had to be executed flawlessly. There's never a way around it for me: if I would not think that I was doing something special, that's worth spending almost a year doing it by myself, I couldn't get it done. When it came to the months of technical, repetitive micro work, I needed to get out and see the big picture again, to keep my spirits up. So I would now and then build a complete render of a certain shot and place it on the time line, to try to see with my eyes exactly what it all can look like. That would definitely keep the engines roaring and, even at crunch times, I could work more and more just to get things done for my next preview.

What sort of problems will someone likely run into when creating their own short film?

Lots of them. It depends on the setting in which you get to work on your short. Since I did mine within a school environment, I will address that. It's basically coming down to the fact that you have less time than you think. That doesn't mean that you have to work tirelessly to get it done, but you have to be smart about it, learning to let go of your fixations on certain aspects of the film even if you worked hard to get them. You must see the whole picture and make tough decisions so that the film works as a whole. Even if you're not on a deadline, you will not get it done if you don't know [what] your goal is. The need of perfection is great, but it will never be perfect (or will it? I don't know); it's a great way to aim high, but finding a realistic compromise is better, and would likely keep the film the spirit that it had when its idea was first conceived. To expand on that: it's easy to lose track of the meaning of the film when it is spread across a long period of time, so it's always (I've learned) better to work on it width-wise—meaning, always working on all the shots somewhat together, blocking in the details all throughout the film, and not finishing a shot entirely and then starting the next one from scratch.

In your opinion, what are the must-have skills a person needs to create their own short, and what can be learned along the way?

You must be autodidact. You'll never learn enough from your school environment and you gotta know how to get there on your own. If you know your stuff and you can pretty much sketch the process of getting there in your head, great: you'll be better at it by the time you finish. If not, you gotta know that you can learn how to do it. You gotta work—research, get critique, make tests: don't have it *almost* there; get it there already in the first stages. If you can show it, you can believe in it. Know your limits. Know how to aim high, and know to regress back when you go too high. Time management is a learned skill; you get better at it as you progress. Just make sure to be aware of your time, and try to calculate what tasks you do faster and what slower. Don't rely on vision alone: make it real. Do tests, show that it can be done. Work from the easy to the hard when you're not sure how to get it done— separate big and scary tasks into mini tasks and schedule them. Make your own deadlines and stick to them … it's OK if you don't get it right the first few times (since you're learning yourself), but if you keep losing track of time, it means you are either not true to your abilities or you don't really give a damn about deadlines—and this will come back at you. When you're in a school environment, it's easier since

273

you get deadlines from your teachers, but if you beat those deadlines and make your own and figure out what's important to achieve at a certain time, you'll gain control over your production.

How did your workflow/pipeline for this short differ from other pipelines you have been a part of? What do you think was the reason behind this change (if any?)

Since I worked almost alone on this project, my workflow was very straightforward. In past projects, when working in a group, a certain person could start a task only when other tasks were done, and sometimes they were handled by other people, so you get unwanted bottlenecks. In this project my bottlenecks were made by me most of the time, and so there was nothing for me to do but keep working till I finished. Even though I was working alone, I treated my material as if I would have worked in a group—that means: naming conventions, folder divisions, documentation, and asset organization. You can never know when you'll need to revisit your project, and after a while you might forget what was going on, and you need the easiest and fastest access possible to the materials you keep. And also—*back up*! I always keep at least three to four version backups on other media, in case my computer explodes.

Did your workflow change when you had to work with specialists outside the animation realm, such as designers or musicians? Do you have any advice for those who are creating a film and don't know anything about those areas?

When I worked with a specialist from outside of the animation world (like the sound designer I worked with, or the programmers), I realized I needed an entire new set of tools to explain myself to them. It also required me to make some changes to the pipeline, to get things that I didn't think necessary out before I needed them—like a timed video board. The one thing I did not know completely was the timing of things till the very late stages of the production, and yet I had to make it happen in order to have my sound designer get the feel of the film from beginning to the end, so she could make the right choices. That also affected my timings when watching the film with the sound effects.

Was there a moment when you knew your film was going to be a success?

The whole process was already a success to me from the start—I went head-on into a world I knew I would love to see made, with challenging, innovative work, a meaning and a purpose. I believed in it. It couldn't be unsuccessful. I didn't go as high as I dreamed with certain things but on others I went well beyond my wildest expectations. I still can't believe sometimes that this film is actually mine.

Were there any major plot points or features of the film that changed because of your capabilities? Would you change it now that you have more experience?

Many. I would change a lot in this film, but that's the whole point …. It can always be more, but I'm very happy of what it is right now. I always struggled to get the brush strokes look more dynamic and to make the cat's body a character of its own, that the cat is struggling with its own skin, and I didn't get exactly to the way I envisioned it at first, purely technical issues … but I came really close. I decided to make it milder, and much more suggestive … I don't know if I would change it now because I love the way it looks, and I did get further than I expected when I knew my limitations as it is, so … dunno.

Are you planning on creating another 3D short film?

Yes please. Shorts are amazing. They can be much more precise and effective than features, because they don't have the need to fill in the blanks …. They can be much more subtle, and tell a great story in a few minutes.

Describe your process for coming up with the idea. Did you build around a simple idea? Cut down from a larger idea? Explain.

It started from a very poetic notion of a dying cat's farewell journey. I recalled this urban legend that cats on their deathbed run away from their homes to perish unseen in areas where they would not be noticed. I researched this rumor a bit and found out that it had a lot of attention, and many interpretations to why do cats do that. All and all it moved me, and I thought that this is an amazing thing that a creature would choose to do such a thing—it felt very humane to me, and it sat really well with the way old people are very dependent on their homes, and that their relationship to their homes is very unique and somewhat obsessive. I started exploring the way the cat would bid farewell to the house—what will he cherish, what will he covet, how will he deal with the leaving part. I went [in] various directions at the beginning—from, will we see him die? What's important for us to know about him and his life? Do we even know that he's dying? It all came down to the fact that I love open stories, that not all is told and that I can build a story of my own into what I'm being told. So I decided that there will be no actual narrative except of the basic musts. There's no real conflict, no antagonist and that it's a spiritual journey. From there I started building the journey.

Explain your pre-production methods and planning. Did you use an animatic, pre-visualization, scratch recordings, or just go straight into production, modeling, and animation?

For me it was really hard during the pre-production stages. Since I was in an academy, my project needed to be approved by a committee in order to be able to proceed to production. But my research was a very long process and took me well over six months to accomplish—thus, I could never explain to the school or even to myself how the story is unraveling. No previz or animatic that I have looks anywhere like what I ended up with in the final cut. So it was hard to get approval for my work since it was really just beginning to take shape in the few months prior to the deadline. Storyboards and video boards are great tools to see a vision and I understand their importance in a production, but specifically in this film it was just a problem for me. That's why the tests were actually my saviors. If I hadn't done so many testings, I could not explain my thoughts and my goals to the people who decided whether I'm to continue working or not.

Please discuss how you developed the look for this film.

As a 3D artist I wanted to get the feel of the film pass well in a 3D environment, though all the signs pointed towards the fact that it should be a 2D film. That's why I started experimenting with 2D textures in 3D setting. I figured that if I can pull it off combining the fluidity of the animation and camera work of a 3D world with the brushy-sketchy look of a 2D painted art, I will make this poem come to life. This is how I got the sets to look the way they do—by drawing textures in 2D and then applying them to basic geometry. The hard part was to get the brush strokes appear in 3D and flow on the cat's body, and that required some extensive research. After spending the better part of the school year developing that technique, I found a way that I could paint real strokes in 3D using a graphic tablet and then control those strokes so they appear flowing on the cat's body, with the ability to control the density, fluidity and look of the brush. Along the way I was working with two programmers who created a set of tools that helped me get some more in-depth control over the brush "rig." This actually meant that I had two layers of animation on the cat—one was the actual puppet animation of the cat's limbs and the other was the painted strokes on his body. Of course, in order to achieve a look that's whole, I combined the two techniques and extended their looks to fit each other and that what's giving this film its unique style.

Was there anything edited out of the film that we didn't get to see?
The rough cut actually had more of a musical soundtrack to it and less ambiance. But when it was finished and I saw the film as a whole, I thought that the music (which was beautiful by itself) was actually taking too much attention from the story and that it developed its own beat to it, so I removed it and pumped up the ambiances to achieve the final, more atmospheric score.

What words of encouragement do you have for someone who wants to create a 3D film at home?
Be serious about it—it can happen. There are a lot of tools that can help you get where you want, and some of them are even free. The problem is always *you*. It's fun to dream about making a movie—but you need to prove you have what it takes. Break down your production to the various stages as a rough schedule (with a goal at the end, which can change but get a basic expectation from yourself). Then break the first stage into specific tasks: creating a tagline, premise, script … learning what you need to know, make look dev tests, and get critique from people you appreciate! If you can do these on schedule, you'll make it!

2D Production

When we talk about 2D production, we are talking about the tasks that occur after you are "done" in 3D. This primarily means compositing, but it may also mean a little bit of effects and "tweaking" in 2D. In *Booty Call*, the amount of work we had to do following rendering was very small. This was primarily due to the fact that we were able to create a light rig that allowed for standardized rendering. Our images were about 90 percent finished straight out of Maya. Still, there was work to do, and I'll show you some of it here.

Compositing

Our film needed very little compositing wizardry. This was ideal because, in short film, the more you can rely on Maya to do the heavy lifting, the better. Here is what you should consider when moving from rendering to the final stage of your production, 2D production.

Setting Up Composites

The first thing we need to do is set up a base composite that serves as a template for the entire film. The longer your modular middle turned out to be, the more you are going to benefit from this stage. Even if you have very few modular shots, setting up a single composite for reuse is the best workflow to employ. Also, remember how in the 3D pre-production chapter we set up a lighting rig? Reusing our lighting rig means that many of the compositing tasks that require fine-tuning, like color correction and adjusting levels, are greatly shortened by using the same lights over and over. This work is already hugely paying off. Take a look at the composite example.

FIG 7.1 This composite has very few layers and is working well for us. I restricted the passes to beauty, ambient occlusion, shadow, depth, and specular passes—plus a mask for the character, to separate him from his environment.

Create a composite in your program of choice with a single frame from one of your most "standardized" shots. If you have a modular middle, then use a shot from this sequence. The reason you are using a single frame is mainly because you can get a single frame out of Maya in very little time, even with five to ten passes per frame. *Booty Call* would not have been possible without reusing composites. When it came time to creating a new comp for a shot, I merely copied an old comp and replaced the footage. If you haven't figure it out by now, everything is based on the concept of creating a decent "baseline" of all of the shots and then being able to tweak from that point onward.

The Basic Comp

Our basic composite uses the passes described above. I showed how to create each one of these passes in the 3D production chapter. The ordering of these passes can be slightly different depending on what you are trying to achieve, but in general, the lighter passes go on top of the darker ones. So specular goes above all, then the shadow and ambient occlusion passes beneath, and beauty is on the bottom.

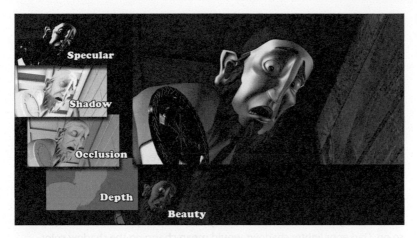

FIG 7.2 This is a very simple composite. Notice how the specular is on top.

We are able to get the full range out of the specular pass because it is the uppermost layer. If you had it underneath the shadow or the occlusion passes, you'd lose the brightest values in the specular pass. The depth pass shown here is used in conjunction with a depth of field plugin I have for After Effects. There is a built-in one but its functionality is limited. The Foundry's Nuke has better integrated tools for motion blur and depth of field.

Once you have a basic comp set up on a single frame, start tweaking!

FIG 7.3 Here is an After Effects file with my composite set up. Notice there are already some effects added to the beauty layer.

Every composite will need a little bit of tweaking, so this basic comp will give you some ideas as to how the renders are turning out. If you have to add some pretty intense effects and filters to get it just to look decent, then you should probably revisit your lighting and rendering settings in Maya.

Take a close look at some of my settings. You will notice that the specular pass used the "Add" blending mode. Any of the other lightening blending modes give too washed-out a look. Also notice that none of the opacities on any of the layers are at 100 percent. The interesting thing to note about that is if you think about it, Maya gives you 100 percent directly out of the render. If you want something less than a full effect, it may mean tweaking more than one attribute. For instance, if the specularity is too high, you might have to change the specular settings on your materials or bring the light intensity down. Doing so would make it so that you have to adjust other settings and so on. Darker or lighter shadows would mean changing the shadow color on your lights, which is cumbersome to do in a scene with many of them. Remember, all of these changes would require a re-render just to see it. When you have a simple set of passes that are easy to set up and manage, like the ones we have here, then making these adjustments is quick and re-rendering is unneccessary.

Scared of Compositing?

If this is your first short film and you have absolutely no experience with compositing, this might all be confusing to you. You might opt out of rendering multiple passes per shot in lieu of trying to get the finished render directly out of Maya. I know a few artists who pride themselves on getting absolutely *exactly* what they want directly from their Maya render.

Erik Anderson prides himself on being able to tweak his Maya settings to produce images that need absolutely no compositing. These two hilarious images amazingly have zero post-processing done on them. He's also a stickler for optimization—these renders take about four minutes per frame, even less than the *Booty Call* render. His company, Go-Ghost, creates software that tries to bridge the gap between lighting and compositing in an artist-friendly way, so perhaps if you are really anxious about working with multiple passes, you should look into his amazing work (www.go-ghost.com).

At the very least you should bring your renders into a compositing package to adjust the brightness/contrast and color. Despite what I've just shown above, it is very, very unlikely that you will be able to get everything absolutely perfect out of Maya. If compositing is scary for you, slight adjustment and color correction shouldn't be a stretch after what you've gone through in 3D!

Back and Forth

In *Booty Call*, the biggest challenge was getting the lanterns to look like they were lighting just the area around them. We experimented for a long time

(A)

(B)

FIG 7.4A,B These two renders are by Erik Anderson, a lighter and 3D software developer.

with the "falloff" values on the lights inside the lanterns to try to get the right effect. Back in After Effects, a new render would replace the old ones, and I would test whether the filters and effects that had been built up on the renders could be removed. This was homing in on a better "out of the box" result from Maya's renderer. A little bit of time (even hours) spent going back and forth from your basic comp to Maya to render a new single frame is a very good investment. Remember, you are just rendering a single frame in Maya and saving it directly out of the framebuffer, avoiding long re-renders and getting to the results you want more quickly.

While it may take a little bit of the romance out of making a short film, it must be said: you need to create an assembly line for your film. Your biggest enemy is the "one-off," the single-shot sequence, and the unique. This is not to suggest that your film should not be unique, only that in order to *finish* it, you should be able to reuse as much of your work as possible. I was able to create the base composite for every single shot within the ship in an average of about five minutes per shot. This includes copying another composite,

replacing all the layers with new renders from the new shot, adjusting filters like saturation, levels, and depth of field and things like the color bloom in my main comps, and doing any masking necessary. In five minutes one can barely import all the footage on a brand-new composite, let alone get to a great starting point for a shot.

In After Effects, the simplest way to use this baseline is to duplicate your base comp and then "replace footage." Most compositing packages have something similar to this functionality. With your lighting rig copied from scene to scene, the differences between the levels, saturation, and other image adjustments should be small. You can focus on working on just the small issues that are unique to each shot. The simplified workflow for compositing is below.

FIG 7.5 Once you have your base composite created, your assembly line is ready. This workflow works especially well with long sequences and even better with a modular middle.

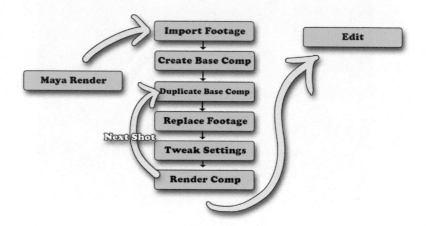

Creating the composite for most of the chase sequence shots in *Booty Call* took less than five minutes per shot. Compare this to the sometimes hours it can take to create a rough composite for a one-off shot and I think you will agree that the time saving more than makes up for the constraints of using a modular middle.

Triage Problems

Whenever there is an issue with a render, you must ask yourself if you can fix the problem in 2D or if an entire re-render is the only solution. Many times, a 2D solution exists that will actually make for a more efficient workflow. For instance, if there is a color problem, but it is only appearing on a single character, rendering a simple mask layer for that character for the shot is probably a better solution than adjusting the color in Maya and rendering again.

I would not want Babinsky to be so red (I made the drastic change here to show how the character mask render works), but this level of fine-tuning is perfect for the time I have to create these comps. In theory you could render dozens of layers per shot for each object, but the set-up time for those layers in Maya, managing those layers in compositing, and the extra render time itself is just not going to contribute to your chances of finishing your film. This is why I go against the normal recommendation of rendering out numerous layers for every single object. When I get a project at my studio for a paying client and am not in control of how many things will change, then having lots and lots of layers makes sense. On a short film with very few assets and a single light rig and, most importantly, where I can approve everything, I can get the look 90 percent done in 3D and render five to six passes. My 2D production deals as much with fixing problems as manipulating rendered images.

Many times, the solution will present itself if you just look at the problem as though you *can't* re-render. Innovative solutions are born from our technical constraints, not hindered by them. A good friend of mine once said that if you have infinite possibilities, it's hard to make *any* decision. So be very strict about your schedule and the resources you can commit to a problem; you just might find that the pressure of innovating makes you do even more. When this problem popped up, I realized that I did not have to render a depth pass on many shots. A faked depth of field sufficed and saved me on render time.

FIG 7.6 A character mask is a very simple pass to set up, and it renders quickly. Best of all though, it lets you do some fine-tuning to your characters while sparing the background.

283

FIG 7.7 In this shot, the depth pass render failed. Rather than re-render the depth for the entire scene, I just added a mask in After Effects and blurred the background in comp. After this mishap I triaged other scenes in which the depth effect could be achieved entirely in comp and saved an entire render pass.

FIG 7.8 In this shot, the boat is penetrating the ocean surface, but all we have to do is render the boat on a different layer and cheat it in the comp. Nobody can tell that the interior of the boat is not penetrating the ocean surface correctly.

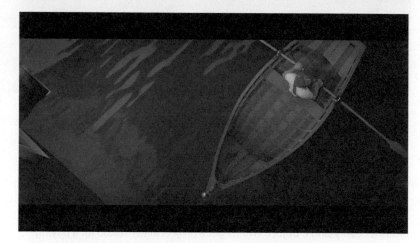

Think ahead as you are setting up your shots for rendering. As you can see in the very first shot of *Booty Call*, the boat is obviously submerged in the water. I didn't need to worry about displacing the water because we can't see inside the boat. But as Babinsky approaches, we look straight into the rowboat. Rather than fret over how to create this composite, all I had to do was put the boat on its own layer. It looks as though the boat is where it is supposed to be because it is, actually. And the water is not penetrating the boat geometry because they are not rendered together. As you are triaging your shots, seek out solutions like this to save you time and headaches.

File Formats

Because we were not rendering our film for display in a true HD cinema, or being output to film format, an 8-bit-per-channel file format was chosen. As was mentioned before, the instances in which you would need a 16 or 32-bit-per-channel image like a 16-bit iff or 32-bit exr are very few and far between for

personal short films. In compositing, these formats create even more problems than just file size and render times; once you start using high bit-depth images, you are committing yourself to a longer compositing time. For starters, most compositing packages manipulate and render 16 and 32-bit comps at much slower speeds than at 8 bits. Also, many filters and effects built into common compositing programs do not work natively at 16 or 32 bits. If you are working slower, you are finishing slower, so unless you are positive you are going to need to export a 32-bit file for recording onto film or a 10-bit file for broadcast, keep everything at 8 bits per channel. Remember, bit depths commonly refer to the combined bit-depths of the RGB channel, so 8 bpc (bits per channel) is commonly referred to as a "24-bit image." Things can get confusing when working between two different companies' software, such as Autodesk Maya and Adobe After Effects.

If you did render with a higher bit depth, you must change your project settings to take advantage of this. In After Effects, this setting is found in the File > Project Settings. When rendering out of your compositing software, preserve your deep image by choosing a format compatible with your high bit depth such as .exr or .tif.

Compositing Effects

It makes a lot of sense to create some effects in 3D. Others should be tackled purely as a composited 2D effect.

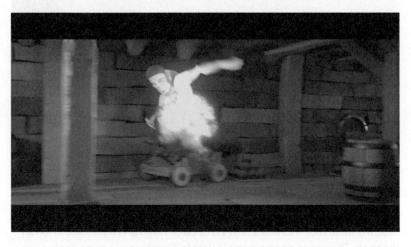

FIG 7.9 It is just good sense to use 2D FX libraries like "Action Essentials" for one-off effects like fireballs, smoke puffs, or water splashes.

Rather than create, adjust, render, adjust, re-render, and tweak fire in Maya, the decision was always to composite a 2D fireball into the scene where Babinsky spits out the fiery rum. I didn't for a second think of using 3D fire effects. Of course, if your short is about a fireman and takes place inside a burning building, then you will need to research that effect to do in 3D. The general rule is that if you are creating an effect for a single shot, try to accomplish it in post. If you are relying on an effect to be in four or more shots, create it in Maya.

FIG 7.10 These little sparkles add a little bit of visual interest to the shot, and while they may be a tiny bit on the cheesy side, they are point-and-click in After Effects, so why not?

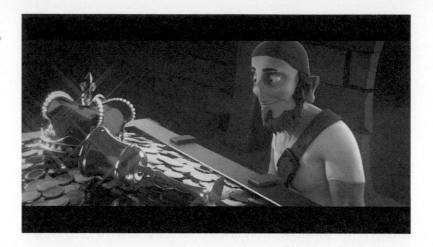

Enhancing the look of your renders is easy when you are at ease in your compositing program. This effect generates sparkles on the brightest light sources in your shot. Enhance the treasure and adding some gleam, this effect was very inexpensive in terms of time and effort.

FIG 7.11 See how the treasure is glowing? Every shot has a little bit of light "bloom," in comp.

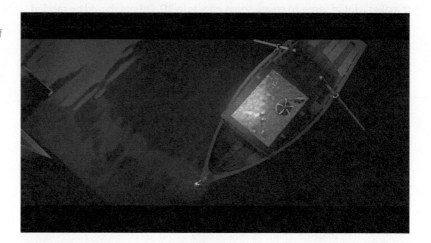

To give all shots a somewhat softer feeling and create a slightly more "filmic" look, my usual trick is to add a little bit of color bleed and light "bloom" on all the shots. The way to go about this is simple. Simply copy a layer, apply a very wide blur (30 pixels or so), then make this new layer "add" or "screen" above the base layer. Turn the opacity down to 15–20 percent or so. What you will end up with is a faint, soft halo around all the brightest areas of the image. To add this kind of effect to all the shots within Maya would require a huge amount of setup, not to mention that the effect would need to be tweaked (and re-rendered to do so). No, the most efficient way to go about this is to create the effect in comp.

Other Effects

I mentioned that I used a third-party plugin for some depth of field in *Booty Call*. We also used a plugin to add motion blur to our renders after they were all done. This plugin, called Reel Smart Motion Blur, automatically detects the motion of pixels and adds a pretty decent 2D motion blur on top of your renders in comp. You would not want to render with Mental Ray's motion blur out of Maya if you can get your hands on a post-processing motion blur instead. Nuke has a built-in effect that is very good.

One last effect that I always do to all my renders is to "blur it and screen it over itself." The basic idea is to take your final composite, duplicate it and blur it heavily. Then you make this new layer a very transparent layer set on "screen" above the unedited final composite. The effect created is a very nice color "blooming" effect, and the surfaces that are the lightest seem to glow a bit.

FIG 7.12 I always have to do this effect—it just makes everything seem so nice and soft and as though the animation was shot on film.

Look at Babinksy's ear and cheeks on the left side of this composite. Notice how the yellow light from the lantern seems to be reflecting off his face and creating a bloom of light. The effect has been turned way up to be noticeable in print format, but when you watch the film you can see the subtle enhancement. You are free to steal this trick and use it in your short! One last thing about it: I like to apply a "levels" to the blurred composite, further bringing down the brightness of the midtones and the shadows so that only the highlights are really contributing to the bloom effect.

Hand-Drawn Effects

A few hand-drawn effects can give a beauty to a scene that is unobtainable by purely computerized methods. While it is outside the scope of this book to talk about all the ways in which hand-drawn effects can add to your film or how to technically achieve such effects, they are worth mentioning. Common programs used for this are Flash and Toon Boom Animate. Or you could draw over the footage in After Effects or Photoshop, but that's a roundabout way to do it. I will look at some effects that have been used in our example films and discuss how and why they are so effective.

FIG 7.13 Hand-drawn effects add a very nice level of craftsmanship to a film.

See in *Meet Buck* this scene when Buck is riding his moped through the city. There are numerous hand-drawn effects on this shot. You can tell that the smoke is hand-drawn because it has a lower frame rate than the rest of the shot and the line quality has a strong hand-drawn feeling to it. Also, it seems like the artist putting the effects into this shot decided to do some hand-drawn 2D smear effects, just like in old cel-painted cartoons. You can tell this was a hand-drawn effect from the fact that the shadow on the ground does not have the same silhouette as the 3D object—it must have been added later. Both of these effects add some slight but important craftsmanship to a short film. Perhaps with more time we would have hand-drawn the cannon explosions and fireballs in *Booty Call*, but the goal was to finish the film; we learned a lot and next time will leave time for those kinds of embellishments.

In this shot, the wine would be far too cumbersome to simulate. Even if the wine was behaving in 3D, getting it to render and look like the style of the rest of the film would be difficult, to say the least. In this example, drawing the wine was a necessity. Sometimes you have to weigh up the time and energy it will take to get a much-needed effect like the sloshing of wine in a glass, and decide on hand-drawing the effect so as to not get caught up in the somewhat boring and laborious simulation stage of 3D production. To make

FIG 7.14 **FIG 7.14** Another frame from *Meet Buck*, in which a hand-drawn element serves a functional purpose.

it easier for you, I'll say that recent trends in visual styles in short films give a lot of leeway for artists to mix and match 2D and 3D, especially for effects. I've overheard conversations among the animation community about how "awesome" the "hand-drawn effects" were in a film. So, if you are worried that stylistically you are not going to be able to make 2D effects match your film, fear not; the animation world actually likes to see the separation of hand-drawn and CG.

FIG 7.15 *Reverso* makes limited use of 2D effects in, for instance, this snot bubble on the kid's face.

It is common to be caught up in your 3D production and overlook how simple and effective a 2D effect can be. This example of the snot bubble popping on the kid's face is a great example. We get engrossed in the process and sometimes arrive at a decision carelessly that could be totally different. I myself am guilty of doing things in 3D that should have been 2D effects. Sometimes it is long after a project is over that I realize I could have saved time and energy by leaving an effect for 2D production!

FIG 7.16 In this After Effects file, you can parent your text layer to the null or use mine. I've circled the attribute you need to change if you want to adjust the speed of the credits. Just know that values other than 4 or 8 seem to stutter and flicker but you may have luck choosing your own.

Credits

We talk about the different kinds of credit in the finaling chapter. Simply put, they are the motion-graphics type that tie-in to the rest of the film and the plain text type. If you want to create the plain text type, there are a few things to know. First of all, you want the credits to scroll at a rate of 4 pixels or 8 pixels per frame. Otherwise the credits jump and stutter. I have included an After Effects project in this chapter's source files with a null that is moving at the correct speed. You can just parent your text credits to this null to give yourself the credits you need.

Next up, you want to use a font that is easy to read, because reading moving text is difficult. Stay away from heavy-set fonts or ones with serifs. Notice how the *Booty Call* credits use a very clean, sans-serif font.

It goes without saying that you must credit everyone who worked on the film. However, a special thanks section should be used for crediting people who went above and beyond to make your short come alive. The special thanks always come at the bottom, after all production credits.

2D Films

We are lucky to have a traditionally animated 2D film called *Crayon Dragon* in our list of supporting films for this book. This is a 3D production book,

though, so it is impossible to describe all the tasks necessary to create a 2D animation film in this one chapter. Of course, the story, writing, design, and pre-production advice given in this book spans all media. If you want to find out more about producing a traditionally animated film, then the following books are great resources for you:

How to Cheat in Adobe Flash CS6 by Chris Georgenes

Character Mentor by Tom Bancroft

Hybrid Animation by Tina O'Hailey

How to make Animated Films by Tony White

All the tips about the modular middle, folder structure and organization, creating a workspace, etc., play an equally huge roll in finishing a traditional animated short. I may not be able to technically guide you in making your 2D film, but honestly, the areas covered by other advice in this book account for the majority of reasons why first-time filmmakers don't succeed, so take it all to heart.

Interview

Crayon Dragon by Toniko Pantoja

FIG 7.17

What was your first experience in creating a short film?

Actually no, I am sort of familiar with making shorts in the past so I kind of had a familiarity to finishing a film. I have done short flash cartoons in the past (this was when I discovered it) and have made a few films during this time. As far as creating an actual short with full-on pre-planning, production phase and post-production, I'd say my first-year film *Serenade to Miette* was my first. It was also my first time arranging a group together to make a finished short, such as one person to do the music and another to do the sounds. I think *Crayon Dragon* was my first real ambitious film, because everything about it was just another step forward. Things were bigger and the planning was more rigorous.

When you felt technically challenged or blocked, what was your go-to resource?

When it comes to choosing an acting choice for animating, I would have to actually stand up and act it for myself. I usually have a problem when it comes to making things subtle or controlled. When I act it out, I understand the important beats to what I have to actually draw.

In many cases with me, I need someone to approach when I have no clue on how to communicate an idea. I think the only go-to resources for me was trying to get as much suggestions and criticism from my classmates and mentor. Sometimes, they have a better understanding of an acting choice than I do, so it was always good to get their help. I would get my friends and my teachers to draw over my drawings to get a visual idea of their suggestion, and I would apply what I got from them to the actual production. Some drew over my drawings to make stronger poses, and some drew over my frames to make sure my proportions remained consistent.

What were some of the biggest challenges in creating your film?

As much as I would love to say everything, I think the biggest challenge for me was maintaining a certain degree of quality. With a strict deadline, we are locked to finish a scene in the given amount of time, and therefore we would have to sacrifice quality. Many of the scenes in *Crayon Dragon* are considered

rush and unpolished, due to the strict time limit I was under. Also, I'm never the most technical person in drawing when it comes to form and construction, so trying to maintain that while under a very tight deadline was a difficult balance to carry. The big challenge there was always deciding whether to move on or to keep polishing the scene, which I could only do to a small number of scenes within the film.

What was your main focus in completing this project? Completing a film? Making a statement? Getting a job?
Well, by the summer after my first year of Cal Arts, I made myself a promise that I would land some sort of internship. I think when I was working on the film more and more, I kind of shifted my focus in making a risky film, in terms of disqualifying myself from the judgment by the teachers and for the school's producer show. I decided that if it is my second year, then I should give myself a chance to maybe fail.

Though I do feel that the film itself met its criteria in delivering the vision I wanted. The aim for the film was make something more character relationship-based, and a film with heart (which is the characters' interaction).

What inspiration or reference outside of animation did you use to complete your film? For example, cinematography, classic paintings, music?
During the summer, I listened to a lot of the Riverdance soundtrack and a few collections of Celtic-based music. It was both high in energy at times and very soft and earthbound, a great element to have in storytelling. When I was researching for some visual elements, I was looking at Celtic art because I was captivated by both the culture and environment of Ireland (which is where *Crayon Dragon* is set).

In animation, it needs a lot of proper planning to get the visual aesthetics for something like Celtic art, and I don't think I was ready to do something of [that] higher level. When I thought of the characters of Brianne (the girl) and the dragon, the way they would communicate is through the use of chalk. I researched art that was easier for me to approach into animation and having that chalk feel to it, so I looked at art by Mary Blair who worked as one of the most influenc[ial] visual development artists at Disney to understand her whimsicalness to her work. Another thing I looked into was the books of Dr Seuss—a great storyteller and an excellent artist too. I wanted my film to read like a Dr Seuss book, to have that certain rhythm and constant discovery.

Which was your favorite character to work on in the film? Why?
My top favorite character to work on was the dragon. He was fun to animate because of the overall broad shape he carried (which is like a pear, or a giant flour sack), and that he resembled me pretty much. I could make him do expressions I would do, and give him funny acting choices that would make the character appealing and relatable. He's a big guy that thinks he's little, so it gives me some fun attitudes to play with; such as his size and how he reacts to things smaller than him.

Brianne (the girl) was also fun to work with, but because I was animating a girl, it was hard to relate. The fun part about the challenge was making her believable and making her a mask that even guys can wear when relating to the character. I'm never good at drawing or portraying girls at all, but I'd have to put a bit of myself in her to make her seem not stereotypical. In my character design class with Rik Maki as a teacher, us guys tend to make girls seem idealistic and stereotypical, and vice versa for girls. I referenced my sisters to have that dominating older sister attitude towards the dragon, hence complimenting the irony of their sizes.

But really, the dragon was the most [fun] character to work with in the film.

Did you employ any organizational tools such as charts or calendars that were pivotal in staying on deadline?

Yes, of course. Every day I carried a binder with printed-out calendars, with blocks reserved for a shot or sequence. This would help me keep in track with how much work I have to do depending on how long each part takes me. I would have some blocks reserved for animation, then blocks reserved for clean-up, and some reserved for fun time. When each shot was finished with animation, I would cross it out with an ex and by the time coloring happened, I'd shade in the block to notify myself that the shot was done.

One of our teachers introduced us to a workbook which is a portfolio/binder that serves as an organizer for our film. It has pages for each shot, with a breakdown of necessary effects, animation thumbnails, and notes. I also had my calendar in this too, so it really saved my life in terms of being organized and staying on the deadline.

What were some of the benefits of working alone?

I guess that you are your own boss. You work the way you want to, or should. In Cal Arts, everyone works so differently for their films that you need again more time to organize a structure for everyone to work with. There's also no argument involved, and no one is dependent on the other. Although it can be beneficial when needing help finishing painstaking tasks such as clean-up or coloring.

Was there another medium you considered for this short film? What were the benefits of working in the medium you chose?

Honestly, I knew I was going to stick with Flash the whole way through since I wanted to make a film with things I was already comfortable with. If I had all the time in the world and could choose, I'd probably have given color pencils a shot. The benefits I had with Flash was that I could somewhat implement symbol-based animation without having to redraw a small change of animation. I did not use this too much, since I only applied it to more subtle things like the girl's head during her run cycle. I didn't redraw the head all of the time, but used a graphic of the head that was used for the previous frames. Therefore, it saved me time during production.

What were some of your favorite tools to work with? What did they do to increase the quality of your film?

Easily, post-production with After Effects. I save this part for the very last during production because it is endlessly fun. It's when I'm importing the animation and the backgrounds together and experimenting post-effects that make the scene stand out. With After Effects, I can alter the mood by changing the colors of the scene, or add other effects that make the film more pleasant to look at. The experimenting is limitless, like I would add lighting to the characters or blur out some of their movements and see if it works for my film or not. I could add things like particles or vignette shadows to play with the overall composition of each frame.

What were some tricks for keeping yourself motivated during this film?

For me, it was always thinking of the end result. I always want to avoid that feeling where I give up on something and many months later I am watching my peers' films feeling ashamed. I guess I would always think about where will this film end up, where will I end up because of this film, how will people react to the film, and what I could learn overall throughout the whole process.

What sort of problems will someone likely run into when creating their own short film?

A lot of it can be specific really. From my experiences and my friends', someone could try shooting for a highly ambitious film that would be hard and maybe demotivating when working on it under a strict deadline. Some can be perfectionists and just keep redoing a segment over and over again until they have little time for other scenes. The biggest one I had for me was my files going corrupt, so I had to re-do a few shots and coloring. All this can be contributed by procrastination, our worst enemy. All I can say for this is to just keep a steady and organized schedule and not hold off things too much.

In your opinion, what are the must-have skills a person needs to create their own short, and what can be learned along the way?

My answer in the simplest form: organization. I don't have the best organization skills at all, but you need a certain degree of it to go around the hurdles of production. This involves planning, such as planning the staging of your shots, planning how long each shot/sequence will take you to finish, timing, and arranging your files so it is in a manner that is easy to access. It's pretty much the essential skill for everything in production.

Things like design, animation acting, or story elements are learned through experience. Experience as in working with a project or a film. Some people get it right for the first time, but people learn more when something doesn't work—and that they have to find ways to turn that problem into a solution. That is what experiencing and learning is all about, but even these would require a general idea of planning and organizing.

How did you decide who would be helping you with your film?

For my composer, I knew Denny Schneidemesser for a long time since high school, and we'd always do things for highly ambitious projects. He can do great magical, sentimental, dramatic and bold scores, and is very smart when approaching music and storytelling. I think it's because of the common stuff we share; I asked him if he was free to help on my second-year film.

For sound, Glenn Harfagre did an excellent job for my first-year film and I wanted him to help do the sound designs for *Crayon Dragon*. Glenn adds a lot of texture to the sounds, and it only strengthens the believability of the world that *Crayon Dragon* takes place in.

As for animation criticism, I usually just go to peers and mentors I trusted so they could give me their suggestions and advice for things they felt could be stronger.

How did your workflow/pipeline for this short differ from other pipelines you have been a part of? What do you think was the reason behind this change (if any?)

The pipeline I had for *Crayon Dragon* was much better than my last-year film *Serenade to Miette*. My first-year film was done in paper for all the animation, therefore the pipeline was much longer and redundant. I'd have to scan the drawings frame by frame, load up the frames into Photoshop, alpha-channel it so only the line work is visible, and color the keys in another layer. I would then have to export it as a png and then import them into After Effects, retiming the whole thing to its originally planned layout.

In my second-year film, all the animation and the coloring for the characters was done in Adobe Flash. The great thing about Flash and After Effects is that you can immediately import flash movie files (.swf) instead of having to save an image sequence of it. This was great because it maintained all the timing of the animation, and the file size was economically small—making performance efficient.

Did your workflow change when you had to work with specialists outside the animation realm, like designers or musicians? Do you have any advice for those who are creating a film and don't know anything about those areas?

Most definitely. After pre-production is finished, I would email my composer and sound designer about the film and what I have in mind when I finish production. We would then organize some sort of schedule of how long each pass would take for a chosen deadline. The thing I am going to start off by saying is make sure everything is time-locked before your composer or sound designer is near the final stages of their track. The timing in an animatic heavily differs from the actual animation, in which you later figure out that some of the animation needs to be longer than the given animatic. This would cause problems between me, my composer and my sound designer because by the time I go further into production, I decide I wanted to change some timing when they are already far into their tracks. This would cause production problems and would make it harder for everyone else. Therefore, I had to try and work with a way that would be efficient for all of us. The thing about sound and music (besides voice acting and dialogue) is that it needs to compliment the moving imagery. I do use a temp track to give my composer an idea of the beat, the rhythm, the mood, and the direction I want for the music, but it will flow better when the film has been picture/time-locked.

Was there a moment when you knew your film was going to be a success?

Idealistically, I wanted people to enjoy it and find it somewhat engaging. I think it caught me a bit off-guard when I heard it spread like a wild fire online; that I did not see coming. I've gotten some great responses, great feedback, and some sharing emotional responses relating to it. It's great to see that the film has been doing well.

Were there any major plot points or features of the film that changed because of your capabilities? Would you change it now that you have more experience?

The initial idea I had was totally different. The very first idea was about a girl overcoming the death of her mother who was an artist, meeting a dragon years later that helps her overcome this loss and her hatred for her mother. After many story passes, I'm happy that I just broke it down to only the girl and the dragon—because that's where the heart of the film should be: their relationship towards one another. Also, it would make it a tighter film rather than having things that seem unnecessary. I wouldn't change it at all if I was given the chance, but only expand it if that world became bigger.

Are you planning on creating another short film?

Yes, definitely. It's also a requirement for every year at Cal Arts too!

Describe your process for coming up with the idea. Did you build around a simple idea? Cut down from a larger idea? Explain.

Like the previous question, I built it from a larger idea and broke it down to what should be the main focus of the film. It had a completely different story, which was bigger and unnecessary. Sometimes the large idea might be too grand or too confusing for a short film that's under four minutes, so simplifying and making the core story strike harder is the best way to go. I think now I will start with a simple idea and then maybe expand on that.

How important was organization to your process? Do you feel being unorganized would have drastically changed the outcome of your film?

Without it, I don't think I would have finished the film; or it would take me a very long time. It is essential to have some sort of organization for the film. It's what manages everything from beginning to end.

Describe how you designed the dragon.

When I was doing sketches of the character, I wanted it to look kind of inhuman and threatening, but wanted to retain a feeling of innocence when you look at the face. When I thought of dangerous, I thought of an alligator because of their mass and their somewhat hideous appearance. I wanted the dragon to be ironic, with a body of something tough and dangerous, it would also appear friendly. The face is based off a dolphin, animals that look like they are smiling all the time, and are generally friendly to human beings. I just kept in mind how can I make a character that is big and threatening yet so small? I have done a lot of sketches for the dragon to capture a design with appealing shapes. The first sketches looked grotesque, while the later designs became a bit more cutesy. I would then try and merge what I liked about the grotesque designs and what I liked about the cutesy approaches and see what I would come up with the next ones. It's pretty much an experimental process of design; you just keep doing it until you find the right design for the story.

What words of encouragement do you have for someone who wants to create a film at home?

Stay motivated and keep focused, at the same time balance your life. Have fun; go out with friends, and have time for everything else. If you work too hard and too much on your film, you can get burned out and that's not the best thing, ever. Make a schedule that works for yourself and for your film. The thing about film (specifically animation) is portraying what we experience from life. I usually keep the end vision of the product in my head when working, and picturing what I would get out of it to keep me motivated. I would still be focused on working on the film without procrastinating too much.

Editorial

If you have been following the advice in the production chapter, you have a working timeline in your editing package of choice. Though Adobe Premiere is my favorite, almost all non-linear editing packages have the features used in this book. Up to this point you have been swapping out your boards for playblasts, your playblasts for renders, and hopefully keeping organized with shot labels and frame counters. My best advice is to not get too creative with the editing until you have most of the film rendered. This might seem the worst way to access the best end result, and you would be partly right if you thought this. But don't forget, major studios with multi million dollar budgets have a different agenda to you and me. They can afford to re-edit their story a hundred times. They can afford to change the entire story mid-production. In the short film world, we have to actually *finish* a stage of production and learn to move on from it. At a certain point, the film you have is just the film you have. The next one will be even better in every aspect, so you cannot spend

unlimited time reworking your film again and again. Thus, while it is true that making major story changes in edit gives you the freedom to get the best end result you can, we need to save the major editing until the end.

The Final Cut

In the pre-production phase, I warned that you were not going to get another chance to really explore ideas in the film. And while that was mostly true, there is a little bit of discovery left in the film—particularly if you have a modular middle, as in *Booty Call*. A full editing curriculum is outside the scope of this book, but here are a few questions you can ask yourself to try to get the strongest edit of the film.

1. Is the narrative clear? This question asks if you have enough footage to actually tell the story you set out to tell. If you are missing angles, coverage, or an essential shot, only *now* is the time to go back and create the Maya scene. Think about how many extra scenes you might have created if you were "feeling around" the edit this entire time. Show the film in its current state to friends and family and ask them if they understand what happens. One of the blessings and curses of animation is that laypersons know nothing about what we do but are our target audience. Even your mom is a great critic.

2. Are the shots in the right order? This question may seem a little silly, but in fact a discovery can sometimes be made in the final cut that opens up some amazing possibilities for the story. Here's an example to illustrate such a discovery:

 A man waits at a bus stop for his ride home after a long day at work. As the bus arrives he sees an old lady hobbling towards him. He helps her step onto the bus, but he also notices she has no money in her purse. Considering for a second, he extends his hand, which is grasping his last dollar, offering to pay for her ride. Without his own ticket, he gets off the bus and takes off his coat. He walks and walks, the scenery changing from city to suburban surroundings and the shadows growing longer around him. Hours later, in the dark, he walks up to the front porch of his house. He walks inside and sees that his wife is fuming; there are half-burned candles standing pitifully on the dinner table and she is dressed up for a meal he obviously missed. He sits and looks at her and a smile grows on his face. Knowing the person he is, she cracks a smile and leans forward to hear his story. We fade out on him pouring the wine and launching into the tale of his chivalry.

 OK. This is working fine, but what if we told the tale a little bit differently, using ostensibly the exact same shots even after everything is completed? Here is what I would consider to be a much stronger edit of this film:

A man walks along a sidewalk; the sun is beginning to set.

The same man is standing at a bus stop; the bus rolls up.

Back to him walking home, the scenery is beginning to transition from city to suburban surroundings.

Back to the bus stop, as he is about to get on the bus he notices an old lady. She arrives and he helps her onto the bus.

Back to the man on the sidewalk. The sun is setting and the shadows stretch around him.

On the bus, the woman fumbles around for money, but she has none. The man furrows his brow.

At his house, it is dark outside when he arrives on the porch. He goes through the door to find his wife waiting for him with a beautiful meal sitting cold on the dinner table. The tall candles lit hours ago are burned down almost to stubs. She glares at him.

In the bus, he pulls out his money and looks at the old lady.

He looks up at his wife, and a smile creeps across his face.

He hands the money to the driver. The bus pulls away, revealing him standing on the sidewalk.

His wife smiles back.

He throws his coat over his shoulder as he starts the long walk home.

We fade out on the couple pouring the wine as he launches into the tale of his chivalry.

Do you see how, using the exact same shots, I can construct a story that has much better progression, conflict, tension, and resolution? We get such a different (and better) experience from seeing the character find his way home as he stews on the decision he just made. This new edit sings the qualities of the character much more clearly.

So you must ask yourself if you are actually using what you have to the furthest extent, or if an alternate edit might bring a better perspective to the characters.

3. Is the film the right length? Again, another silly question. But as much as it might seem that a longer film is by definition clearer and more impressive, every story has a correct length. If you have an ending that is reasonably predictable, you need to show your film to friends and family and ask them at which point they figured out the ending. Using this information, you can edit the film so that the audience is not left bored once the resolution is in sight. Nothing is worse than a film that drags on after the climax.

So with these three questions as your guide, finish up your edit of the film. With *Booty Call*, we found there were a few shots that didn't seem to make

total sense in the final edit. One of the major benefits of the modular middle was that when we added those shots to the end credits sequence, it gave the audience extra action and fun.

FIG 8.1 We had the ability to show extra animation that didn't make the final edit as the credits roll. You'd never guess we animated the film in ten days with the amount of footage that was created.

Revisiting the Modular Middle

In *Booty Call*, the middle is truly modular. I called upon the animators at Anomalia to contribute their ideas for shots that fill the middle of the film, and they delivered. The result was over 15 different shots that featured Babinsky running from right to left, chasing the coin.

FIG 8.2 Babinsky runs from screen right to screen left, chasing the coin, in the entire middle sequence.

Since the middle was so modular, it left a really interesting amount of flexibility for editing at the end. Think about it another way; the number of distinct permutations of 16 shots is 20,922,789,888,000. Yes, that's twenty trillion, nine hundred and twenty-two billion, seven hundred and eighty-nine million, eight hundred and eighty-eight thousand. When I think about it, I don't know how we settled on an order! All kidding aside, since we had a great modular middle, the film was able to be cut together using an iterative process; testing how a cut "felt" and then swapping shots until we saw improvement. I am proud of the edit and of how use of the modular middle came through for us in a big way.

Handles

Take one more look at each edit. Every single cut should be scrutinized as closely as every other aspect of the film. We know that, in animation, one frame of difference can be *all* the difference. The handles you've created give you even more flexibility in the edit. Even on edits where you are sure of what you are seeing, try to move the cut point back and forth a bit and really get the best result. You are almost done—get in these last minute improvements while you can!

Double Cuts

On major action sequences you may even want to extend your shots as long as possible and introduce some double cuts. With these, you see an action happen twice, to show the exact same movement from two different angles. This is commonly used in action films when a car explodes or a character is punched. As long as it is not overused, double cutting can be another effective storytelling tool. Again, this is your last opportunity to make story edits, so consider each frame carefully one last time.

Cutting a Trailer

Some festivals do not accept entries that have been screened in their entirety online (check out our list of festivals in Chapter 11). I highly recommend getting some form of your film online to drum up a little bit of buzz and for there to be something to watch on the website you will undoubtedly create for the purpose of "housing" your film. The goal of a trailer is to show a little bit of the story, some of the acting and the action, and some contact and

credit information in case a distributor or production company is interested in speaking further with you regarding your short.

FIG 8.3 Michael Cawood provided his trailer for *Devils, Angels, and Dating* for us. A link to watch the full film is available at www.devilsangelsanddating.com.

As you see in the trailer provided for *Devil's, Angels, and Dating*, with the right amount of story setup and action, you are left wanting to see more.

Other Editing Considerations

Energy

One thing that successful shorts do well is using the speed of the editing to really emphasize a change in energy or a plot point. A simply formula is to have a bunch of quick cuts to get the pace flowing very quickly to match the energy of the characters and the progression of the story.

FIG 8.4 *Beat* has some amazing editing. As the character moves along with the rhythm of his humdrum life, the cuts come predictably and methodically. But when his routine is messed up, the fast-paced cuts come at us with shocking tempo.

Watching *Beat*, you get a great sense of the creator's control over the edit. This is something to aspire to. Not all films will have the opportunity to showcase editing like this (*Beat* really establishes a rhythm with the movement of the characters), but that doesn't mean that you should be careless in your treatment of the energy.

Opening

Consider opening your film without credits or a big drawn-out sequence. There is something very powerful about being "dropped" into a film with no idea where you are as an audience. *Crayon Dragon* does this perfectly.

FIG 8.5 In *Crayon Dragon*, this is the first frame of the film. No swirling titles or large building visuals to the credits, just a jarring cut to the action.

Beat, *Meet Buck*, and *Reverso* also cut right into the action, which I find appealing. In *Booty Call* the full moon was too tempting not to incorporate into our opening title, but I like the idea of starting my next short by cutting into the action.

Final Thoughts

In editing *Booty Call*, the largest change to the film involved the choice and order of the chase sequence shots. The ones that did not make it into the main edit and were moved to the credits were moved not because they weren't well animated (in fact, some of the strongest shots did not make it into the edit) but because there did not seem to be a logical way to edit them in and keep the pace and flow of the film. I really like that we get to see "extra" shots in the credits and that we don't lose them entirely.

FIG 8.6 Editing is tough, but what you don't use might come in handy later.

ANIMATORS
Jordi Gaspar Aldea
Joost De Jong
Edwin De Loor
Victor Escardo
Pavel Hruboš
Nick Groeneveld
Michaela Jindra
Tomas Juchnevic
Angelique Kesselring
Carlo Loffredo
Daniel Řehák
Kenny Roy
David Toušek
Irina Wolf
Georgi Zahariev
Juraj Zubáň

Most of your editing decisions were made at the animatic stage. I want to reiterate that editing your film is ongoing throughout production. But even so, you should save major timing changes until you are looking at your near-finished film. As attractive as the prospect of working the edit is, you had plenty of opportunity to do it when you were making your animatic. At that stage, large changes only mean having to redraw a few boards, not create entire shots from scratch. Of course, to make absolutely the best film possible, you would give yourself the freedom to make editing choices all the way up to the end of production. This is not our workflow, though. Rather, as short filmmakers we strive to learn and improve with each project and, above all, to finish our films. Next time you will have even more tricks up your sleeve to make an even more amazing short. If this seems a rather cavalier attitude to the art, it's only because my goal for this book is to give you the advice you need to finally create that short you've always wanted to make.

In a few years, with a couple films under your belt, go right ahead and edit your film all the way through production: be my guest!

Interview

Adrift by Ben Casey, Matt Smart, and Ben Clube

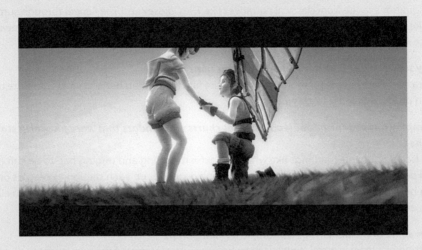

FIG 8.7

What was your first experience in creating a short film?

Clube: I made a music video for my friend's band just after I left school. We hired this building out, lit everything with lamps, and used a skateboard as a camera dolly. It was a lot of fun.

Smart: Mine was in my final year at school. I made a short film for film studies—mostly live action with elements of 3D. This was when I first started getting into CGI.

Casey: My first experience was making a short animation in my second year at university. I enjoyed the process of doing everything myself but was really looking forward to creating a short with some friends whose talents were my weaknesses.

When you felt technically challenged or blocked, what was your go-to resource?

Casey: There are a lot of great websites for 3D artists, all with plenty of tutorials and problem threads: 3D total, cgtalk, zbrushcentral, 3dbuzz. There's a really great online community for this industry all ready to help each other out!

What were some of the biggest challenges in creating your film?

Casey: I think that our biggest challenge overall was creating grass that could be rendered in time for the deadline. We had to use lots of cheats and workarounds to be able to get out what we did.

What was your main focus in completing this project? Completing a film? Making a statement? Getting a Job?

Smart: Proving we had the skills to move into the professional world and to work on something in a team from start to finish like in the real world of filmmaking.

What inspiration or reference outside of animation did you use to complete your film? For example, cinematography, classic paintings, music?

Clube: There are obvious elements of fantasy and the surreal; it's a little bit steam punk and a little bit anime. Inspirations range from classical narratives like *The Odyssey* and *The Aeneid* through surrealist painters like Magritte, old fairy tales and fables, illustrators like Sylvian Chomet and Jamie Hewlett, studios like AKA, Ghibli and Square Enix. Quite eclectic!

Who was your favorite character to work on in the film? Why?

Smart: Cora, the main female protagonist. Most of the film focused on her and I just loved the final design Ben produced for me to play with.

Did you employ any organizational tools such as charts or calendars that were pivotal in staying on deadline?

Casey: We had a timetable for things like when character modeling and rigging had to be completed so it could be handed over to animation. We put rough deadlines on each section to keep us on track. It can be a bit of a guessing game working out how long each part will take and how long to allow for rendering, etc. But it gave us a template and something to work towards.

What were some of the benefits of working in a small group?

Clube: Getting in a team is great! It makes the whole project a lot more fun and you get the benefit of everyone's different strengths. So whilst we all know how to draw, model and animate etc., we definitely all major in different areas and it just made sense to team up to make the project look as good as it possibly could.

Was there another medium you considered for this short film? What were the benefits of working in the medium you chose?

Casey: Whilst we had a great time making concept art for the film and making the animatic for the film in hand-drawn 2D, we always wanted to make the film in 3D. We are all 3D artists and we wanted to create a vast and open 3D landscape for our film. I think it helped give the film a sense of scale.

What were some tricks for keeping you/your team motivated during this film?

Clube: Morning star jumps and the Rocky theme on loop. Seriously though, I think we were motivated because we all enjoyed the project; we put ourselves into it and we believed in it! We wanted to make something that looked good, that we were proud of and would get us a good job doing what we love. We made sure we had fun! It was something we wanted to make and we made it.

What sort of problems will someone likely run into when creating their own short film?

Smart: Time management, working well in a team, and with CG films, render times/problems.

Casey: Yeah, allowing enough time for rendering—you need to plan ahead and shape your scenes to fit your deadlines. This means building lower poly assets where higher poly ones aren't needed and using smaller texture maps. Just making a lot of compromises in terms of sometimes unecessary detail.

In your opinion, what are the must-have skills a person needs to create their own short, and what can be learned along the way?

Clube: You need an idea and you need the passion to see it through. Technically you obviously need some know-how, but if you're creative enough you can make it work.

Smart: Self-motivation for starters, keeping to deadlines, but especially working well and bouncing off other people's ideas/suggestions/criticisms—it really is a must.

Did you develop any new tools or innovative workarounds you would like to share? For example, if the hair didn't render properly, you created a new script.
Clube: The clouds required a lot of R&D; originally we tried simulations, complex textures, plug-ins, etc., but it all either looked wrong or took ages to render. In the end, the best-looking option was also one of the simplest and I ended up painting the clouds digitally and tracking them to the scenes.

Casey: We had to come up with a lot of workarounds for the grass too. Originally we had the grass rendering out with the rest of the scene using the same lighting set up, which proved to be a nightmare with render times. In the end I had to make separate scene states, separate lighting set-ups, separate render settings and took the grass out completely separately—comping it in using the odd mask. It saved us loads of time and ultimately gave us more control in post.

Did your workflow change when you had to work with specialists outside the animation realm, such as designers or musicians? Do you have any advice for those who are creating a film and don't know anything about those areas?
Clube: The animation realm! Sounds majestic! We worked with a great upcoming soundtrack composer called Goncalo Martins and he was totally a part of the team. He was great and got involved from the early animatic stages through to the final film. He was very understanding when we told him we had to change timings, cut scenes and rework edits. You have to work with people who are good at what they do and are flexible to change things around.

Was there a moment you knew your film was going to be a success?
Clube: We never set out to make something "successful" so I don't think it ever really crossed our minds when we were making it. I think when we first got the 3D characters modeled up and saw them moving around we thought it was pretty cool. Honestly, since finishing the film we've been amazed and humbled at the response. Adrift has been nominated at festivals around the world inlcuding BFI, Woodstock, and Animex and taken a few awards. I think the big moments of realisation that we'd made something people enjoyed was our big feature in 3D World and representing British Animation at the World Expo in Shanghai. That was awesome!

Were there any major plot points or features of the film that changed because of your capabilities? Would you change it now that you have more experience?
Smart: More time to work on the plot would have been great as it changed almost every other day in pre-production; and then personally for me the animation—only having three months to work with three to four characters pushed me right up to my limit.

Describe your process for coming up with the idea. Did you build around a simple idea? Cut down from a larger idea? Explain.
Smart: The initial idea was two rather isolated and lonely people finding each other in an extraordinary way. The original idea was that they were going to be younger and the girl would be living with parents, and then one day this boy comes crashing out of the sky and she finds a friend in him after helping him. Due to the time scale, though, making even more characters would have been impossible, so we cleaned up the script and condensed the idea to the main two people and kept the theme of them finding each other.

Explain your pre-production methods and planning. Did you use an animatic, pre-visualization, scratch recordings, or just go straight into production, modeling, and animation?

Smart: We started with extensive storyboarding to get a sense of timing, mood and pace, and once we felt happy moved into pre-visualization, eventually replacing objects with the final models as we went along.

How important was organization to your process? Do you feel being unorganized would have drastically changed the outcome of your film?

Casey: We had to stay fairly organized as we were working as a team and needed to be in contact with each other a lot so we all knew who was working on what to most effectively use our time.

Clube: You can afford to be flexible, but you can't afford to be disorganized.

Please discuss your environment design for the two flying islands.

Clube: It actually developed from a few different angles. At one point, both the boy and the girl lived on giant sea creatures in the sky. Later we decided to have the boy on an island to contrast the girl's very natural environment; with his being a more man-made, steampunk, industrial environment made of metal. We also had the idea of him being from a group of sky pirates, and his island was a hunting island, harpooning the sky whales (it got crazy for a short three-minute film!). But a lot of those bigger ideas fell into the cleaner final design with the boy's lookout house, sails on the island and the harpoon gun becoming the rope.

Casey: We wanted a very fantastical feel to our film and also an innocent charm. The Studio Ghibli films were a great inspiration for the designs.

Talk a little about your decision to use a whale.

Smart: From the original sketches/paintings I did while brainstorming the idea back in the second year of uni, the creature was originally just a large flying snail-like creature with the house instead of a shell. Over time the idea of the whale came along, as their sad call really emphasized and mixed perfectly [with] the loneliness of the girl living on its back. This theme of "a sea in the sky" started changing things as well: for example, the boy was going to ride an enormous manta ray until we moved onto the idea of his little flying island, as the story required him to not be able to control his vessel/creature.

How did you approach camera movement and angles for Adrift?

Smart: Not having a lot of time, the cameras we're essentially made directly after we liked the look of storyboards. The camera also turned out (for better or worse) being quite reactive to the on-screen action, almost like it was its own character, which is generally not the case in most live-action films, where it would follow the action.

What words of encouragement do you have for someone who wants to create a 3D film at home?

Casey: It's a huge amount of fun and even though it's a lot of hard work and late nights you'll enjoy every minute of it and at the end you'll look back at your film and feel proud to have been a part of it.

Sound

Even though I have placed this chapter towards the end, sound should not be an afterthought! In the long run, the sound of your film will have a key role in determining its impact on an audience. Great sound choices can have many added benefits, from making your world seem larger to supporting your animation choices. Let's go over a few of these benefits as heard in *Booty Call* and our supporting films.

Build an Environment

First and foremost, environment sounds are absolutely essential to establishing the setting of your film. You may remember that in the chapter on story I launched into a pirate film example featuring a crowd of pirates and an expansive set. Well, instead of spending all that time and energy creating dozens of pirates manning a ship, why not use sound to our advantage?

FIG 9.1 Watching the film, you get a real sense of life on the boat from the sounds we used.

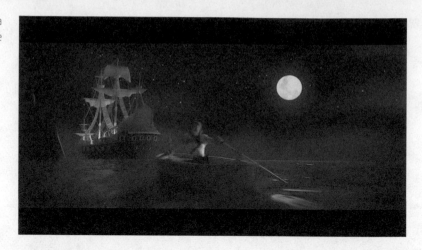

As Babinsky approaches the ship, the sound of rowdy pirates fills the air. He is clearly trying to be covert as he approaches a party in progress. Think of how much development time we saved by using sound here.

FIG 9.2 In *Adrift*, we never lose the sense of being high above the clouds because of the really nice wind and creaking noises throughout. The environment is very well established in this film.

Our supporting films also make great use of environment sound. In *Drink Drunk*, the bar seems filled with people because of the voices we hear when the door opens.

Clearly, the use of environment sounds is an important part of creating a rich experience for your audience. Match the visuals with a rich environment or use sound effects as a shortcut—anything to increase the impact.

FIG 9.3 In *Reverso*, the office seems busy, though the animators didn't have to create a single worker.

FIG 9.4 All you need is a full-*sounding* room—the audience will fill in the rest!

Smart Sound Effects

At a superficial level, having sound effects that match the visuals on screen enriches the way an animation is experienced. But you can do a lot more with sound effects that give a deeper meaning to what we see. While it is common to feel the need to fill your scenes with sound effects, it's actually unnecessary. It can be very time-consuming (or expensive if you hire an outside person or company) to create a sound effects track that is completely accurate. In the end it is not important to have a sound effect for every single movement on screen. Instead, use strategically placed sound effects to enhance the performance and drive the story.

313

FIG 9.5 *Our Wonderful Nature* has some incredible sound design. Notice when you are watching it how much the sound accompanying the fast and slow motion supports the animation.

Our Wonderful Nature really plays on this concept. It is extremely difficult to animate anything in slow motion. The animation could feel floaty and underdeveloped. The slow-motion sound effects, such as the whooshing arms, the loud crunches when a shrew is hit, and the moaning and groaning, all serve to support the performance choices. If you watch it muted, you get an entirely different experience.

FIG 9.6 With big action sequences, the sound effects can make or break the scene.

Devils, Angels, and Dating has some of the most robust sound design of all our supporting films. The sound effects really add to the tension, particularly in the action sequences. Notice the crackling noise that can be heard when the Devil and Cupid start firing their controllers at each other. It really makes it feel like there is a huge amount of opposing energy in the scene. Very nice.

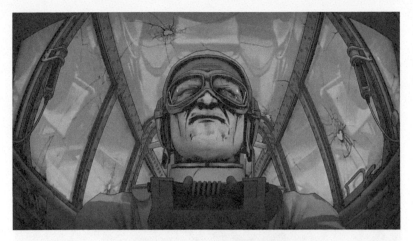

FIG 9.7 Sound effects rule the day in *Paths of Hate*. Damian Nenow uses shifts in the depth of the sound to draw attention to the conflict in the film.

The absence of sound effects can be important too. In *Paths of Hate*, the moments that are silent give us a stark sense of the brutality that is going on. It is almost uncomfortable for an audience member when the director brings down the sound. Uncomfortable can be extremely powerful—as long as it's intentional!

In *Booty Call* there were several sound effects that I knew were going to be crucial. After establishing the pirates on deck with the environment sounds, I needed to make sure that we got a sense of the size of the ship. The moment to establish this easily was when the coin rolls away from Babinsky.

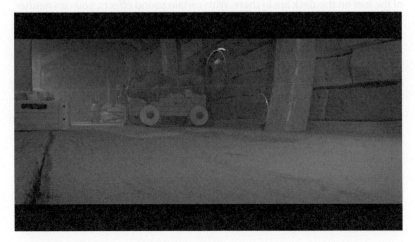

FIG 9.8 As the coin bounces, the sound effect fades very quickly, which establishes the size of the ship.

Very quickly, we can no longer hear the coin that is bouncing away from us. The great length of the ship is therefore internalized by the audience, and we are then free to run Babinsky to insane lengths without it being felt that he should be reaching the other end of the ship.

Another moment when sound features is when Babinsky opens the grate in the ground.

FIG 9.9 When the grate is open, all we see is eyes but they're paired with a very ferocious-sounding snarl.

The first version of the script had Babinsky getting pulled into the grate by a pair of long tentacles. It would have been a nightmare to model, rig, and animate those scenes as written. When it came down to it, I changed the ending to be achievable with simpler visuals and the support of good sound effects. In the end what we got serves all purposes—and you don't even notice that we just have a pair of eyeballs floating in the blackness!

You will notice when you listen to *Booty Call* that for the most part the sounds of the feet on the deck are in there. With certain sound effects, you can neither skimp nor, when you apply them, pick and choose. Unlike the engine sounds and gunfire in *Paths of Hate*, Babinsky's footsteps could not be toned down to create a large impact. No, his footsteps are there to "ground" him in the scene and give some reality and connection to the visuals, and also because they are expected by an audience.

Efficient Dialogue

The best-case scenario is that your dialogue is performed and recorded by professionals under professional conditions. If you have to sacrifice anything, recording quality should go before performance quality. It's much better to have some incredible dialogue performed with heart that is a little scratchy than a flat performance. I also point out that our supporting films only have a small amount of dialogue.

In *Booty Call*, the aim was to show the increasing frustration of our hero as he tries desperately to get the coin. To add some dialogue or monologue to the short would be to take the universal quality away from it. Meaning, if he starts speaking to himself about his toils, suddenly audiences from around the world will become outsiders.

FIG 9.10 Babinsky's screams and grunts are all the voice we need to get the point across.

FIG 9.11 *Drink Drunk* has minimal dialogue. Even smarter on the part of the animator is that all the dialogue is slurred—easier to animate.

Using only limited dialogue in *Drink Drunk* was a smart choice because it means it does not interfere with the character's arc. We are totally on board to watch a drunken fool go through the stages of regret, even without—or especially without—him talking us through it. Although there is some dialogue near the end, the animator was very smart to make the main character's friend be facing away from camera. This is a way to get dialogue into your short with as little extra work as possible. Depending on how fast and well you can animate lip sync, the amount of dialogue in your short is one of the main factors determining whether you finish or not.

A Crafty Narrator

In feature film, writing a narrator into the picture is often regarded as lazy. The idea behind this centers on the fact that if you are a good enough writer, the character's actions and dialogue speak more about the theme than a narrator

talking directly to the audience ever could. So it is generally frowned upon to have a narrator helping with the exposition. However, in short film, the rules are a little different. A narrator is great when you are using it for a purpose other than "spelling out" the story.

One clever device is when the narrator is one of the characters, like the narrator in *Devil's, Angels, and Dating*.

FIG 9.12 In this film, the Devil is actually the narrator, despite the different voice tones.

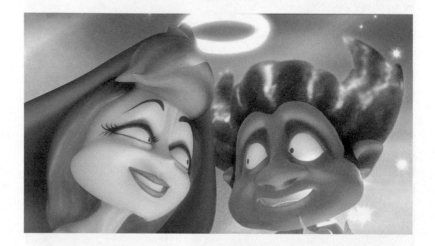

Even though the Devil and the narrator don't have the same voice (kind of a *Wonder Years* vibe going on here), the narrator is very effective in this film. A narrator of this kind provides a little extra perspective when the story needs it, gives the audience someone to relate to as the action is unfolding, and is in general a "soft landing" into the scene. Meaning, it's almost as if the person telling you the story is going to keep you safe, usher you through the excitement, and be there for you.

FIG 9.13 *Our Wonderful Nature* has a narrator as well, but the best thing about this narrator is that it is part of the joke the director is playing on the audience!

In *Our Wonderful Nature*, the narrator is in on the secret; this is not your ordinary nature show. I love how Tomer Eshed builds up the gag of the fake nature show, complete with British narrator. A clever use of voice is exactly the kind of innovative methodology you must employ to finish a film.

So think long and hard about how you are going to use dialogue, if at all, in your film. The best rule might be to always try to "show it" before you resort to "telling it."

Music

Although the vast majority of animated shorts have a musical score, it is not entirely essential. Our very moody and melancholy supporting film *For the Remainder* has no music, and it does not suffer for it. In fact, the atmospheric layered sound effects do more to establish the mood than I think music could for a short of this style.

On the other hand, some shorts rely entirely on music. For example, *Dubstep Dispute* is obviously completely reliant on its music. The robots that are arguing do so by flashing their lights and making mechanical grating noises, which in turn creates the dubstep sound track.

However, most films will rely on music in a more traditional way, as all the other films in this book do; with thoughtful application of music to support the tone and mood of a scene, mixed well with the sound effects and dialogue.

The one major workflow tip to follow when working with music is to not get too attached to a certain piece of music. Unless you are sampling from a music library such as my favorite www.sounddogs.com, you can never be sure that the music you love for the film is affordable or even available for your use. That is to say, even if you have a budget for music, you may be disappointed when an artist simply does not want their song in your animation. To avoid the complication of having to reanimate scenes that were heavily influenced by particular music, I like to cut together temporary music that gives a good sense of pace and timing. Then when it comes down to choosing the actual music, I show the animatic with the temp score to my composer friends and ask for their thoughts. Generally they will offer very good feedback, and usually I can get someone to offer to create the score for next to nothing. Truly passionate composers are always volunteering to work on shorts that are inspiring because it is far more fulfilling than creating jingles for toothpaste commercials.

I want to reiterate here that by putting a little bit of effort into networking you will actually be setting up your future projects for success. See a short with some great sound effects? Look through the credits, contact the mixer who provided them, and tell them you enjoyed their work. Same applies for score; *all* artists want to hear praise for a job well done. Down the road, great sound people will come out of the woodwork to create some amazing things with you.

Sound and Picture

By the time you make it to creating your 3D images, the bare-bones sound is in place in your short in animatic form. As mentioned in the last chapter, it is not always a good idea to cut directly to the beats of the music. You will end up with too predictable, unimaginative an edit of your film. The timing of the scenes will seem to move too rhythmically and methodically. There will be a lack of visual interest. All from simply trying to make the visuals *match* the music. Therein lies the problem; our goal is not to match the sound to the picture, but to *marry* sound and picture. And just as in marriage in the real world, the two parties shouldn't be exactly matched: it is the differences that make it interesting. Matching music perfectly to the imagery is also a huge waste of time. In order to finish your film, you should be focusing much more on the emotional impact your film has, and using sound and music to enhance those qualities.

Interview

Dubstep Dispute by Jason Giles

FIG 9.14

What was your first experience of creating a short film?

This is actually my first experience in completing a short film. I've worked on several 3D animation projects that include storyboarding and shot breakdown for television programs and commercials but I've never had the opportunity to develop and complete a short. I really enjoyed it and plan to do some longer pieces in the future.

When you felt technically challenged or blocked, what was your go-to resource?

I use many resources when there are technical challenges. The web itself is a fantastic resource but on many occasions I needed to dig a little bit deeper. For the particular 3D software I used during this project there were multiple avenues I used, such as the forums, free training videos available on the site, as well as some advanced training resources I bought. The most useful resources ended up being the materials I purchased, as there were in-depth projects and training from professionals. Best of all, I was able to tear apart their scenes, see how they were built, and apply it to my particular challenges.

What were some of the biggest challenges in creating your film?

The first challenge with *Dubstep Dispute* was matching all of the character animations, lights, and luminescent materials precisely to different instruments in the music track. The solution really ended up being a fair amount of work and developing a few rigging techniques to speed up the process and keep everything flexible. It was a great experience and I created several simple tools that I've been using in music projects since.

Probably the most surprising and difficult challenge was the choreography of the scene. Interpreting the musical sounds as moving robots was one step but tying those robots and movements into a sort of story ended up being the biggest challenge. It was kind of like a Three Stooges skit, but the difficulty was that the music could not change, and the skit had to be fit into the time that already existed. There never really ended up being a big breakthrough; I just had to keep running the scene over in my head until it all clicked.

What was your main focus in completing this project? Completing a film? Making a statement? Getting a job?

My main focus was really just creating and completing a 3D short for myself. I wanted to enjoy the freedom of designing, building, and polishing a project without intervention or deadlines. I found the experience to be extremely satisfying and hope to find time to do more.

What inspiration or reference outside of animation did you use to complete your film? For example, cinematography, classic paintings, music?

With this piece, I really wanted to pull reference from some of the key inspirations that got me into 3D animation in the first place. *Dubstep Dispute* is born of *Blade Runner*, *Star Wars*, *Tron*, with a bit of the Muppets. Usually I try to be a little more discreet about the art I draw inspiration from, but I felt this was more of an homage to those works.

Which was your favorite character to work on in the film? Why?

Actually, I think they all were about equally fun to work with. They each play such a small part that I never got bored with any of them and maybe never even had the chance to get attached to one in particular. I enjoyed how simple they were but still somehow managed to carry a fair amount of character.

Did you employ any organizational tools such as charts or calendars that were pivotal in staying on deadline?

Interestingly, not with this project. Normally I would say that organization and time tracking is an absolute essential element to the process, but there were two key differences with this project. First, the deadline was flexible and I gave myself three to six months to finish. Secondly, with only having one long camera shot and no separate scenes, there was no need for complex scene breakdowns or even storyboards. I knew exactly what needed to be done and I could spend my time on the work and not the calendar. This was an exception to the rule, though.

What were some of your favorite tools to work with? What did they do to increase the quality of your film?

Well, my 3D tool of choice is Modo, and it was great being able to use it for most everything in this project. I use it primarily for modeling and texture-baking at work, but it has much more power and I was thrilled to use its deeper tool set and rendering capabilities. The only other tool that I would mention was Optical Flares, a lens flare plug-in for After Effects. It caught me off guard as to how easy it was to use, with some very flexible and great-looking lens flare post effects. I needed something quick, easy and attractive; and it did the trick.

What were some tricks for keeping you motivated during this film?

Lots of exported movies. I got in a habit of setting off a render each night and viewing a movie in the morning to see how things were progressing. I also snuck ahead in a few spots and did some final texturing on a few elements before the scene had fully been roughed out. Getting just a few pretty visuals or some simple physics now and then kept me moving towards the end goal.

What sort of problems will someone likely run into when creating their own short film?

I feel that the most common problem I run into is being overwhelmed. Overwhelmed with the complexity of the idea, the amount of time it would take to complete, or even the amount of money it may cost to have the software and hardware I would need. I just suggest keeping it as simple as possible. If the piece begs for more complexity later on, so be it, but try to start simple. Something you feel confident you could finish with the least amount of risky unknowns.

***Did you develop any new tools or innovative workarounds that you would like to share?
For example, if the hair didn't render properly, you created a new script.***

Modo has this concept of "Assemblies," which allows you to build logic into reusable modules. You can reuse them in the same project or even export them for later use in other projects. There were commonalities between the characters in how they reacted to pitch and volume and I was able to build some of the logic once and use it for the different characters.

Was there a moment when you knew your film was going to be a success?

Well, I had a pretty good feeling people would enjoy it once I ran my first physics test. I placed a pan full of batteries in the robot's hand, animated the robot jumping up to the music, and I was laughing out loud. It reminded me of the Swedish Chef.

***Were there any major plot points or features of the film that changed because of your capabilities?
Would you change it now that you have more experience?***

I had originally imagined using several more special effects such as liquids, smoke, and fire, but I didn't own all the software I needed to make that happen. I decided to just stick with rigid body physics for this project. I hope to incorporate some more organic effects into future projects.

Are you or anyone on your team planning on creating another 3D short film?

Most definitely. I very much enjoyed the overall experience with this short and have started a few other projects.

***Describe your process for coming up with the idea. Did you build around a simple idea?
Cut down from a larger idea? Explain.***

I've been envisioning the concept of [animating] vocal luminescent robots to dubstep for some time but the idea of taking on a five-minute music track seemed overwhelming. I let the idea sit for about a year and when I heard the very concise chorus of the music track I ultimately chose, I was ready to get started. I simplified the idea of giant dubstep robots battling through a city down to a few bots just arguing around the kitchen table. The environment would be simpler but also only using the chorus of a track kept the length to something I could manage in just a few months.

Explain your pre-production methods and planning. Did you use an animatic, pre-visualization, scratch recordings, or just go straight into production, modeling, and animation?

The first step was to run some simple tests of the concept to make sure the vision was solid enough to move forward. I created a very rough robot, added some moving parts, luminous parts, lights and quickly animated them in sync with each other. I then dropped the robot into a simple room to see how everything looked in a closed environment and was ready to start production right after I ran my first physics test.

How important was organization to your process? Do you feel being unorganized would have drastically changed the outcome of your film?

Organization is fundamental for most any digital project. Organization of my assets, textures, and rigging was very important and everything would have just ended up turning into a spaghetti mess if I didn't keep it all in check from the start.

What words of encouragement do you have for someone who wants to create a 3D film at home?

I think it is important to start writing and sketching out your ideas. The prospect of creating a 3D film can sometimes be very daunting and ideas always seem to come and go. I try to at least write my ideas down as I would never be able to remember all of them. Lastly, I think it's important to experiment with a few ideas. It doesn't mean you have to jump into production but just spend a few nights experimenting with your ideas and see if you can fuel the fire to get the project moving.

Finaling

When you are done with the edit, your film is ready to be "finaled." This is the process of making sure you have conformed your film to the display formats that your film will be viewed in. For instance, many films will go through a final coloring by a colorist, to unify the look of the shots across the entire picture. And if you are submitting to festivals in foreign countries, you might have some converting to do. Let's go through some of the issues you may face.

Final Sound

If you have only been listening to the audio on your computer, you absolutely must listen to your film on a set of calibrated studio monitors (the word for speakers when talking about editing and mixing). I have had films screened at a festival and on pressing "play" the audience had to strain to hear anything coming out of the speakers. You might think it worse to have your sound too

loud, but if it's too soft the projectionist does not know whether it is supposed to be that soft and won't turn it up for fear there is a very loud sound coming that might blow out their speakers and the audience's eardrums. If the sound is too loud they turn it down to an acceptable level. It was pure agony looking around and seeing audience members tilt their heads towards the speakers. If you followed my advice early on in this book and used an outside expert for voice recording, perhaps they will offer to mix the sound of your film when it is done. To repeat what I said earlier, the very end of your film is no time to try to learn how to create a really nice mix of your sound. It's hard enough to create a stereo mix, let alone a 5.1 channel surround sound mix. While it might not be the most chivalrous advice I can give to say that someone else should be doing your sound, a short film is much more affordable to mix than you think.

FIG 10.1 If the tools for a particular medium look like this, it's probably best to leave it to the professionals. *Photo: Rebecca Wilson*

Final Color

Even with the greatest care, your film will have color inconsistencies between shots. A coloring program like Apple Color or Adobe Speedgrade takes your rendered images and presents you with a suite of tools to fine-tune the look for consistency. Colorists too are very good at what they do, but this task would not be one that I would say is absolutely essential for you to farm out. It is good practice to learn about colors and your color choices as they appear on film. That said, It is easiest to take care of the inconsistencies in your renders as you composite the shots, and, if there are severely errant pixels, in Maya itself.

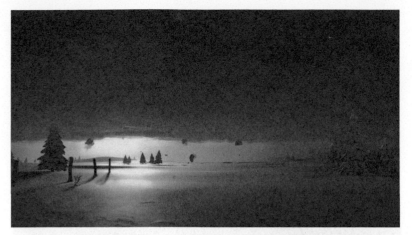

FIG 10.2 One of the best aspects of *Paths of Hate* is its gorgeous vivid color. You can bet your short that Damian Nenow spent a long time working the color of this film.

Depending on how much variation you are getting in your renders, you may be able to get away with using the built-in color tools in After Effects, Autodesk Compositor, or even Premiere.

Credits

This is an important issue that cannot be overlooked. Absolutely everyone who contributed substantially should be credited in your film. No excuses!

There are two main kinds of credit. The first requires fun, colorful motion-graphics treatment. Most feature films have the budget to put a lot of effort into their credits and end up using this type. The obvious advantage of this type is that they look a lot cooler and can continue the aesthetic of the film. It's kind of a cool thing to see the credits perpetuate the visual story. The downside is that they can be a whole project on their own. Again, unless you are a motion graphics powerhouse, you may be signing yourself up for disappointment when you see your results.

FIGURE 10.3 The final imagery of *Paths of Hate* blends beautifully into the fast, layered, violent end credits of the film.

The other kind of credit is the more serious, plain text type. These appear by cutting to the next card, dissolving, or scrolling. The only thing you need to know about scrolling credits is that you have to have them scrolling at either 4 or 8 pixels every frame. For some reason, any other speed flickers and strobes at HD resolution. Just take my word for it.

FIG 10.4 *Adrift* has very simple, plain credits. This is not a bad thing; the nice way in which they fade in and fade out matches the tone of the actual film. *Booty Call* also has plain credits, and we're happy with them. The length of the credits made us opt for the 8 pixels per frame scrolling speed. Four felt much too slow—almost pretentious. But if you do not have a long credit list, four is fine.

Outputting to Media

Depending on which festivals and markets you are looking to submit to and whether or not you are trying to line up meetings with distributors, networks, producers, and the like, your film will likely exist on an array of media types when it is complete.

A 10-bit uncompressed QuickTime is all that is necessary for most festivals, networks, etc. These days, a digital submission is actually preferred. However, there may be a few festivals that require delivery in physical media. The most common format is called HDCAM; Digibeta is also popular. The decks that record a digital file to these media types are very expensive and cost prohibitive to own, especially if you are only outputting a few tapes every year. So do a search in your area for HDCAM or Digibeta transfers. You will find companies that own these decks and will record your film to the appropriate media for a very small fee. They will be able to steer you through the process of outputting the right formats from your editing system or coloring station, too; they do this every day.

FIG 10.5 HDCAM is a very popular format for submission to festivals due to its high bitrate and full-resolution HD picture. *Photo: Dylan Reeve*

DVD/Blu-Ray Authoring

For the rest of your fans (read: family) and loyal audience (read: friends) you will need to author DVDs and Blu-Rays to enable them to watch your film. I might be weird, but for some reason I love this process. It could be that modern software makes the DVD authoring process extremely easy—almost point-and-click. Adobe Encore gives you a suite of easy-to-use tools and the freedom to create almost anything you like with menus, buttons, and embeddable media. For this reason Encore is my tool of choice. However, if a festival, production company, or other serious group requested your film on DVD or Blu-Ray, it would be wise to give them a version that literally auto-runs: no menus, the disc of the film just put into a computer or player and auto-playing. Save the fun menu music, colorful buttons, and hidden Easter eggs for your fans.

A word about DVD authoring in the real world: it takes a lot of time. When working on projects for clients who are distributing the animation on DVD, they need to have at least three months to manufacture the first run of DVDs. Because their run-up time is so long, if you find yourself in a conversation with a distributor or production company, it's advisable to know the kinds of schedule they deal with. For example, if you are nearing the end of your production and a distributor, excited about your film, tells you that they'd like to include your film on a DVD that is coming out in four months, you have only a month (if that) to finish it entirely. Rather than getting yourself

into a tight spot or, worse, not finishing your film the way you want it, let the distributor know that the timeline is too tight for this year.

Internet Streaming

When the festivals are over and the smoke clears, you are going to want the world to see your film. Beware! Not all formats are created equal! Every single online streaming service transcodes your film to its own streaming format when you upload it. This means that you should always use every single pixel and byte that you are allowed when uploading. If possible, an uncompressed 1080p QuickTime would be the best. YouTube, Vimeo, and others will transcode it to an mp4 for streaming. For display on your own website, with your own player, I recommend any h.264 preset designed for streaming, be it for iPad or an android tablet. You will notice our supporting films are almost all encoded this way, and they play smoothly and look good too.

Wrapping Up

Phew! You're done! That wasn't so bad, was it!?

In all seriousness, if you learn anything from this book, I hope it is that a methodical approach is best when it comes to finishing your film. As with any monumental task, with its many ups and downs, finishing a film takes perseverance, a healthy sense of adventure, and perhaps a slightly unhealthy pain threshold. With your final film in hand, you can proudly say that you are joining a very small group of people. People with the guts to take a vision and work at it relentlessly until the dream is realized. People for whom the only satisfaction is a finished film. And finally, people for whom the act of creating something entirely new and artistic will be one of the most rewarding experiences of their lives. Welcome to the club!

Now let's finish another!

Interview

Drink Drunk by Leonardo Bonisolli

FIG 10.6

What was your first experience of creating a short film? Each person can answer separately.
Actually, *Drink Drunk* was my first short film experience. The school I went to required any animator student to graduate with a short film, and that's what I ended up doing. Their pipeline was well structured to pinpoint every important phase of the pre-production and, even if everything is up to you, I've been driven along a path that worked well for the previous students and keeps on working now that I've already graduated.

When you felt technically challenged or blocked, what was your go-to resource?
As you might know, I realized this short film while studying at Vancouver Film School and I was very lucky having lots of people to ask for help whenever I needed it. I obviously had [much] advice from my teachers, but I think my classmates helped me at least as much as the teachers did. I like to believe that animation can always be improved and that fresh eyes are like oxygen for your shots. Sometimes you might feel like you're drowning after three days you're animating the same shot and you can't figure out why something is not working exactly as you wish. In those cases all you need to do is having a different perspective on it. Try asking advice and try solutions that can come up [from] discussing with other fellow animators and (why not) even modelers. My desk-mate at VFS was a modeler and I always showed him my shots when I thought something wasn't working. He might have not known the technical side of animation, but he could understand when something felt off and he always started me thinking why that particular moment of my animation didn't feel right to him.

What were some of the biggest challenges in creating your film?
The biggest challenge in creating this short film was keeping up with my own schedule and at the same time reaching an average level of quality through all the shots of my short. When you animate non-stop for months, you might not really understand how much you are improving and some things that you did one or two months before might not be as good as you thought they were back then.

In those cases I had to [make] a judgment call and decide what was really worth being reworked and what was already good enough. When you first pitch the ideas and decide what your story should be about, I found out that both me and my fellow classmates often tried to do everything the hard way. When you are just brainstorming and just developing your film on paper, if you don't have much experience (as I didn't have), you want to put in the story always much more than what you will be really able to do in the time given for the production phase. Making choices and knowing what to drop and when to drop it was the hardest task of realizing this short film, but I think it makes you understand the importance of deadlines and of a very well-defined schedule.

What was your main focus in completing this project? Completing a film? Making a statement? Getting a job?

My main objective once graduated was finding a job. I wanted to come out of school with a nice short film that could showcase what I could do as an animator that wants to start a career in the movie industry. I was very lucky to find a job two months after my graduation date and since then I've been working in the same TV studio. I'm working on Saturday morning cartoons and I keep on learning a lot of things even though the deadlines for TV are not nearly as soft as those you have in school and you don't have much time to try out many solutions for the same shot. What you don't realize when you are in school is that movie and TV industries have completely different standards from what you are used to. You essentially do the same things, but you have to do them better, faster while learning and listening to the directors and supervisors.

Did you employ any organizational tools such as charts or calendars that were pivotal in staying on deadline?

I made an extensive use of schedules and charts to establish what needed to be done every day. I planned out my schedule every two months giving an average idea of how long each task would have taken me. Obviously I couldn't guess everything precisely and I often underestimated the time it would have taken me to do each thing, but I did my best to stay on schedule even if that meant sacrificing lots of hours of sleep (especially at crunch time). Without a well-defined schedule I would have had a way harder time to get this result and I strongly recommend doing one to whoever wants to start realizing his/her own short film. Being organized means working faster and knowing exactly when you can and cannot relax.

What were some of your favorite tools to work with? What did they do to increase the quality of your film?

I definitely recommend any animator having a mirror on their desk. For how[ever] stupid it may sound, while animating the face of my character I spent almost all the time redoing the same expressions and trying to push my facials the same way I wanted my character to look like. If you can look at yourself any time you have a doubt, you will always have a ready-to-use reference.

I also suggest everybody to put a transparent plastic sheet on their monitor and start drawing on it to point out problems in spacing, posing, and shapes that you might need to refine. I still do these things at work and I actually see some other people doing the same.

What were some tricks for keeping you/your team motivated during this film?

After you finish a shot, it doesn't matter how long it takes, it's always like seeing a piece of the puzzle falling into place. When you start seeing a whole sequence flow together you can understand the potential of your film. In my opinion, an easy way to keep yourself motivated is working alternatively

on something you really like and something that you like less. If you keep shifting back and forth from something really hard to something easier, it's like giving your brain some treats for the effort made so far. Always take breaks if you feel like you are going to burn out soon and remember that if you feel like you're lacking of motivation you can always get some positive feedback showing your WIP to your family and friends and they will push you in the right direction!

What sort of problems will someone likely run into when creating their own short film?

You will likely end up working on the same thing for a long time because you feel like it's not coming out properly. Animation, modeling, texturing … it doesn't matter. Always ask for other people's opinions and try to interpret feedback according to your directions. You always need to have the final say on everything, but this doesn't mean you have to ignore other people's comments; if they say that something doesn't feel right try to understand why they think that way and try to solve the problem.

In your opinion, what are the must-have skills a person needs to create their own short, and what can be learned along the way?

- Being organized
- Being strongly motivated and having a strong objective/reason for creating a short film
- Having a good knowledge of the medium you are going to use (whether it's classical animation, stop-motion, 3D …)
- Knowing how to draw helps a lot for character and set design, storyboarding and color schemes, but if you lack practice with the pencil, don't feel discouraged. I'm a decent drawer only when I have something to copy from; if I have to draw something from scratch I'm not very good at all. But if you keep up your ideas and keep working them out on paper, you will eventually meet your needs and hopes and come out with something you won't regret!

You can always learn on the way some technical aspects that will improve the quality of your short film, but you need to have a strong foundation that will grant you a solid start. There's always space for improvement, but it's important to start from somewhere!

Did your workflow change when you had to work with specialists outside the animation realm, such as designers or musicians? Do you have any advice for those who are creating a film and don't know anything about those areas?

My advice is: try to talk to whoever is going to be on charge of those aspects as soon as you can, even if the production has just started or it hasn't started yet, it doesn't matter. It's better trying to be on the same page from the very beginning than having to go back and try to fix something that you won't have time to fix.

Unfortunately, I can say my experience in this short film suffered a bit [with] this issue. I didn't know anything about audio and music choices, but since I was working into my school pipeline, the audio for my short has been done almost entirely after the animation was completed 100 percent. As you might notice sometimes, the voice-over required some adjustments on the digital performance, but I think that for having been such a fast-paced production it worked out quite well anyway.

I strongly recommend to any animator to animate to sounds, record your actor voice [from] the beginning and animate on top of your audio file. There will be some stuff like footsteps and Foley recordings that will come after the animation is done but you have to capture the performance of the character from the very beginning. Animating on the voice actor performance creates a very strong connection between real and digital character and I'm sure the results will be visible.

Was there a moment when you knew your film was going to be a success?
Actually at the end of production I was happy with my short, but I didn't think that my film was better than many others I had seen before. Out of 32 people in my class, 13 were animators and almost all of them had great pieces that I thought were as good or even better than my short film. Even when I entered the CGSA yearly competition I thought that it was a good way to showcase my reel and to get some opinions on my short from some people in the movie industry. The day the first round of results came out I didn't even know I qualified in the top 20 students until my ex-desk-mate called me and told me to check the website out. I thought it was a joke until I went on the website!

I'm still very impressed and extremely happy with how far this short film is going. I wish anybody the same luck I had because it feels very good when somebody gives you credit for something you spent so much time and energies on and it just gives you more motivation to keep doing what you already love to do.

Describe your process for coming up with the idea. Did you build around a simple idea? Cut down from a larger idea? Explain.
The process I used to come up with the idea for my project was fairly simple. I started thinking of what I really wanted to show in my short and what challenges would highlight my qualities as an animator. One of the very first ideas that came to my mind was animating a drunken character, but I considered also a lot of other options like animating quadrupeds or aiming for a very emotional piece of animation.

I then developed each idea trying to build their concept around a few strong story points until I narrowed down my list to three final options, but I already knew that I just couldn't resist giving life to a drunk and goofy character.

The original story was obviously longer than the final product, but I developed each sequence in a way that could allow me to cut out the least important shots/gags without losing continuity or interrupting abruptly the film flow. The final result is a two-min short that unfortunately didn't end with an extra shot after the credits as I originally planned. In this shot, that didn't make the cut, Harry was supposed to stop a couple meters after the light post and to start lecturing a mailbox, but the time constraints forced me to take this gag and a few others out of the short film. I hope you enjoyed the final product anyway!

Explain your pre-production methods and planning. Did you use an animatic, pre-visualization, scratch recordings, or just go straight into production, modeling, and animation?
Everything started from pitching the idea and reducing it to the minimum necessary. "A drunken guy thinks a light post to be a policeman." Once decided the idea it was time to start gathering references to be used as inspirational material and to set a mood to the whole short film.

In my opinion, the best way to develop a strong and simple idea is using storyboards and a lot of simple sketches. I used all the reference I could find on internet, books and anything that came across my way to sketch color and light schemes, perspective and dynamic framings that I thought would fit the mood of my story. "The more different solutions you try, the better the result will be": these were the words I kept on repeating to myself when I was bored of drawing and I still believe that all those hours spent on paper were some of the most useful for the success of my short.

While adjusting the story and refining the boards, I also spent a long time trying to come out with an appealing design for my characters and for my set. I knew what I wanted the set and the policeman to

look like, but I had a lot of problems coming up with a good design for the main character of my story. He never felt right until I decided to use the design I liked the most and I started tweaking the model directly in 3D. Then and only then I came up with a result that satisfied me and captured the personality of my drunken protagonist.

Once established story and designs, it's time to start production. My advice: "Try to get as much as you can on paper and have your ideas as clear as you can since the very beginning, it's going to help you big time!"

Please discuss your approach to reference material for the main character's movements.
Using and interpreting reference materials are one of the most important tasks of being an animator.

After having set up every shot and finished the layout phase to establish cameras and framing problems in the 3D environment, I started collecting reference.

I already had a vague idea of how I wanted my character to move and I started browsing [the] internet looking for what had already been done on this topic (and I assure you there's plenty of drunk characters in cartoons out there!) and how I could use it, improve it and make Harry become my own kind of drunk. After putting together a small library of funny drunk videos, I had to shoot my own reference and start rehearsing exactly what my digital protagonist would have done on screen.

Whenever I had to start a shot for my short, despite the complexity/simplicity of the actions in it, I always shot some footage of myself trying to figure out in first person how my body was moving or reacting. This doesn't mean that internet references were useless, but I believe that watching a video of somebody doing a specific motion doesn't give you as many information as you would collect doing the same thing yourself. I normally used extensively both kinds of references and I generally tried to edit in a video editor the footage I collected in order to cut together the takes and the best beats of each piece of reference.

After having put a frame counter on the final footage, I used the edited version and all the other takes for timing, mechanics and all those little details that you wouldn't see unless you filmed yourself and watched the videos frame by frame for a million times.

I remember having struggled for a long time with the very first shot of my short and I came to a point when I decided that I had to feel for real as stunned and unbalanced as I could even while shooting reference. Well, I ended up spinning for a minute or two on the same spot in order to get as dizzy as possible before shooting every take, but I think this method improved my performance quite a bit.

Video references helped me a lot also while animating acting shots. In those cases, reference videos were more useful to point out subtleties and small details rather than mechanics.

Always shoot reference when you can, or, if you can't, find somebody else online that did the same thing or something similar to what you need. If you remember to do it, it will already make your animations look ten times better than whatever you would have done without any reference.

Festivals and Markets

Since you are going to be putting so much effort into your film, you may as well enter it in as many festivals as possible. Bringing your film to a market means looking for a distributor who will release your film to a wider audience. Normally this is done when said distributor sees a screening of your film and expresses his/her interest to you directly. At major markets, like Cannes, Sundance, etc., the competition is stiff; you may want to do a little bit of research and determine if there is going to be a distributor in attendance to the festival who you can invite to your screening. A little bit of time on the phone might go a long way. There are only a few considerations when looking into festivals; let's discuss them.

Deadline

First and foremost, do not ever feel pressured to finish your film just for a festival entry deadline. There are plenty of festivals (as you will see below).

If you miss the deadline for this year, you can always submit next year. You want only artistic and technical considerations affecting your deadline, not submission dates.

Categories

Know which film festivals have a category that your film nicely caters to. Michael Cawood, a contributing filmmaker to this book, gives some solid advice; he says look at films that are like yours and apply to the festivals where those films won last year. In this way you are tailoring your submissions to festivals where you have a good chance of winning or at least being accepted.

Eligibility

Many festivals have strict eligibility policies regarding where and how your film can screen. Specifically, many do not allow for your film to be posted in its entirety *online*. Still others (though a much smaller number) ask that your film not be screened by a major distributor. Check the rules of each festival you apply to and come up with a roadmap for your submissions. Meaning, hit the festivals that are strictest *first*, then, as you move through the festival season, submit your film to the progressively more lenient and open festivals.

Withoutabox.com

Simply put, withoutabox.com is an extensive resource site for independent filmmakers. It includes a submission form and media repository for submission to hundreds of festivals. I highly recommend that you sign up on their website in order to submit to the festivals that accept their form and gain access to their other resources.

 FIG 11.1

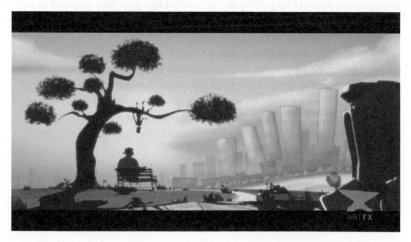

List of Festivals

This is a good starting point for your search for festivals. There are many more out there, so keep your eyes open and submit to as many as you can find time for, and as much as your budget allows.

Festival Name	URL
3D Wire Animation Market	www.3dwire.es/mercado.html
Abitibi-Témiscamingue (FCIAT)	www.festivalcinema.ca
AFI Film Festival	www.afi.com/afifest/
Akron Art Museum	www.akronfilm.com
Alcine 38	www.alcine.org/home/index.php?idioma=2
Alpinale Short Film Festival	www.alpinale.net
Anibar Animation Festival (Kosovo)	www.anibar.com
AniFest (Czech Republic)	www.anifest.cz
Anim'est Romania	www.animest.ro
Anima Mundi 2010 (Brazil)	www.animamundi.com.br/pt/festival/
Animayo	www.animayo.com
Animex International Festival of Animation and Computer Games	http://animex.tees.ac.uk/student_awards.cfm
Animafest	www.animationcenter.gr
Animiami	www.animiami.com
Ann Arbor Film Festival	www.aafilmfest.org/
Annecy International Animation Festival	www.annecy.org/home
Annie Awards	www.annieawards.org
Anonimul International Independent Film Festival	www.festival-anonimul.ro/home_en
Arcipelago–International Festival of Short Films and New Images	www.arcipelagofilmfestival.org
ArtFutura	www.artfutura.org/v2/index.php?lang=En
Artscape (part of Maryland Film Festival)	www.mdfilmfest.com
Asiana International Short Film Festival	www.aisff.org
Aspen Shortsfest	www.aspenfilm.org/index.php/events/aspen-filmfest
Athens Film Festival	www.athensfest.org
Atlanta Film Festival	www.atlantafilmfestival.com
Aurora Picture Show	www.aurorapictureshow.org/pages/home.asp

Festival Name	URL
Austin Film Festival	www.austinfilmfestival.com
Australian International Animation Festival	www.aiaf.com.au
Azyl Short Film Festival	http://azyl.zeroone.sk/
Badalona Film Festival	www.festivalfilmets.cat/
Bases Festifil	http://webs.ono.com/cine-lafila
Bay Area International Children's Film Festival	www.baicff.com/
Be There Corfu Animation Festival	www.betherefest.gr/index.php?option=com_content&view=article&id=117%3Atainies-diagwnistikou-2011&catid=46%3Aregulations&Itemid=179&lang=en
BEFilm New York	www.Befilm.net/
Berlin International Film Festival	www.berlinale.de/en/HomePage.html
Berlin Interfilm International Short Film Festival	www.interfilm.de/en/festival2012/home.html
Beverly Hills Shorts Festival	www.beverlyhillsshortsfestival.com/
Big Bear Film Festival	www.bigbearlakefilmfestival.com/
Bilbao International Festival of Documentary and Short Films	www.zinebi.com/Zinebi55Preview/index.php/en/
Black Maria Film Festival	www.blackmariafilmfestival.org/
Boston International Film Festival	www.bifilmfestival.com/
British Academy of Film and Television Arts Awards	www.bafta.org
Brussels Short Film Festival	http://bsff.be/
Byron Bay International Film Festival	www.bbff.com.au/
Calgary Underground Film Festival	http://calgaryundergroundfilm.org/
California Independent Film Festival	www.caiff.org/
Cannes International Film Festival	www.festival-cannes.com/en.html
Cannes Short Film Corner–Court Métrage	www.cannescourtmetrage.com/en/
Capalbio Cinema ISFF	www.capalbiocinema.com/iscrizione/risposta.htm
Cartagena International Film Festival	http://ficcifestival.com/index.php?leng=1
Cartoon Club (Italy) –Children's Jury	www.cartoonclub.it
Chesapeake Film Festival	www.chesapeakefilmfestival.com
Chicago International Children's Film Festival	www.cicff.org/

Festival Name	URL
Chicago International Film Festival	www.chicagofilmfestival.com/
Children's Film Festival Seattle/REDCAT	www.childrensfilmfestivalseattle.org/
Cinanima International Animation Film Festival	www.cinanima.pt/
Cine Verdi, Sala Montjuïc (Barcelona)	www.salamontjuic.org/
Cinema Tous Ecrans	www.tous-ecrans.com/2013/en/home
Citrus Cel Animation Film Festival	citruscel.com
Clermont-Ferrand Short Film Festival	www.clermont-filmfest.com/index. php?nlang=2
Cleveland International Film Festival	www.clevelandfilm.org/
CMS International Children's Film Festival	www.cmsfilms.org
Comedy Cluj	www.comedycluj.ro
Comic Con	http://www.comic-con.org/cci/film-festival
Concorto Film Festival	www.concorto.com
Cortoons International Short and Feature Animated Film Festival	www.cortoons.it
Courts Devant	www.courtsdevant.com/
Creative Talent Network animation eXpo	www.ctnanimationexpo.com/
Cucalorus Film Festival	www.cucalorus.org/entry_form.asp
Curtas Vila do Conde International Film Festival	www.curtas.pt
Curtocircuito International Short Film Festival	www.curtocircuito.org
Cyprus International Film Festival	www.cineartfestival.eu/
DC Shorts Fest	www.dcshorts.com
Détours en Cine Court	www.cinecourt-bellevue.com/
Digital Media Festival/Australian Effects and Animation Festival Awards	www.vfxfestival.com/
Encounters Short Film Festival	www.encounters-festival.org.uk/
EuroAsia Shorts Film Festival (Washington, DC)	euroasiashorts.com
Expresion Corto International Film Festival	www.expresionencorto.com
Fano International Film Festival	www.fanofilmfestival.it/?lang=en
Fantastic Fest	www.fantasticfest.com/
Fargo Film Festival	www.fargofilmfestival.org/
Festival of Contemporary Animation and Media-Art–Linoleum	www.linoleumfestival.ru/festival-en

Festival Name	URL
Festival de Cine Fantástico de la Universidad de Málaga–Fancine	www.fancine.org/
Festival de Cinéma du Grain á Demoudre	www.dugrainademoudre.net/
Festival Illumines (L'école des Mines de Douai)	www.illumines.fr/
Festival International des Très Courts	http://trescourt.com/?page=en_home
Film Festival of Lanzarote	www.festivaldecinedelanzarote.com/
FilmCaravan Imperia Travelling Shorts Fest	www.filmcaravan.org
Filmfest Dresden	www.filmfest-dresden.de/english/home.html
Flatland Film Festival	www.flatlandfilm.org/
Flickerfest International Short Film Festival (Sydney)	www.flickerfest.com.au
Flix in the Stix	www.flixinthestix.com.au
Florida Film Festival	www.floridafilmfestival.com/
FMX Conference of Animation (Stuttgart)	www.fmx.de
Fort Lauderdale International Film Fest	www.fliff.com/
Fresh Film Fest	www.freshfilmfest.net
Future Film Festival (Italy)	www.futurefilmfestival.org
Garden State Film Festival	www.gsff.org/
Gijon International Film Festival for Young People	http://en.fic.gijon.es/
Granada Filmfest Animación	www.filmfest-granada.com/
Green Bay Film Festival	www.gbfilmfestival.org
Gulf Film Festival (Dubai)	www.gulffilmfest.com/en/
Hamptons International Film Festival	http://hamptonsfilmfest.org/
Hatch Audiovisual Arts Festival (Bozeman, MT)	www.hatchfest.org/
Hawaii International Film Festival	www.hiff.org/
Heartland Film Festival	www.heartlandfilmfestival.org/
Hill Country Film Festival (Texas)	www.hillcountryff.com/
Hiroshima International Animation Festival	http://hiroanim.org/index.html
Holland Animation Film Festival	www.haff.nl/en/
IndieLisboa (Portugal)	www.indielisboa.com/?lang=2
International Festival of Animation Arts–Multivision	www.multivision.ru
International Short Film Festival (Nijmegen)	www.goshort.nl
Jackson Hole Film Festival	www.interfilm.de/en/interfilm-de.html

Festival Name	URL
Jerusalem International Film Festival	www.jff.org.il
KLIK! Amsterdam Animation Festival	http://klikamsterdam.nl
Kracow Internation Film Festival of Short Films	www.krakowfilmfestival.pl/en/
KROK International Animation Film Festival	www.krokfestival.com/?ver=eng
KUKI–Berlin Short Film Festival for Youth	www.shortfilmdepot.com
L'Idea di Clèves (L'Aquila)	www.cleves.it/en/index.php
Lago Film Festival	www.lagofest.org
Leeds Film Festival	www.leedsfilm.com
Leiden International Short Film Festival	www.lisfe.nl
Leids Film Festival	www.leidsfilmfestival.nl
Les Nuits Magiques	www.lesnuitsmagiques.fr
Lille International Short Film Festival	www.festivalducourt-lille.com
London Film Festival	www.bfi.org.uk/lff/
London International Animation Festival	www.liaf.org.uk
Los Angeles Film Festival	www.lafilmfest.com/
Los Angeles International Short Film Festival	http://lashortsfest.com
Lucas International Children's Film Festival	www.lucasfilmfestival.de
Manhattan Short Film Festival	www.msfilmfest.com/
Maryland Film Festival	www.mdfilmfest.com
Maui Film Festival	www.mauifilmfestival.com
MECAL International Short Film Festival	www.mecalbcn.org
Medina Del Campo FF	www.medinafilmfestival.com
Mediterranean Short Film Festival	www.ccm.ma/en/festcmmt.asp
Melbourne International Film Festival	www.melbournefilmfestival.com.au/
Milano Film Festival–Short Marathon Focus on Animation	www.milanofilmfestival.it
Milwaukee Film Festival	www.milwaukee-film.org
MONSTRA–Lisbon Animated Film Festival	www.monstrafestival.com
Montreal International Festival of New Cinema	www.nouveaucinema.ca/en/
Montreal World Film Festival	www.ffm-montreal.org/en_index.html
MUMIA–Underground World Animation Festival	www.mumiainternational.blogspot.com/
Mundos Digitales	www.mundosdigitales.org/en/index.html

Festival Name	URL
MusiK à Pile	www.musikapile.fr
Nantucket Film Festival	www.nantucketfilmfestival.org
Naples International Film Festival	www.naplesfilmfest.com
Nashville Independent Film Festival	www.nashvillefilmfestival.org/
Nevada City Film Festival	www.nevadacityfilmfestival.com/
Nevermore Horror Film Festival	http://festivals.carolinatheatre.org/nevermore/
New York International Children's Film Festival (NYICFF)	www.gkids.com
New Zealand Film Festival	www.nzff.co.nz
Newport Beach Film Festival	www.newportbeachfilmfest.com
NYC Shorts	www.nycshorts.com/
Oberhausen International Short Film Festival	www.kurzfilmtage.de/
Off-Courts Trouville Short Film Festival	www.off-courts.com
Ojai Film Festival	www.ojaifilmfestival.com/
Oscars	www.oscar.com/
Other Venice Film Festival	http://othervenicefilmfestival.com/
Ottawa International Animation Festival	http://oiff.ca/
Oxford Film Festival	www.oxfordfilmfest.com
Palm Springs International Short Film Festival	www.psfilmfest.org/index.aspx
Paris Courts Devant	www.courtsdevant.com
Petaluma International Film Festival	www.PetalumaFilmFestival.org
Planet in Focus–Environmental Film and Video Festival	www.planetinfocus.org/
Port Townsend Film Festival	www.ptfilmfest.com/
Portland International (Zonker Films)	www.nwfilm.org/festivals/piff/
Prague Short Film Festival	www.pragueshorts.com
Puchon International Fantastic Film Festival (aka PiFan)	www.pifan.com/eng/index.asp
Reel 2 Reel–International Film Fesival for Youth	www.r2rfestival.org
Rencontres Audiovisuelles France	www.rencontres-audiovisuelles.org
Rhode Island International Film Festival	www.film-festival.org/
Rio de Janeiro International Short Film Festival	www.curtacinema.com.br

Festival Name	URL
RiverRun International Film Festival	www.riverrunfilm.com
Roanne Animation Festival	http://animationfestival.roanne.fr/
Rooftop Films NYC Summer Series	http://rooftopfilms.com/summerseries.html
Rushes Soho Shorts Festival	http://sohoshorts.wordpress.com/
Salento Finibus Terrae Film Festival	www.salentofinibusterrae.com/index_eng.php
San Francisco International Film Festival	http://festival.sffs.org/
San Luis Obispo International Film Festival	www.slofilmfest.org
Santa Barbara International Film Festival	http://sbiff.org/main/
Sao Paulo Shorts Festival	www.kinoforum.org.br/curtas/2013/index_en.php
Sapporo Shorts Fest	http://sapporoshortfest.jp/en/
Sardinia Film Festival	www.sardiniafilmfestival.it
Savannah Film Festival	www.scad.edu/filmfest/
Science Fiction and Fantasy Short Film Festival	www.empsfm.org/filmfestival
Seattle International Film Festival	www.siff.net/
Sedicicorto International Film Festival (Forli)	www.sedicicorto.it
Seoul International Cartoon and Animation Festival	http://new.sicaf.org/xe/sicafmain_eng
Seoul International Youth Film Festival (SIYFF)	www.siyff.com/eng/
Sequence Short Film Festival	www.sequence-court.com
Short Film Section, Guardian Hay Literature Festival	www.hayfestival.com/wales/
Short Shorts (Japan)–register at www.shortfilmdepot.org	www.shortshorts.org/2013/index-en.php
Shortcuts Berlin	www.shortcuts.blogsport.de
Shorts International Film Festival	http://shortsfilmfestival.com/
Showcomotion Young People's Film Festival	www.showcomotion.org.uk/
Sidewalk Moving Picture Festival	www.sidewalkfest.com/
Siggraph	www.siggraph.org
Slamdance Film Festival	www.slamdance.com/
Sottodiciotto Filmfestival–Turin Young Screen	www.sottodiciottofilmfestival.it
St Louis International Film Festival	www.cinemastlouis.org/
Stuttgart International Animation Festival	www.itfs.de/en/start.html
Sundance Film Festival	http://festival.sundance.org

Festival Name	URL
SWISS FILMS Short Film Night on Tour 2010	www.swissfilms.ch
SXSW	http://sxsw.com/
Sydney Film Festival	http://sff.org.au/
Syracuse International Film Festival	http://filminsyracuse.com/
Tallgrass Film Festival	www.tallgrassfilmfest.com
Telluride	http://telluridefilmfestival.org/
The Boulder International Film Festival	www.biff1.com/
The Director's Cut	www.thedirectorscut.org/
Toronto International Film Festival (TIFF)	http://tiff.net/thefestival
Toronto Worldwide Short Film Festival	www.shorterisbetter.com
Traverse City Comedy Shorts Film Fest	www.comedyartsfest.org
Tri-City Film Festival	www.tcif3.com
Tribeca Film Festival	www.tribecafilm.com/festival/
Tucson Film and Music Festival	www.tucsonfilmandmusicfestival.com/
Turin International Film Festival of Young Cinema	www.torinofilmfest.org/
USA Film Festival (Dallas)	www.usafilmfestival.com/
UTS Sydney International Animation Festival	www.siaf.uts.edu.au
Vail Film Festival	www.vailfilmfestival.org/
Vendome Film Festival/Centre Images France	www.vendome-filmfest.com
Venice International Film Festival	www.labiennale.org/en/cinema/
VIEW Conference	www.viewconference.it/
Washington, DC International Film Festival	www.filmfestdc.org
Webcuts 10 Berlin Online Film Festival	www.webcuts.org
Wild and Scenic Film Festival	www.wildandscenicfilmfestival.org
Williamsburg International Film Festival	www.willifest.com
World Festival of Animated Films	www.varnafest.org
Zagreb World Festival of Animated Films	www.animafest.hr/en
Zinebi International Festival of Documentary and Short Film (Bilbao)	www.zinebi.com

Glossary

Term	Definition
3 ds Max:	Much like Autodesk's Maya, 3 ds Max is a 3D animation software.
Alpha Channel:	See Matte
Ambient Pass:	See Occlusion Pass
Animatic:	A movie file made from editing storyboards together into scenes with the dialogue and music.
Animator:	Person responsible for creating motion on an animated film. The public commonly mistakes animator to mean a CG artist, but this person specifically deals with motion.
Arcs:	Most natural movement moves on arcs, in nature. In Animation, we use this concept to create smooth motion that is appealing to the audience, as opposed to straight and mechanical motion.
Assets:	Any digital file created to be used in a short film from models to rigs to textures and more.
Beat:	A single moment in an animated scene that contains a thought or a small part of the action. A shot can have multiple beats within it.
Beauty Pass:	A rendered image that combines all of the passes together to give a baseline image that can be further tweaked using other rendered layers.
Blendshape:	A mesh whose topology matches that of another mesh but has some modifications done to the position of the vertices. For instance, you may have a base model of your character's head and then a blendshape of your character smiling, so that Maya can blend between the two shapes.
Blocking:	The stage after layout in which the main poses of an animation are created but the character is still moving in a rudimentary way.
Breakdown:	A keyframe created between two more "important" or "storytelling" keyframes meant to refine the transition between the keys.
Cache:	All of Maya's dynamic effects and some other nodes can be cached, whereby a file is created that contains all of the information of the dynamic effect that Maya then reads when playing the animation as opposed to calculating it freshly each time.

CG:	Computer Generated. Often coupled with CGI to mean Computer Generated Imagery or CG Artists to mean computer graphics artists
Chess-Piece:	Animating your character using the master controller, with no posing. This is done for your 3D Animatic.
Climax:	The pivotal moment of a story that is the most exciting turning point in the action.
Compositing:	Assembling the rendered layers into the final image known as a composite. This is done within a compositing program such as Adobe's After Effects.
Composition:	The arrangement of objects and characters and sets in the camera frame.
Constraint:	A method of linking object's transforms together that has the advantage over simple Parenting in that the link can be animated on and off.
Controller:	A NURBS curve used as part of a rig system as an object the animator is meant to use to move the character.
Creased Edges:	An edge that has been given a crease value using the Crease Tool, thereby making it so it does not smooth when it is subdivided, rather stays as a hard edge.
Depth of field:	The distance between the nearest and furthest objects in a scene that appear sharp in a rendered image. Also sometimes referred to as the Focal Plane.
Depth Pass:	A rendered image that contains the depth of an object's position in space signified by value from black to white with white being close to camera and black being very far away from camera.
Displacement Mapping:	Deformation of a mesh using an image that deforms the geometry based on the values of the pixels. Typically brighter values mean higher displacement and lower values mean less displacement.
Economical:	Using the best methods to save time and energy on your short film while not sacrificing too much quality
Edge Loop:	A series of continuously connected edges that travel across a mesh.
Focal Length:	The "Zoom" of your camera. Higher values are more zoomed, low values are more fisheye.
Foley:	Creating sound effects by watching the film playback silently, while recording yourself making the sounds live like stomping your feet for a walking character, or dropping a bag of fruit when your character hits the ground. This live recording often has a more real quality to it over assembling pre-recorded sound effects.

Frame-by-frame:	Watching animation a single frame at a time so as to be able to pick out the minute details.
Generalist:	A CG artist with skills in all areas of production, from modeling to animation, texturing to rigging.
Grease Pencil:	A tool in Maya used to draw over a panel, giving you the ability to quickly work out issues such as spacing and arcs.
Group:	A transform node without a shape node that acts as a "container" for other objects.
Image plane:	An image that is connected to a camera and can be seen through the camera's view
In-Betweens:	Much like a breakdown (see breakdown), an in-between is even finer refinement on the motion between main poses.
Incremental Save:	A feature of Maya accessed by clicking the square next to File > Save that creates a new file every single time you save your file and adds an increment to the file name. This is done so that even if you do not "version up" your saves, you still have access to multiple versions of the scene.
Instance:	A copy of an object that still retains all of the edits done to the original, and that will also update with new edits done to the original as well.
Key/Keyframe:	Setting a "key" tells Maya to save the position of an object or the value of a channel on a specific frame. By interpolating between keys, Maya creates smooth motion.
Layout:	An animated scene that contains the roughly positioned and animated characters for the purpose of establishing a starting point for animation to commence.
Lighting:	The placement and adjustment of lights in a 3D scene, as well as the creation of layers for later assembly in compositing.
LMB:	Left mouse button
Manipulator:	The axis handles that appear on a select object which can be used to translate, rotate, or scale the object.
Matte:	Either referring to a background image created to lessen the amount of work needed to portray a large expansive environment OR an alpha channel, which is the transparency information of an image.
Maya:	Autodesk's flagship, full-featured 3D animation software.
MMB:	Middle Mouse Button
Modeling:	Creating the 3D polygonal models used in CGI by using techniques such as box modeling, sub-division, and sculpting.

Motion Blur:	The effect of blurring objects based on their speed that is a result of the amount of time a real world photographic camera's shutter is opened.
Mudbox:	A procedural modeling tool created by Autodesk that simulates sculpting with clay.
Narration:	Voice-over from an omnicient third-party observer describing thoughts, actions, or events for the audience.
Normal:	The "direction" that a polygonal face is facing.
Null:	Any object that has no other information upon it other than transform information i.e. position, rotation, and scale
Occlusion Pass:	A rendered image that takes into account the amount of ambient light that is blocked by parts of an object. This commonly looks like the object is made out of clay and is outside on a cloudy day. Also known as the "dark in the cracks" render.
One-Off Shot:	A shot in your film that is a completely unique shot in that it reuses very few if any assets, thereby making it so that you are putting much more effort into the single shot than others in your film.
Orthographic:	In design, a drawing of a 'flattened' angle of a prop or character, e.g. a "side view" or a "front view". In 3D, a panel with no perspective, which can also be "front" or "side".
Panel:	A window within Maya's interface. Panels can display camera views, animation editors, etc.
Pantomime:	Performance without dialogue. The word 'mime' comes from the word pantomime.
Parent:	An object that has other objects arranged in a hierarchy BELOW it, called children. A parent's transformations affect all of the child objects. Creating this relationship is also called "Parenting".
Payoff:	The moment in a film when the emotional build up of the short culminates with a satisfying and rewarding moment of completion.
Phoneme:	The smallest part of audible speech. CG artists mistakenly use phonemes to create facial rigs. See Viseme.
Pipeline:	The combination of workflow and software that defines how a film is created from start to finish.
Playblast:	A movie generated from a Maya panel to view the animation at 24 frames p/second rather than the slow playback of a heavy Maya scene file
Plot:	The sequence of events in a story that reveal the characters' actions and motivations.

Polish:	The final stage of animation when the fine details like blinks and finger movement is added.
Pre-Production:	All of the tasks leading up to producing a film from design to writing to storyboarding and more.
Preroll:	Frames added to the beginning of a scene so that dynamics can calculate to a decent starting position. If you start your animation on frame 101, then you do not need preroll, as the dynamics can run in the first 100 frames before your animation can begin.
Previz:	Rough animation, a level above that of 'layout', done to further refine the idea of a scene.
Primitive:	An object that is built into Maya's creation tools, such as a sphere, cube, or torus. Primitives do not need to be modeled polygon by polygon, rather they can be starting points for your objects.
Production:	The set of tasks that encompasses animation, lighting, rendering, and compositing.
Prop:	Anything that your character interacts with or that is animated in a scene, besides the characters. (A hat, a hammer, and a hacksaw are all props)
Public Domain:	Any property that has lapsed in the time that the copyright can be renewed enters the Public Domain meaning anyone in the world can make a work derived from this property. Some notable examples of Public Domain properties are Snow White and Jack in the Beanstalk and the Little Cinder Girl (Cinderella).
Push/Pull Workflow:	In Push workflow, an updated asset is published and therefore is PUSHED into all of the scenes that were referencing the published file automatically. In Pull workflow, an asset is updated and then all of the scenes that need the new asset will have to be opened to PULL in the new asset.
RAID array:	A way of combining disk drives into a virtual array to take advantage of speed and storage increases gained from having many hard drives in your computer.
Reference Video:	Footage either collected from online sources or shot yourself to help you create lifelike motion.
Referencing:	A method of creating a file link within MAYA so that you can collect multiple assets into a shot without having to actually import the large scenes together.
Rendering:	The calculation of the final image by a computer program called "The Renderer" built in to most animation 3D software.
Rigging:	The creation of joints and control systems to animate characters.
RMB:	Right mouse button

Root Folder:	This is the base directory for your project. The way MAYA handles projects, it designates the Root folder as the relative starting point for the relative starting paths for your assets. For example, if your Root folder is called projects/3D than a file in //assets/models is actually in projects/3D/assets/models.
Scale:	The combination of production value and the literal size of a film
Scope:	The size of the vision of the film in terms of how deep a story you are trying to tell, how expansive your world is that you are trying to create, the number of characters, and the overall production effort needed to build your short.
Shaders:	Small computer algorithms built into the rendering engine that tell the computer how a surface is supposed to behave under different lighting conditions.
Shadow Pass:	A rendered image that contains only the cast and received shadows of an image in a scene.
Shot:	The moving image whose duration is from the beginning of a editorial cut to the end of the specific cinematic thought.
Skinning:	Applying a mesh to a joint chain so that the joints deform the mesh according to the weighting of the joints. Adjusting the weights and adding extra deformations are also part of skinning.
Smooth Mesh Preview:	Pressing the 3 key on your keyboard activates the smooth mesh preview, whereby you can preview your mesh as it will be rendered smooth in Mental Ray.
Solid State Drive (SSD):	A storage device made from flash memory and therefore, without moving parts. Solid State Drives can read and write data almost 10x faster than normal disk drives.
Specular Pass:	The render layer that has only the highlights of shiny objects included in it
Spline:	A NURBS curve that shows up a wire shape in Panel; also a tangent type in animation that favors smoothness over motion continuity.
Stop Motion:	Animation created using a frame-by-frame technique, either by moving objects in front of a camera and shooting a single frame or by manipulating other materials such as paper cut-outs.
Storyboard:	A drawing of a shot used to plan the staging and composition of the characters and camera.
Technical Director:	A CG artist typically in charge of applying lights in an animated shot. Sometimes TD's can be specified as Character TD's or Pipeline TD's who have jobs similar to their names.

Tempo:	Creating your animation with timing choices in mind as opposed to posing choices first. This can be accomplished by animating a simple helper object as you would your character, and then filling in the poses with your character afterwards. Animating with Tempo produces much more exciting and unique timing choices.
Texture:	An image file used in a material to define a property of the material, like the color, the specularity, or the transparency.
Texturing:	Creating and applying the drawn or photographed images that are applied to 3D modes to give them color and texture.
Thumbnails:	A very small drawing (it gets its name from its size) of a scene, either to explore framing, staging, or posing choices for your character.
Timecode:	A counter that displays the running time of a piece of film or video
Turbosquid.com:	A very popular 3D asset repository online, with thousands of free and paid downloadable models and textures.
UV Map:	A 2D representation of how a texture will be stretched over the surface of a 3D object.
VFX:	Visual Effects. Computer generated imagery that appears and incorporated into live-action filmmaking.
Viseme:	The smallest part of visibile speech, that is, all of the unique shapes the mouth makes when speaking. The list of visemes is far less than the number of phonemes, and as such is much better to use to create facial blendshapes.
Visual Development:	The creation of a "look." This can be anything from the palette of the film, the geometric details of the models, the stylization of the render, and anything that can contribute to the film's "look."
Volumetric:	A dynamics simulation used for creating effects such as fog, fluid, smoke, and fire.
Wacom Tablet:	An input device, much like a mouse for your computer, that uses an electronic surface and a pen; recommended for painting textures and in the case of animators with wrist problems for general use.
Withoutabox.com:	An essential website for short filmmakers to use to find out about and submit the film to hundreds of festivals worldwide.
Workflow:	The methods and practices used to create an animated scene as well as the order of those techniques maximized for efficiency and creative freedom.

Index

Note: page numbers in italic type refer to Figures.